Gauguin's World
Tōna Iho, Tōna Ao

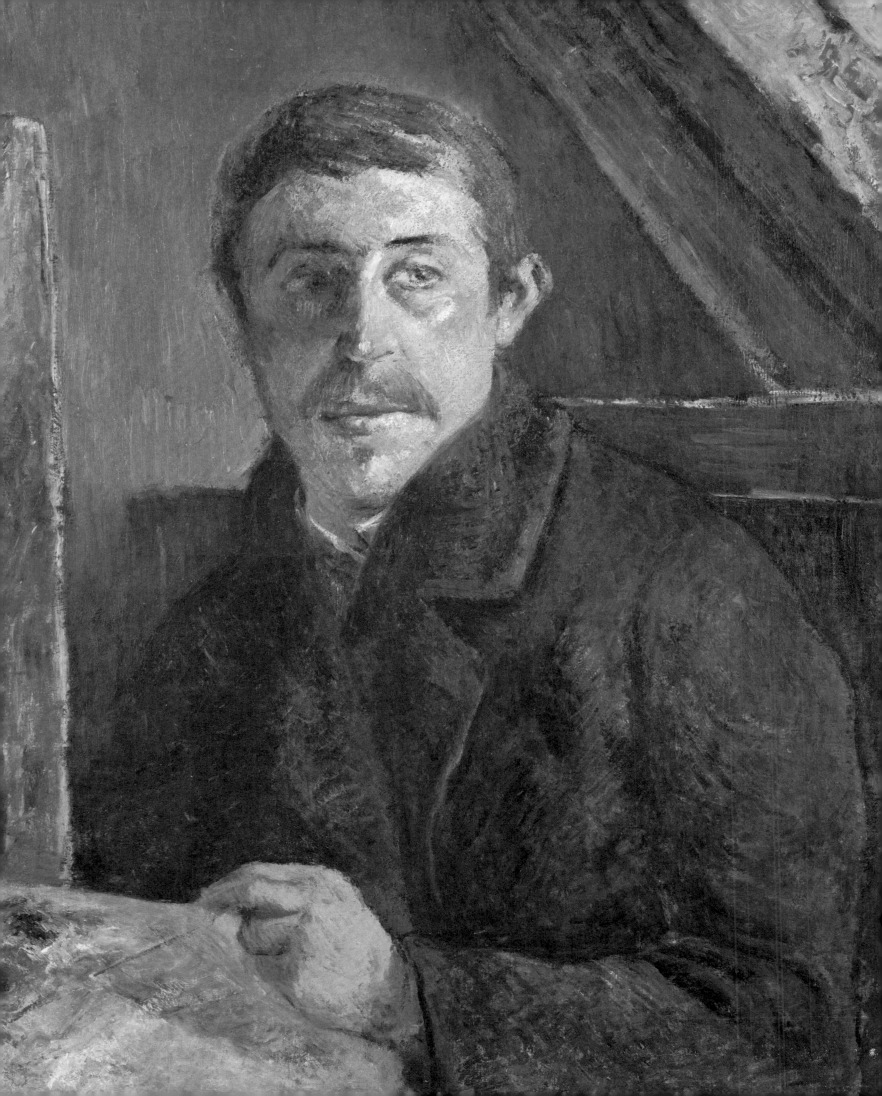

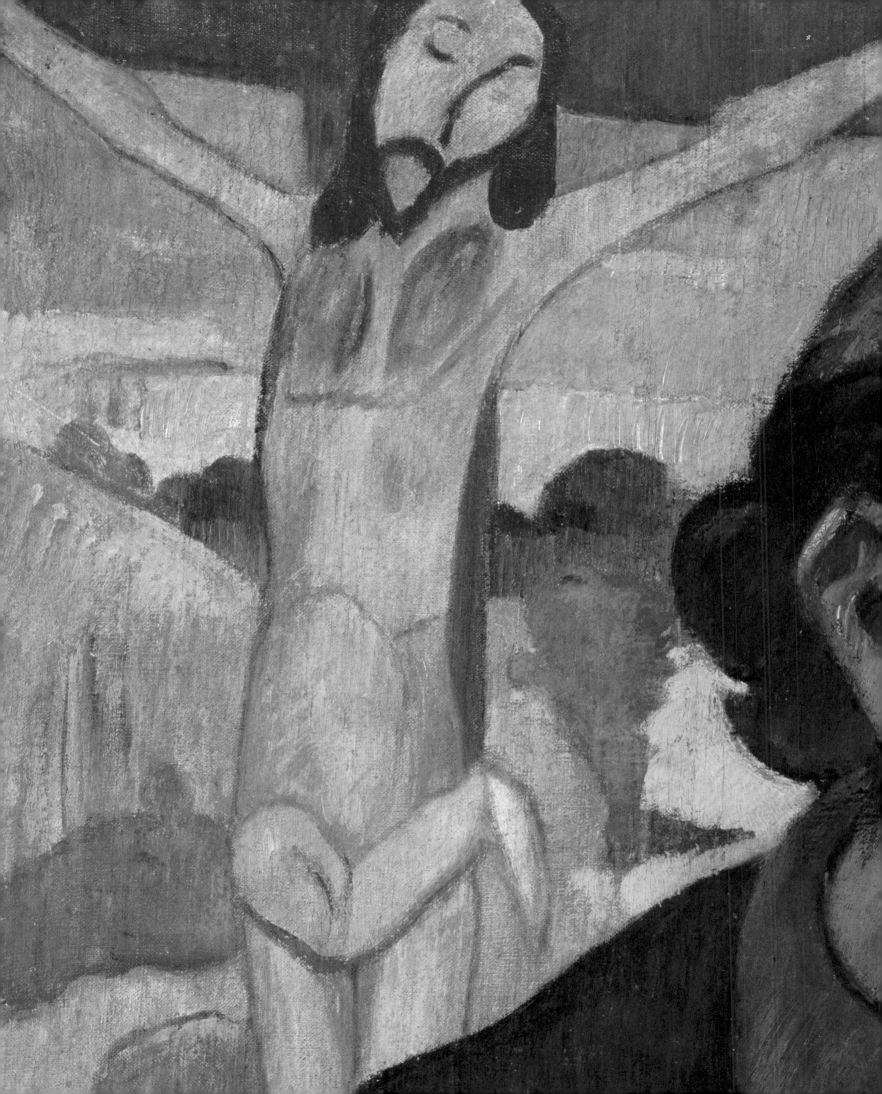

(photo: Claude Germain); p 221 (right): © Musée du quai Branly – Jacques Chirac, Paris; p 222: image courtesy Van Gogh Museum, Amsterdam; p 223: image courtesy Baltimore Museum of Art; p 225 (fig 19): © Musée du quai Branly – Jacques Chirac, Paris, distributed GrandPalaisRmn (photo: François Vizzavona); p 226: © Musée d'Orsay, Paris, distributed GrandPalaisRmn (photo: René-Gabriel Ojeda); p 227: image courtesy Museu de Arte de São Paulo Assis Chateaubriand (photo: Eduardo Ortega); p 228: image courtesy the Morgan Library and Museum, New York; p 229: © President and Fellows of Harvard College; p 230 (fig 20): © Musée d'Orsay, Paris, distributed GrandPalaisRmn / © Thierry Le Mage; p 231: image courtesy National Museum of Serbia, Belgrade; p 232 (fig 21): image courtesy Tallandier / Bridgeman Images; p 233 (top): image courtesy Bibliothèque nationale de France, Paris; p 234 (bottom): image courtesy Bibliothèque nationale de France, Paris; p 235 (left): image courtesy Bibliothèque nationale de France, Paris; p 235 (top right): image courtesy Bibliothèque nationale de France, Paris; p 235 (bottom right): image courtesy Bibliothèque nationale de France, Paris; p 237: image courtesy National Gallery of Art, Washington, DC; p 239: image courtesy National Galleries of Scotland, Edinburgh; p 240 (left): © Sotheby's, Inc 2024; p 240 (right): © Musée du quai Branly – Jacques Chirac, Paris; p 241 (top): image courtesy Te Fare Iamanaha – Musée de Tahiti et des Îles, Papeete (photo: Danee Hazama); p 241 (bottom): © Musée d'Orsay, Paris, distributed GrandPalaisRmn (photo: Franck Raux); p 242: © Musée Marmottan Monet, Paris (photo: Studio Christian Baraja SLB); p 246 (top): image courtesy the J Paul Getty Museum, Los Angeles; p 246 (bottom): image courtesy Te Fare Iamanaha – Musée de Tahiti et des Îles, Papeete (photo: Danee Hazama); p 247: image courtesy National Gallery of Art, Washington, DC; p 248 (top): © Musée du quai Branly – Jacques Chirac, Paris (photo: Claude Germain); p 248 (bottom): © The Trustees of the British Museum, London; p 249: image courtesy the Morgan Library and Museum, New York; p 250: image courtesy the McNay Art Museum, San Antonio; p 251: © 2024 Museum of Fine Arts Boston; back cover: © Paolo Vandrasch.

First published in 2024 by
National Gallery of Australia
Ngunnawal Country
Parkes Place East, Parkes
ACT 2600

Art Exhibitions Australia Limited
Gadigal Nura
98 Cumberland Street
The Rocks, Sydney
NSW 2000

Published for the exhibition *Gauguin's World: Tōna Iho, Tōna Ao*, an exhibition organised by the National Gallery of Australia, the Museum of Fine Arts, Houston, and Art Exhibitions Australia; and held at the National Gallery of Australia, Parkes, Kamberri/Canberra, 29 June – 7 October 2024 and the Museum of Fine Arts, Houston, 1001 Bissonnet Street, Houston, 3 November 2024 – 16 February 2025.

The National Gallery of Australia is an Australian Government Agency.

Title: Gauguin's World: Tōna Iho, Tōna Ao
Editor: Henri Loyrette
ISBN: 9780642335081
First published: June 2024

Design: Small Tasks (Andrew Darragh and
 Ricardo Felipe)
Text editor: Alan Lockwood
Proofreader: Clare Williamson
Translator: Chris Miller (essays by Miriama Bono,
 Vaiana Giraud and Henri Loyrette)
Imaging: Sam Cooper, Eleni Kypridis, Brooke
 Shannon and David McClenaghan*
Rights and permissions: Ellie Misios, Michelle
 Andringa and Emma Round*
Publishing Assistant Manager: Meagan Down*
Publishing Manager: Penny Sanderson*
Pre-press: Adams Print
Printed by: Adams Print
*National Gallery of Australia

Front cover: *Three Tahitians* (*Trois tahitiens*) 1899 (detail). National Galleries of Scotland, Edinburgh. Presented by Sir Alexander Maitland in memory of his wife Rosalind 1960, NG 2221

P 2: *Self-portrait* (*Autoportrait*) 1885 (detail). Kimbell Art Museum, Fort Worth, AP 1997.03

P 3: *Bonjour, Monsieur Gauguin* 1889 (detail). Hammer Museum, Los Angeles. Gift of the Armand Hammer Foundation. The Armand Hammer Collection, AH.90.31

PP 4–5: *Portrait of the artist with The yellow Christ* (*Portrait de l'artiste au Christ jaune*) 1890–91 (detail). Musée d'Orsay, Paris. Purchased with the participation of Philippe Meyer and Japanese sponsorship coordinated by the daily *Nikkei* 1993, RF 1994 2

P 6: *Self-portrait* (*Autoportrait*) c 1889 (detail). Musée d'Art Moderne et Contemporain de Strasbourg. Purchased 1921, XXI 159

P 7: *Portrait of the artist with the idol* (*Autoportrait à l'idole*) c 1893 (detail). The McNay Art Museum, San Antonio. Bequest of Marion Koogler McNay, 1950.46

P 8: *Self-portrait (near Golgotha)* (*Autoportrait [près du Golgotha]*) 1896 (detail). Museu de Arte de São Paulo Assis Chateaubriand. Gift of Guilherme Guinle, Álvaro Soares Sampaio, Francisco Pignatari, Fúlvio Morganti 1952, MASP.00108

P 9: *Portrait of the artist by himself* (*Portrait de l'artiste par lui-même*) 1903 (detail). Kunstmuseum Basel. Bequest of Dr Karl Hoffmann 1945, inv 1943

Back cover: *Still life with Hope* (*Nature morte à l'Espérance*) 1901. Private collection, Milan

Jane Messenger

Paul Gauguin: chronology

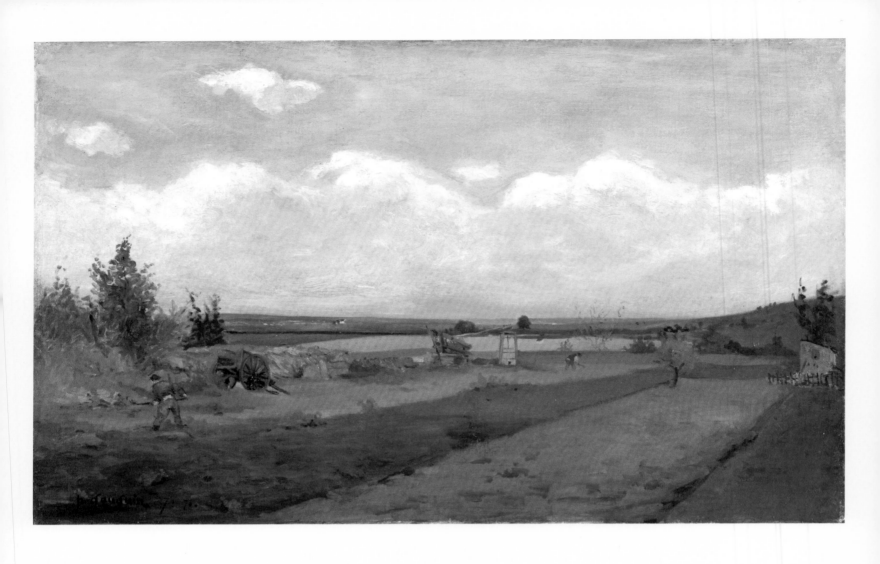

Landscape 1873
oil on canvas
50.5 × 81.6 cm
The Syndics of The Fitzwilliam
Museum, University of
Cambridge. A gift to the museum
from the Very Rev E Milner-
White, CBE, DSO, Dean of York,
in devoted memory of his
mother, Annie Booth-Milner-
White, PD.20-1952

1848 **7 June**
Eugène Henri Paul Gauguin
is born in Paris, son of Pierre
Guillaume Clovis Gauguin, a
newspaper editor, and Aline Marie
Chazal. His grandmother is Flora
Tristan (1803–1844), the daughter
of a Peruvian-born Spanish
aristocrat and a bourgeois French
mother. Tristan is a renowned
feminist and social activist.

December
Louis Napoléon Bonaparte
(1808–1873) becomes the first
President of France under the
Second Republic. At the end of
his four-year term he declares
the dissolution of the Republic,
establishing the Second Empire
and taking the title Emperor
Napoléon III.

1849 **August**
Clovis Gauguin's anti-Bonaparte
political leanings make it unsafe
to remain in France. He and the
family leave for Peru; he dies on
the voyage. Aline, Paul and Marie
live with their great uncle, Pío de
Tristan, in Lima.

1855 Aline and her children return
to France and move into the
family's home in Orléans. Gauguin
attends the local school, then
the Junior Seminary of the Saint
Mesmin Chapel.

1861 Aline relocates to Paris and works
as a seamstress. She becomes
friends with Gustave Arosa (1818–
1883), a wealthy businessman and
art collector.

1865 Gauguin enlists as an officer
candidate in the merchant
marine, travelling the world in
the coming years.

1867 **July**
Learns of his mother's death while
in India. Gustave Arosa becomes
Marie and Paul's guardian.

1870 **19 July**
Napoléon III declares war on
Prussia, which leads a coalition
of German states against
France. Gauguin is called up
for naval service.

September
Napoléon III is deposed, and the
Third Republic is proclaimed.

1871 **18 January**
France surrenders. The Treaty
of Frankfurt cedes Alsace and
half of Lorraine to newly unified
Germany.

Gauguin is released from naval
service.

10 May
The Third Republic resumes
control after the revolutionary
government of the Paris
Commune seized power for
72 days.

1872 Gauguin is hired by a stock
brokerage following an
introduction by Arosa. He meets
Claude-Émile Schuffenecker (1851–
1934) and a lifelong friendship
and passion for art begins. Arosa
also introduces him to Mette
Gad (1850–1920), a well-educated,
modern Danish woman. They
marry the following year.

1873 Begins to paint in his spare time,
teaching himself from the Realism
and Barbizon School artworks in
Arosa's collection. He paints his
first known large-format painting,
Landscape (p 126).

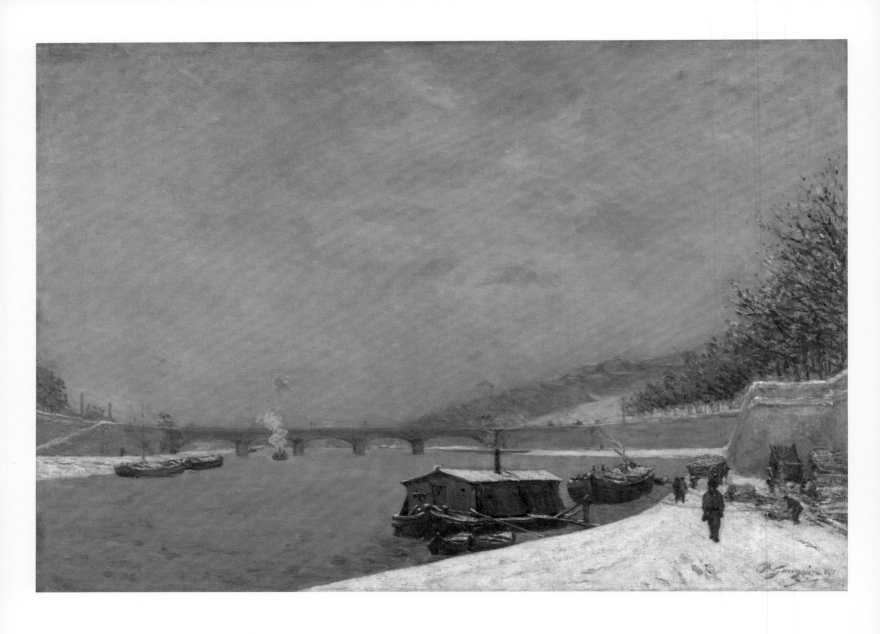

The Seine, Pont d'Iéna. Snowy weather (La Seine au pont d'Iéna. Temps de neige) 1875
oil on canvas
65.4 × 92.4 cm
Musée d'Orsay, Paris. Bequest of Paul Jamot 1941, RF 1941 27

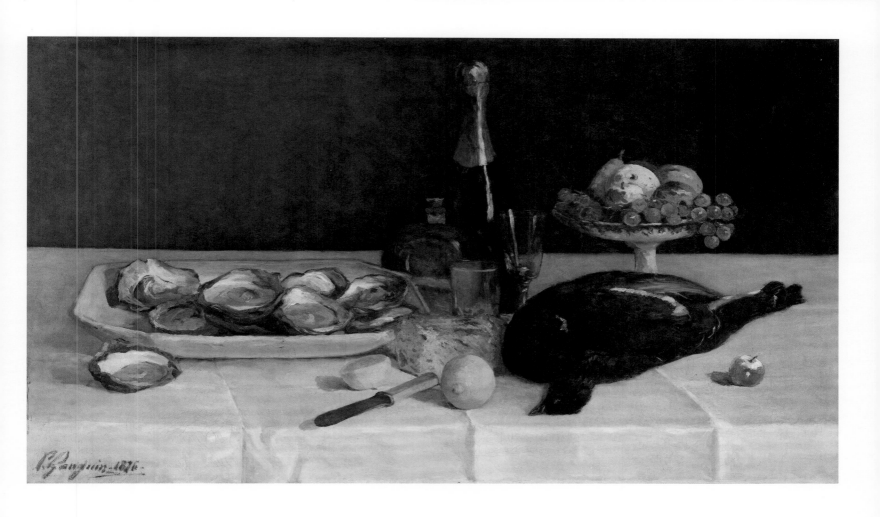

Still life with oysters
(*Nature morte aux huîtres*) 1876
oil on canvas
53.3 × 93.3 cm
Virginia Museum of Fine Arts,
Richmond. Collection of Mr and
Mrs Paul Mellon, 83.23

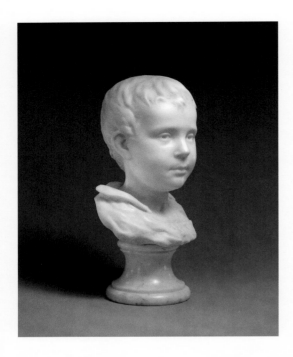

1874 **April**
The first exhibition of the
Société Anonyme des Artistes.
The painting by Claude Monet
(1840–1926) *Impression, sunrise*
(Musée Marmottan Monet, Paris)
famously earns the group the
epithet of 'impressionists'.

August
Gauguin and Mette's first child,
Émile, is born, followed by
daughter Aline (b 1877) and sons
Clovis (b 1879), Jean (b 1881) and
Paul Rollon (b 1883).

1876 **May**
Exhibits at the Salon for the first
time (an unidentified landscape).

Paints his first presumed *Self-
portrait* (Harvard Art Museums,
Cambridge). The genre will
from the mid 1880s form an
increasingly important aspect
of his practice, through which
he explores personae and alter
egos, providing insights into
his successive campaigns of
self-promotion.

1877 Leases an apartment in the house
of academic sculptor Jules-Ernest
Bouillot (1837–1894). Under his
tutelage Gauguin sculpts marble
portrait busts of Mette and Émile.

1879 Begins collecting paintings by
the impressionists.

April
Edgar Degas (1834–1917) and
Camille Pissarro (1830–1903)
invite him to exhibit in the fourth
Impressionist exhibition, 10 days
prior to opening. He is already
participating as a lender of three
paintings by Pissarro. He submits
the marble bust *Émile Gauguin*
(The Metropolitan Museum of Art,
New York, fig 1), the first sculpture
to be exhibited in an *Impressionist*
exhibition.

Pissarro, by now an important
mentor, invites Gauguin to
Pontoise for the summer.
Gauguin begins to paint under
his influence (see *Apple trees at
l'Hermitage*, p 131).

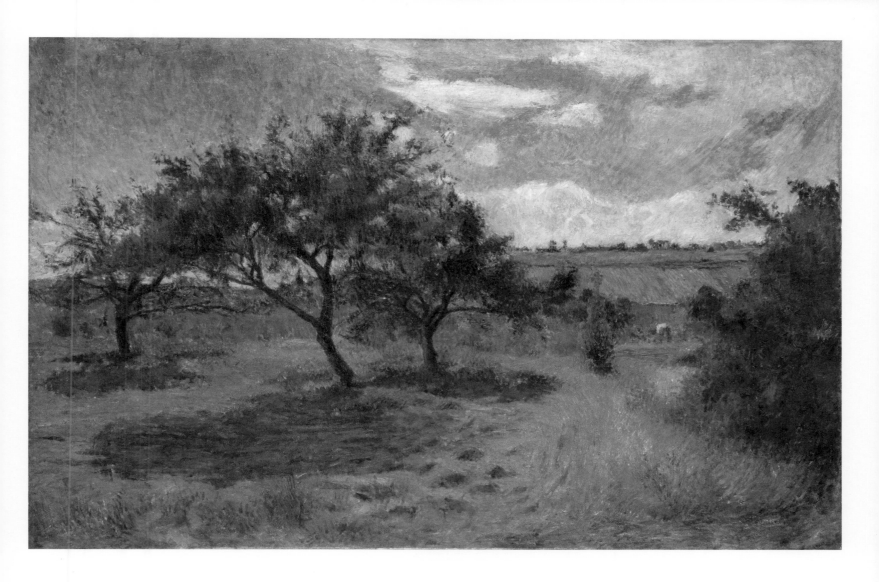

OPPOSITE (FIG 1)
*Émile Gauguin (1874–1955),
the artist's son* c 1877–78
carved and polished marble
43 × 23.2 × 20 cm
The Metropolitan Museum of
Art, New York. Gift of the Joseph
M May Memorial Association Inc
1963, 63.113

ABOVE
*Apple trees at l'Hermitage
(Les pommiers de l'Hermitage)*
1879
oil on canvas
65 × 100 cm
Aargauer Kunsthaus, Aarau.
Bequest of Dr Max Fretz 1958,
1086

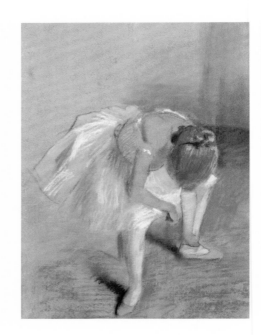

1880 **April–May**
Gauguin participates in the fifth
Impressionist exhibition with works
including *Garden under snow*
(Museum of Fine Arts, Budapest).
Monet declines to exhibit, critical
of invitations including to a 'first-
come dauber' like Gauguin.[1]

Buys a painting by Paul Cézanne
(1839–1906), *Still life with fruit
dish* (The Museum of Modern
Art, New York, fig 2), which will
become one of Gauguin's most
valued possessions and one of six
Cézanne oils he will collect.

Tahiti, a protectorate since 1842,
becomes a French colony.

Le mariage de Loti (*The marriage
of Loti*) by Pierre Loti (1850–1923)
is published. Set in Tahiti, it
tells of the love affair between a
beautiful Polynesian girl called
Rarahu and a British naval officer.
Gauguin will later be inspired
to critique the novel in crafting
the public narrative of his own
experiences in Tahiti and in
presenting them in *Noa Noa*.

1881 **March**
Art dealer Paul Durand-Ruel
(1831–1922) makes his first
purchase of works by Gauguin,
buying three paintings.

April–May
Participates in the sixth
Impressionist exhibition,
including a still-life painting
he had exchanged with Degas
for *Dancer adjusting her slipper*
(Ordrupgaard, Copenhagen, fig 3).

Summer
Pissarro introduces him to
Cézanne while they are staying
in Pontoise. Gauguin benefits
from their lengthy conversations
(see *Quarry around Pontoise*,
p 135). Cézanne, along with Degas,
remains the artist for whom he
has the greatest admiration.

LEFT (FIG 2)
Paul Cézanne
Still life with fruit dish
(*Nature morte au compotier*)
1879–80
oil on canvas
46.4 × 54.6 cm
The Museum of Modern Art,
New York. Gift of Mr and Mrs
Rockefeller, 69.1991

RIGHT (FIG 3)
Edgar Degas
Dancer adjusting her slipper
(*Danseuse ajustant son chausson*)
c 1879
pastel on paper
55.9 × 45.6 cm
Ordrupgaard, Copenhagen

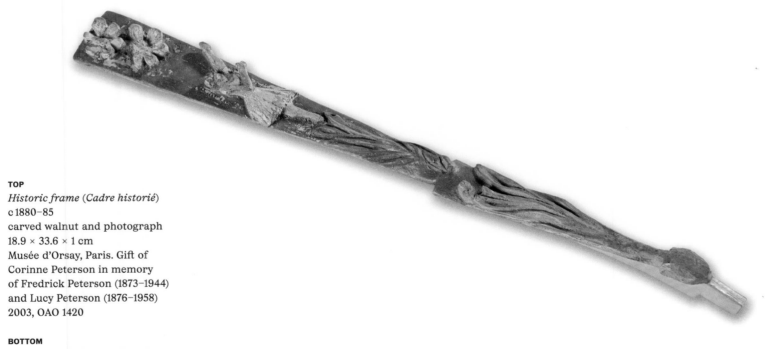

TOP
Historic frame (Cadre historié)
c 1880–85
carved walnut and photograph
18.9 × 33.6 × 1 cm
Musée d'Orsay, Paris. Gift of
Corinne Peterson in memory
of Fredrick Peterson (1873–1944)
and Lucy Peterson (1876–1958)
2003, OAO 1420

BOTTOM
*Narcissus fan handle with Degas
dancer (Poignée d'eventail aux
narcisses avec danseuse de
Degas)* 1884–85
painted and carved wood
27.9 × 2.9 × 1.9 cm
The Gwinnett family,
Tarntanya/Adelaide

Quarry around Pontoise
(*Carrière aux environs
de Pontoise*) 1882
oil on canvas
89 × 116 cm
Kunsthaus Zürich. Bequest
of the Zürcher Kunstfreunde
association 1981, 1981/0005

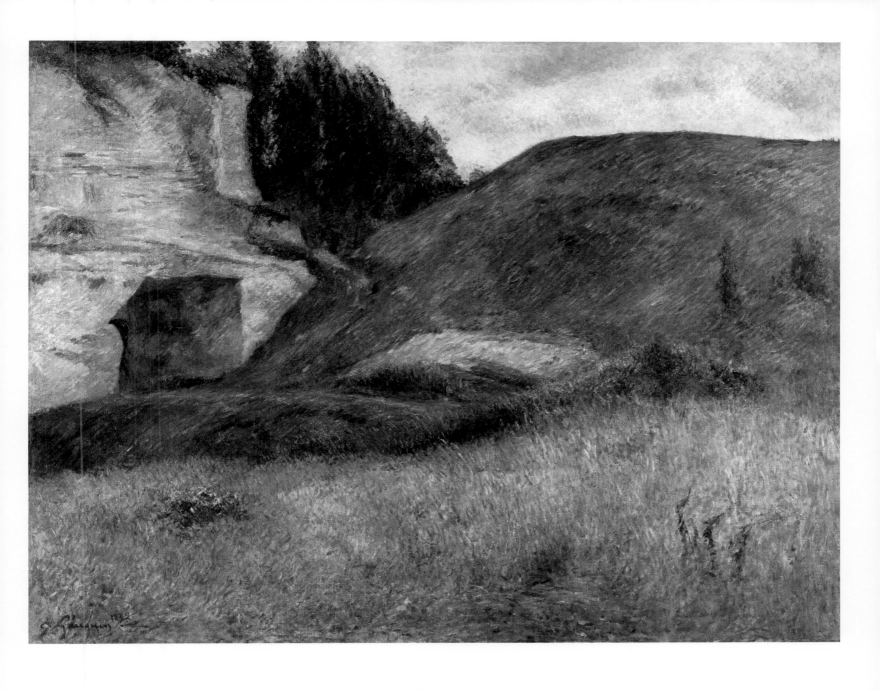

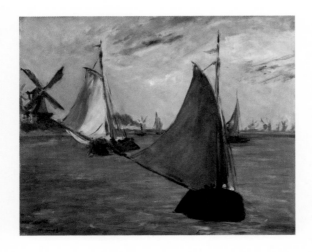

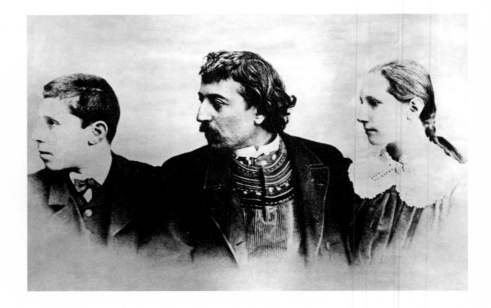

1882 **January**
The bank L'Union Générale declares bankruptcy and the Paris Bourse crashes. Gauguin loses a considerable amount of money. France enters a period of economic decline.

March
Participates in the seventh *Impressionist* exhibition, though the group's spirit of solidarity is fractured by artistic rivalries.

1883 **30 April**
Édouard Manet dies. The following year Gauguin lends one of his two paintings by the influential modern master, *Marine in Holland* (Philadelphia Museum of Art, fig 4), to *The Manet memorial* exhibition.

October
Loses his job at the Bourse in the wake of the financial crisis and decides to become a full-time career artist.

December
Signs his son Paul Rollon's birth certificate 'artiste-peintre' (painter by trade).

1884 **January**
Moves with his family to Rouen, unable to afford living in Paris and encouraged by Pissarro. He paints prolifically but is unable to sell any of his canvases.

Without an income, the decision is made to live in Copenhagen, to be near Mette's family. She travels ahead with the children. He joins in November.

December
They move into their own rented apartment. Mette begins giving private lessons in French. He sets about painting winter scenes and explores a new direction in carving, taking motifs from Degas's compositions with ballet dancers (see *Narcissus fan handle with Degas dancer*, p 133).

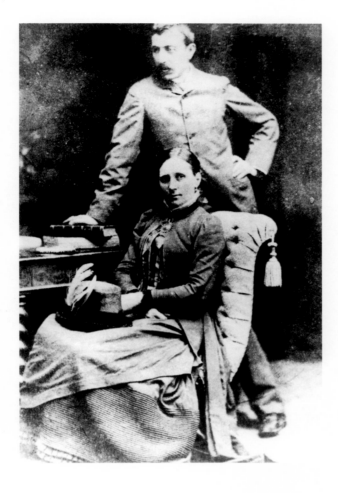

1885 **May**
Holds his first solo exhibition at
the Society of the Friends of Art
but it closes after five days.

Writes to Schuffenecker of his
inability to grasp Danish and
of feeling ostracised due to his
vocation, Catholic upbringing
and lack of money.

June
The isolation and constrained
bourgeois values prompt his
return to Paris with favourite
son Clovis; Mette and the other
children remain in Copenhagen.
He will spend the majority of his
life without financial security
from his artist practice, relying
for income on the generosity
of his friends and low-wage
menial jobs.

Most of his artworks and
collection remain with Mette.
Selling the collection over
the coming years will provide
important income for them both.

July
Visits a friend in Dieppe, where he
stays until October, with a brief
mid August trip to London. Sees
the Parthenon sculpture *Horse's
head* 438–32 BCE in the British
Museum (see *Still life with horse's
head*, p 140).

Ostre Anlaeg Park, Copenhagen
1885
oil on canvas
59.1 × 72.8 cm
Glasgow Life Museums on
behalf of Glasgow City Council.
Presented by the Trustees of the
Hamilton Bequest 1944, 2465

*Still life in an interior,
Copenhagen (Nature morte dans
un intérieur Copenhague)* 1885
oil on canvas
60 × 73 cm
Private collection

ABOVE

Still life with horse's head
(*Nature morte à la tête de cheval*)
1886
oil on canvas
49 × 38.5 cm
Artizon Museum, Ishibashi
Foundation, Tokyo, 22588

OPPOSITE

Landscape with red roof
(*Paysage au toit rouge*) 1885
oil on canvas
81.5 × 66 cm
Rudolf Staechelin Collection

140

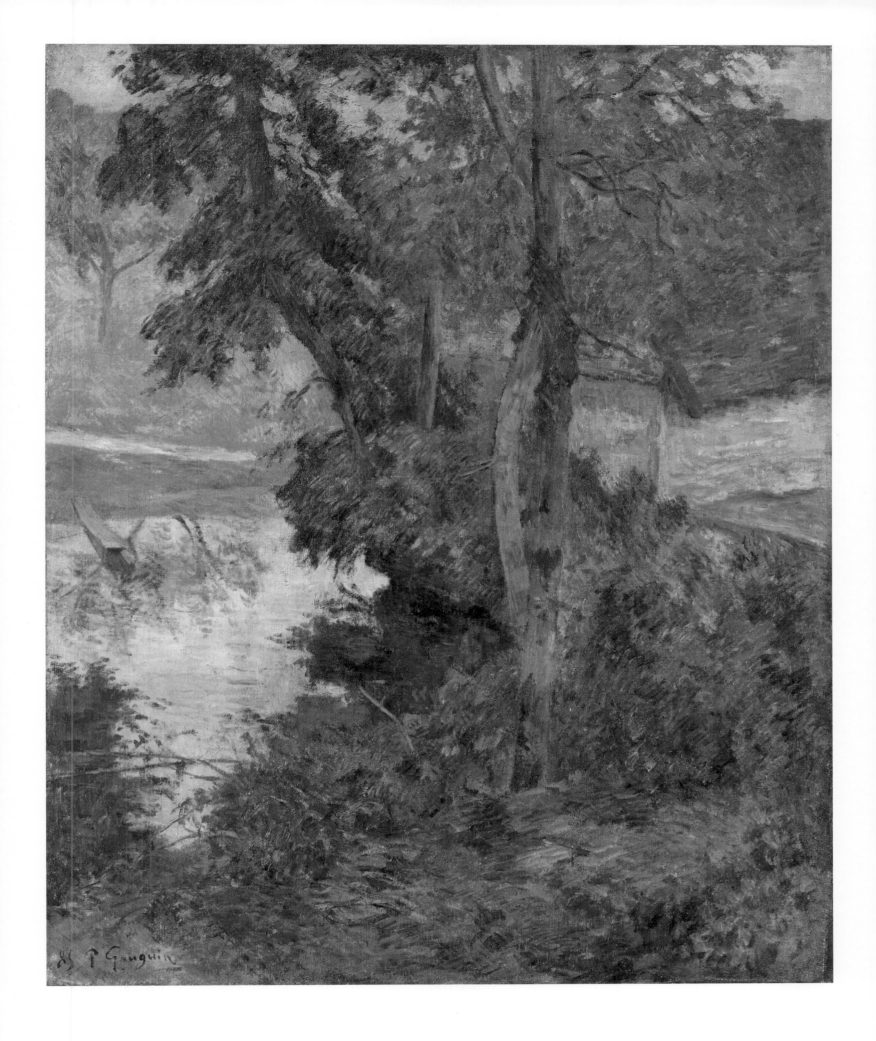

1886 **May–June**

Participates in the eighth and final *Impressionist* exhibition with works including *Ostre Anlaeg Park, Copenhagen* (p 138). The pointillist painting by George Seurat (1859–1891) *A Sunday on La Grande Jatte* (The Art Institute of Chicago) is the major attraction.

July

Leaves Paris for the popular artists' colony in Pont-Aven, Brittany, staying at the Pension Gloanec where the proprietor, Marie-Jeanne Gloanec, is known to extend credit. Drawn there because it is cheap, he quickly discovers new motifs, inspired by the ideal of Breton peasant life and a folklore infused with vestiges of a pagan Celtic past.

Develops associations between his artistic practice and an interest in 'primitive' cultures, marking the beginning of his alienation from Impressionism and of his advocacy of living a simple existence, removed from urban civilisation.

Mid October

Returns to Paris, accepting the invitation to collaborate on a commercial venture with the celebrated studio potter Ernest Chaplet (1835–1909) in his workshop. Gauguin glazes Chaplet's forms while also creating his own 'ceramic sculptures', revealing the extent of his responsiveness to different mediums and experimentation with technique (see *Vase decorated with Breton scenes*, p 143, and *Jug with a double spout*, p 146).

December

The Chaplet venture is a commercial failure but an important creative breakthrough. He writes to Mette: 'I am doing ceramic sculpture. Schuffenecker says that they're masterpieces and so does the ceramicist, but it's probably too artistic to sell.'[2]

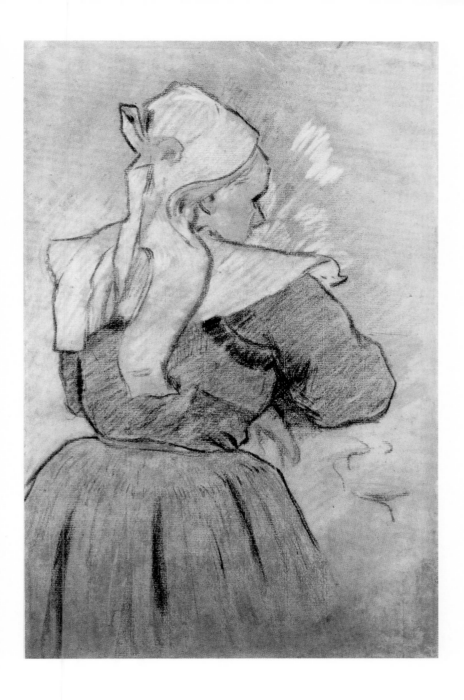

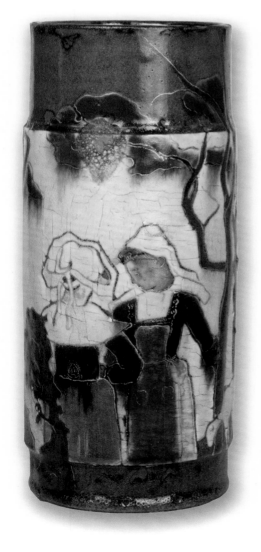

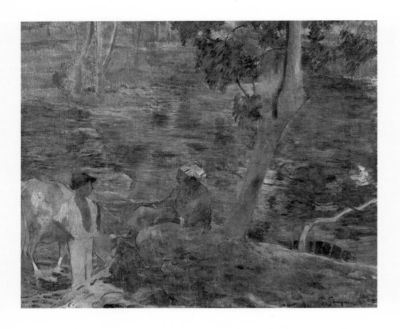

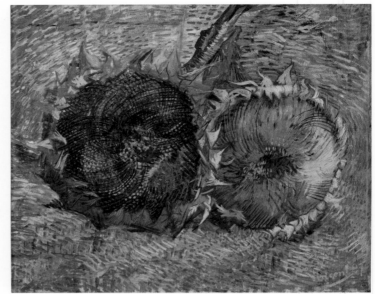

1887 **June**

He and Charles Laval (1861–1894, see *Still life with profile of Laval*, p 151) travel to Martinique in search of 'a land that is fertile and where food is abundant', following a disappointing trip to Panama where they had intended to live cheaply and like 'savages'.[3]

For Gauguin, the morality of the 'savage' in 'primitive' pre-industrial society is superior to that of 'civilised' people, affording a purer and more truthful existence, to which he aspires. He would strive to live out this dream of 'primitivism'.

His imagination is captivated by the richness and beauty of his surroundings in Martinique, inspiring a freedom and clarity within his work. The experience has a decisive impact on his artistic objectives and how to achieve them. Malaria complicated by dysentery and hepatitis prevents him from completing more than 16 canvases and prompts his return to Paris in late October, paid for by Schuffenecker.

December

Meets Theo van Gogh (1857–1891), an art dealer working for Goupil & Cie, who exhibits several of his recent paintings and ceramics. Theo arranges to buy *The mango trees, Martinique* (Van Gogh Museum, Amsterdam) for 400 francs, one of his most expensive acquisitions.

Theo introduces him to his brother, Vincent van Gogh (1853–1890). The two artists exchange paintings: *On the banks of the river, Martinique* (Van Gogh Museum, Amsterdam, fig 7) for *Sunflowers* (The Metropolitan Museum of Art, New York) and *Withered sunflowers (two cut sunflowers)* (Kunstmuseum Bern, fig 8), which Van Gogh had painted in late summer.

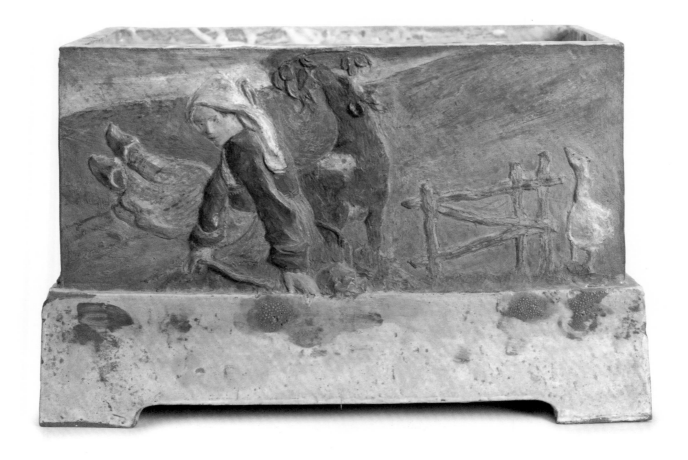

OPPOSITE LEFT (FIG 7)
On the banks of the river,
Martinique (Au bord de l'étang)
1887
oil on canvas
54.5 × 65.5 cm
Van Gogh Museum, Amsterdam.
Vincent van Gogh Foundation,
s0220V1962

OPPOSITE RIGHT (FIG 8)
Vincent van Gogh
Withered sunflowers
(two cut sunflowers) 1887
oil on canvas
50 × 60.7 cm
Kunstmuseum Bern. Gift of
Prof Hans R Hahnloser, Bern
1971, G 2140

ABOVE
Planter decorated with Breton
shepherdess motifs (Jardinière
[sujets de Bretagne]) c 1886–87
glazed stoneware, slip
27 × 40 × 22 cm
Private collection

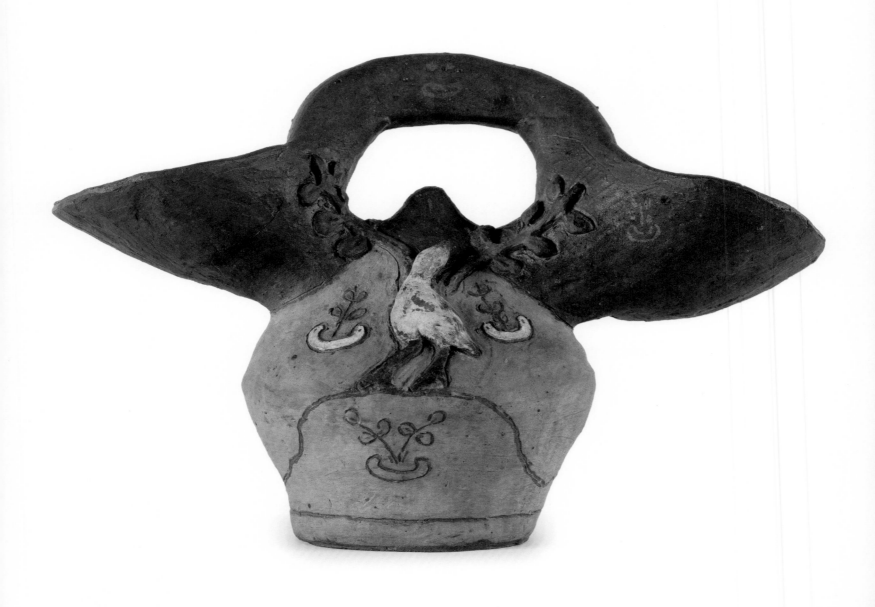

Jug with a double spout
(*Verseuse à double bec*) 1886–87
glazed stoneware, slip
12.5 × 20.5 × 8 cm
Musée d'Art Moderne de Paris.
Donated by Henry Thomas 1976,
AMOA 353

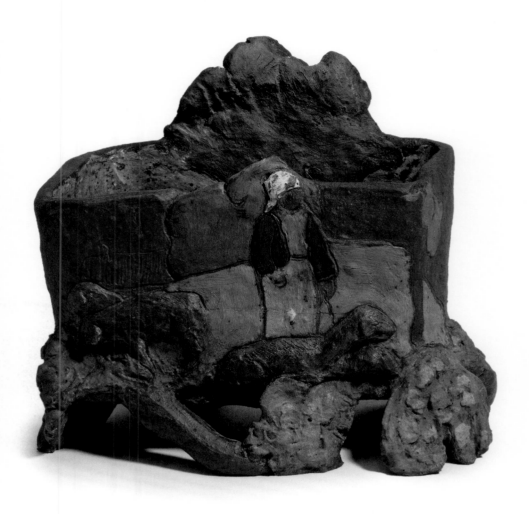

*Planter with Breton woman and
sheep (Jardinière avec bretonne et
moutons)* c 1886–87
incised and modelled stoneware,
paint and enamel
13.3 × 15.5 × 11.5 cm
Petit Palais, Musée des Beaux-
Arts de la Ville de Paris. Dutuit
bequest 1902, ODUT1787

Vase with geese (Vase aux oies)
c 1886–87
modelled and painted
earthenware
12 × 17.5 (diam) cm
Private collection. Courtesy
Galerie Dina Vierny, Paris, P32

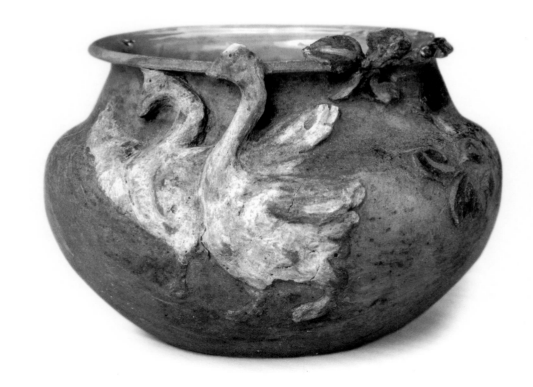

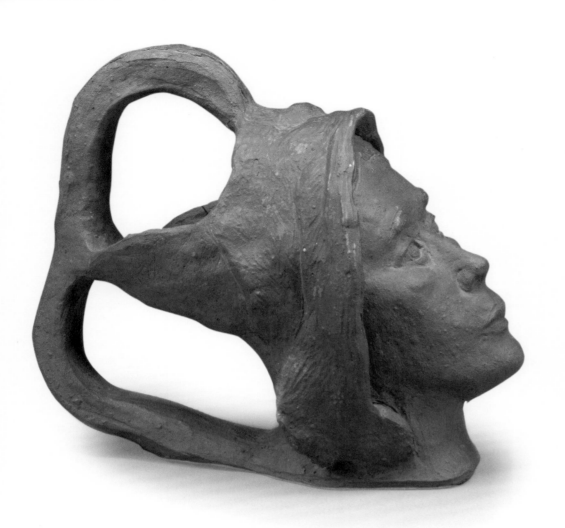

*Pot in the form of the head of a
Breton woman (Pot en forme de
tête de bretonne)* 1886–87
stoneware, slip and gilded
highlights
14 × 9.2 × 16.5 cm
Private collection

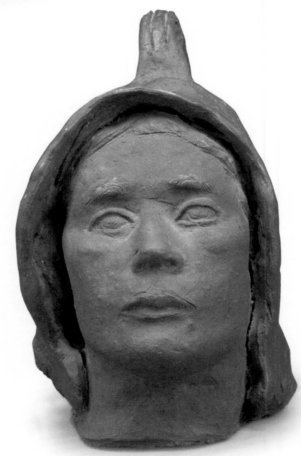

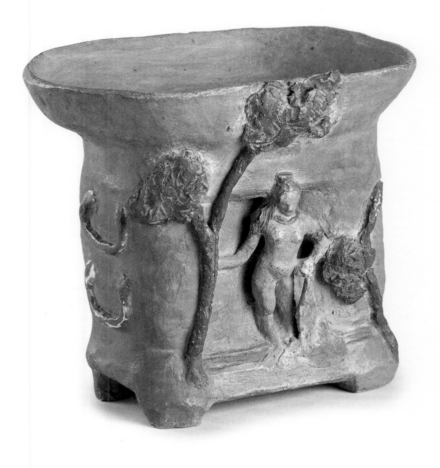

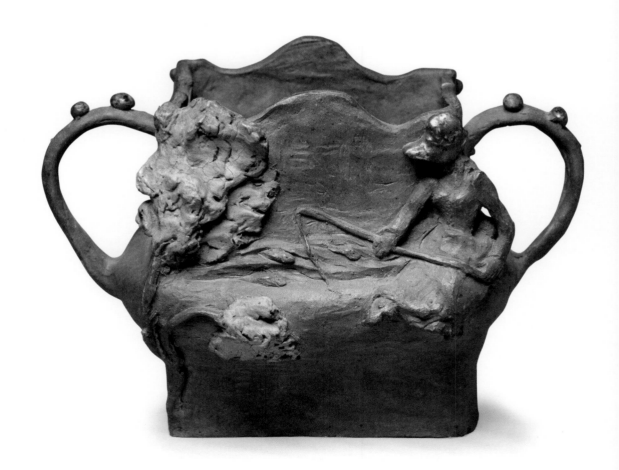

ABOVE
*Vase with bather, setting sun
(Potiche à la baigneuse, soleil
couchant)* 1887–88
unglazed stoneware, coloured
slips, gilded highlights
13.1 × 15.1 × 11.6 cm
Musée d'Orsay, Paris. Gift of
Lucien Vollard 1943, AF 14329 6

RIGHT
Vase 1886
partially glazed stoneware, paint
14.6 × 20.5 × 10.5 cm
Musée d'Orsay, Paris. Gift of
Lucien Vollard 1943, AF 14329 4

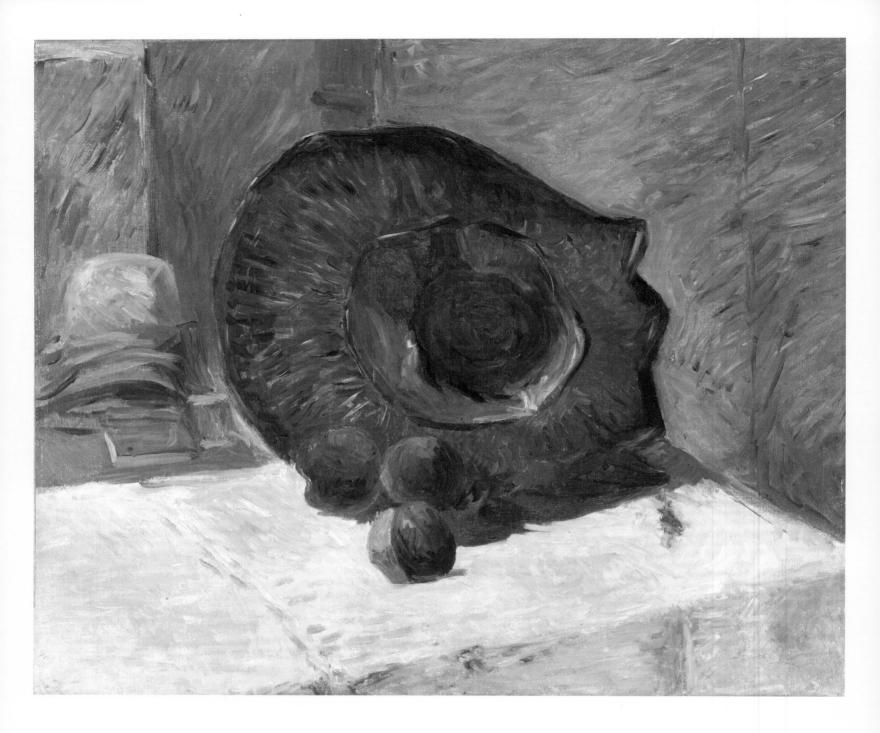

ABOVE

The red hat (Le chapeau rouge)
1886
oil on canvas
44.5 × 53 cm
Musée d'Orsay, Paris. Purchased
2019, RF MO P 2019 8

OPPOSITE

*Still life with profile of Laval
(Nature morte au profil de Laval)* 1886
oil on canvas
46 × 38 cm
Indianapolis Museum of Art at
Newfields. Samuel Josefowitz
Collection of the School of
Pont-Aven, through the generosity of
Lilly Endowment Inc, the Josefowitz
Family, Mr and Mrs James M Cornelius,
Mr and Mrs Leonard J Betley,
Lori and Dan Efroymson, and other
Friends of the Museum, 1998.167

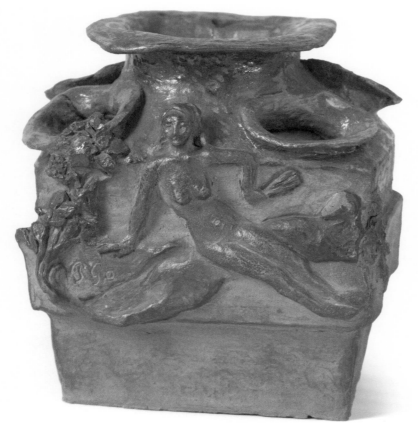

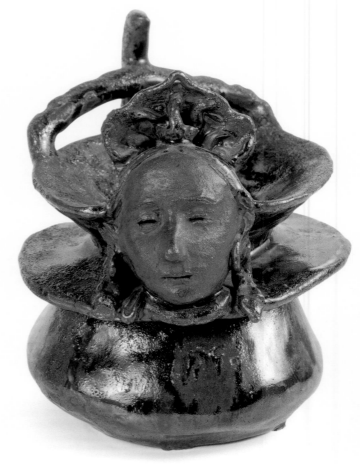

ABOVE
Cleopatra pot 1887–88
partially glazed stoneware,
slip and gold paint
13.5 × 12.5 × 10 cm
Van Gogh Museum, Amsterdam.
Vincent van Gogh Foundation,
V0037V1978

RIGHT
*Vase with the portrait mask of a
woman (Pot décoré d'une tête de
femme)* 1887–88
partially glazed stoneware with
gilded highlights
18 × 15 (diam) cm
Association des Amis du Petit
Palais, Geneva

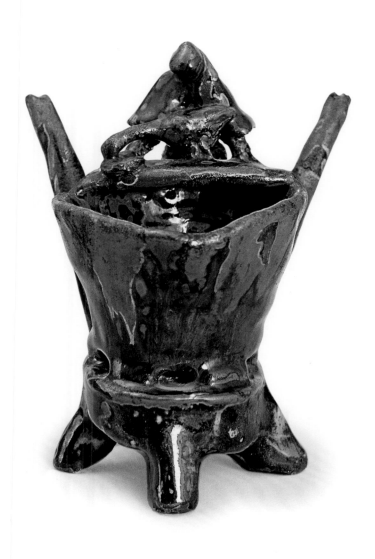

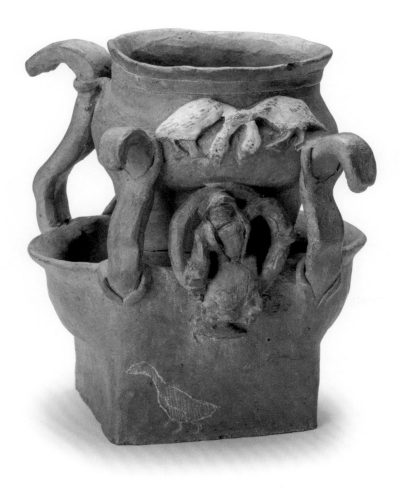

ABOVE
Jar with four feet (Jarre à quatre pieds) 1887–88
glazed stoneware, gilded highlights
18.2 × 15 × 15.5 cm
Private collection. Courtesy Galerie Dina Vierny, Paris, P31

RIGHT
Double pot c 1887–89
unglazed stoneware
15.5 × 12.8 × 11.5 cm
Te Fare Iamanaha – Musée de Tahiti et des Îles, Papeete

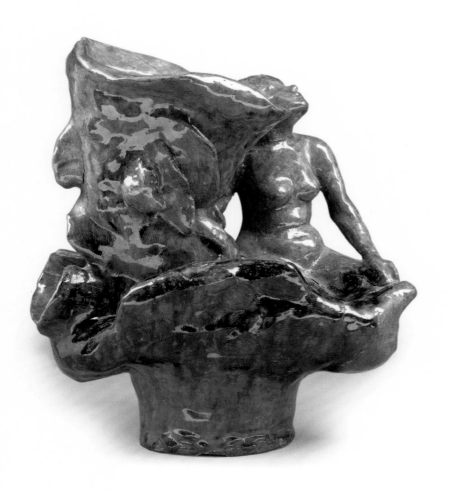

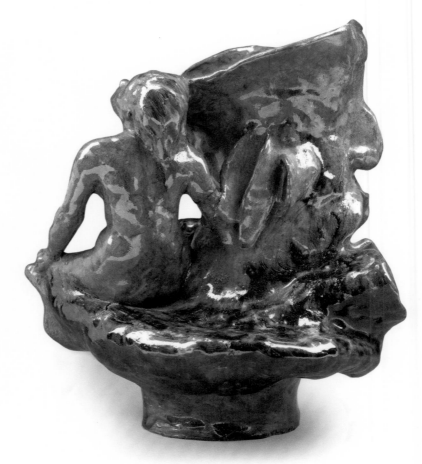

*Fantastic vase with a grotesque
head and the figure of a female
bather, titled The Marchand
d'esclave* c 1887–89
glazed stoneware
26.7 × 22.9 × 17.8 cm
Private collection

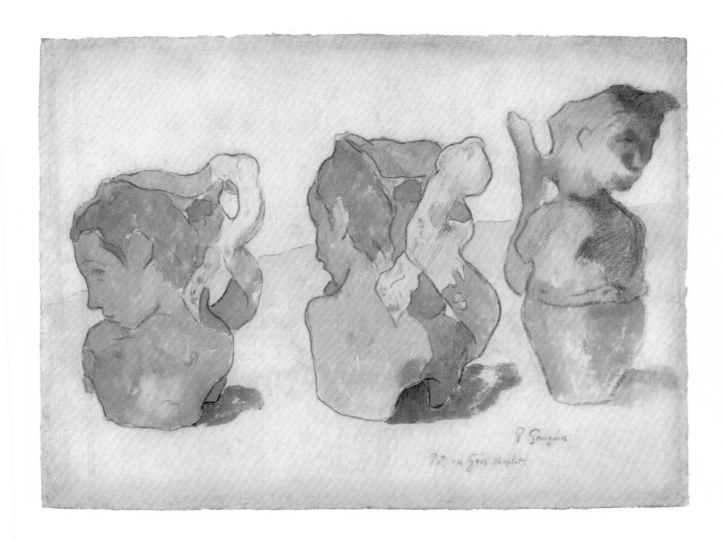

Chaplet stoneware jugs
(*Pots en grès Chaplet*) c 1888
gouache, watercolour, charcoal
on Japan paper
30.5 × 40 cm
The Frances Lehman Loeb
Art Center, Vassar College,
Poughkeepsie. Bequest of Sarah
Hamlin Stern, class of 1939, in
memory of her husband, Henry
Root Stern Jr, 1994.2.1

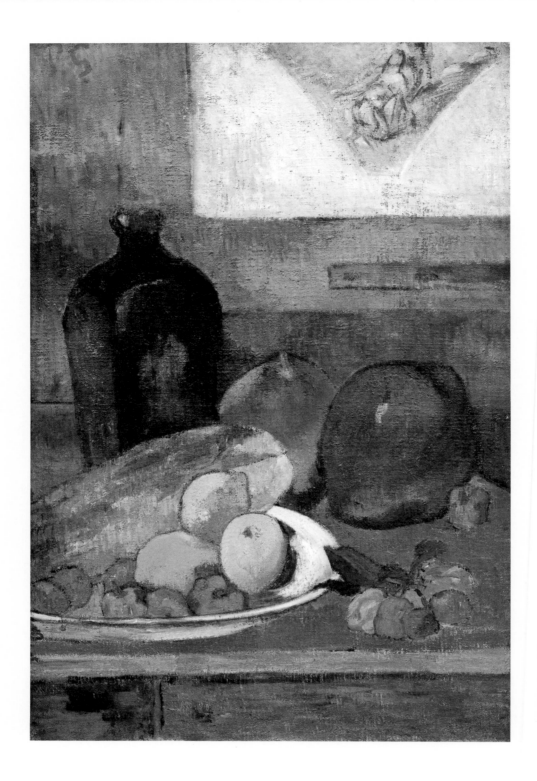

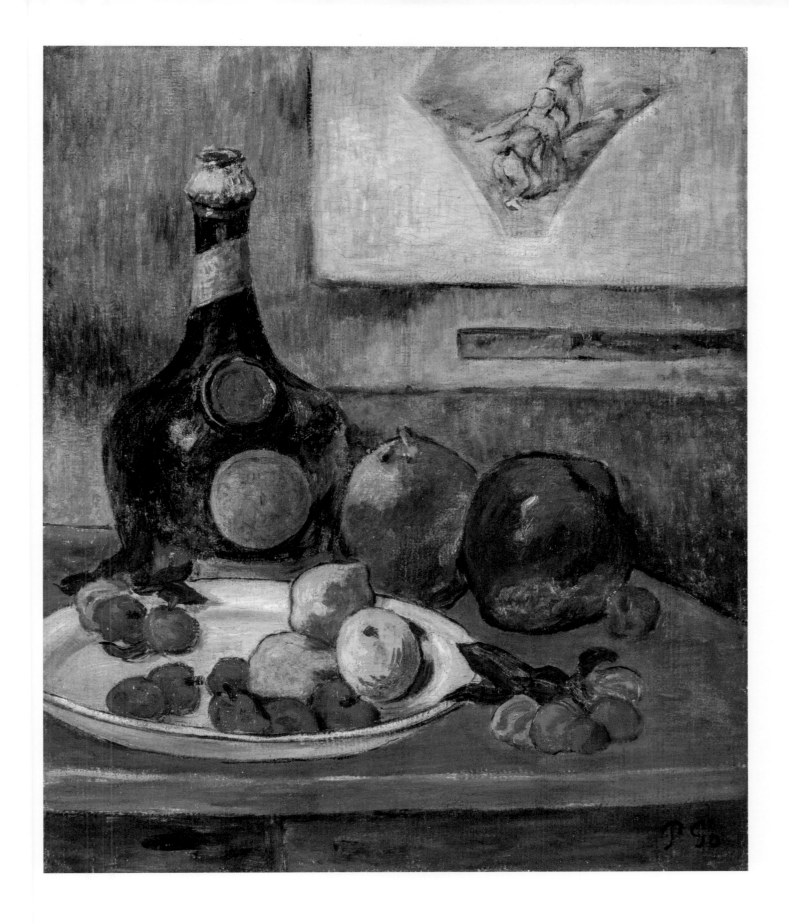

157

1888 **January**

Writes enthusiastically to Mette about a new book by the Norwegian writer Bjønstjerne Björnson (1832–1910) causing a sensation in proposing social emancipation of women. He suggests she translate it and he would arrange for publication.[4]

February

Goes to Pont-Aven, staying at the Pension Gloanec, but due to complications from malaria remains too weak to paint (fig 10). He writes to Schuffenecker: 'I like Brittany; here I find a savage, primitive quality. When my wooden shoes echo on this granite ground, I hear the dull, muted, powerful sound I am looking for in painting.'[5]

March

The critic Édouard Dujardin (1861–1949) describes paintings by Louis Anquetin (1861–1932) as cloisonnist, referencing cloisonné enamels in his application of flat areas of colour and contour outlines. The technique, developed with Émile Bernard (1868–1941), becomes an influential characteristic of Gauguin's style.

July

Gauguin relates the idea of his 'savage' self to his Incan ancestry when writing to Schuffenecker about *Children wrestling* (p 65). In forming the construct of his dual character as civilised (French) and savage (Incan), he omits that his Peruvian heritage is from Spanish nobility. He also writes to Van Gogh about the painting, describing it in relation to Japanese prints (fig 9).

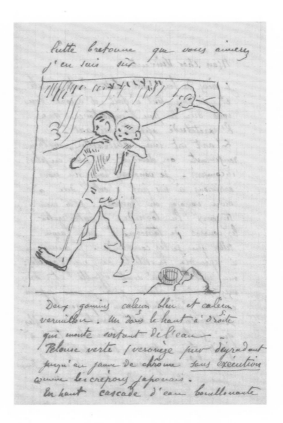

August

Bernard arrives in Pont-Aven and together they progress with Bernard's concept of Synthetism: a brilliantly coloured and highly stylised form of art, intended to capture 'the abstract'—the analysis of ideas and experiences. Gauguin becomes the leader of a new group known as the Pont-Aven School.

September

Paints his masterpiece *Vision of the sermon (Jacob wrestling with the angel)* (National Galleries of Scotland, Edinburgh), marking his decisive shift to a new expressive and symbolist pictorial vocabulary disassociated from the impressionists' interest in depicting what they saw before them.

He is introduced by Bernard to Paul Sérusier (1864–1927), to whom he famously explains his theory on painting, resulting in *The talisman* (Musée d'Orsay, Paris).

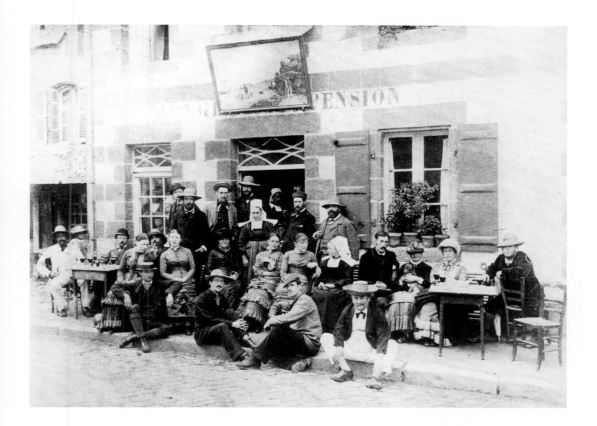

OPPOSITE (FIG 9)
Sketch of *Children wrestling* in a letter from Gauguin to Vincent van Gogh, 22 July 1888 Van Gogh Museum, Amsterdam

ABOVE (FIG 10)
Gauguin (first row, middle) sitting in front of the Pension Gloanec in Pont-Aven, Brittany 1888

Late October
Travels to Arles to stay with Vincent van Gogh, financed by Theo in support of his brother's ambition to establish a 'studio of the south'—an artists' enclave fostering collaboration and creative experimentation. In anticipation, Vincent decorates Gauguin's room with paintings of sunflowers.

Gauguin evolves the idea of a shared atelier into founding his own 'studio of the tropics'. They discuss how 'the future of a great renaissance in painting' will arise from subjects not yet painted.[6]

They experiment with coarse-weave canvas, which Gauguin will make his own preference in Tahiti (taking a roll there then ordering more from Paris). He will use the strong textural surface to enhance associations with his views of primitive art.[7]

December
Their artistic differences, initially a source of inspiration, become an irritation, with increasingly fraught exchanges. Gauguin, conscious of his debt to Theo and Vincent, writes to Schuffenecker: 'I can't hold a grudge against an excellent heart that is ill, that is suffering, and that needs me'.[8] Vincent's mental breakdown and act of self-mutilation occur soon after.

25 December
Gauguin and Theo return to Paris together. Vincent remains in hospital where he slowly recovers.

Lane at Alyscamps, Arles
(*L'allée des Alyscamps, Arles*)
1888
oil on canvas
72.5 × 91.5 cm
Sompo Museum of Art, Tokyo,
W.316

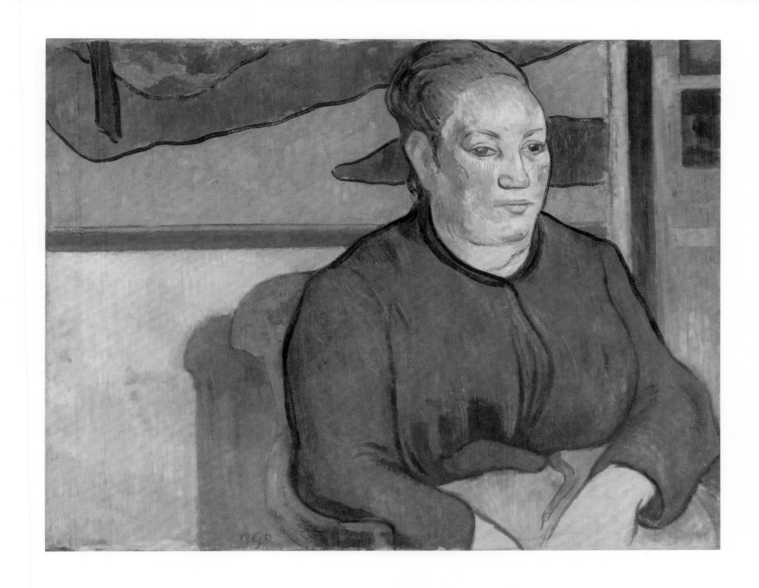

Madame Roulin 1888
oil on canvas
50.5 × 63.5 cm
Saint Louis Art Museum. Funds
given by Mrs Mark C Steinberg,
5:1959

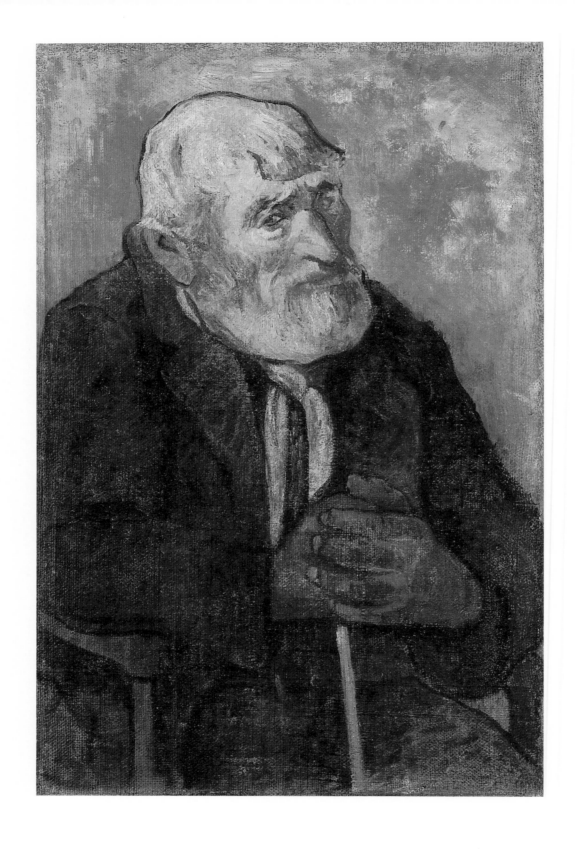

Old man with a stick
(*Vieil homme au baton*) 1888
oil on canvas
70 × 45 cm
Petit Palais, Musée des Beaux-
Arts de la Ville de Paris, PPP623

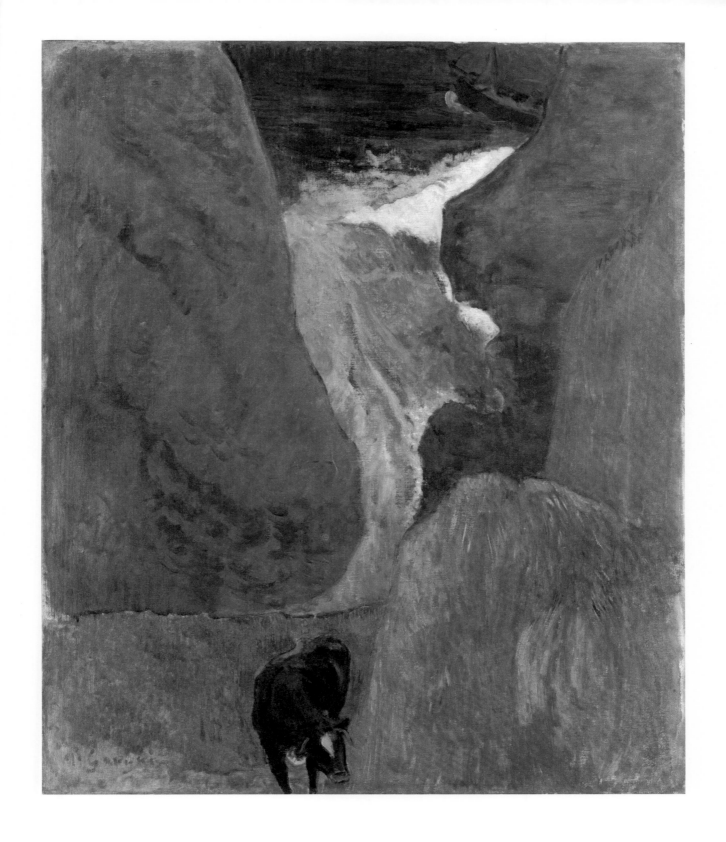

Seascape with cow
(*Marine avec vache*) 1888
oil on canvas
72.5 × 61 cm
Musée d'Orsay, Paris. Gift of
Countess Vitali in memory of
her brother Viscount Guy de
Cholet 1923, RF 1938 48

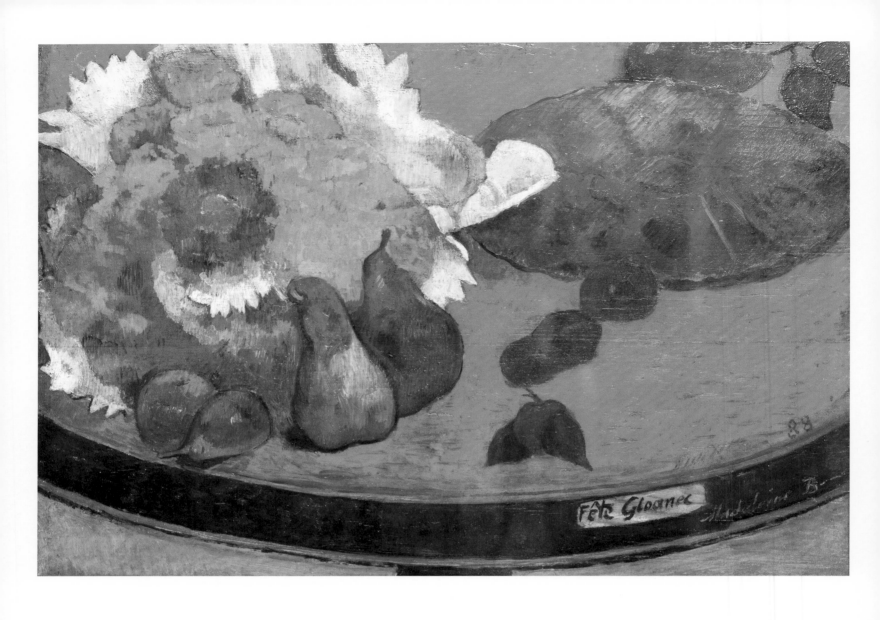

Still life 'Fête Gloanec'
(*Nature morte 'Fête Gloanec'*) 1888
oil on canvas
36.5 × 52.5 cm
Musée des Beaux-Arts d'Orléans,
MO.64.1405

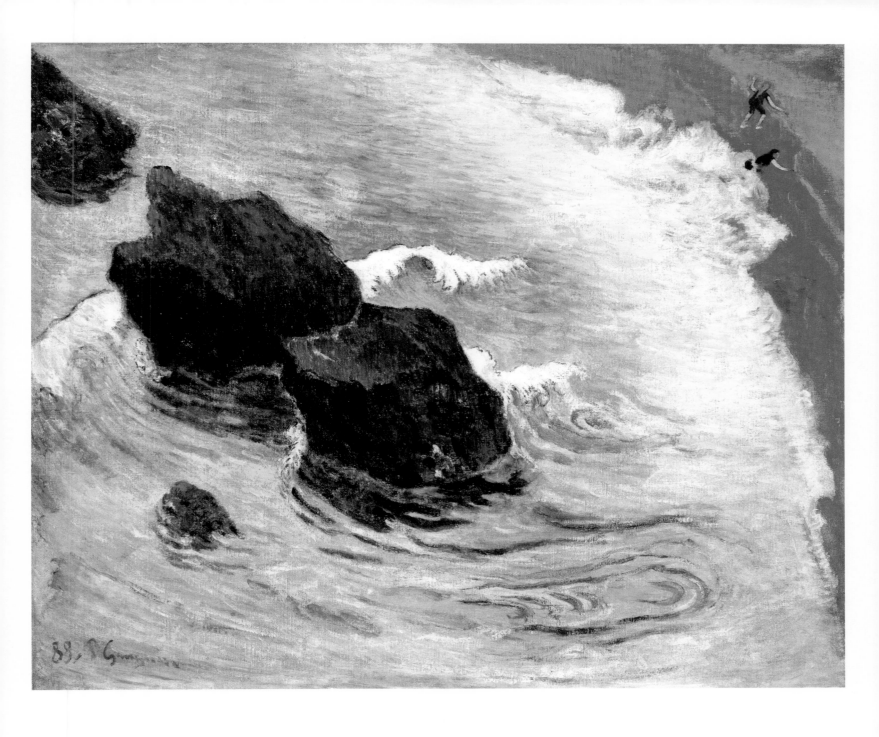

The wave (*La vague*) 1888
oil on canvas
60.2 × 72.6 cm
Private collection

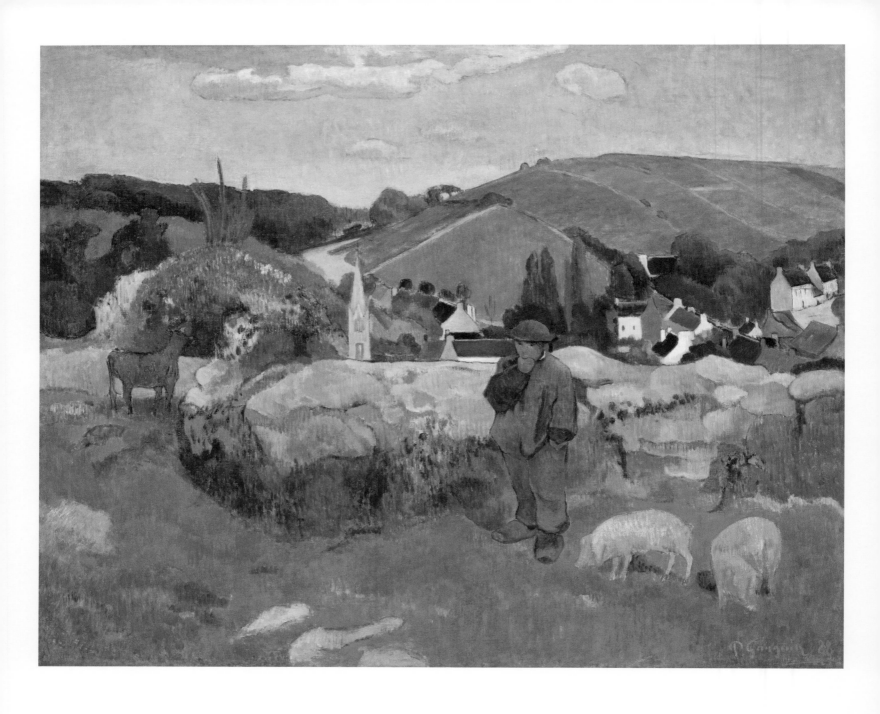

The swineherd
(*Le gardien de porcs*) 1888
oil on canvas
73 × 93 cm
Los Angeles County Museum
of Art. Gift of Lucille Ellis Simon
and family in honour of the
museum's 25th anniversary,
M.91.256

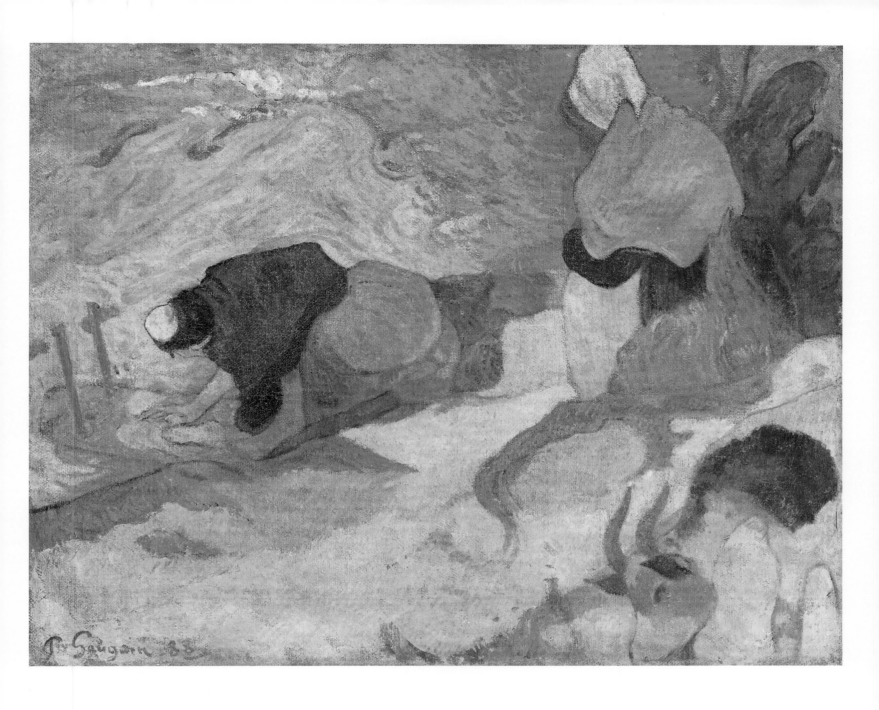

Washerwomen in Arles
(*Laveuses à Arles*) 1888
oil on canvas
74 × 92 cm
Museo de Bellas Artes de Bilbao.
Contributed by the Provincial
Council of Bizkaia in 1920, 82/18

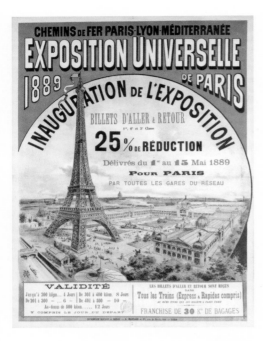

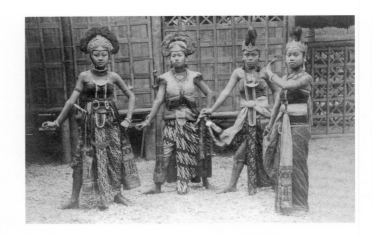

1889 5 May
The Exposition Universelle opens
(fig 11), attracting more than
32 million visitors. A celebration
of France's imperial power,
it promotes the colonies as
abundant and 'exotic' through
a fusion of art and life.

Gauguin is captivated by the
Javanese *kampong* (village) with
dancers from Java (fig 12) and the
plaster reliefs of the Borobudur
Temple, of which he already
owns photographs. The Tahitian
Pavilion has two collections of art
and artefacts from the Marquesas
Islands. The exhibitions further
inspire his desire to travel to a
pre-industrial locale.

June–July
Excluded from the official
Decennial exhibition in the
Palais des Beaux-Arts, Gauguin
and Schuffenecker, in a
subversive act, organise an
installation of their work inside
the exposition grounds at the
Café des Arts. JP Volpini is the
proprietor. Their *Exhibition of*
paintings by the impressionist and
synthetist group becomes known
as the *Volpini* exhibition. It also
represents Gauguin's first foray
into printmaking in creating an
accompanying suite of zincographs
(see *Volpini suite*, pp 179–81).

June
Travels to Pont-Aven, where he is
joined by Laval and Sérusier, then
moves to the more remote village
of Le Pouldu. He paints *The yellow*
Christ (Buffalo AKG Art Museum)
and *Breton calvary* (p 57), which
are amongst his most important
synthetist works (see *Portrait of the*
artist with The yellow Christ, p 52).

November
Writes to Theo van Gogh: 'You know
I have Indian, Incan blood in me,
and it comes across in everything
I do. It's the basis of my whole
character. I'm looking for something
more natural to set against the
corruption of civilization.'[9]

November–December
Gauguin and the Dutch artist
Meijer de Haan (1852–1895) stay
in the inn of Marie Henry in Le
Pouldu, decorating the dining room
with their paintings, including
Breton girl spinning (p 171) and
Caribbean woman (p 183).

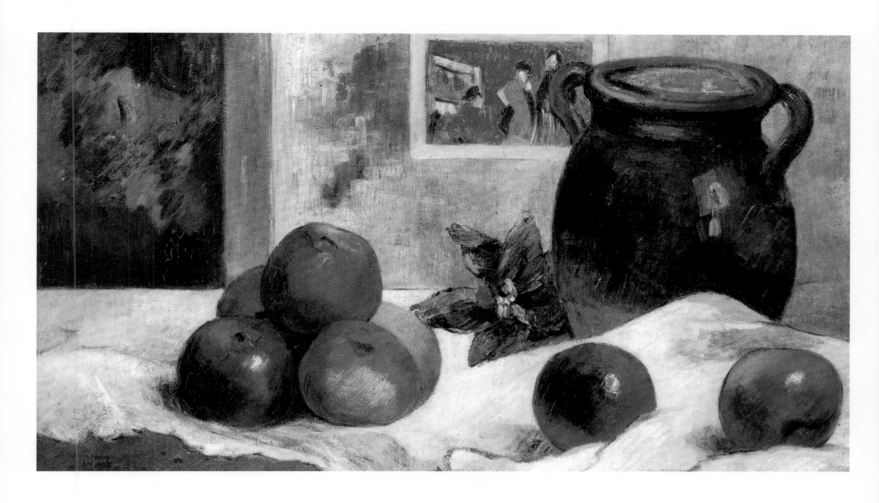

OPPOSITE LEFT (FIG 11)
Artist unknown
Exposition Universelle poster
1889
lithograph
80.8 × 60.5 cm
Musée Carnavalet,
History of Paris, AFF2479

OPPOSITE RIGHT (FIG 12)
Dancers from a Javanese
kampong (village) in traditional
dress at the Exposition
Universelle 1889

ABOVE
Still life with Japanese print
1888
oil on canvas
31.7 × 55.5 cm
Private collection

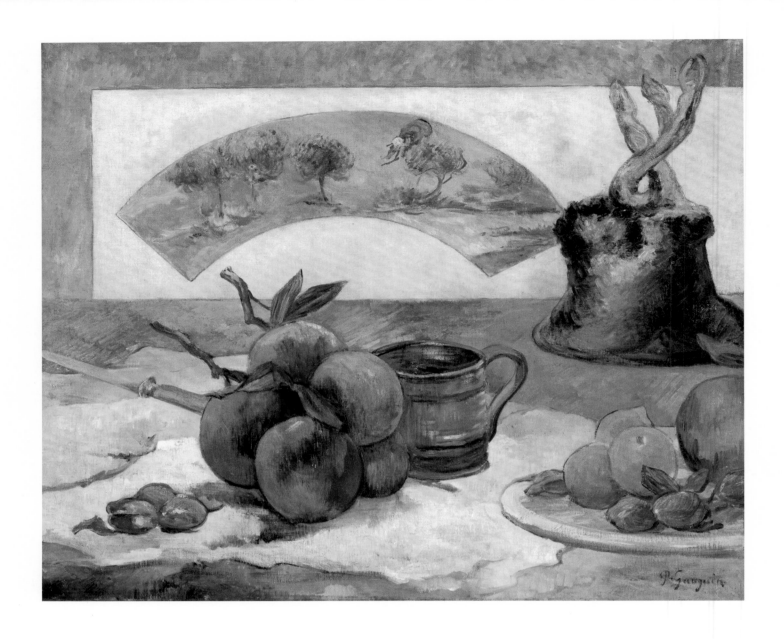

Still life with fan (Nature morte à l'éventail) c 1889
oil on canvas
50.5 × 61.5 cm
Musée d'Orsay, Paris. Cession under the peace treaty with Japan, 1959, RF 1959 7

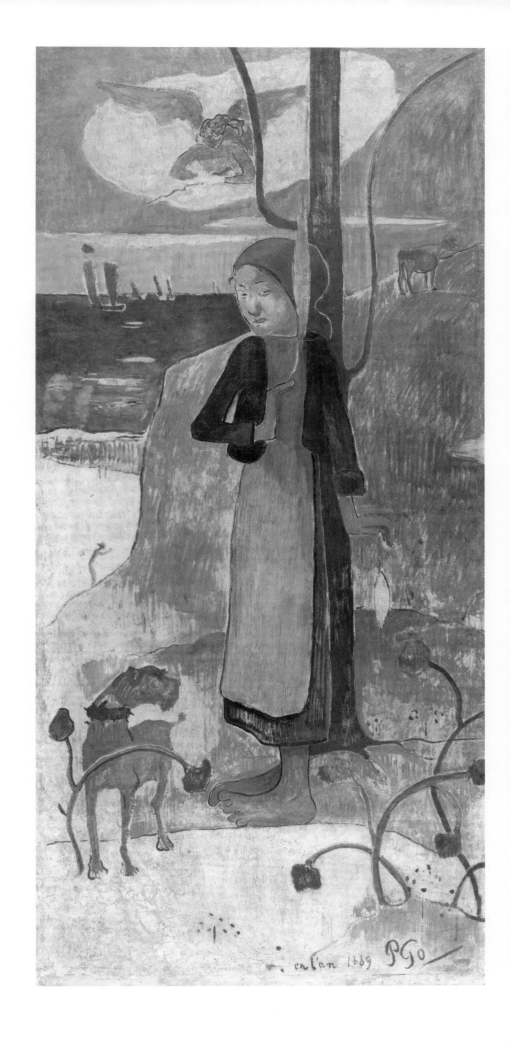

Breton girl spinning 1889
also known as *Joan of Arc*
(*Jeanne d'Arc*)
oil on plaster
135 × 62 cm
Van Gogh Museum, Amsterdam,
S0513S2006

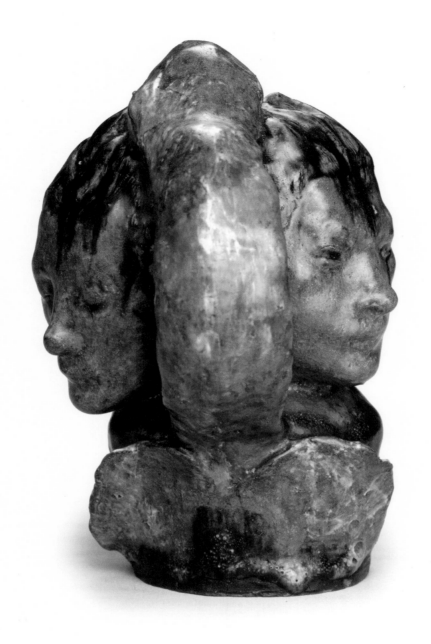

Double-headed vase (Vase en forme de double tête de garçon)
1889
glazed stoneware
21 × 14 × 21 cm
Private collection. Courtesy
Galerie Dina Vierny, Paris, P33

Self-portrait (*Autoportrait*)
c 1889
charcoal on wove paper
31 × 19.9 cm
Musée d'Art Moderne et
Contemporain de Strasbourg.
Purchased 1921, XXI 159

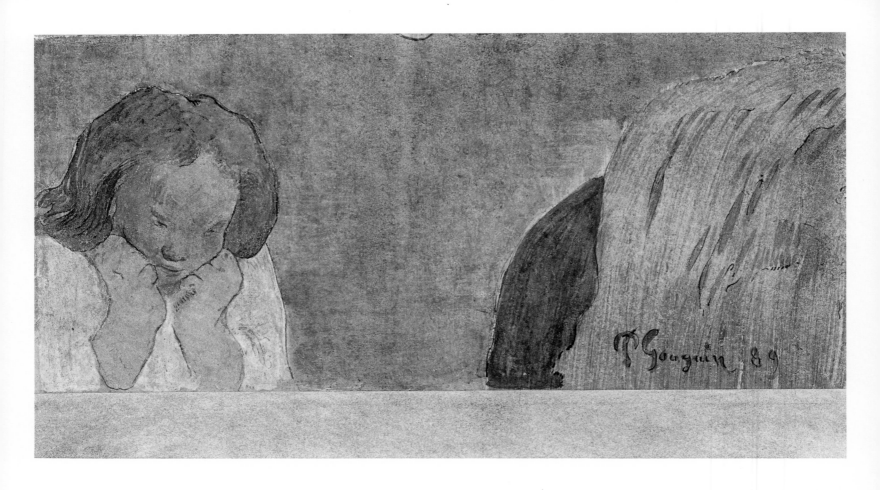

ABOVE
Human miseries
(*Misères humaines*) 1889
graphite, ink and watercolour
on tracing paper
21 × 39 cm
Private collection. Courtesy
Galerie Dina Vierny, Paris, P38

OPPOSITE
In Brittany (*En Bretagne*) 1889
watercolour, gold paint and
gouache on paper
37.7 × 27 cm
The Whitworth, The University
of Manchester, D.1926 20

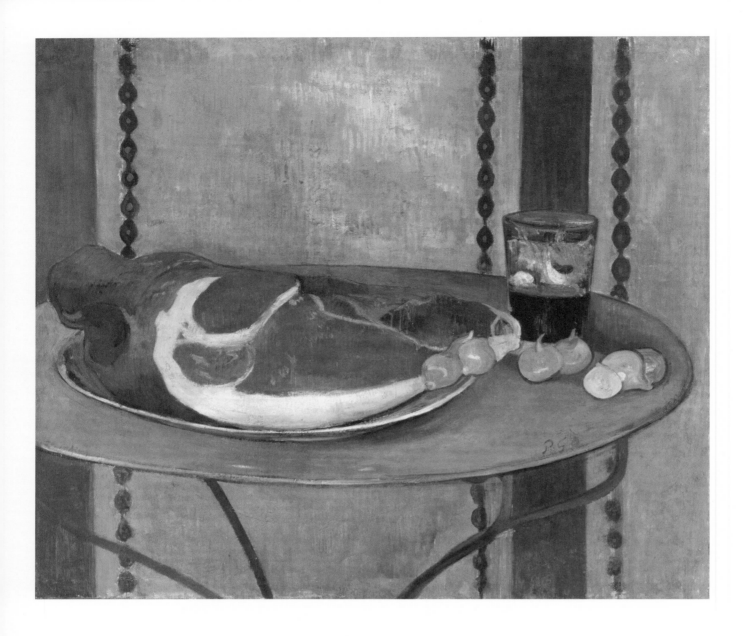

ABOVE

The ham (Le jambon) 1889
oil on canvas
50.1 × 57.7 cm
The Phillips Collection,
Washington, DC. Acquired 1951,
0761

OPPOSITE

The red cow (La vache rouge)
1889
oil on canvas
90.8 × 73 cm
Los Angeles County Museum of
Art. Mr and Mrs George Gard De
Sylva Collection, M.48.17.2

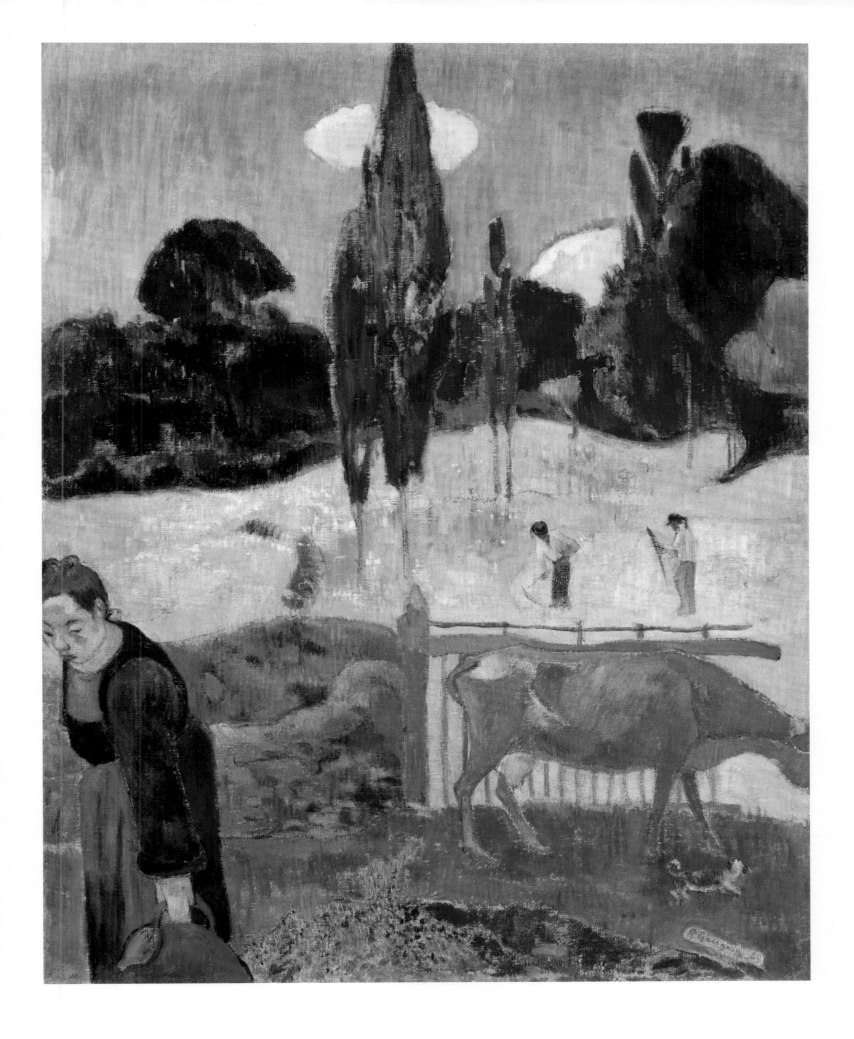

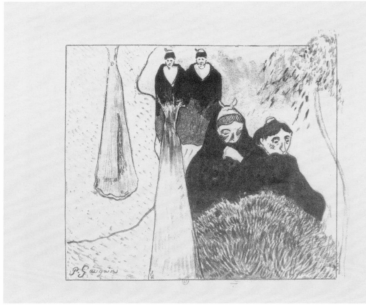

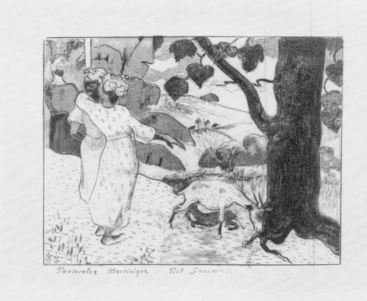

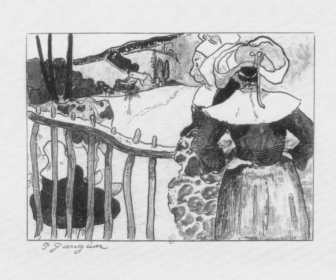

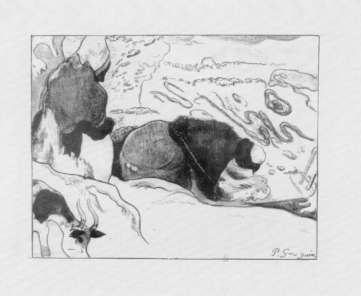

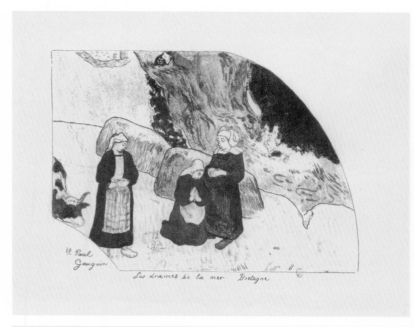

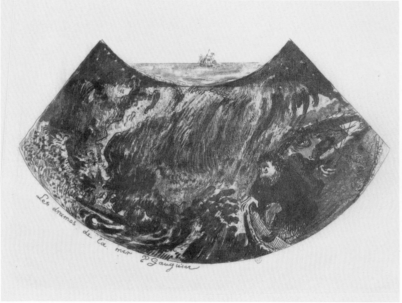

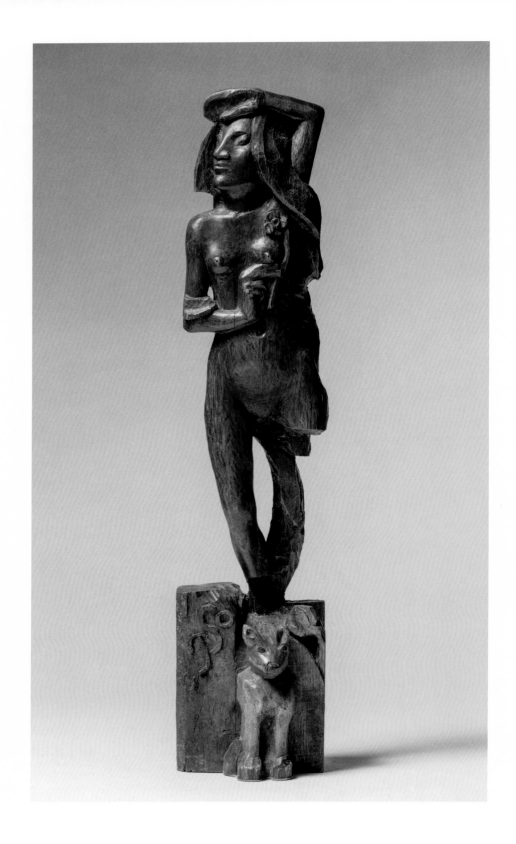

Lust (*La luxure*) 1890
carved oak and pine, with
gilded highlights and metal
70.5 × 14.7 × 11.7 cm
Willumsens Museum,
Frederikssund, G.S.14

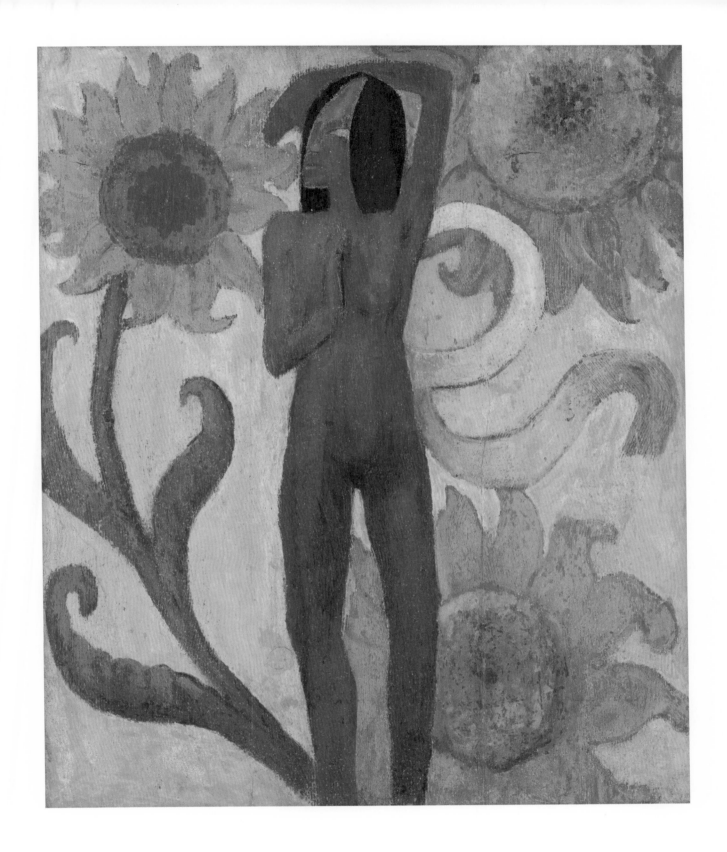

Caribbean woman
(*Femme caraïbe*) 1889
oil on wood panel
66.7 × 55.3 cm
Yoshino Gypsum Art Foundation,
Tokyo

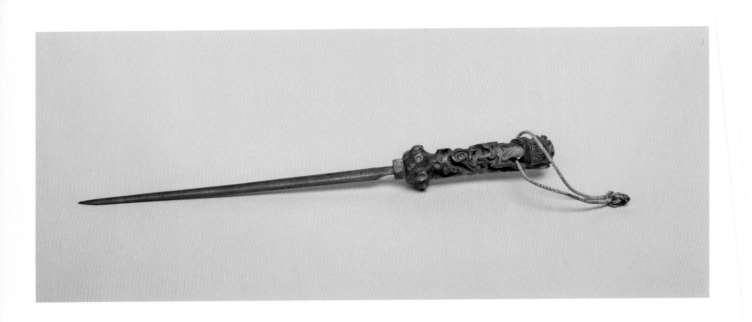

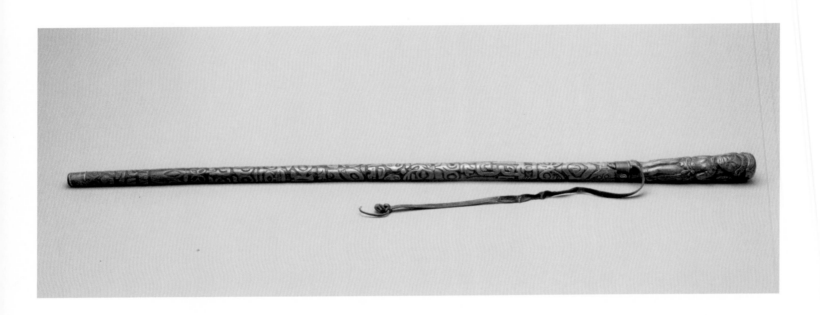

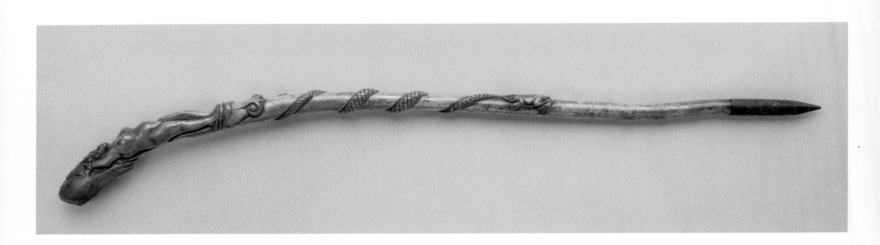

1890

February

Returns to Paris determined to establish a studio in a French protectorate or possession, where possibilities could include government support. He writes to Mette that he will soon be on Tahiti, an island in Oceania, in 'the silence of the beautiful tropic nights'.[10]

April

Writes to Bernard of going to Madagascar, where other artists will join him, but will resolve it is 'too close to the civilised world'.[11]

Friendship with Laval ends in a rage over Laval's announced engagement to Madeleine Bernard (see *Portrait of Madeleine Bernard*, p 55).

June

Travels to Le Pouldu. Meets the Danish painter and sculptor Jen Ferdinand Willumsen (1863–1958), developing a new friendship. He exchanges *Lust* (p 182) for one of Willumsen's paintings.

27 July

Van Gogh takes his own life. Gauguin writes to Bernard that he understood their friend's 'struggles with madness. To die at this time is a great happiness for him [...] and if he returns in another life he will harvest the fruit of his fine conduct in this world (according to the law of Buddha).'[12]

Theo's health deteriorates rapidly following his elder brother's death; he is admitted to hospital in mid October. Gauguin loses the stability provided by his main promoter as an increasingly influential dealer.

November

Returns to Paris. Meets symbolist poets and writers Charles Morice (1861–1919) and Stéphane Mallarmé (1842–1898), becoming lifelong friends and inspiring artistic endeavours. (see *Portrait of Stéphane Mallarmé, dedicated to Daniel de Monfreid*, p 186, Gauguin's expressive, sole etching).

Juliette Huet, a seamstress in her 20s, becomes his model and mistress (see *Bust of a young girl with a fox [study for The loss of virginity]*, p 187). The following year, she gives birth to a girl in August.

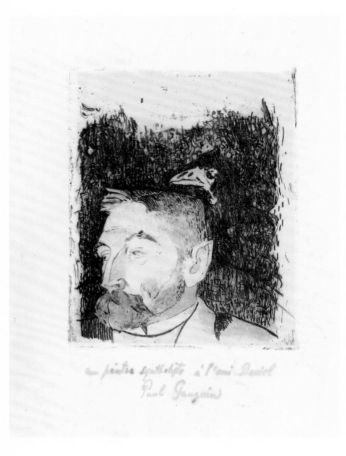

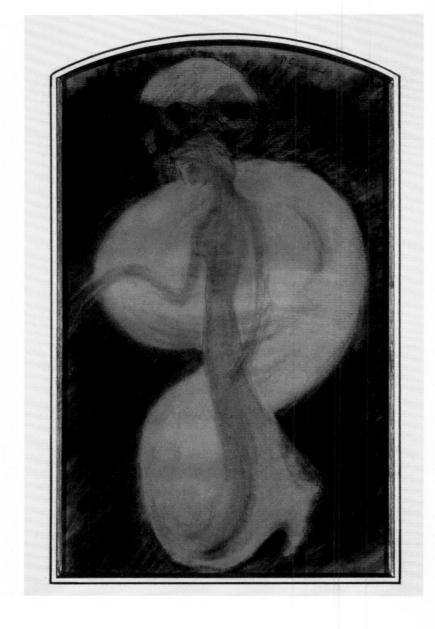

LEFT

Portrait of Stéphane Mallarmé,
dedicated to Daniel de Monfreid
1891
etching, with drypoint and
engraving
state 2
image 18.3 × 26.1 cm
Chancellerie des Universités
de Paris – Bibliothèque littéraire
Jacques Doucet, Paris,
MNR OA 237

RIGHT

Madame death (Madame la mort)
1891
charcoal with white-wash
highlights on paper
33.5 × 23 cm
Musée d'Orsay, Paris. Gift from
the Society of Friends of the
Musée d'Orsay 1991, RF 42998

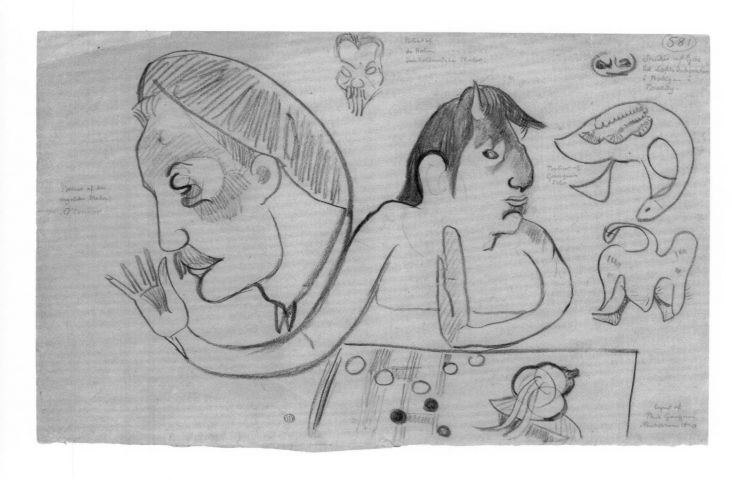

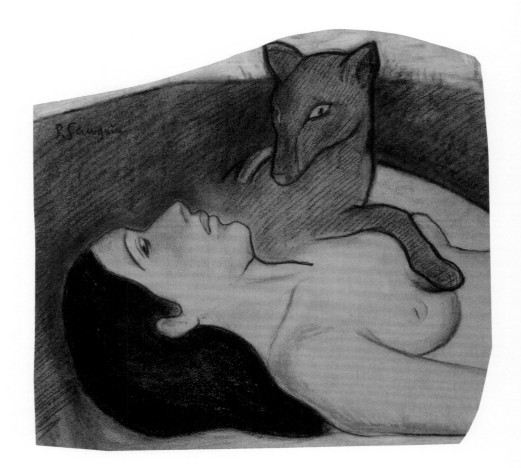

TOP
*Portraits of Roderic O'Connor
and Jacob Meyer de Haan and
self-portrait* 1890
crayon on paper
sheet 24 × 44.5 cm
Willumsens Museum,
Frederikssund, CS581

RIGHT
*Bust of a young girl with a fox
(study for The loss of virginity)
(Jeune fille et renard [étude pour
La perte du pucelage])* c 1891
conté crayon, white pastel and
red chalk over graphite on wove
paper
31.2 × 33.2 cm (irreg)
Keith Stoltz, Wilson, Wyoming

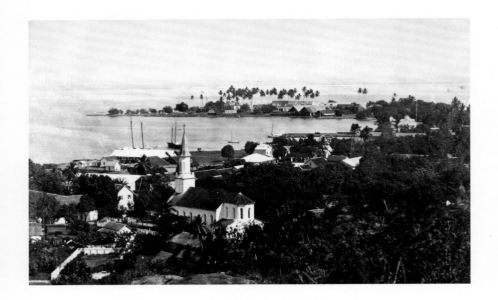

1891 25 January
Theo van Gogh dies.

23 February
Auction of his works at Hôtel Drouot to raise funds for his trip to Tahiti, including the sale of *The wave* (p 165). In the catalogue preface the novelist and art critic Octave Mirbeau (1848–1917) extols: 'Never satisfied with what he has created, he always goes searching for what is beyond [...] until he arrives at a spiritual synthesis, a profound and eloquent expression'.[13]

Mirbeau, then a new acquaintance, quickly becomes an ardent supporter and lifelong friend. During one of their initial meetings he acquires *Bust of a young girl with a fox*.

March
Critic Albert Aurier (1865–1892) pronounces him the leader of the symbolist movement in an article in the radical journal *Mercure de France*. The praise is significant as Gauguin is still little known outside artistic circles.

The Minister of Public Education and Fine Arts funds Gauguin's artist mission to Tahiti to 'study and ultimately paint this country's customs and landscape'.

23 March
Mallarmé hosts a farewell dinner in Gauguin's honour at the Café Voltaire, including writers, poets and painters. Gauguin shares his optimism for the future in a letter to Mette, sure of the wealth and pride it will bring his family.[14]

1 April
He leaves Marseille aboard *L'Océanien*.

5 May
Arrives in Sydney after calling at the ports of Albany, Adelaide and Melbourne, listed as 'Mr Ganguni'. He departs for Noumea the following day, where he will board *La Vire* for Tahiti.

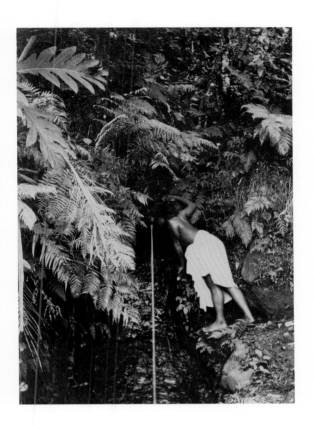

9 June
Arrives in Papeete (fig 13).
Befriends a young lieutenant,
Édouard Jénot, who helps
him with accommodation and
introductions. He also starts
learning the Tahitian language
(fig 14) from Jénot and then
from the colony's official
translator, who also assists
with questions about local life
and Māori history.[15]

9 June
Death of Pomare V, the last
monarch of Tahiti (see *Arii
matamoe*, p 80).

Seeks out Oceanian objects in
the port's curio shops which
offer items imported from
the Marquesas Islands and
from Rapa Nui (Easter Island).
He sees a notable collection at
the home of the gendarmerie
chief, including Marquesan
stone statues, clubs and bowls[16]
(see *U'u* [*Club*], p 83).

Buys photographs depicting
Marquesans with tattoos, likely
from Charles Georges Spitz's
curio shop. These also inform
his early carving experiments
(see *Umete* [*Ceremonial dish*],
p 82).[17] He will adapt the Spitz
photograph *Tahitian boy drinking
at a waterfall* c 1880 (fig 15) to
compose *Pape moe* (*Mysterious
water*, Private collection) and
Hina tefatou (*The moon and the
earth*, p 70).

July
The subject of his only known
commission during this time,
Portrait of Suzanne Bambridge
(p 77), refuses to display the
completed painting, quelling his
hopes of establishing an income
with portrait commissions among
the wealthy colonial and noble
Tahitian classes.

He writes to Mette that 'my mind is in a whirl [...] I feel all of this is going to overwhelm me [...]. Don't let this make you think that I am selfish and that I'm abandoning you. But let me live this for a while'.[18] He describes the silence and how he aims to better understand the way of the people: their stillness and melancholy expressions, and how they live in harmony with the environment and each other (see *Te faaturuma* [*The brooding woman*], p 73, and *Tahitian women*, p 197).

He also laments the loss of Tahitian culture caused by colonial influence, writing: 'little by little, this ancient way of life will disappear [.... Our missionaries] take away part of the poetry'.[19] He endeavours to interpret Tahitian spirituality, expressed through invented imagery, layered with diverse references (see *The afternoon of a faun*, p 198, a totem that combines Tahitian deities with a Mallarmé poem).

First use of Tahitian titles is *Vahine no te tiare* (*Woman with a flower*, Ny Carlsberg Glyptotek, Copenhagen). While this is partially meant to enhance a sense of the 'exotic', the importance he gives to the Tahitian language and his commitment to learning it reflect his desire for authentic engagement.

Likely sees Polynesian dancers organised to perform in the Place de Musique, including a version of *'upa 'upa* to inspire *Upa upa* (*The fire dance*). An Australian tourist in 1887 described the *'upa 'upa* performed by girls to the accordion and drum:

'The gestures and contortions are again so strange that no impression can be conveyed in words of the queer effect'.[20]

August
Wishing to isolate himself from colonial society in Papeete and seek a more 'authentic' encounter with Tahitians, he moves to Mataiea, a small village approximately 64 kilometres south of the capital, and rents a traditional hut.

Meets Teha'amana (sometimes Tehamana or Tehura) who becomes his *vahine* ('wife') and model. She is likely between 13 and 15 years old. Little is known about her, other than through his paintings and description in *Noa Noa*.

Writes in letters to Mette and friends of the importance of continued study and drawing. He also reflects on his loneliness to Sérusier, with 'yes, my dear Séruse, I am quite alone in the country [...] no one with whom to talk art, nor even French, and I'm still not very good at the local language, despite all my efforts'.[21]

Two nudes on a Tahitian beach (Deux femmes tahitiennes nues sur la plage) 1891–94
oil on canvas
90.8 × 64.8 cm
Honolulu Museum of Art. Gift of Anna Rice Cooke 1933, 35099

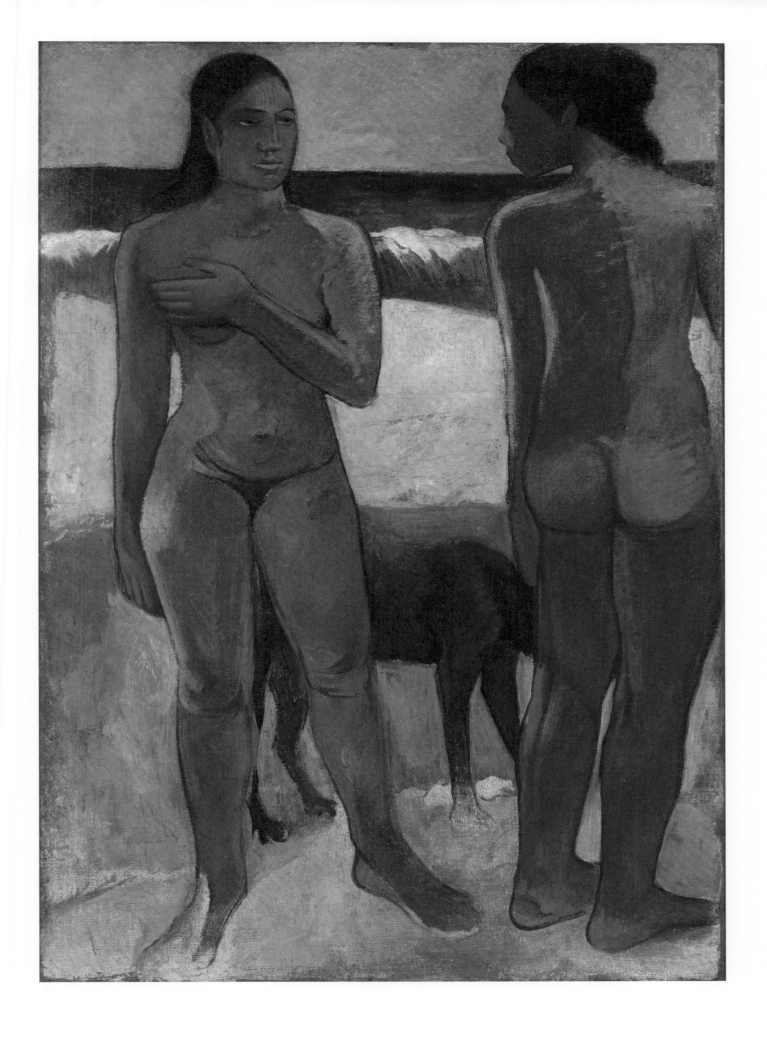

Faaturuma (*Melancholic*) 1891
oil on canvas
94 × 68.3 cm
The Nelson-Atkins Museum
of Art, Kansas City. Purchase:
William Rockhill Nelson Trust,
38-5

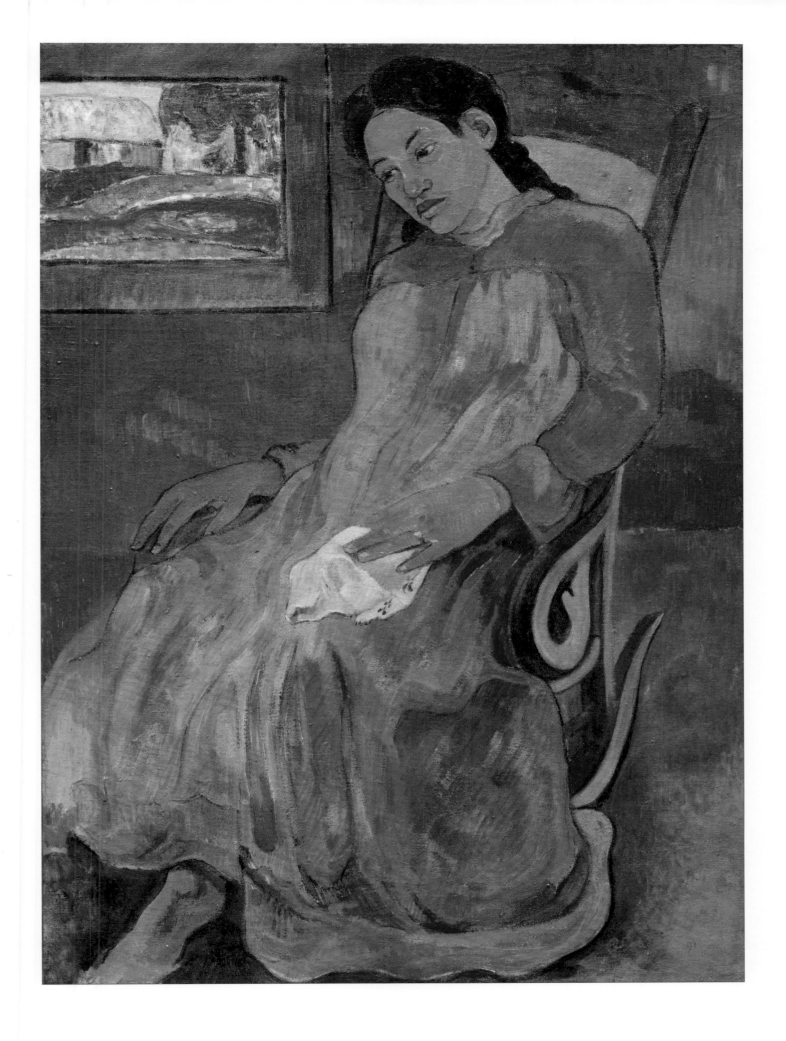

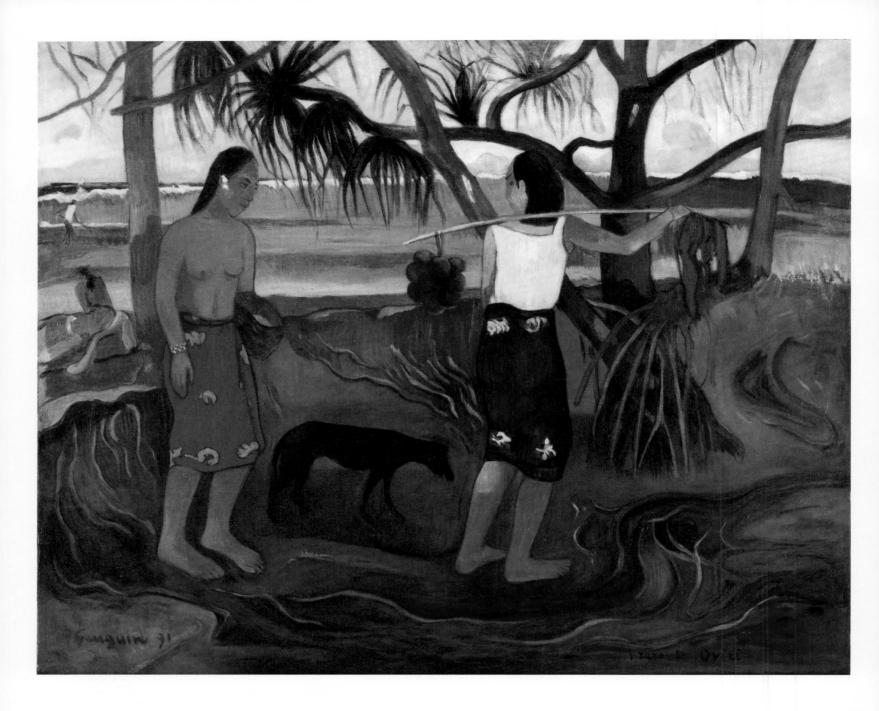

ABOVE
I raro te oviri (*Under the pandanus*)
1891
oil on canvas
73 × 91.4 cm
Minneapolis Institute of Art. The
William Hood Dunwoody Fund, 41.4

OPPOSITE
Street in Tahiti (*Rue de Tahiti*) 1891
oil on canvas
115.5 × 88.5 cm
Toledo Museum of Art. Purchased
with funds from the Libbey
Endowment. Gift of Edward
Drummond Libbey, 1939.82

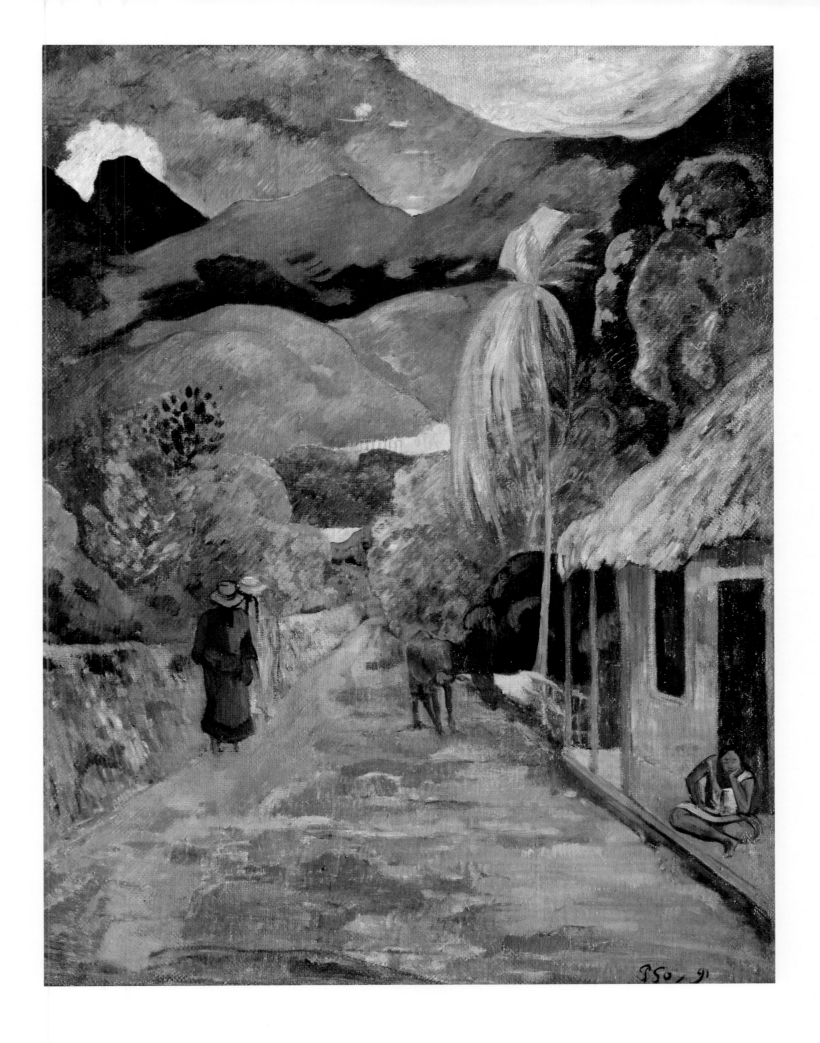

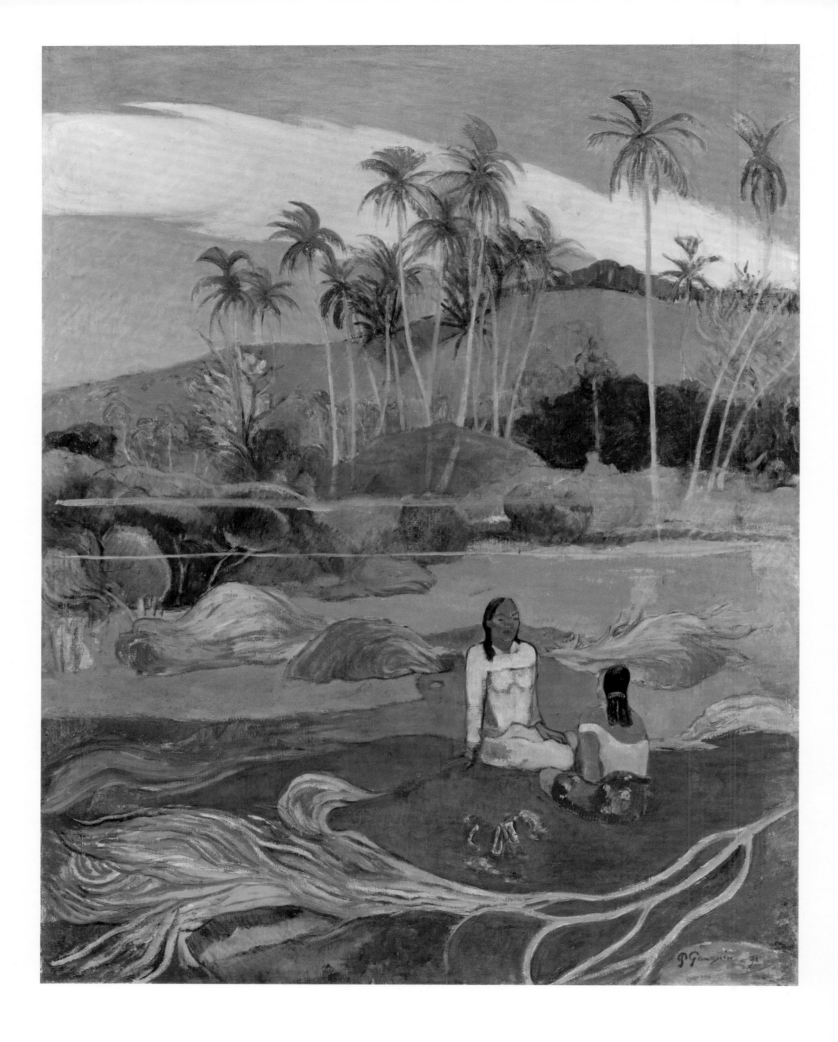

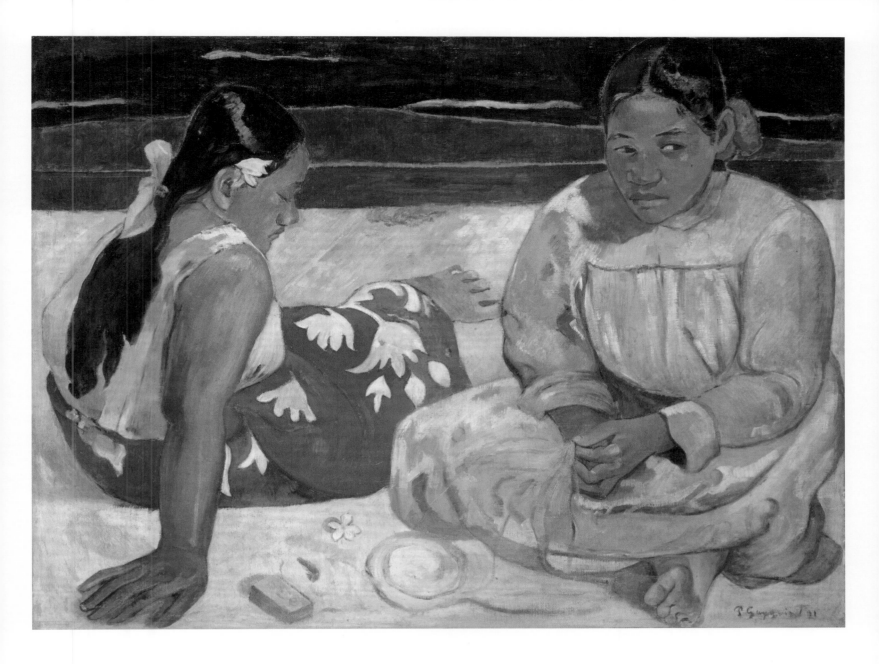

Tahitian women under the palm
trees (Femmes près des palmiers)
1891
oil on canvas
92.1 × 71.8 cm
Private collection

Tahitian women
(Femmes de Tahiti) 1891
oil on canvas
69 × 91.5 cm
Musée d'Orsay, Paris. Gift of
Countess Vitali 1923, RF 2765

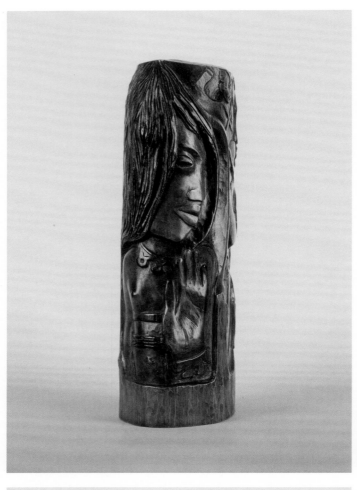
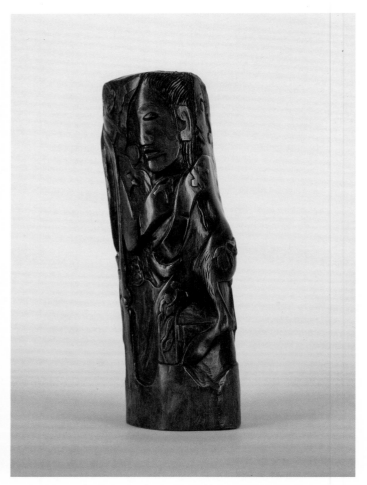
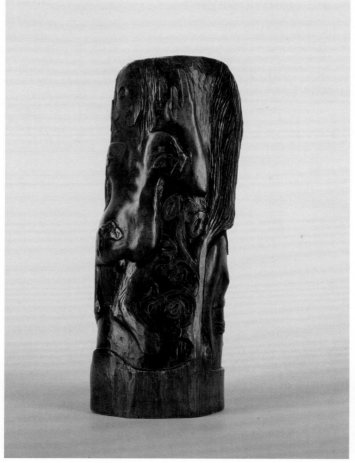
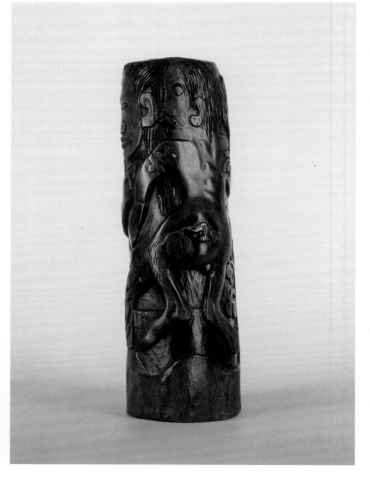

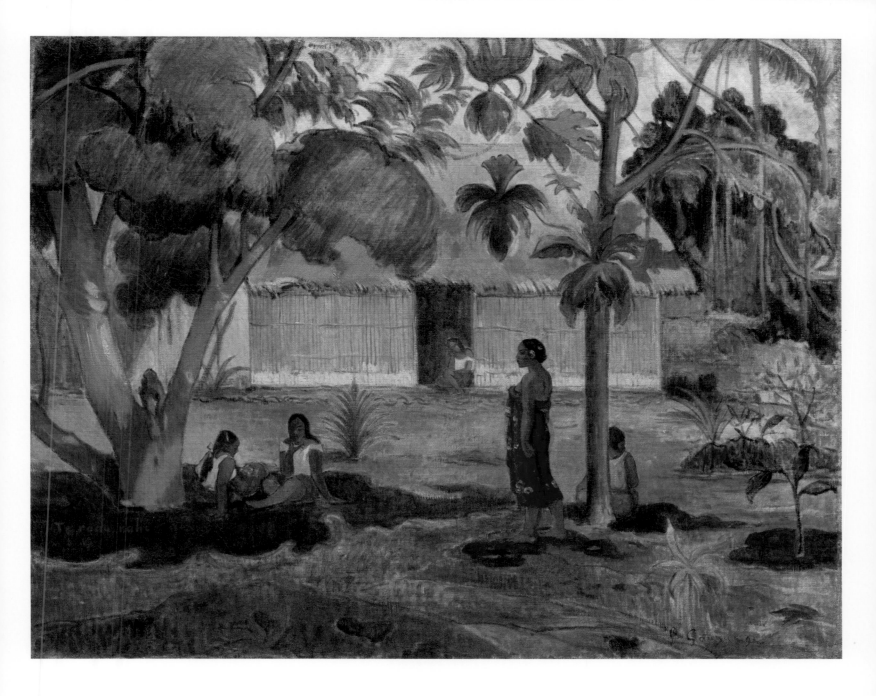

OPPOSITE
The afternoon of a faun
(*L'après-midi d'un faune*) c 1892
carved (likely *tamanu*) wood
35.6 × 14.7 × 12.4 cm
Musée départemental Stéphane
Mallarmé, Vulaines-sur-Seine,
995.5.1

ABOVE
Te raau rahi (The large tree) 1891
oil on canvas
74 × 92.8 cm
The Cleveland Museum of Art.
Gift of Barbara Ginn Griesinger,
1975.263

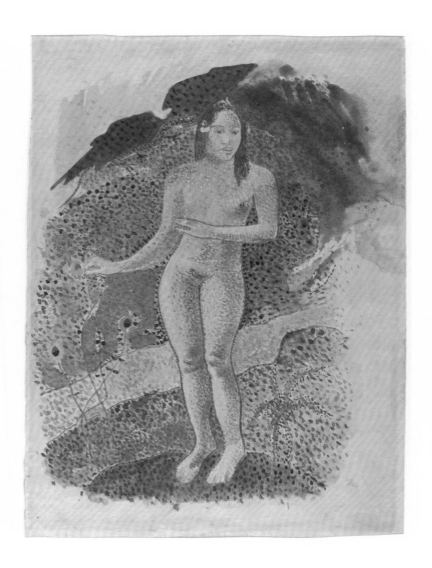

LEFT

Te nave nave fenua
(*The delightful land*) (recto)
c 1892
pen and brown ink, brown ink
wash, watercolour and gouache
on wove paper
29.5 × 21.8 cm
Musée de Grenoble. Bequest of
Agutte-Sembat 1923, MG 2227
(RO)

RIGHT

Two Tahitian women standing
(*Deux tahitiennes debout*) 1894
watercolour monotype on Japan
paper, mounted on cardboard
18.5 × 14.5 cm
Private collection. Courtesy
Galerie Dina Vierny, Paris, P34

OPPOSITE

Reworked study for *Te nave
nave fenua* (*The delightful land*)
(recto) 1892–94
charcoal and pastel on paper
94 × 47.6 cm
Des Moines Art Center. Gift
of John and Elizabeth Bates
Cowles, 1958.76

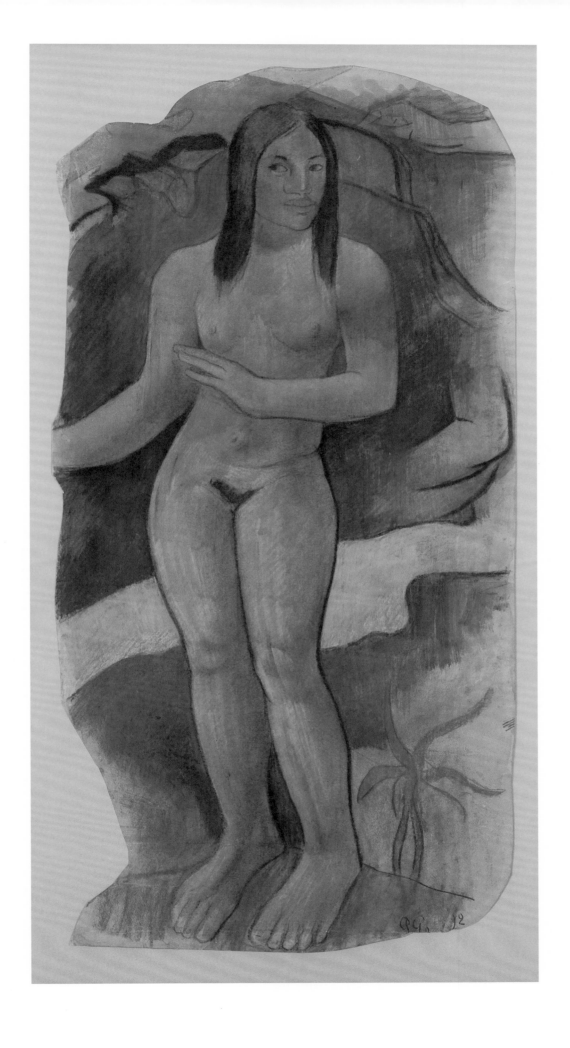

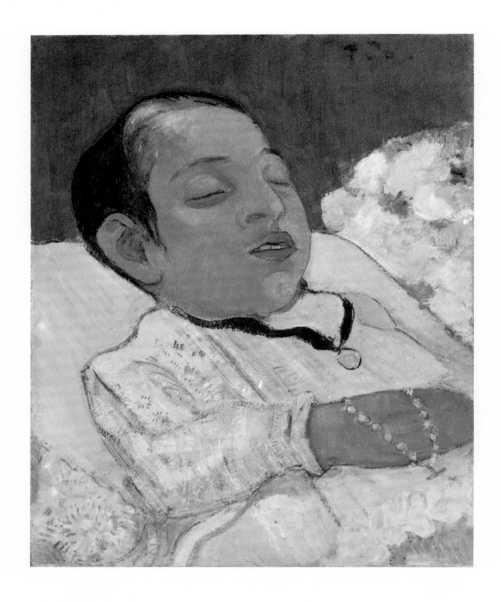

ABOVE
Atiti 1892
oil on canvas
29.7 × 24.7 cm
Kröller-Müller Museum, Otterlo,
KM 104.366

OPPOSITE
Mahana ma'a 1892
oil on canvas
55.2 × 30 cm
Cincinnati Art Museum. Bequest
of John W Warrington, 1996.466

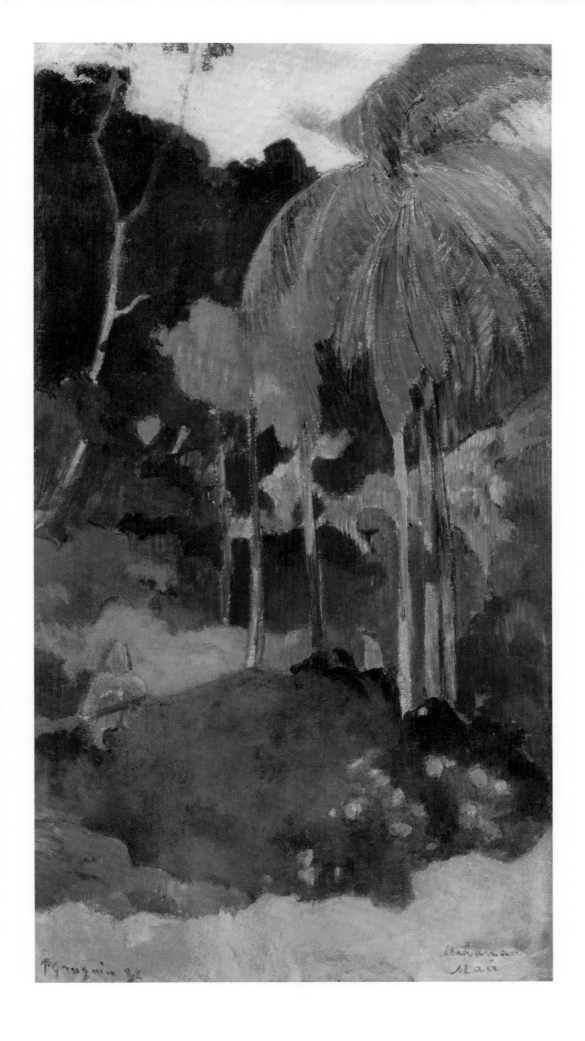

Mata mua (*In olden times*) 1892
oil on canvas
91 × 69 cm
Museo Nacional Thyssen-
Bornemisza, Madrid, Carmen
Thyssen-Bornemisza Collection,
CTB.1984.8

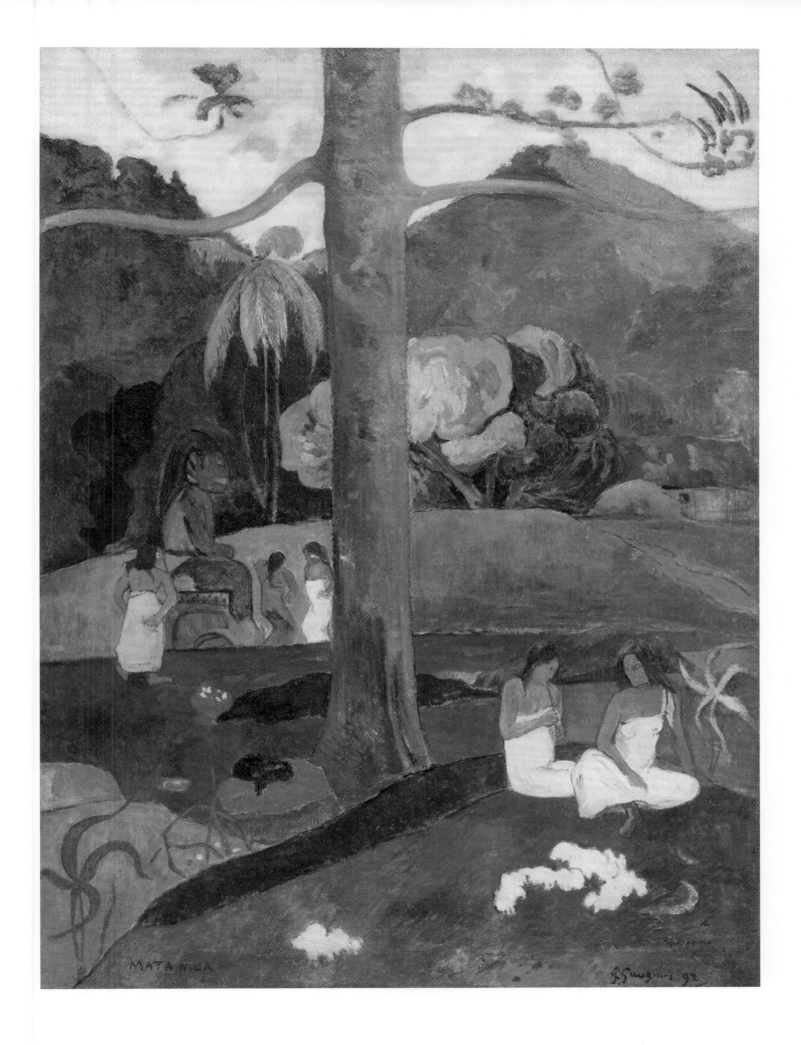

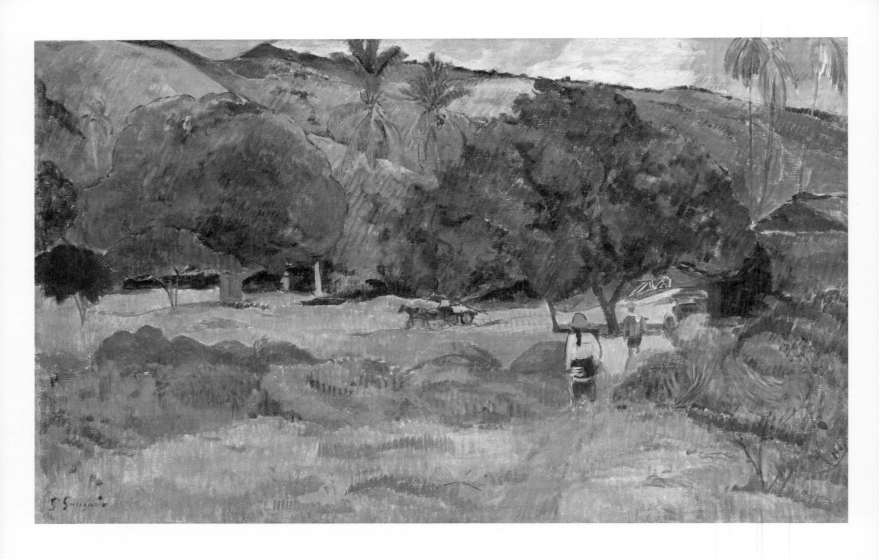

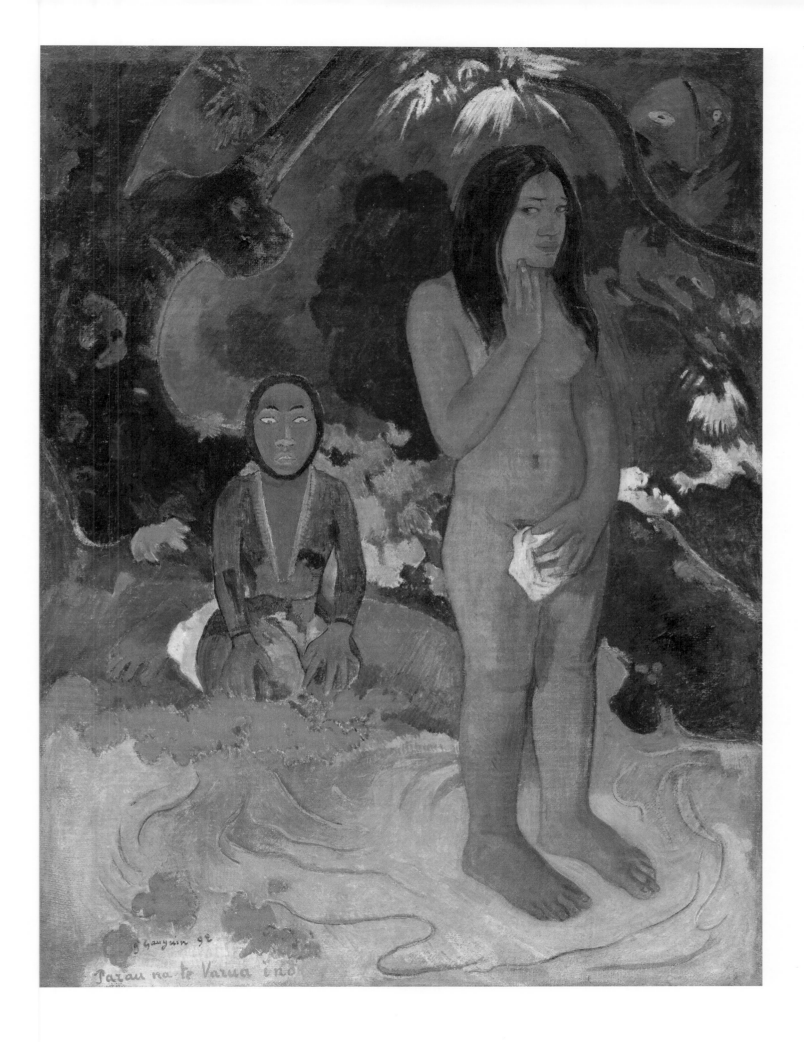

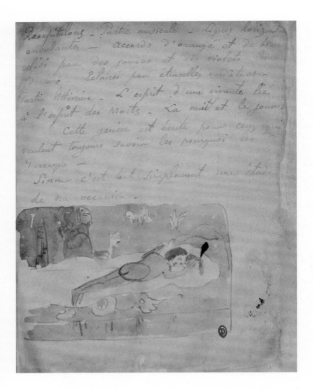

1892 February

His application for a vacant civil post in the Marquesas Islands is refused.

Copies sections of text from Jacques-Antoine Moerenhout's *Voyages aux îles du grand océan* (*Voyages to the islands of the great ocean*) 1837, a detailed two-volume account of Polynesian cultures explaining the pantheon of Māori deities and creation myths. Later he will credit Teha'amana as his source of knowledge in *Noa Noa*.[22]

Writes to Sérusier: 'What a religion the ancient Oceanian religion is. What a marvel!'[23]

June

Appeals to the governor for funds to repatriate to France, which are granted in November.

Sends 44 paintings to Paris in care of his friend, the artist Daniel de Monfreid (1856–1929), who is assisting him as an agent.

September

Vahine no te tiare is his first Tahitian painting exhibited in Paris.

December

Sends eight canvases to Mette for an exhibition planned in Copenhagen. Mette writes to De Monfreid: 'I hope something good will come out of this great man whom I married. The paintings have been perceived as wonderful!'[24]

Begins writing *Cahier pour Aline* (*Notebook for Aline*, fig 17), an illustrated manuscript of art criticism dedicated to his daughter, with tender passages of introspection. Art, he proposes, becomes 'the reproduction of what one sensibly grasps in nature but which is seen through the veil of the soul'.[25]

1893 4 June

Leaves Tahiti with 66 paintings and several sculptures. He arrives in Marseille at the end of August.

June–July

Fifty-one of his works and paintings by Van Gogh are exhibited in Copenhagen including recent paintings from Tahiti and several ceramics. Three paintings and two ceramics are sold. Mette writes to Schuffenecker: 'I don't think Paul's art is understood by the public—but at least amongst his friends'.[26]

Degas persuades Durand-Ruel to host an exhibition of Gauguin's Tahitian works. Gauguin starts writing *Noa Noa*, his fictionalised account of his time in Tahiti, to accompany the exhibition and explain its 'foreignness'. He invites Morice to collaborate on the text.

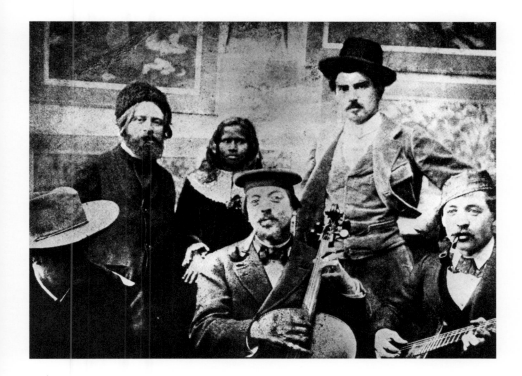

November
*Exhibition of recent works by
Paul Gauguin* opens at Durand-
Ruel's gallery. Gauguin is buoyed
by the number of reviews and
critical acclaim, although it is
not a financial success. Degas
purchases *Hina tefatou* (p 70).
He gifts *Faaturuma* (*Melancholic*,
p 193) to De Monfreid.

1894 Ambroise Vollard (1866–1939), a
young art dealer, recommends
a Southeast Asian adolescent
known as Annah la Javanaise,
whom he suggests would make a
suitable model. She also becomes
Gauguin's mistress (fig 18).

Paints the walls of his studio
brilliant chrome yellow,
decorating them with unsold
Tahitian paintings and artefacts
including a *tapa* (bark cloth).
He hosts weekly gatherings
with artists, writers, poets and
musicians. Annah and her pet
monkey add a sense of the 'exotic'.

Begins to make woodblock prints
for *Noa Noa* (see pp 210–15),
radical for his experimentation
with carving techniques, papers,
inks and hand-printing. He
transforms but also revives the
woodcut medium, signifying a
nostalgia for a pre-industrial past.

May
Moves to Brittany with Annah.
Sustains a serious broken ankle
and is compelled to convalesce
for two months in his room at the
Hôtel Ajoncs d'Or in Pont-Aven.
The break does not heal correctly
and he experiences ongoing—at
times debilitating—pain.

September
Considers returning to Tahiti
permanently, realising the
opportunity to consolidate his
position as the leader of the Paris
avant-garde.

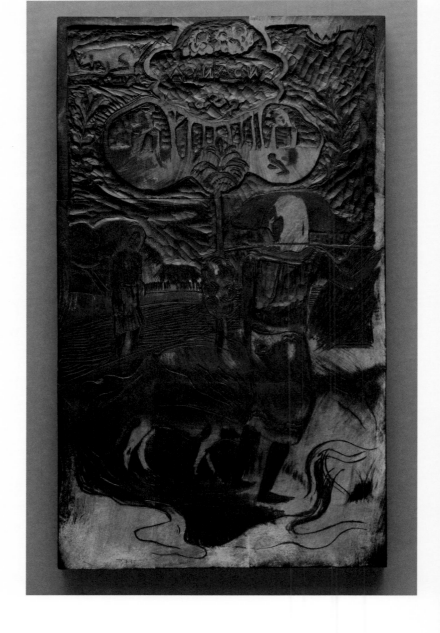

Noa Noa (Fragrance), title block
1893–94
woodblock, fruit wood, with
traces of zinc white paint and
ink
35.2 × 20.3 × 2.2 cm
The Metropolitan Museum of
Art, New York. Harris Brisbane
Dick Fund 1937, 37.97

Noa Noa (Fragrant scent)
1893–94
from the *Noa Noa suite*
woodcut, printed in black ink
on cream wove paper
state 3
image 36.2 × 19.8 cm
sheet 47.6 × 27.4 cm
Musée du quai Branly – Jacques
Chirac, Paris. Gift of Lucien
Vollard to Musée de la France
d'outre-mer, 75.14463

Noa Noa (Fragrant scent)
1893–94
from the *Noa Noa suite*
woodcut, printed twice from
the same block, in black ink and
yellow ochre, signs of repainting
along the lower edge
state 3(b)
image 36.2 × 19.8 cm
Musée du quai Branly – Jacques
Chirac, Paris. Gift of Lucien
Vollard to Musée de la France
d'outre-mer, 75.14431.6

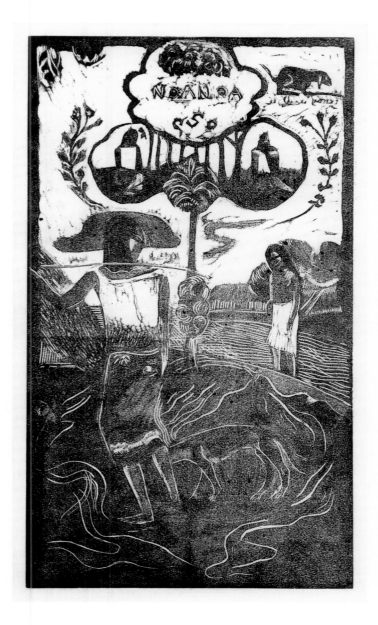

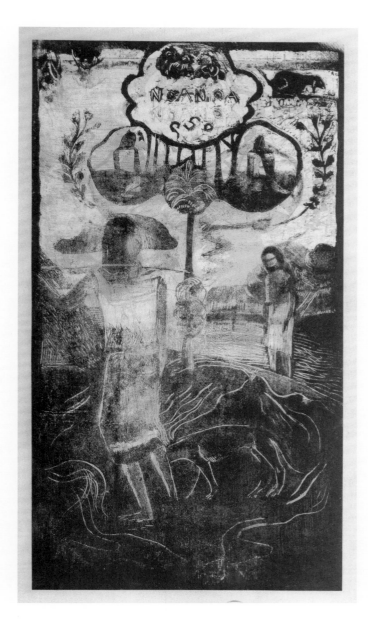

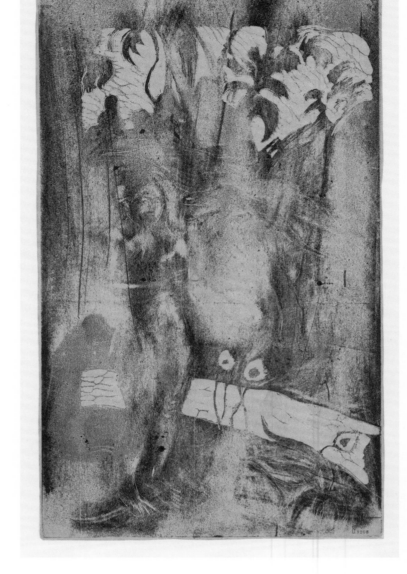

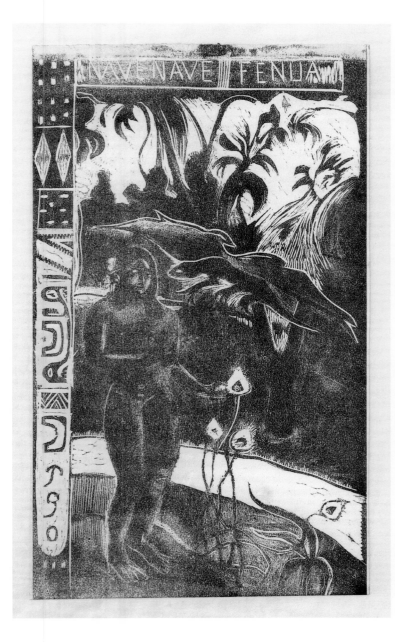

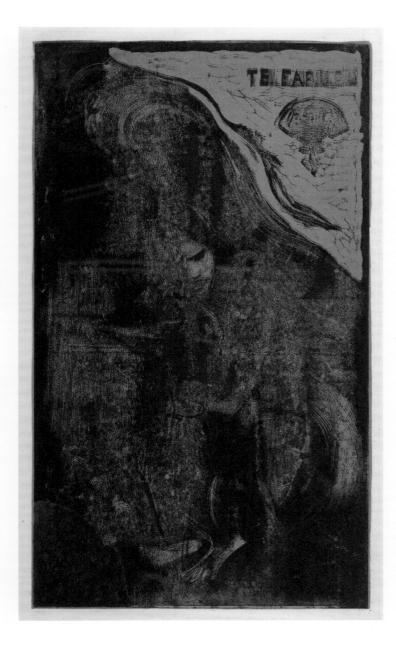

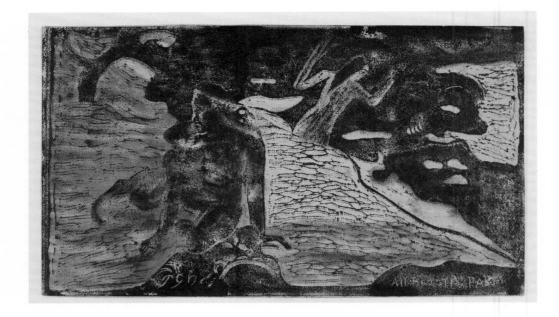

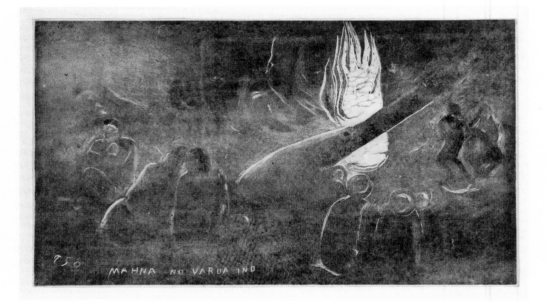

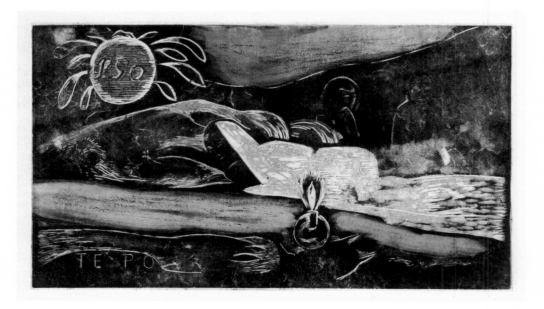

TOP

Auti te pape (Women at the river)
1893–94
from the *Noa Noa suite*
woodcut, printed in black ink,
hand-coloured in yellow and
blue-grey wash on laid Japan
paper
state 2(a)
20.4 × 35.5 cm
The British Museum, London.
Bequest of Campbell Dodgson,
1949,0411.3674

MIDDLE

Mahna no varua ino
(The devil speaks) 1893–94
from the *Noa Noa suite*
woodcut, printed twice from the
same block, in brown and black
inks on laid Japan paper
state 3
image 20.4 × 35.8 cm
Musée du quai Branly – Jacques
Chirac, Paris. Gift of Lucien
Vollard to Musée de la France
d'outre-mer, 75.14431.4 bis

BOTTOM

Te po (Eternal night) 1893–94
from the *Noa Noa suite*
woodcut, printed twice from the
same block, in brown and black
inks on laid Japan paper
state 2
sheet 20.5 × 35.7 cm
Musée du quai Branly – Jacques
Chirac, Paris. Gift of Lucien
Vollard to Musée de la France
d'outre-mer, 75.14431.1

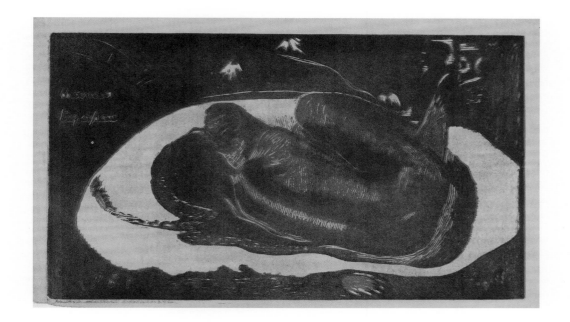

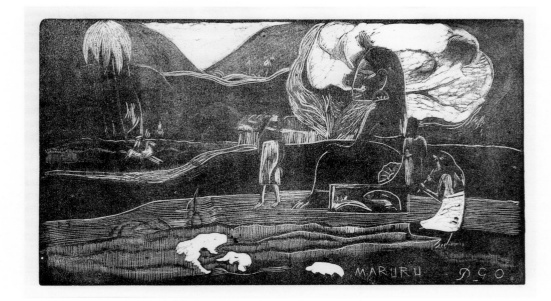

TOP

Manao tupapau (*The spirits of
the dead are watching*) 1893–94
from the *Noa Noa suite*
woodcut, printed in brown, light
black and yellow ochre on Japan
paper
state 4(b)
image 20.3 × 35.5 cm
The British Museum, London.
Bequest of Campbell Dodgson,
1949,0411.3678

MIDDLE

Maruru (*Offerings of gratitude*)
1893–94
from the *Noa Noa suite*
woodcut on wove paper
state 3
image 20.5 × 35.5 cm
sheet 27.6 × 47.7 cm
Musée du quai Branly – Jacques
Chirac, Paris. Gift of Lucien
Vollard to Musée de la France
d'outre-mer, 75.14466

*Square decorative object with
Tahitian gods (Objet décoratif
carré avec dieux tahitiens)*
1893–95
earthenware with painted
highlights
34.4 × 14.1 × 14.1 cm
Musée d'Orsay, Paris. Gift of
David David-Weill 1938, OA 9514

Mask of a woman c 1893
modelled wax
38.5 × 23.3 cm
Private collection

ABOVE

Tahitian idol—the goddess Hina
(*Idole tahitienne*) c 1894–95
woodcut, printed in black ink
over monotype printed in
terracotta and orange ochre on
wove paper
state 1
14.9 × 11.8 cm
Seibert Collection

OPPOSITE

Portrait of the artist with the idol
(*Autoportrait à l'idole*) c 1893
oil on canvas
43.8 × 32.7 cm
The McNay Art Museum, San
Antonio. Bequest of Marion
Koogler McNay, 1950.46

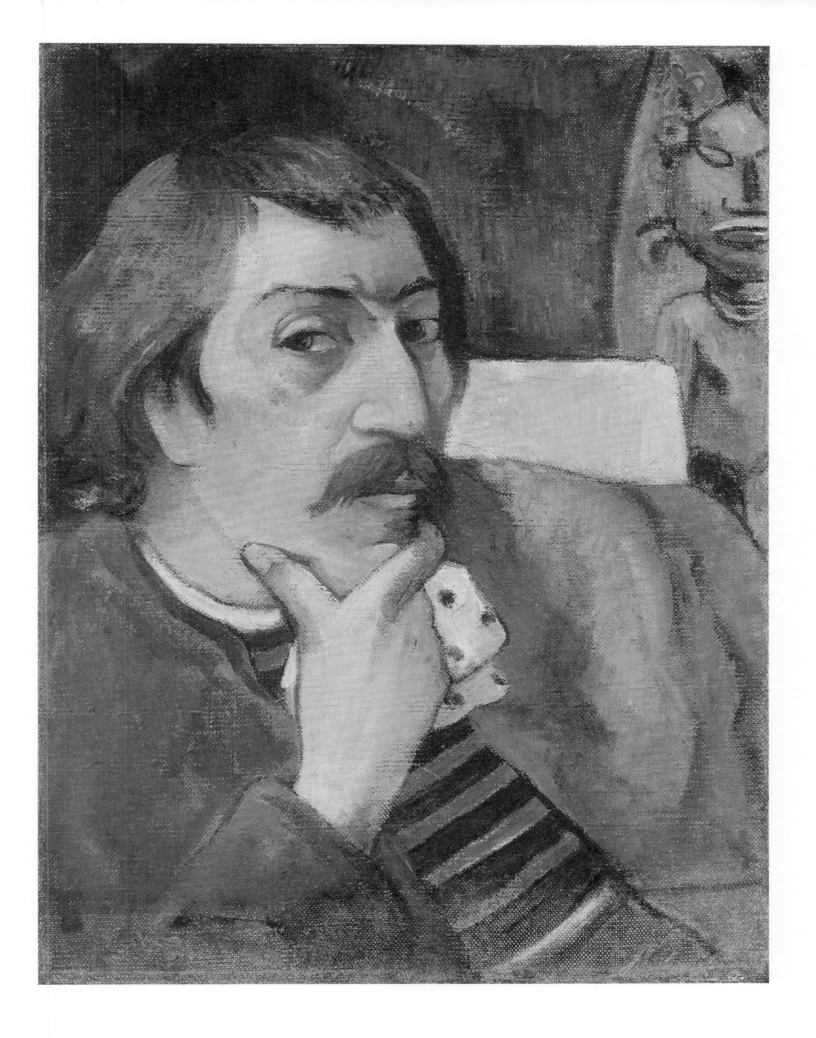

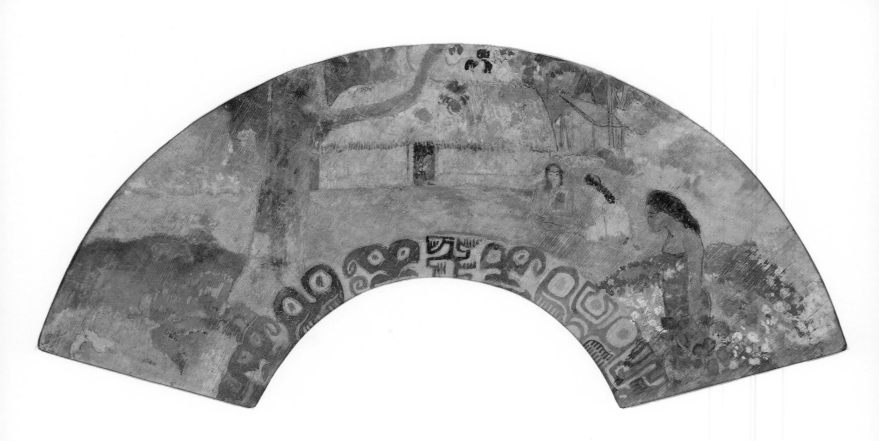

Fan decorated with motifs from
Te raau rahi (The large tree)
c 1894
gouache on crepe paper
17.2 × 57.5 cm
Collection of the Carrick Hill
Trust, Tarntanya/Adelaide.
Hayward bequest 1983

220

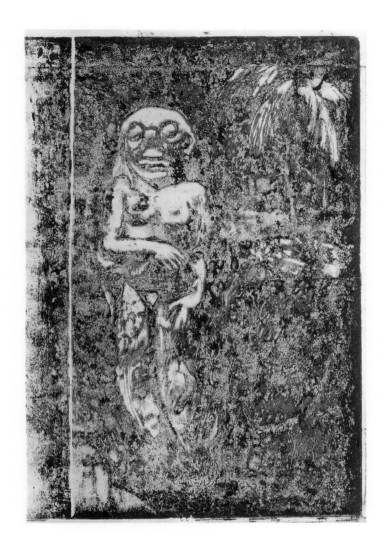

Oviri (*Savage*) 1894
woodcut, in brown and black
ink, with grey-wash highlights
on wove paper
image 24.8 × 18.2 cm
sheet 33.5 × 39 cm
Musée du quai Branly – Jacques
Chirac, Paris. Gift of Lucien
Vollard to Musée de la France
d'outre-mer, 75.14342.1

Manao tupapau (*The spirits
of the dead are watching*);
*Māori woman in a landscape
of branches and trees; Māori
woman standing* (*Femme maorie
dans un paysage de branches
d'arbres; Femme maorie debout*)
1894–95
woodcut print from three
blocks, printed in yellow and red
ochre on fine laid paper lined on
wove paper
sheet 31.9 × 41.5 cm
Musée du quai Branly – Jacques
Chirac, Paris. Gift of Lucien
Vollard to Musée de la France
d'outre-mer, 75.14465

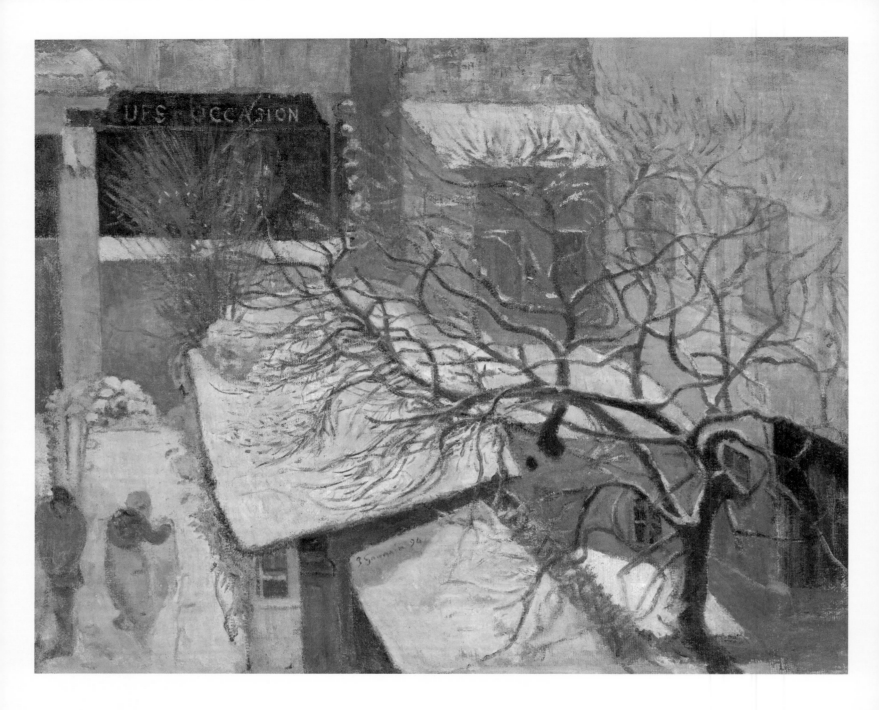

ABOVE
Paris in the snow
(*Paris sous la neige*) 1894
oil on canvas
72 × 88 cm
Van Gogh Museum, Amsterdam.
Vincent van Gogh Foundation,
s0223V1962

OPPOSITE
Upaupa Schneklud
(*The player Schneklud*) 1894
oil on canvas
92.7 × 73.3 cm
Baltimore Museum of Art. Given
by Hilda K Blaustein in memory
of her late husband, Jacob
Blaustein, BMA 1979.163

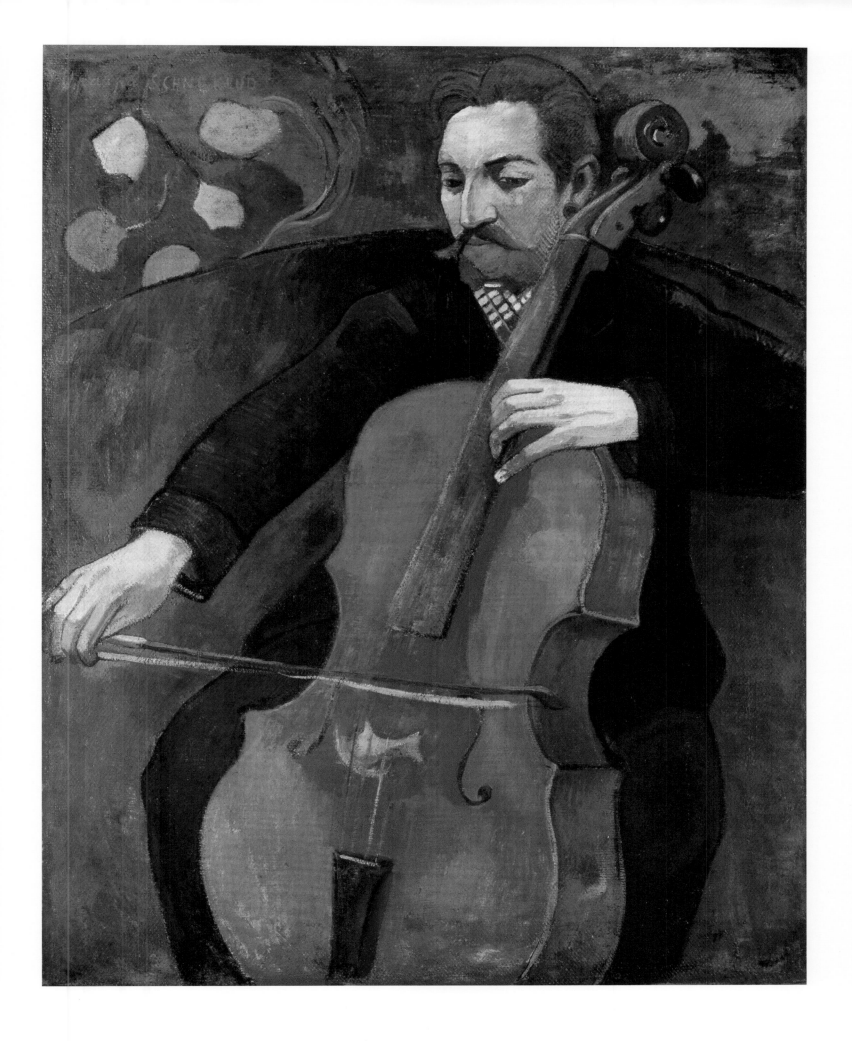

1895 **18 February**
Public auction of his work is held at Hôtel des Ventes to fund his return to Oceania. Only 9 paintings of 47 works sell. Degas buys two paintings.

Postpones the trip to Tahiti due to insufficient funds. Schuffenecker buys *Parahi te marae* (*The sacred mountain*, p 78) from him.

Consigns his two Van Gogh sunflower paintings to Vollard in Paris; Degas buys *Withered sunflowers (two cut sunflowers)* (Kunstmuseum Bern, fig 8).

3 July
Departs Marseille aboard the steamer *L'Australien*, taking his 'museum' of prints and photo reproductions and his manuscript of *Noa Noa*. The steamer calls at the ports of Albany, Adelaide and Melbourne before docking in Sydney on 5 August. There is no record of how he spent the following days.

14 August
Departs Sydney for Auckland aboard the *Tarawera*.

19 August
Arrives in Auckland where his departure for Tahiti aboard the *Richmond* is delayed until 29 August. He studies and sketches Māori art in the Auckland Museum's newly opened Ethnological Hall. He will reinterpret motifs and objects in his later works (*Sunflowers and mangoes*, p 243).

9 September
Arrives in Papeete, now lit with electricity, and complains of the urban developments.

November
Rents a plot of land in Puna'auia, 16 kilometres south-west of Papeete, enlisting the help of locals to build a traditional Tahitian hut. He has yet to begin painting with the exception of an oil-on-glass door, which reflects medieval stained-glass traditions combined with Tahitian imagery.

1896 **January**
The adolescent girl Pahura becomes his *vahine*. Teha'amana, having remarried, prefers not to take up with her former lover again.

Poverty and illnesses impede his productivity and continue to constrain him over the coming years. He paints *Self-portrait (near Golgotha)* (p 54), identifying his suffering with the Passion of Christ.

August
Receives a rare portrait commission to paint Vaïte, the daughter of Auguste Goupil, a wealthy and prominent lawyer who owns a plantation. He also gives drawing lessons to Vaïte and her sisters.

December
Pahura gives birth to a daughter who dies shortly after.

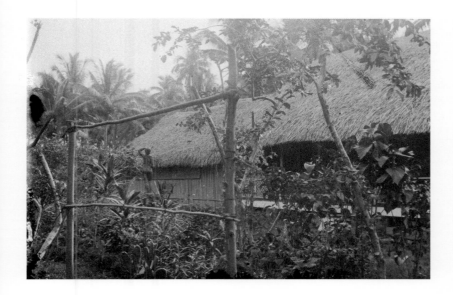

1897 His interest in dialogue between western, eastern and Oceanian sources—cultural and spiritual, ancient and modern—manifests within his artistic and writing practices. Writing becomes increasingly prominent with illness compromising his artistic endeavours.

Begins to write *L'esprit moderne et le catholicisme* (*Modern thought and Catholicism*), a critique of western culture with comparative references to world religions and belief systems (Christian, Buddhist, Polynesian), reflecting his interest in doctrines of theosophy. He also advocates for the rights of women. His progressive position on marriage and the rights of women draw on writings by his grandmother Flora Tristan.

March
Continues to follow developments in the Paris art world by reading the *Mercure de France*, conscious of his critical positioning relative to the modernists Cézanne and Van Gogh. For that reason, he writes to De Monfreid: 'whatever you do, don't let Schuff.[enecker]

go ahead and stick me in an exhibition along with Bernard, Denis, Ranson and Co'.[27]

April
Learns that his daughter Aline, his favourite child, has died of pneumonia in Copenhagen. He writes to Mette: 'I have just lost my daughter, I no longer love God [...]. Her tomb is here near me, my tears are her flowers, they are living things.'[28]

May
Purchases two parcels of land in Puna'auia after the property he was renting is sold. He adds a studio to the existing hut and decorates it with sculptured panels.

October
Suffers a series of heart attacks, a symptom of syphilis. He will continue to have heart problems. He likely passed on the then-incurable venereal disease when he returned to Tahiti. Syphilis and other diseases introduced by Europeans had devastating effects on Polynesian populations over an extended period from the late eighteenth century.

Morice publishes the first part of *Noa Noa* in *La Revue Blanche*.

December
Paints his magnum opus *Where do we come from? What are we? Where are we going?* (Museum of Fine Arts Boston. See p 61, a study for the painting), reflecting on the haunting universal question of human destiny. He will write to De Monfreid about the painting and his own attempted suicide (fig 20).

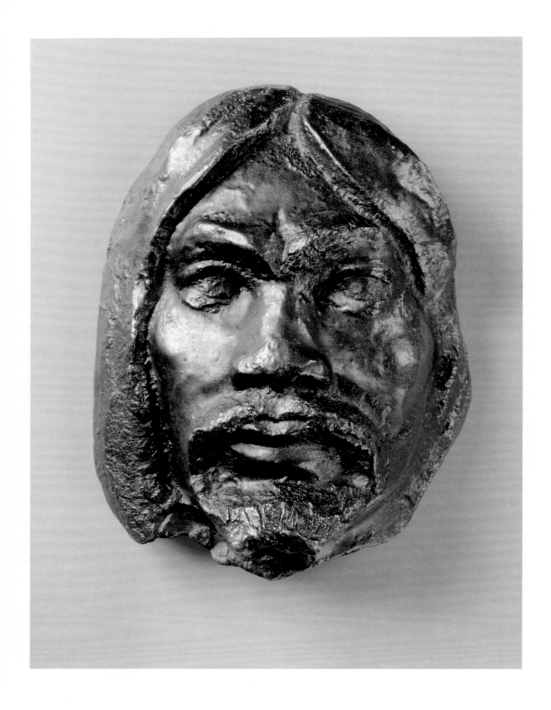

Tahitian (*Tahitien*) c 1895
bronze
25 × 19 × 10 cm
Musée d'Orsay, Paris. Gift of
Lucien Vollard 1943, AF 14392

Poor fisherman (*Pauvre pêcheur*)
1896
oil on canvas
75 × 65 cm
Museu de Arte de São Paulo
Assis Chateaubriand. Gift of
Henrik Spitzman-Jordan,
Ricardo Jafet, João Di Pietro
1958, MASP.00109

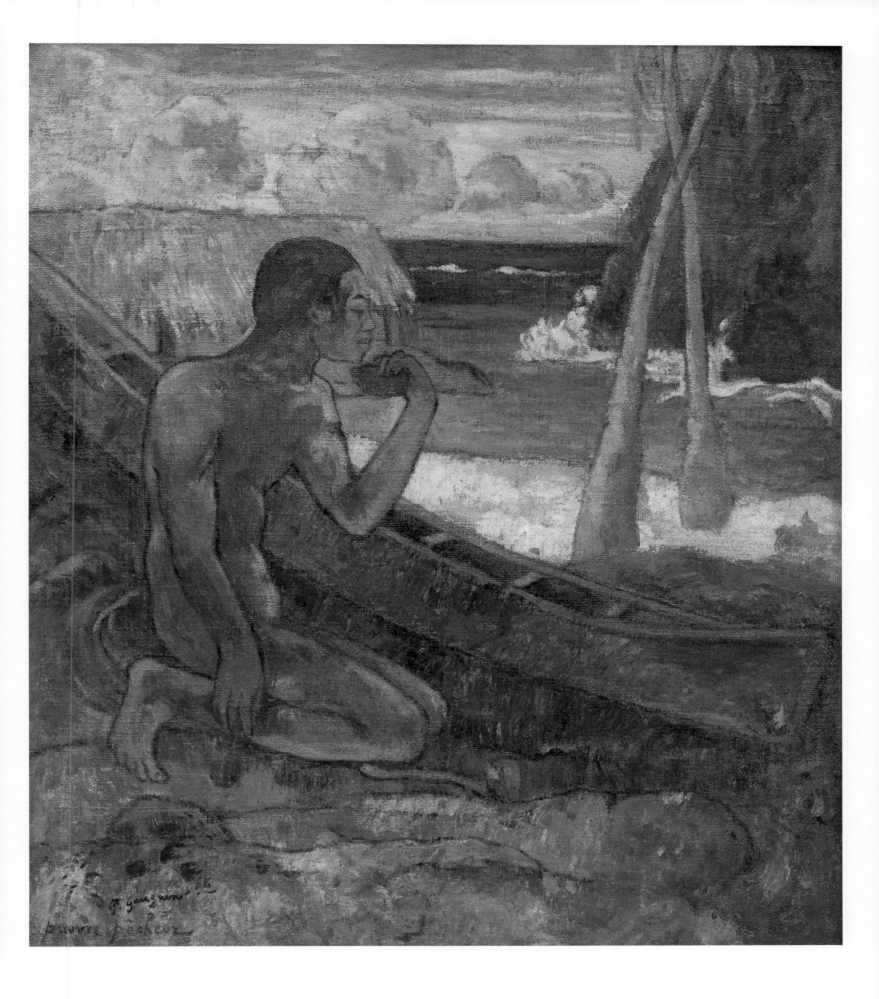

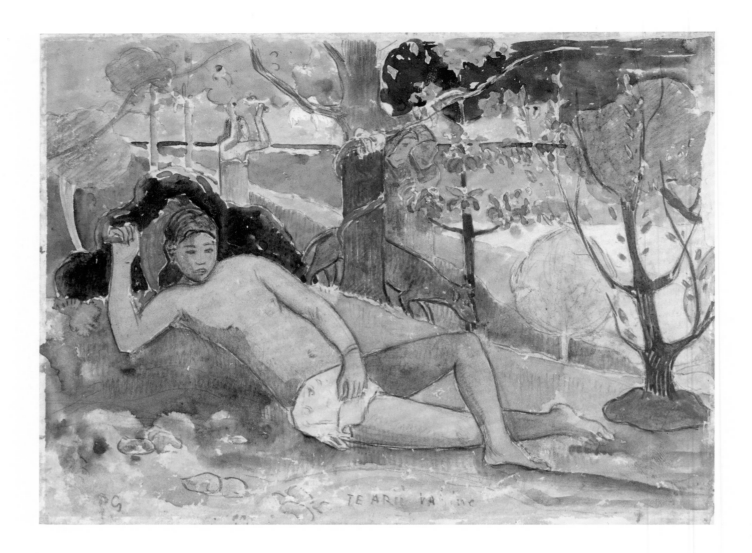

ABOVE

Te arii vahine (*The queen*) (recto)
1896–97
watercolour, with opaque
watercolour, over black chalk
17.6 × 23.5 cm
The Morgan Library and
Museum, New York. Thaw
Collection, 2006.55

OPPOSITE

Savage poems (*Poèmes barbares*)
1896
oil on canvas
64.8 × 48.3 cm
Harvard Art Museums / Fogg
Museum, Cambridge. Bequest
from the Collection of Maurice
Wertheim, Class of 1906, 1951.49

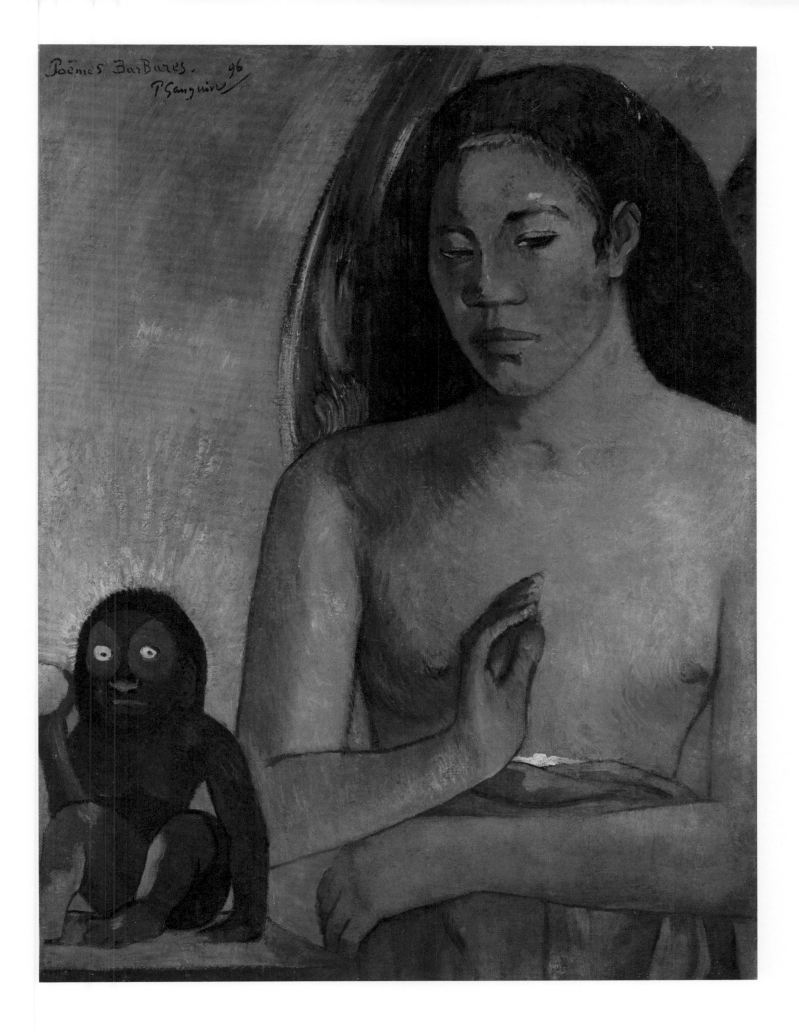

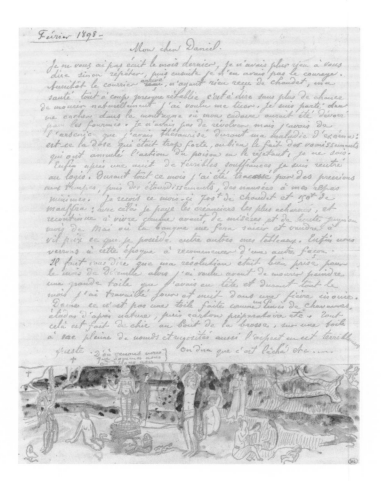

1898 Late March
Returns to Papeete with Pahura, in bad health and a state of poverty. He takes a job as a draftsman in the Department of Public Works.

9 September
Mallarmé dies. Gauguin reads the news in the *Mercure de France*, reflecting with sadness: 'one more man who has died a martyr to art: his life is as beautiful as his work, if not more so...'.[29]

November–December
Degas acquires *Te faaturuma* (p 73) from Vollard, who had bought it through Gauguin's dealer and friend Georges Alfred Chadet (1870–1899).

December
Still unable to paint, he writes to De Monfreid that he has lost all 'moral reasons for living'.[30]

1899 Late January
Quits his job and returns to Puna'auia to find his home ruined by rats and rain.

April
Pahura gives birth to a baby boy whom he names Émile.

June
Maurice Denis (1870–1943) seeks to reunite the exhibiting artists from the *Volpini* exhibition, along with new ones, in a new presentation. Gauguin declines, explaining that he has moved past the artist he was then.

August
Forays into journalism, founding and editing his own satirical journal *Le sourire* (*The smile*), and as editor-in-chief of the pro-Catholic *Les guêpes* (*The wasps*). Uncompromising and polemicist, he criticises the colonial administration.

By the end of the year, he has completed the *Suite of late woodblock prints* (pp 233–5), a series of 14 woodcuts printed on fine Japan paper. The expense of the paper, ordered from Paris, reflects his hope of a commercial and marketing success that will promote his work among a growing circle of collectors and critics. The series becomes known as the *Vollard suite*.

1900 January
Agrees to Vollard's proposal for a small yearly stipend in exchange for an established number of canvases, on the condition that he retains artistic independence. He writes:

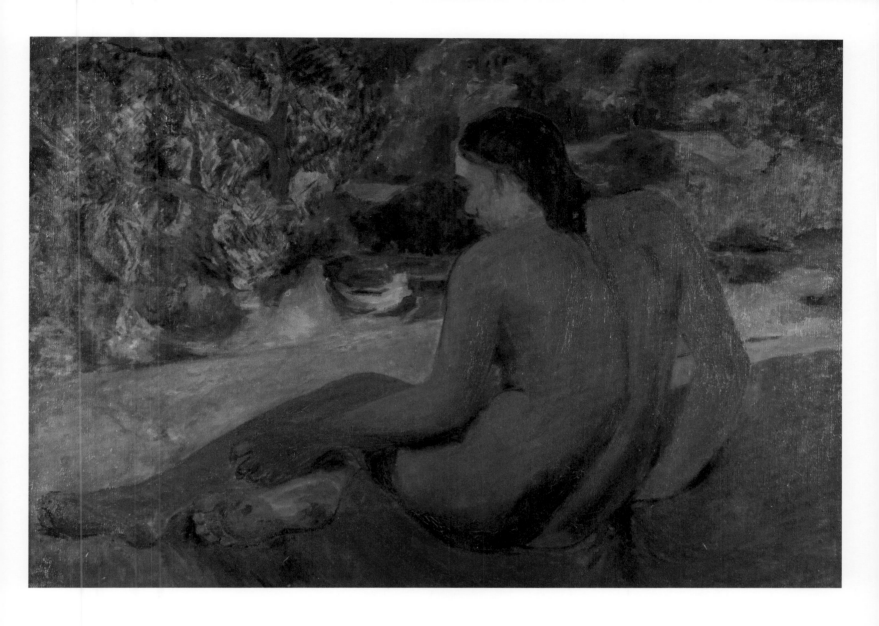

OPPOSITE (FIG 20)
Sketch of *Where do we come from? What are we? Where are we going?* in a letter from Gauguin to Daniel de Monfreid, February 1898
Musée d'Orsay, Paris, RF 41648, Recto

ABOVE
Tahitian woman II (Femme tahitienne allongée dans un paysage) 1898
oil on canvas
93.5 × 130 cm
National Museum of Serbia, Belgrade

'[I am] not a machine to produce on order [...]. What I am *and what I want to go on being is this: a great artist.'*[31] The agreement will provide him with financial stability for the first time.

16 May
His son Clovis dies of blood poisoning following an operation. Gauguin seems never to have learned of his death.

1901 Paints a series of four sunflower still lifes, having asked De Monfreid a few years before to send sunflower seeds for planting, as both a testimonial to his friend Van Gogh and an assertion of how he is now the greater modern master (see *Still life with Hope*, p 43, and *Sunflowers and mangoes*, p 243).

April
Commits to moving to the Marquesas to escape the cost of living in Tahiti and in the continuing hope of discovering a way of life untainted by colonial modernity, with new motifs to inspire his painting.

7 August
Sells his land in Tahiti.

10 September
Leaves Tahiti bound for Fatu Hiva in the Marquesas, the world's most remote archipelago.

16 September
Stops at Atuona, Hiva Oa. Enchanted by the resonant and rugged mountain setting, he stays. His quest for a primitive existence is answered, recognising it means living alongside rather than as one of the local people and enjoying the benefit of modest infrastructure.

He ingratiates himself to the local bishop, Joseph Martin, by attending mass each morning, in order to facilitate the purchase of land owned by the Catholic mission.

Develops a friendship with Nguyen Van Cam (1875–1929, known as Ky Dong), a Vietnamese political activist exiled to Hiva Oa by the colonial French administration at home. He will be the recipient of Gauguin's last self-portrait (see *Portrait of the artist by himself*, p 45).

27 September
Buys land in the village centre; promptly stops attending mass. He begins building his 'little Marquesan fortress', a two-storey structure with woven bamboo walls, with the help of neighbours. He names it his Maison du Jouir (House of Pleasure). The house represents a *Gesamtkunstwerk*, a total work of art and an aesthetic journey. His ambition of a 'studio of the tropics', though now a solo project, is finally realised.

November
Writes to De Monfreid of his happiness and the inspiring new surroundings: 'Here poetry is created all by itself, and all you need do in order to suggest it is give way to your dreams while you paint'.[32]

Vaeoho Marie Rose, the teenaged daughter of a local village chief, becomes his *vahine*.

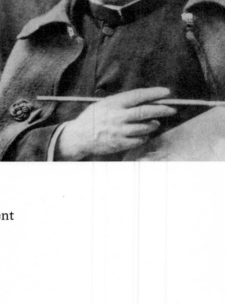

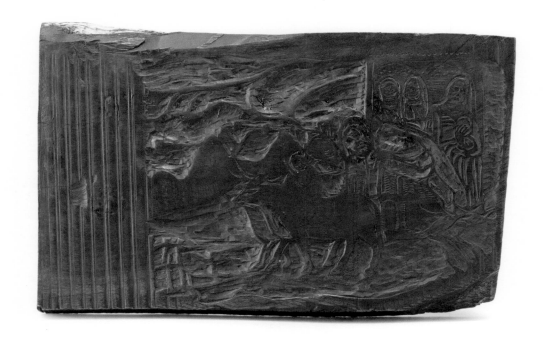

TOP

Change of residence
(*Changement de résidence*) 1898–99
from *Suite of late woodblock prints*
woodcut
first state in brown overprinted by
the artist with the second (final) state
in black, numbered 28 by the artist
image 16 × 30.1 cm
Seibert Collection

MIDDLE

Women, animals and leaves
(*Femmes, animaux et fueillage*)
1898–99
from *Suite of late woodblock prints*
woodcut on thin Japan paper
state 2
image 16.3 × 33.5
Seibert Collection

BOTTOM

Eve 1898–99
from *Suite of late woodblock prints*
woodcut in black ink on Japan paper
image 29.5 × 21.9 cm
Bibliothèque nationale de France,
Paris, FRBNF46738020

OPPOSITE LEFT

Te atua (*The god*) 1898–99
from *Suite of late woodblock prints*
woodcut in black on Japan paper,
second state impression printed on
thin Japan paper pasted on first state
impression
image 24.4 × 22.7 cm
Bibliothèque nationale de France,
Paris, FRBNF46751984

OPPOSITE TOP RIGHT

Interior of a hut (*Intérieur de case*)
1898–99
from *Suite of late woodblock prints*
woodcut, printed in black ink on thin
Japan paper
image 15.1 × 22.9 cm
Bibliothèque nationale de France,
Paris, FRBNF46737719

OPPOSITE MIDDLE RIGHT

Human miseries (*Misères humaines*)
1898–99
from *Suite of late woodblock prints*
woodcut in black ink on Japan paper
image 19.3 × 29.6 cm
Seibert Collection

OPPOSITE BOTTOM RIGHT

The banana carrier (*Le porteur de fe'i*)
1898–99
from *Suite of late woodblock prints*
woodcut, printed on Japan paper
image 16.2 × 28.7 cm
Bibliothèque nationale de France,
Paris, FRBNF46751857

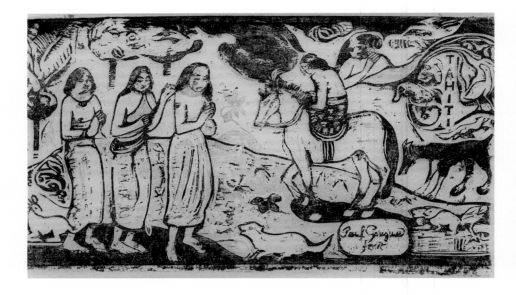

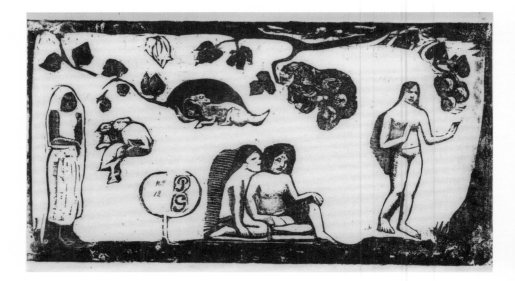

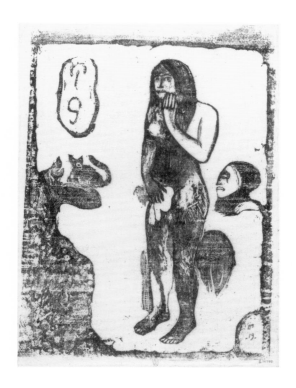

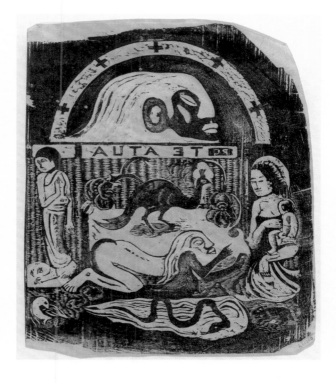

Te pape nave nave
(*Delectable waters*) 1898
oil on canvas
74 × 95.3 cm
National Gallery of Art,
Washington, DC. Collection
of Mr and Mrs Paul Mellon,
1973.68.2

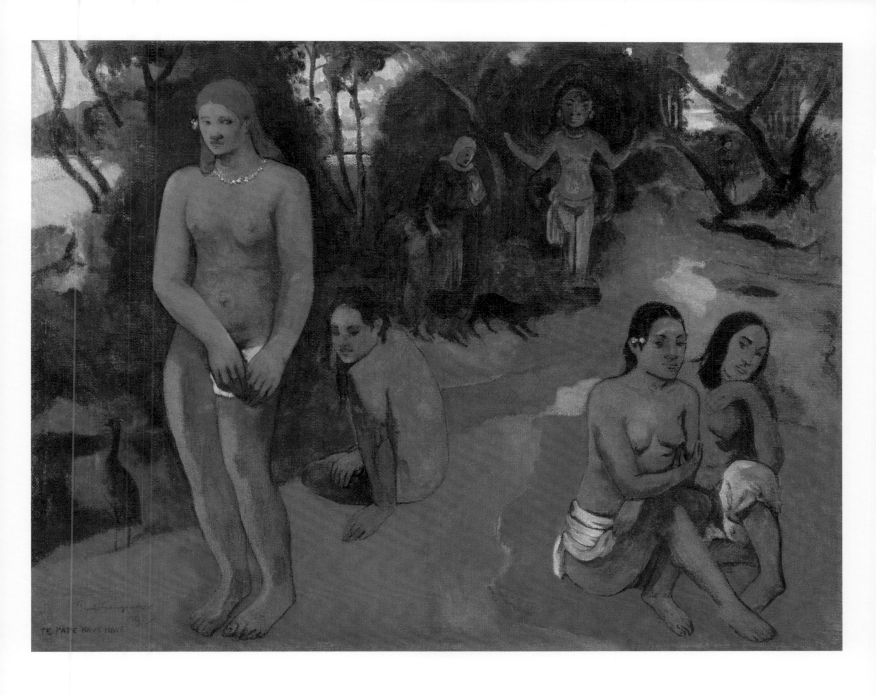

Three Tahitians
(*Trois tahitiens*) 1899
oil on canvas
73 × 94 cm
National Galleries of Scotland,
Edinburgh. Presented by
Sir Alexander Maitland in
memory of his wife Rosalind
1960, NG 2221

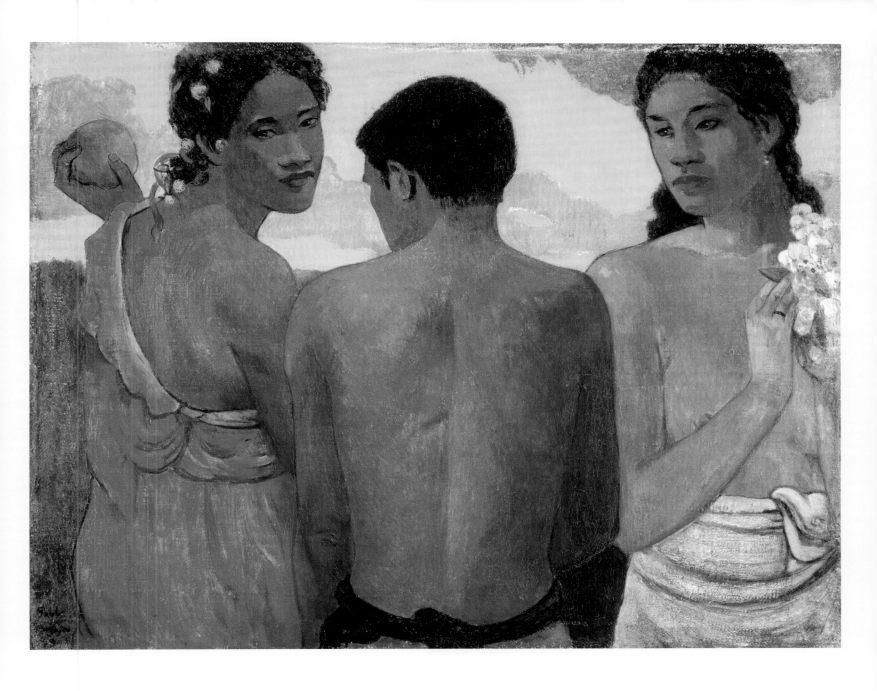

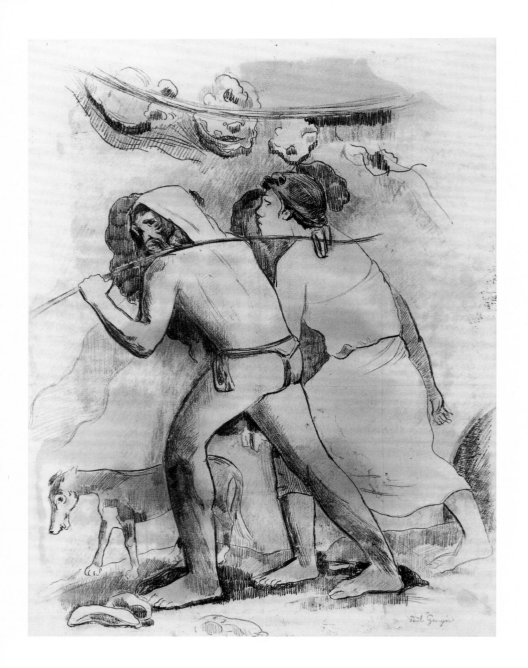

LEFT
The departure of Adam and Eve
c 1900
monotype, pencil and wash on
wove paper
62.9 × 48.5 cm
William W and Nadine M
McGuire, Wayzata, Minnesota

RIGHT
Head of a Tahitian woman
(*Tête de tahitienne*) 1891–1901
charcoal and graphite on paper
mounted on cardboard
16.2 × 11 cm
Musée du quai Branly – Jacques
Chirac, Paris. Gift of Ary Leblond
to Musée de la France d'outre-
mer, 75.8947.1

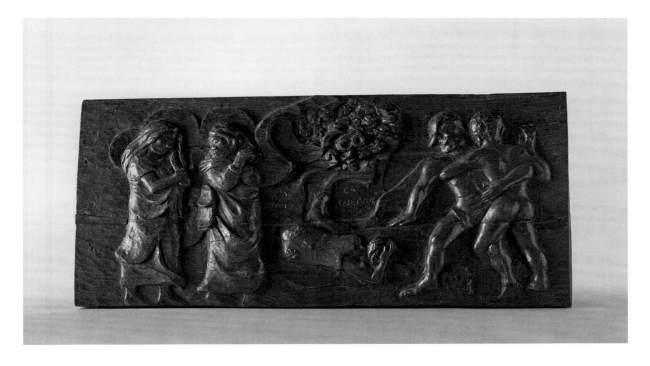

Te atua (*The gods*) c 1901–02
carved and painted redwood
58 × 20 cm
Te Fare Iamanaha – Musée de
Tahiti et des Îles, Papeete

Peace and war (*La paix
et la guerre*) 1901
carved oak with traces of paint
and gold highlights
29.5 × 66 × 4 cm
Musée d'Orsay, Paris, RF 4681

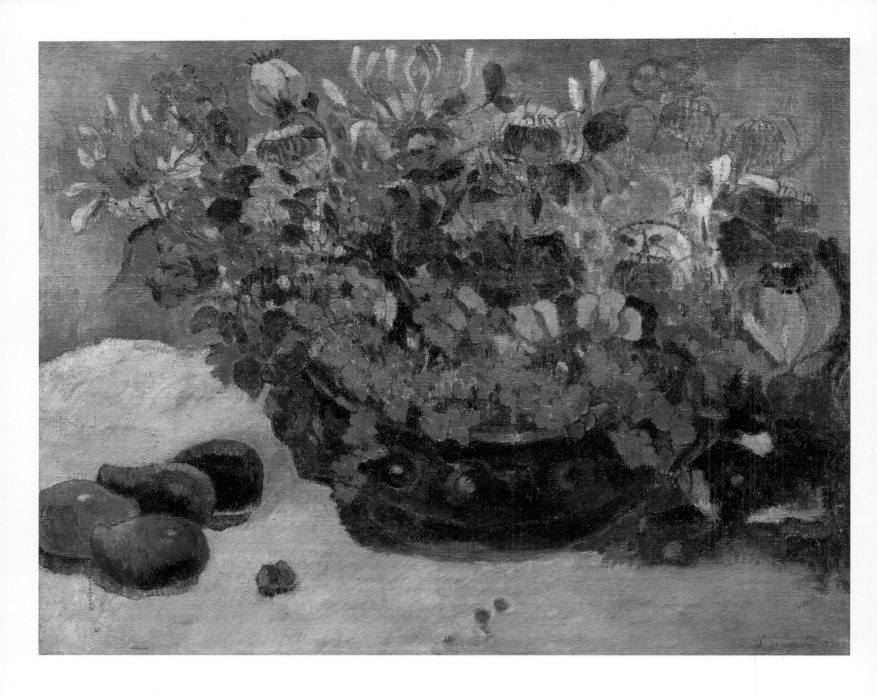

ABOVE
Bouquet of flowers (Bouquet de fleurs avec géraniums, grandes plantes et violettes) 1897
oil on canvas
73 × 93 cm
Musée Marmottan Monet, Paris.
Gift of Nelly Sergeant-Duhem
1985, 5333

OPPOSITE
Sunflowers and mangoes (Tournesols et mangues) 1901
oil on canvas
93 × 73 cm
Private collection

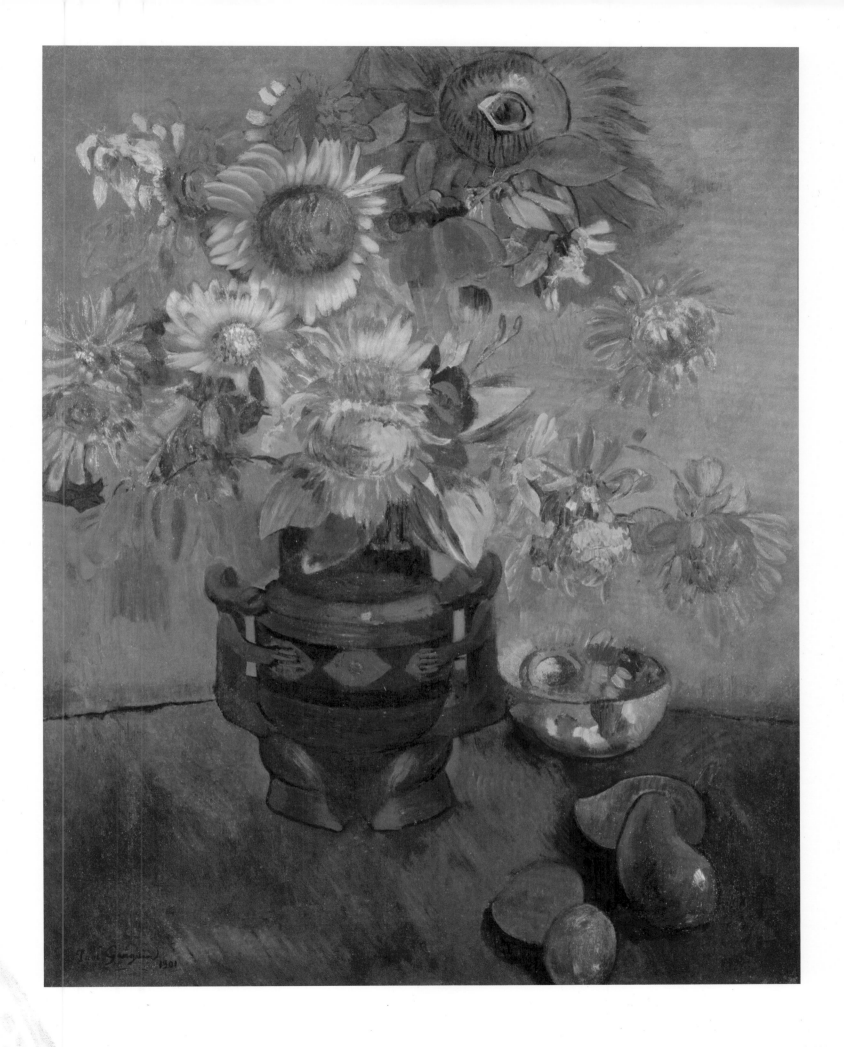

1902

He satirises the bishop in the carving *Père Paillard*, also known as *Father Lechery* (p 247), for his hypocritical liaisons with local women. The sculpture stands like a sentinel in front of the Maison du Jouir.

Mid August

Vaeoho becomes pregnant and leaves to be with her parents. She does not return to Gauguin.

September

His health deteriorates considerably and he is increasingly reliant on morphine injections, then laudanum.

2 September

Completes *Racontars de rapin* (*Ramblings of a wannabe painter*), a manifesto for modern art denouncing the limitations imposed by art criticism on artistic freedom and independence. He praises the impressionists and refers to Pissarro as 'one of my masters'. He sends the manuscript to André Fontainas (1865–1948), a Belgian symbolist poet, critic and friend, instructing him to arrange publication in the *Mercure de France*. It is rejected by the editors.

December

De Monfreid discourages his idea of returning to Paris, writing that 'You are currently this extraordinary, legendary artist who from the depths of Oceania sends disturbing, inimitable works, definitive works of a great man who has in a way disappeared from the world [...]. In short, you enjoy the immunity of great dead men, you have passed into the History of Art.'[33]

1903

January

A cyclone devastates Atuona. Gauguin shares his property with Tioka, a local Marquesan whose home was destroyed.

February

Completes *Avant et après* (*Before and after*), part memoir, part manifesto, which attempts to define his place in the history of art.

March

Takes up the cause of local villagers against the colonial administration. This results in libel charges against him. He is sentenced to three months in jail and fined 500 francs. He appeals for a new trial in Papeete.

April

Sends his last shipment of works to Vollard, consisting of 14 paintings and 11 drawings.

Paints his last work, the stark *Portrait of the artist by himself* (p 45).

8 May

His health deteriorates and Reverend Vernier, a Protestant minister and friend, is sent for by Tioka. Paul Gauguin dies at 11am.

20 July

An auction is held in the Maison du Jouir of Gauguin's household effects. The majority of his paintings, prints and sculptures, including the panels integrated into the Maison du Jouir, will be sent to Papeete for auction.

3 August

La Durance, a French naval ship stationed in Papeete, is sent to Nuku Hiva (the administrative capital of the Marquesas Islands), to collect Gauguin's remaining belongings. The vessel's medical officer, Victor Segalen (1878–1919), spends time reading through the 13 manuscripts and letters and papers, 'collecting impressions of [Gauguin's] final days'.[34] Segalen is inspired to visit Atuona and discovers *Te atua* (*The gods*, p 241) in situ at the Maison du Jouir.

23 August

De Monfreid, executor of Gauguin's will, receives notice of his death.

2 September

Public auction in Papeete of Gauguin's remaining works and studio effects. The Commissionaire de Marine of *La Durance* buys *Three wooden spoons* (p 246). Segalen buys 24 lots, including *Breton village in the snow* (p 30) and *Self-portrait (near Golgotha)* (p 54).

Jane Messenger is Project Manager at Art Exhibitions Australia. She has been Curator of European Art at the Art Gallery of South Australia and Affiliate Lecturer in Art History at the School of History and Politics, University of Adelaide. Her publications include *Making nature: masters of European landscape art* (Art Gallery of South Australia, Adelaide, 2009) and *Japanese prints: images from the floating world* (Art Gallery of South Australia, Adelaide, 2004), with contributions to volumes including *Turner from the Tate: the making of a master* (Tate Publishing, London, 2013) and *Turner to Monet: the triumph of landscape painting* (National Gallery of Australia, Canberra, 2008).

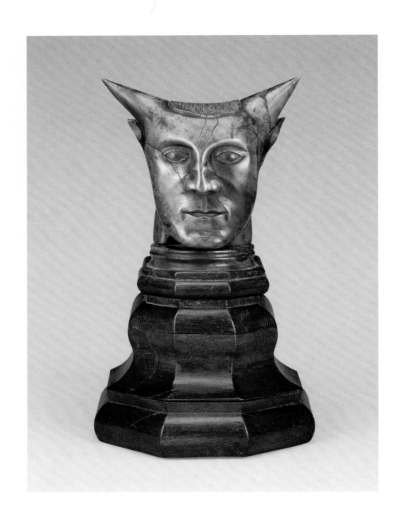

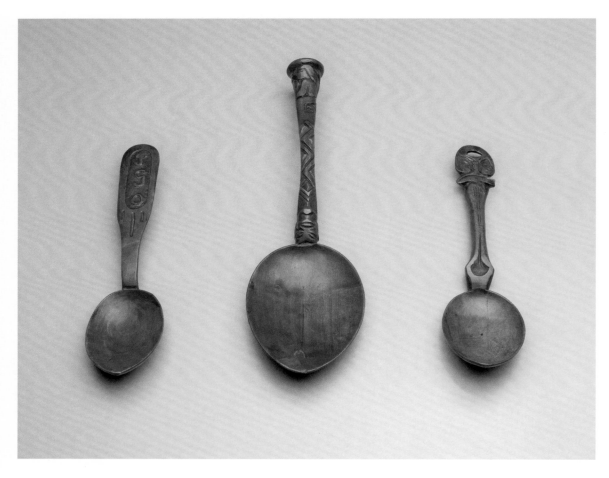

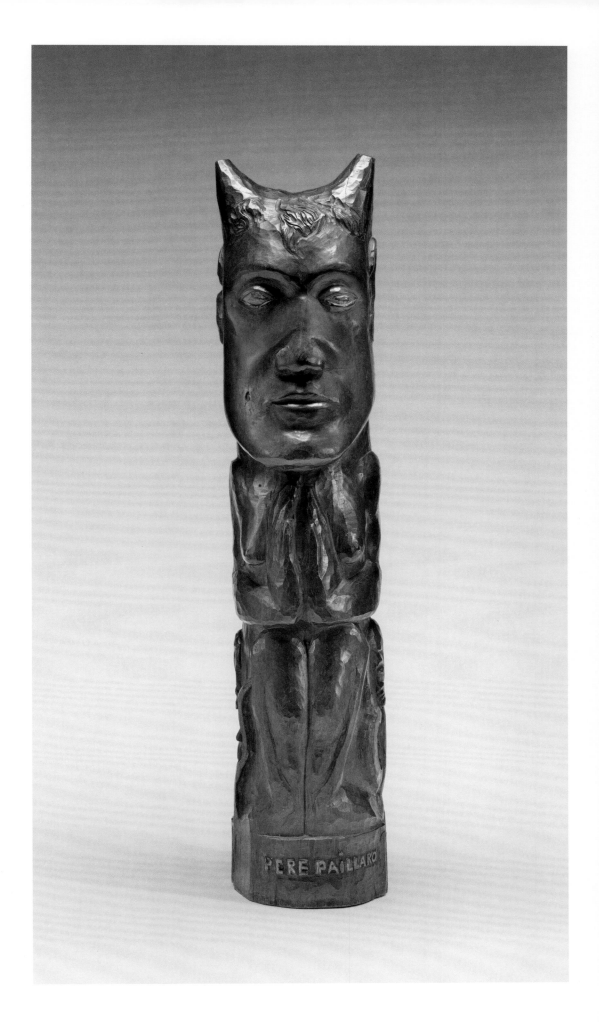

OPPOSITE TOP
Unknown artist
Head with horns before 1894
sandalwood with traces of
polychrome on a lacewood base
22 × 22.8 × 12 cm
The J Paul Getty Museum, Los
Angeles, 2002.18

OPPOSITE BOTTOM
Three wooden spoons 1895–1903
carved (likely *nono*) wood
18 × 5 × 3 cm
25 × 7.5 × 2.9 cm
18.5 × 4.7 × 3.2 cm
Te Fare Iamanaha – Musée
de Tahiti et des Îles, Papeete,
2000.0.048–2000.0.050

RIGHT
Père Paillard 1902
also known as *Father Lechery*
carved and painted miro wood
67.9 × 18 × 20.7 cm
National Gallery of Art,
Washington, DC. Chester Dale
Collection, 1963.10.238

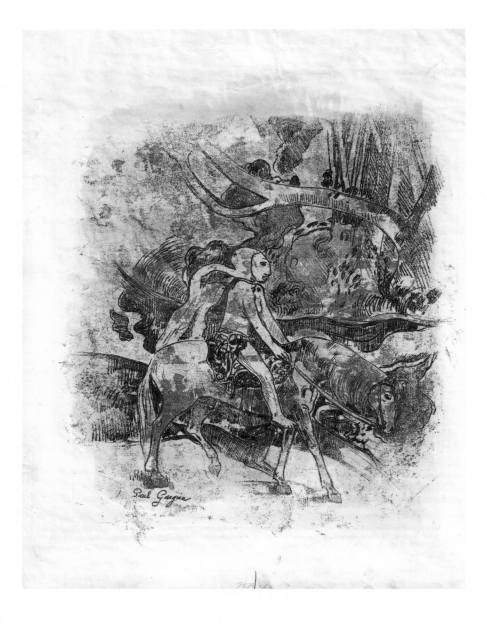

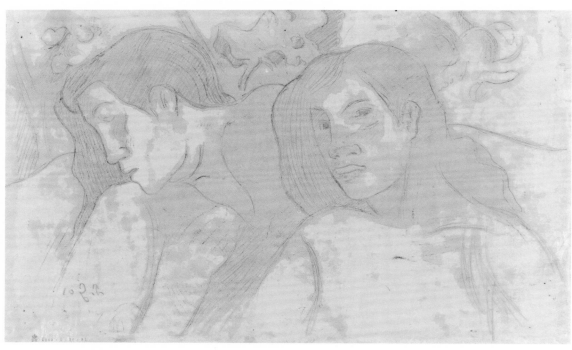

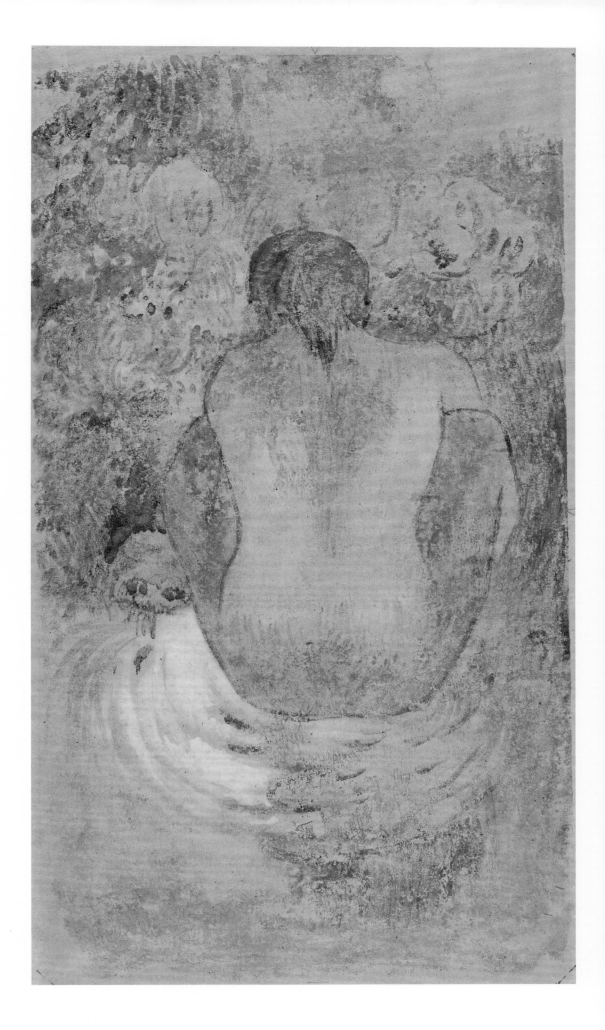

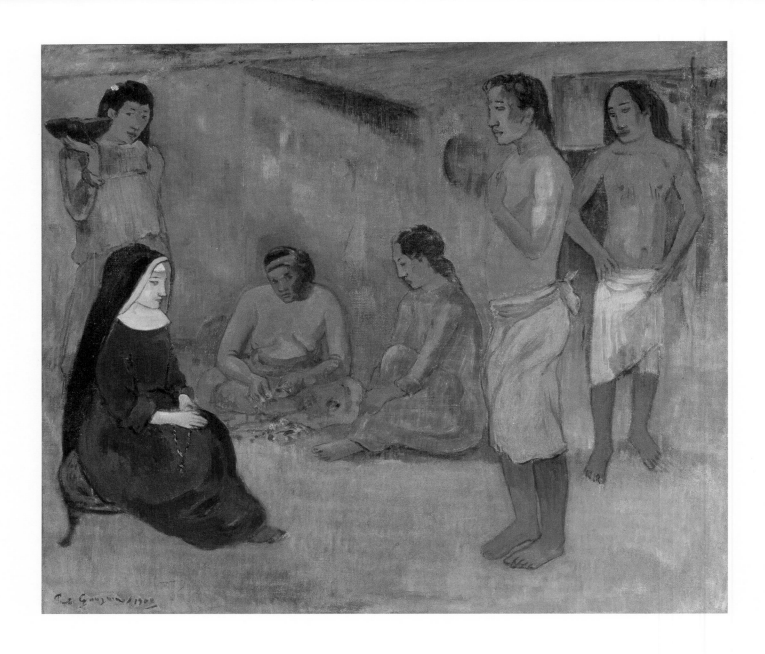

Sister of Charity
(*La religieuse*) 1902
oil on canvas
65.4 × 76.2 cm
The McNay Art Museum, San
Antonio. Bequest of Marion
Koogle McNay, 1950.47

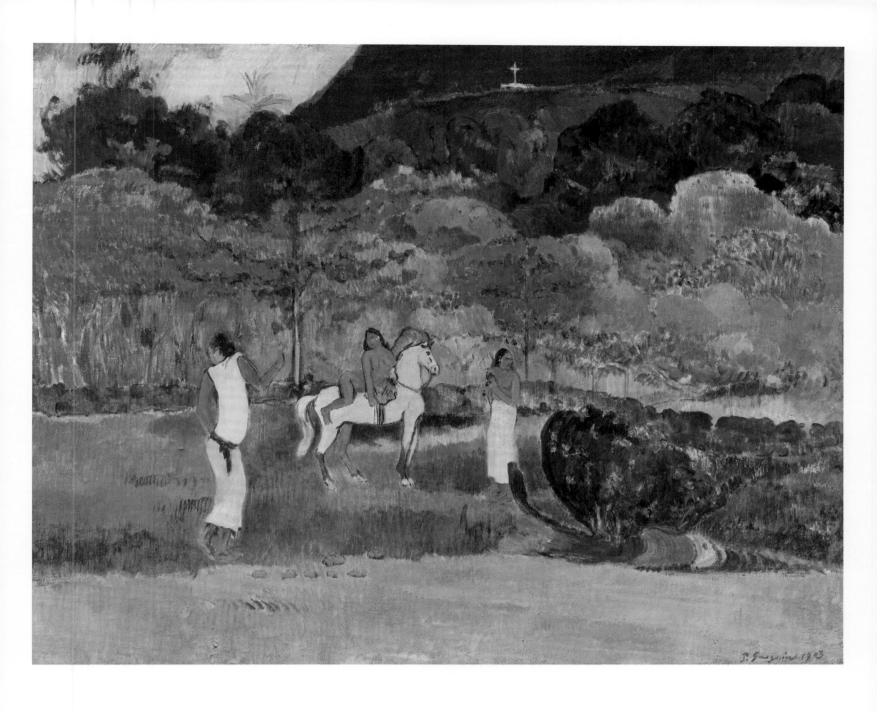

Women and a white horse
(*Femmes et cheval blanc*) 1903
oil on canvas
73.3 × 91.7 cm
Museum of Fine Arts Boston.
Bequest of John T Spaulding,
48.547

Notes

'Into the far distance and into the self': what Gauguin saw from his window in the Marquesas

1 For a discussion of this term, see pp 38–9.
2 For this biographical résumé, see the remarkable edition of Victor Segalen's *Œuvres*, Christian Doumet (ed), Gallimard, La Pléiade, 2 vols, Paris, 2020, here vol 1, pp xli–xlv. Unless otherwise noted, all translations from the French are by Chris Miller. See also Charles Forsdick, 'Gauguin and Segalen: exoticism, myth and the "aesthetics of diversity"', in *Gauguin: maker of myth*, Tate Publishing, London, 2010, pp 56–63.
3 See *Saint-Pol-Roux et son temps*, exhibition catalogue, Musée des Beaux-Arts, Brest, 2008.
4 Segalen, vol 1, p 12.
5 Segalen, vol 2, p 922.
6 Segalen, vol 1, p 92.
7 Victor Segalen, letter to Louise Ponty, August 1903, quoted by Christian Doumet in 'Notice', Segalen, vol 1, p 889.
8 Segalen, vol 1, pp 193–9
9 The editors of Segalen's *Œuvres* observe (pp 909–10) that 'Gauguin reproduced on the plinth that Segalen brought back from the Marquesas, the following verses by Charles Morice for the edition of *Noa Noa* published in 1901: "The Gods are dead and Tahiti dies with them / The sun that once set him ablaze now sets him drowsing / His sleep tortured by abominable shuddering dreams / Fear of the future fills Eve's eyes / Gold-skinned, she sighs as she gazes at her breast / Sterile gold sealed by divine intent." See Paul Gauguin, *Noa Noa* / Charles Morice, *La plume*, 1901, p 210. The differences in wording are noteworthy and perplexing. Was Gauguin reproducing an earlier version of Morice's poem?
10 See 'Case de Gauguin à Atuona d'après un dessin de Timo Vahetetua, communiqué par G Le Bronnec', *Gazette des Beaux-Arts*, 1956, vol 1, p 196.
11 It included a painting, *A Tahitian vision* (Hermitage Museum, St Petersburg), which, according to Segalen, was one of two paintings fixed on the outside wall to the left and right of the entrance. Segalen acquired it at Papeete on 2 September 1903. In November 1908 it entered the collection of Sergei Shchukin.
12 This *Self-portrait*, which Segalen had already mentioned in *Journal des îles* (vol 1, p 82) is surely the one that he bought on 2 September 1903 at Papeete.
13 Segalen wrote his preface in the summer of 1916. Delayed by the war, it was published by Crès in 1919. See Annie Joly-Segalen (ed), *Lettres de Paul Gauguin à Daniel de Monfreid*, Georges Falaize, Paris, 1950. 'Painful spectre' is borrowed from Segalen's description of Rimbaud.
14 Jean de Rotonchamp (Louis Brouillon), *Paul Gauguin*, Comte de Kessler, Weimar, 1906. Republished by G Crès et Cie, Paris, in 1925. References are to the 1925 edition.
15 Philippe Dagen, *La peinture en 1905. L' 'Enquête sur les tendances actuelles des arts plastiques' de Charles Morice*, Lettres modernes, Paris, 1986.
16 See *Gauguin*, exhibition catalogue, Réunion des musées nationaux, Grand Palais, Paris, 1989, pp 486–7. Published in English as *The art of Paul Gauguin*, exhibition catalogue, National Gallery of Art, Washington, DC, 1988.
17 Segalen, vol 2, p 91.
18 Victor Segalen, 'Gustave Moreau, maître imagier de l'orphisme', in *Œuvres complètes*, Robert Laffont, collection 'Bouquins', Paris, 1995, pp 703–22.
19 Daniel de Monfreid, letter to Gauguin, 11 December 1902, in *The letters of Paul Gauguin to Daniel de Monfreid*, trans Ruth Pielkovo, Dodd, Mead, New York, 1922, pp 160–1. Available on *Internet Archive*, viewed 19 April 2024, https://archive.org/details/letterspaulgaug00gauggoog.
20 Bengt Danielsson, *Gauguin in the South Seas,* trans Reginald Spink, George Allen & Unwin, London, 1965, p 238. Danielsson quotes a letter from Louis Grélet. Gauguin mentions the purchase in *Before and after*, hereafter *Avant et après*, The Courtauld Institute, viewed 19 April 2024, https://courtauld.ac.uk/gallery/the-collection/prints-and-drawings/discover-avant-et-apres/turn-the-pages-of-avant-et-apres-by-paul-gauguin/, p 3.
21 See in particular Richard Brettell (in *Gauguin*, 1989, pp 445–8); George TM Shackelford (in *Gauguin–Tahiti. L'atelier des tropiques*, exhibition catalogue, Réunion des musées nationaux, Paris, 2003, pp 290–303); Anne Pingeot (in *Gauguin–Tahiti*, 2003, pp 304–21); Elizabeth C Childs (in Suzanne Greub [ed], *Gauguin/Polynesia*, exhibition catalogue, Art Centre Basel, Basel, & Hirmer, Munich, 2011, pp 306–21); Ophélie Ferlier-Bouat (in *Gauguin l'alchimiste*, exhibition catalogue, Réunion des musées nationaux, Grand Palais, Paris, 2017, pp 236–44).
22 Michel de Montaigne, *The complete works*, trans Donald M Frame, Everyman, London, 2003, p 233.
23 Paule Laudon (author of *Tahiti-Gauguin. Mythe et vérités*, Adam Biro, Paris, 2003), in answer to my question whether it was customary to name homes in Polynesia: 'There is no evidence for inscriptions except on public or religious buildings...'
24 On the cover that Gauguin made for the manuscript of *Avant et après* (The Courtauld Institute, London), he wrote 'Pour Jouir' at the end of his litany: 'Pour Pleurer / Pour Souffrir / Pour Mourir / Pour Rire / Pour Vivre / Pour Jouir / In Secula Seculorum' ('For Weeping / For Suffering / For Dying / For Laughing / For Living / For Taking Pleasure / For Ever and Ever'). See *Avant et après*, p 1.
25 Gauguin, letter to Daniel de Monfreid, November 1901. The translation in Belinda Thomson (ed), *Gauguin by himself*, trans Andrew Wilson and Belinda Thomson, Little,

Brown, New York, 1998, p 272, is combined with that of Ruth Pielkovo in *The letters of Paul Gauguin*, pp 147–8.

26 *Avant et après*, p 29.

27 *Avant et après*, p 81.

28 *Avant et après*, p 81.

29 See Françoise Heilbrun, 'La photographie, "servante des arts"', in *Gauguin–Tahiti*, 2003, p 60. The photo reproduced in this catalogue and subsequent publications is a modern inverted copy published from the negative by the Art Institute of Chicago; though the works on the wall are clearer, it is cropped left and top. We cannot therefore see the pitch of the roof or the empty frame bottom right (against the wall). The more complete photo reproduced in Joly-Segalen, ill 12, is blurrier. There the caption reads: 'The mirror reflects a Maori idol carved by Gauguin'—but this is clearly seen in the Gauguin catalogue to be a stone sculpture of the Buddha.

30 Gauguin had, it seems, created a comparable arrangement in the Paris studio that he briefly rented at 6 rue Vercingétorix in December 1893; see Danielsson, p 148.

31 Douglas W Druick and Peter Kort Zegers, *Van Gogh and Gauguin: the studio of the south*, The Art Institute of Chicago, Chicago, 2001, pp 350–3. Here Gauguin may well have hung an original impression given to him by Degas.

32 Henri Loyrette, *Degas*, Fayard, Paris, 1991, p 525.

33 *The private collection of Edgar Degas*, exhibition catalogue, The Metropolitan Museum of Art, New York, 1997, vol 2, *A summary catalogue*, p 68.

34 Paul Gauguin, *Ramblings of a wannabe painter*, trans Donatien Grau, David Zwirner Books, New York, 2017, p 38.

35 See Loyrette, 1991, pp 615–26, and Henri Loyrette, 'Degas's collection', *Burlington Magazine*, August 1998, pp 551–8.

36 *The private collection of Edgar Degas*, vol 2, p 66.

37 Stéphane Mallarmé, letter to François Coppée, 3 December 1866; Mallarmé, letter to Paul Verlaine, 20 December 1866; in Mallarmé, *Correspondance 1854–1898*, Gallimard, Paris, 2019, pp 178, 180.

38 Danielsson, p 258.

39 Gauguin, letter to Daniel de Monfreid, October 1902, in *The letters of Paul Gauguin*, p 161.

40 Danielsson, p 258.

41 The Fayum portraits first became known and sought after in the early 1880s. The Musée du Louvre had, however, acquired seven in 1826 from the second Henry Salt Collection; more followed in 1834 and 1893. In *L'esprit moderne et le catholicisme* (Saint Louis Art Museum), completed in 1902, Gauguin noted (p 29): 'Consult [...] translations of papyri by Monsieur Ledrain...'. In 1877, Eugène Ledrain published 'Les momies gréco-égyptiennes ornées de portraits peints sur panneaux', Maisonneuve, Paris, 1877. My thanks to Caroline Thomas of the Musée du Louvre for these details.

42 Gauguin, letters to Camille Pissaro, late May 1885 and 30 January 1885, in Victor Merlhès (ed), *Correspondance de Paul Gauguin*, Fondation Singer Polignac, Paris, 1984, pp 108, 92.

43 Armand Séguin, 'Paul Gauguin', *L'Occident*, March 1903, p 160.

44 *Gauguin*, 1989, p 304.

45 Charles Morice, 'Gauguin', *Mercure de France*, 1 December 1893, pp 293–4.

46 Gauguin, letter to Vincent van Gogh, 26 September 1888, *Vincent van Gogh: the letters*, trans Diane Webb, John Rudge, Lynne Richards et al, letter 688, viewed 19 April 2024, https://vangoghletters.org/vg/letters.html.

47 Gauguin, letter to Vincent van Gogh ('mask'), 1 October 1888, *Vincent van Gogh: the letters*, letter 692; and to Émile Schuffenecker ('abstraction', 'peculiar drawing'), 8 October 1888, in Maurice Malingue (ed), *Paul Gauguin: letters to his wife and friends*, trans Henry J Stenning, MFA Publications, Boston, 2003, p 105.

48 See in particular Alastair Wright, 'Gauguin's self-portraits: egos and alter egos', in Cornelia Homburg and Christopher Riopelle (eds), *Gauguin: portraits*, National Gallery of Canada, Ottawa, 2019, pp 23–55.

49 Charles Morice, *Gauguin*, H Floury, Paris, 1920, p 215.

50 See in particular Françoise Cachin in *Gauguin*, 1989, pp 179–80.

51 'We went to Montpellier; Vincent is writing to you with his impressions', he reported to Theo. Gauguin, letter to Theo van Gogh, third week of December 1888, in Merlhès, p 302.

52 Vincent van Gogh, letter to his brother Theo, 17 or 18 December 1888, see *Vincent van Gogh: the letters*, letter 726.

53 *Avant et après*, pp 183–4.

54 Gauguin, letter to Émile Schuffenecker, c 20 December 1888, in Merlhès, p 306. See also Cachin in *Gauguin*, 1989, p 179.

55 Gauguin, letter to Schuffenecker, c 20 December 1888, in Merlhès, p 305. In the letter to Theo describing their visit to the Musée Fabre, Vincent speaks of a 'strange and superb portrait of a man' then attributed to Rembrandt (Musée du Louvre, La Caze Collection) in which he sees 'a certain family or facial resemblance' to Delacroix and Gauguin. Which is why, he adds, he 'always calls this portrait "the traveller" or "the man who is coming from far away"'. *Vincent van Gogh: the letters*, letter 726.

56 On the dating of *Portrait of the artist with The yellow Christ*, see Cachin in *Gauguin*, 1989, p 185; *Gauguin et le Christ jaune*, exhibition catalogue, Musée de Pont-Aven, Pont-Aven, 2000.

57 Gauguin, letter to Émile Bernard, June 1890, in Malingue, p 145.

58 Vincent van Gogh, letter to his brother Theo, c 19 November 1889, in *Vincent van Gogh: the letters*, letter 820.

59 Definition of 'abstraction' in the *Dictionnaire Grand Robert de la langue française*.

60 Vincent van Gogh, letter to his brother

Theo, c 19 November 1889, *Vincent van Gogh: the letters*, letter 820.

61 Gauguin, letter to Schuffenecker, 8 October 1888, in Malingue, p 105.

62 Gauguin, letter to Émile Bernard, in Malingue, p 115.

63 Octave Mirbeau, *Des artistes, première série, 1885–96, peintres et sculpteurs*, Ernest Flammarion, Paris, 1922, pp 124, 126, 125, 127, 123.

64 Gauguin, letter to Charles Morice, May 1896, in Malingue, pp 205–6.

65 Segalen, vol 1, p 196. Victor Segalen bought *Near Golgotha* at the auction of private effects at Papeete of 2–3 September 1903 but sold it in 1906.

66 Gauguin, letter to Daniel de Monfreid, June 1901, in Daniel Guérin (ed), *The writings of a savage*, trans Eleanor Levieux, Da Capo, New York, 1996, p 210.

67 Gauguin, letter to Daniel de Monfreid, March 1902, in *The letters of Paul Gauguin*, p 153.

68 Gauguin, letter to Daniel de Monfreid, May 1902, in Guérin, p 212.

69 Gauguin, letter to De Monfreid, March 1902, in *The letters of Paul Gauguin*, p 153.

70 Gauguin, 2017, p 13.

71 Gauguin, letter to André Fontainas, February 1903, in Guérin, p 232.

72 Gauguin, letter to Daniel de Monfreid, 25 August 1902, in *The letters of Paul Gauguin*, p 158.

73 Émile Zola, 'Salon, May 1896', in Zola, *Salons*, FWJ Hemmings and J Niess (eds), Droz, Geneva, 1959, p 115.

74 Paul Gauguin, *Modern thought and Catholicism*, trans Stamos Metzidakis, Saint Louis Art Museum, viewed 19 April 2024, https://www.slam.org/collection/objects/18302/, p 1.

75 Gauguin, *Modern thought*, p 76.

76 Gauguin, *Modern thought*. Separate dedication page, glued into the manuscript.

77 There is a fine analysis of this work by Elizabeth C Childs, 'L'esprit moderne et le catholicisme. Le peintre écrivain dans les dernières années', in *Gauguin–Tahiti*, 2003, pp 274–89. See also Debora Silverman, *Van Gogh and Gauguin: the search for sacred art*, Farrar, Straus and Giroux, New York, 2000; Christian Jamet, *Gauguin. Les chemins de la spiritualité*, Cohen et Cohen, Paris, 2020.

78 *Avant et après*, pp 1, 5, 20, ff.

79 *Avant et après*, p 32.

80 Victor Hugo, *Les Misérables*, trans Julie Rose, Vintage, London, 2008, p 184.

81 *Avant et après*, p 2.

82 *Avant et après*, p 2.

83 *Avant et après*, p 32.

84 *Avant et après*, p 116.

85 Gauguin, 2017, pp 34–5.

86 Gauguin, letter to De Monfreid, May 1902, in Guérin, p 212.

87 *Avant et après*, p 12.

88 Gauguin, 2017, pp 23, 29. Donatien Grau translates as 'he plays the organ constantly'. *Grand orgue* suggests the orchestra-like variety available from the manuals of a cathedral organ.

89 *Avant et après*, p 32. The section heading is on p 30.

90 Gauguin, 2017, p 25. Gauguin is once again rewriting history. In July 1883, *The prodigal child* had been acquired by the collector Henry Lerolle and *The poor fisherman* by the French state prior to the opening of the *Exposition des tableaux, pastels, dessins par M. Puvis de Chavannes*, Galerie Durand-Ruel, 20 November–20 December 1887, which is where Gauguin saw them.

91 Joris-Karl Huysmans, 'Puvis de Chavannes', in *Certains*, 1889 (reprinted in Huysmans, *Écrits sur l'art, 1867–1905*, Bartillat, Paris, 2006, pp 345–6). Gauguin's answer was posthumously published by Jean Loize: 'Un inédit de Gauguin', *Les Nouvelles littéraires*, 7 May 1953. On Gauguin's relations with Puvis, see Monique Nonne, 'Puvis de Chavannes et les peintres du petit boulevard. Émile Bernard, Paul Gauguin, Vincent van Gogh', in *De Puvis de Chavannes à Matisse et Picasso*, exhibition catalogue, Palazzo Grassi, Venice, & Flammarion, Paris, 2002, pp 70–87.

92 Gauguin, letter to Émile Bernard, in Guérin, p 26.

93 Huysmans, 2006, p 346.

94 Gauguin, letter to Charles Morice, July 1901, in Malingue, pp 226–7.

95 Gauguin, letter to Camille Pissarro, 14 December 1881, in Thomson, p 18.

96 Gauguin, letter to Camille Pissarro, late May 1885, in Merlhès, p 107.

97 Gauguin, letter to De Monfreid, 25 August 1902, in *The letters of Paul Gauguin*, p 158.

98 Daniel Halévy, *My friend Degas*, trans Mina Curtiss, Middletown, 1964, Éditions de Fallois, Paris, 1995, p 58 (entry for 17 May 1891). Translation slightly altered for this publication.

99 Gauguin, letter to to Émile Bernard, November 1888, in Malingue, p 112.

100 Gauguin, 'Miscellaneous things', in Guérin, p 127.

101 Gauguin, letter to Emmanuel Bibesco, July 1900, in Malingue, p 223.

102 Rosalind de Boland Roberts and Jane Roberts (eds), *Growing up with the impressionists: the diary of Julie Manet*, trans Rosalind de Boland Roberts and Jane Roberts, Sotheby's Publications, London, 1987, p 177.

103 Camille Pissarro, letter to Lucien Pissarro, 23 November 1893, in J Rewald (ed), *Camille Pissarro: letters to his son Lucien*, trans Lionel Abel, MFA Publications, Boston, 2002, p 221. (Translator's note: The Kanaks are the native Melanesians of New Caledonia.)

104 *The private collection of Edgar Degas*, vol 2, pp 54–7. In 1879, Gauguin wanted to acquire a Degas. He swapped one of his still lifes, *On a chair*, for a modest pastel study, *Dancer adjusting her slipper* (Ordrupgaard, Copenhagen). Degas willingly lent the Gauguin to the *Impressionist* exhibition of 1881 and the latter could proudly annotate the catalogue

entry: 'Belongs to Monsieur Degas'. Loyrette, 1991, p 420.

105 Gauguin, letter to Daniel de Monfreid, 15 August 1898, in Thomson, p 261.

106 *Avant et après*, p 61.

107 Gauguin, 2017, p 34.

108 Ambroise Vollard, *Degas: an intimate portrait*, trans Randolph T Weaver, Crown, New York, 1937, p 48. Available on *Internet Archive*, viewed 19 April 2024, https://archive.org/details/degaspor00voll.

109 Charles Baudelaire, 'Correspondences', in *The flowers of evil*, trans James McGowan, Oxford University Press, Oxford, 1998, p 19.

110 Gauguin, letter to Daniel de Monfreid, August 1901, in Guérin, p 211.

111 Gauguin, letter to Émile Schuffenecker, February 1888, in Guérin, p 22.

112 Vincent van Gogh, letter to his brother Theo, from Arles, c 5 November 1888, *Vincent van Gogh: the letters*, letter 717.

113 Théophile Gautier, *Charles Baudelaire, his life*, trans Guy Thorne, Greening & Co, London, 1915, p 73.

114 See Dario Gamboni's remarkable analyses in Gamboni, *Paul Gauguin: the mysterious centre of thought*, trans Chris Miller, Reaktion Books, London, 2014.

115 Gauguin, letter to Émile Bernard, 1889, in Guérin, p 33.

116 On this point, see Henri Loyrette, Kimberly A Jones, Leïla Jarbouai and Marine Kisiel, *Degas à l'Opéra*, exhibition catalogue, Musée d'Orsay, Paris, Réunion des musées nationaux, Grand Palais, Paris, & National Gallery of Art, Washington, DC, 2019.

117 Gauguin, letter to Émile Bernard, November 1888, in Merlhès, p 275.

118 Gauguin, letter to Daniel de Monfreid, August 1901, in Thomson, p 271.

119 Gauguin, letter to Daniel de Monfreid, May 1899, in *The letters of Paul Gauguin*, p 119.

120 'Do you know that Gauguin is partly the inventor of the white frame?' Vincent van Gogh to his brother Theo, 10 November 1888, *Vincent van Gogh: the letters*, letter 718.

121 This was particularly the case with the memorable exhibition curated by William Rubin and Kirk Varnedoe, *Primitivism in 20th century art*, The Museum of Modern Art, New York, 1984: Gauguin featured in the entry hall. On Primitivism, the most complete synthetic account is that of Philippe Dagen, *Primitivismes*, Gallimard, Paris, vol 1, 2019, and vol 2, 2021.

122 Victor Hugo, 'Preliminary chapter – Ursus, IV', in *The man who laughs*, see *Project Gutenberg*, viewed 19 April 2024, https://www.gutenberg.org/files/12587/12587-h/12587-h.htm.

123 Stéphane Mallarmé, letter to Julien Leclercq, 29 March 1891, in Mallarmé, 2019, p 936.

124 *Avant et après*, p 193.

125 *Avant et après*, p 197.

The painting of modern Polynesian life

1 This essay draws on arguments presented in my recent book: Nicholas Thomas, *Gauguin and Polynesia*, Head of Zeus, London, 2024, which includes fuller references to the Gauguin literature. Key resources include the Wildenstein Plattner Institute's online *Gauguin: catalogue raisonné of the paintings 1891–1903*, https://digitalprojects.wpi.art/gauguin/.

2 Classic accounts of Tahitian religion, tradition and sacred sites include Teuira Henry, *Ancient Tahiti*, Bishop Museum, Honolulu, 1928.

3 For Marquesan art traditions, see Carol S Ivory (ed), *Matahoata: arts et société aux îles Marquises*, Actes Sud, Paris, 2016.

4 Gauguin, letter to Ambroise Vollard, January 1900, in 'Reconstitution of shipments', WPI Research Appendix, *Gauguin: catalogue raisonné*, viewed 19 January 2024, https://digitalprojects.wpi.art/gauguin/introduction/essay-detail?essayId=9.

5 For the composition of *Noa Noa*, see Christopher Wadley, *Noa Noa: Gauguin's Tahiti*, Phaidon, Oxford, 1983, and Linda Goddard, *Savage tales: the writings of Paul Gauguin*, Yale University Press, New Haven, 2019. The relevant passages from the manuscript of the 1893 draft (held in the library of the Getty Research Institute in Los Angeles) are discussed in Thomas, *Gauguin and Polynesia*, ch 9.

Gauguin the writer: *Noa Noa* and other prose

1 Victor Segalen, 'Gauguin dans son dernier décor', in *Gauguin dans son dernier décor et autres textes de Tahiti*, Fata Morgana, Paris, 1975, p 24. Unless otherwise noted, all translations from the French are by Chris Miller.

2 Segalen, p 18.

3 Gauguin, in Daniel Guérin (ed), *The writings of a savage*, trans Eleanor Levieux, Da Capo, New York, 1996, p 268.

4 Gauguin, letter to André Fontainas, February 1903, in Maurice Malingue (ed), *Paul Gauguin: letters to his wife and friends*, trans Henry J Stenning, World Publishing Company, Cleveland, 1949, p 233.

5 Gauguin, letter to André Fontainas, September 1902, in Malingue, pp 352–57.

6 Gauguin, letter to Paul Sérusier, 25 March 1892, in Guérin, p 57.

7 Paul Gauguin, *Ancien culte mahorie*, Les éditions Hermann, Paris, 2001, p 9. This passage was mostly inspired by a long poem by Leconte de Lisle (1818–1894) on Polynesian origins.

8 Guérin, p xxi.

9 Gauguin, letter to Mette Gad, October 1893, in Malingue, p 285.

10 Copy held in the library of the Getty Research Institute in Los Angeles.

11 Paul Gauguin, *Noa Noa: voyage to Tahiti*, trans

Jonathan Griffin, Pallas Athene, London, 2010, p 38.

12 Gauguin, in Guérin, p 110.

13 Gauguin, letter to Daniel de Monfreid, May 1902, in Guérin, p 212.

14 Manuscript in the collection of Temple University Library, Philadelphia.

15 Gauguin, 2010, pp 10–11.

16 Gauguin read the Polynesian cosmogony myth in a work by JA Moerenhout (French consul in Tahiti, 1842–43), *Voyage aux îles du grand océan*, from which he adapted the content of *Ancien culte mahorie* and passages in *Noa Noa*.

17 Pierre Loti enjoyed great literary success with his novels inspired by his travels and personal experiences. He was elected to the Académie française in 1891.

18 Gauguin, 2010, p 7.

19 Gauguin, 2010, p 11.

20 Pierre Loti, *The marriage of Loti*, trans Clara Bell, T Werner Laurie, London, 1925, p 14.

21 Loti, p 15.

22 Gauguin, 2010, p 69.

23 Gauguin, 2010, p 71.

24 Gauguin, letter to Daniel de Monfreid, 14 July 1897, in *Gauguin's letters from the South Seas*, trans Ruth Pielkovo, Dover Publications, New York, rev edn, 1992, p 54.

25 Gauguin, letter to Fontainas, September 1902, in Malingue, p 231.

Paul Gauguin and his art in the era of cancel culture: reception and reassessments

1 The foundational texts are Linda Nochlin, 'Eroticism and female imagery in nineteenth-century art', in Thomas B Hess and Linda Nochlin (eds), *Woman as sex object: studies in erotic art, 1730–1970*, *Art News Annual* 38, Newsweek, New York, 1972, pp 8–15; and Abigail Solomon-Godeau, 'Going native: Paul Gauguin and the invention of Primitivist Modernism', *Art in America* 77, July 1989, pp 118–29; reprinted in Norma Broude and Mary D Garrard (eds), *The expanding discourse: feminism and art history*, HarperCollins, New York, 1992, pp 313–29.

2 See eg Farah Nayeri, 'Is it time Gauguin got canceled?', *New York Times*, London, 18 November 2019; reprinted as 'No more excuses for Gauguin', *New York Times*, New York, 19 November 2019, section C, p 1. See also Michael Glover, 'Gauguin's predatory colonial gaze', *Hyperallergic*, 26 October 2019.

3 From the audio guide to the 2019 *Gauguin portraits* exhibition at the National Gallery, London. The question was picked up from there and widely commented on in the press.

4 See the essays in Norma Broude (ed), *Gauguin's challenge: new perspectives after Postmodernism*, Bloomsbury Visual Arts, New York & London, 2018.

5 Broude, 2018, pp 69–100.

6 For bibliographies of Tristan's extensive writings, see Máire Cross and Tim Gray,

The feminism of Flora Tristan, Berg, Oxford, 1992, pp 172–3; and Doris and Paul Beik, *Flora Tristan, utopian feminist: her travel diaries and personal crusade*, Indiana University Press, Bloomington, 1993, pp 185–6. Good introductions to Tristan's complicated life story are found in Cross and Gray, pp 7–13; and Beik, pp ix–xxi.

7 From *L'esprit moderne et le catholicisme* (1897–1902), in Paul Gauguin, *Oviri, écrits d'un sauvage*, Daniel Guérin (ed), Éditions Gallimard, Paris, 1974, pp 211–12.

8 Gauguin, 1974, p 214.

9 Gauguin, letter to Madeleine Bernard, October 1888, in Maurice Malingue (ed), *Paul Gauguin: letters to his wife and friends*, trans Henry J Stenning, MFA Publications, Boston, 2003, p 103.

10 Octave Mirbeau, 'Paul Gauguin', *L'Écho de Paris*, 16 February 1891, cited by Karyn Esielonis, *Gauguin's Tahiti: the politics of exoticism*, University of Michigan Press, Ann Arbor, 1993, pp 34–5, note 30.

11 Paul Gauguin, *Avant et après, avec les vingt-sept dessins du manuscript original*, G Crès et Cie, Paris, 1923, pp 133–4. The relevant passages are translated and further discussed in Broude, 2018, pp 74–5.

12 See Broude, 2018, pp 76–80.

13 For examples, see Gauguin, 1923, pp 141–5, 146–54, 186.

14 Paul Gauguin, *Noa Noa: a journal of the South Seas*, trans OF Theis, Noonday Press, New York, 1957, pp 46–7. From the Louvre manuscript: 'Quelque chose de viril est en elles, et, en eux, quelque chose de féminin. Cette ressemblance des sexes facilite leurs relations.' For Flora Tristan's condemnation of the corseting of women's bodies in Europe see her 1838 novel *Méphis*, in Beik, p 47.

15 See Solomon-Godeau, in Broude and Garrard, pp 318–19, 322.

16 See Gauguin, 1957, pp 49–52; on Queen Maraü, pp 12–13.

17 June Hargrove, '*Woman with a fan*: Paul Gauguin's heavenly Vairaumati, a parable of immortality', *Art Bulletin*, vol 88, no 3, September 2006, pp 552–66.

18 On the complex iconography and multiple meanings of this figure for Gauguin, see Sue Taylor, '"Oviri:" Gauguin's savage woman', *Konsthistorisk Tidskrift/Journal of Art History*, vol 62, nos 3–4, 1993, pp 197–220; and Irina Stotland, 'Paul Gauguin's self-portraits in Polynesia: androgyny and ambivalence', in Broude, 2018, pp 56–9.

19 See eg Solomon-Godeau, in Broude and Garrard, p 326.

20 On women and oral traditions, see Heide Goettner-Abendroth, *Matriarchal societies: studies on Indigenous cultures across the globe*, Peter Lang, New York, 2012, p 23 ff.

21 See Marie-Noëlle Ottino-Garanger on the traditional meanings of tattoos, fans and other ornaments, in Suzanne Greub (ed),

Gauguin/Polynesia, exhibition catalogue, Art Centre Basel, Basel, & Hirmer, Munich, 2011, pp 124–37, esp p 133.

22 This tale as told by Moerenhout is repeated by Gauguin in *Ancien culte mahorie* (1892–93), René Huyghe (ed), La Palme, Paris, 1951, p 13.

23 See Ngāhuia Murphy, '*Te Awa Atua, Te Awa Tapu, Te Awa Wahine*: an examination of stories, ceremonies and practices regarding menstruation in the pre-colonial Māori world', master's thesis, University of Waikato, Hamilton, NZ, 2011. The author uses her research to counter the false but 'powerful discourses of menstrual pollution and female inferiority' in colonialist narratives about traditional Māori society (p ii). Those narratives from the late eighteenth century on are reviewed in close detail by anthropologist F Allan Hanson, who questions and refutes the long-held anthropological theory that women and menstruation were regarded as polluting in Polynesia, arguing instead that 'women had a special affinity with the gods and represented a conduit for the communication of influences between the physical and spiritual realms.' See also F Allan Hanson, 'Female pollution in Polynesia?', *The Journal of the Polynesian Society*, vol 91, no 3, 1982, pp 335–81; this quote, p 363.

24 For recent thinking, see Per Hage and Jeff Marck, 'Matrilineality and the Melanesian origin of Polynesian Y chromosomes', *Current Anthropology*, vol 44, no S5, 2003, pp 121–7; and Jeff Marck, 'Proto Oceanic society was matrilineal', *The Journal of the Polynesian Society*, vol 117, no 4, December 2008, pp 345–82, esp p 350. For anthropological thinking closer to Gauguin's era on proto-Oceanic and present-day societies, see WHR Rivers, who wrote that 'the existing matrilineal descent is little more than the last surviving relic of a social state in which matrilineal institutions were far more general and important' (Rivers, *The history of Melanesian society*, 2 vols, Cambridge University Press, Cambridge, 1914, vol 2, p 319, quoted by Marck, p 345).

25 Anne D'Alleva, *Shaping the body politic: gender, status, and power in the art of eighteenth-century Tahiti and the Society Islands*, ProQuest Dissertations Publishing, Columbia University, New York, 1997, p 1.

26 Anne D'Alleva, 'On 1890s Tahiti', in Greub, pp 174–87; this quote p 179. See also Niel Gunson, 'Great women and friendship contact rites in pre-Christian Tahiti', *The Journal of the Polynesian Society*, vol 73, no 1, 1964, pp 53–69.

27 D'Alleva, 1997, pp 397–404.

28 For the painting's history, see Richard Brettell, 'Portraits of women', in *The art of Paul Gauguin*, exhibition catalogue, National Gallery of Art, Washington, DC, 1988, pp 426–7.

29 Brettell, pp 426, 427, note 1.

30 Goettner-Abendroth, pp 194, 196.

31 John Richardson, 'Gauguin at Chicago and New York', *Burlington Magazine* 101, May 1959, p 190, cited by Brettell, p 427.

32 On late nineteenth-century debates over the theory of a matriarchal prehistory, see Cynthia Eller, 'Sons of the mother: Victorian anthropologists and the myth of matriarchal prehistory', *Gender & History*, vol 18, no 2, August 2006, pp 285–310.

33 H Rider Haggard's novel is contextualised in these terms by Julia Reid, 'Novels', in Miriam Dobson and Benjamin Ziemann (eds), *Reading primary sources: the interpretation of texts from nineteenth- and twentieth-century history*, Routledge, London, 2009, pp 166–70.

34 See eg Gauguin, letter to Armand Séguin, 15 January 1897, in Broude and Garrard, p 326.

35 Gauguin, *Avant et après*, pp 133–4.

36 Cross and Gray, pp 38–43.

37 Cross and Gray, pp 125 ff.

38 On women's rights and education in nineteenth-century Denmark, see Kirstine Frederiksen, 'Denmark', in Theodore Stanton (ed), *The woman question in Europe: a series of original essays*, GP Putnam's Sons, New York, 1884, pp 221–33.

39 Gauguin, letter to Mette Gad, 6 December 1887, in Malingue, p 90.

40 For the older masculinist view of Mette as the cold evil wife and Paul as the loving husband who suffered from the loss of his children and his wife's lack of empathy and understanding, see Malingue, pp ix–xi. For more recent and sympathetic views of Mette, her active professional life in Copenhagen, her admiring circle of friends, and her long-term involvement with the exhibition and marketing of her absent husband's work, see Merete Bodelsen, *Gauguin and Van Gogh in Copenhagen in 1893*, exhibition catalogue, Ordrupgaard, Copenhagen, 1984, pp 24–8; Nancy Mowll Mathews, *Paul Gauguin: an erotic life*, Yale University Press, New Haven & London, 2001, passim; and Anne-Birgitte Fonsmark, *Gauguin and Impressionism*, exhibition catalogue, Yale University Press, New Haven & London, 2005, pp 76–9 and passim.

41 Gauguin, 1923, p 4. This translation is by Van Wyck Brooks, *Paul Gauguin, intimate journals*, WW Norton, New York, 1970, p 18.

Imagining a reconciliation beyond myth and polemics

1 Jean-Marc Pambrun, quoted in *Paul Gauguin: héritage et confrontations*, Acts of the Conference, 6–8 March 2003, Université de Polynésie française, Éditions le Motu, Papeete, 2003. Unless otherwise noted, all translations from the French are by Chris Miller.

2 Hiriata Millaud, 'Les titres tahitiens de Gauguin', in *Ia Orana Gauguin*, exhibition catalogue, Somogy, Paris, 2003, pp 81–90.

3 Tara Hiquily and Christel Vieille-Ramseyer, *Tiki*, Au vent des îles, Papeete, 2017, pp 16–17.

4 Alain Babadzan, *Les dépouilles des dieux:*

essai sur la religion tahitienne à l'époque de la découverte, Éditions de la maison des sciences de l'homme de Paris, Paris, 1993, pp 116–17.

5 Babadzan, pp 116–17.

6 Teuira Henry, *Tahiti aux temps anciens*, trans Bertrand Juanez, Société des Océanistes, Paris, 2004, pp 438–9.

7 Pambrun, 2003, quoted in *Paul Gauguin: héritage et confrontations*, pp 25–6.

8 Jean-Marc Pambrun, *Les parfums du silence: Gauguin est mort!*, Éditions le Motu, Papeete, 2009.

9 Chloé Angué, '"Les parfums du silence" et "La lecture" de Jean-Marc T Pambrun: le refus du second rôle', *Loxias* 34, published online 14 September 2011, viewed 16 January 2024, http://revel.unice.fr/loxias/index/html?id=6817.

10 Kanaky in conversation with the author, 26 November 2023.

11 Kanaky in conversation.

12 *Talanoa*, or a process of open dialogue, is a Sāmoan term widely used in the Pacific islands.

Paul Gauguin: chronology

1 Douglas W Druick and Peter Kort Zegers (eds), *Van Gogh and Gauguin: the studio of the south*, Thames & Hudson, New York, 2001, p 41.

2 Gauguin, letter to Mette Gad, 26 December 1886, in Daniel Guérin (ed), *The writings of a savage*, trans Eleanor Levieux, Viking Press, New York, 1978, p 17.

3 Gauguin, letter to Mette Gad, early April 1887, in Guérin, pp 17–18.

4 Gauguin, letter to Mette Gad, January 1888, in Guérin, pp 21–2.

5 Gauguin, letter to Émile Schuffenecker, February 1888, in Guérin p 22.

6 Vincent van Gogh, quoted in Daniel Wildenstein, *Gauguin: a savage in the making; catalogue raisonné of the paintings (1873–1888)*, Skira, Milan, & Wildenstein Institute, Paris, 2002, p 615.

7 Morgan Wyler, *Les techniques de peinture de Gauguin en relation avec son travail dans d'autres médias*, Musée d'Orsay, 19–20 October 2017, viewed 25 March 2024, https://youtu.be/MxnXd0tQSUg?si=GlFirZhIO34c3A1k.

8 Gauguin, letter to Émile Schuffenecker, late December 1888, in Guérin, pp 26–7.

9 Gauguin, quoted in André Cariou, *Gauguin and his friends*, exhibition catalogue, Ordrupgaard, Copenhagen, 2022, p 32.

10 Gauguin, letter to Mette Gad, February 1890, in Guérin, p 40.

11 Gauguin, letter to Odilon Redon, September 1890, in Guérin, p 42.

12 Gauguin, letter to Émile Bernard, August 1890, in Guérin, p 42.

13 Octave Mirbeau, quoted in Ernest Flammarion (ed), *Des artistes, première série, 1885–1896, peintres et sculpteurs*, Paris, 1922, p 139; see 'Octave Mirbeau: champion of the French avant-garde', Sotheby's, viewed 25 March 2024, https://www.sothebys.com/en/articles/octave-mirbeau-champion-of-the-french-avant-garde.

14 Gauguin, letter to Mette Gad, 24 March 1891, in Guérin, p 51.

15 Richard Brettell and Elpida Vouitsis, 'Gauguin in Tahiti, First Period 1891–1893', in *Gauguin: catalogue raisonné of the paintings*, Wildenstein Plattner Institute, viewed 24 March 2024, https://digitalprojects.wpi.art/gauguin/introduction/essay-detail?essayId=1.

16 Suzanne Greub (ed), *Gauguin / Polynesia*, exhibition catalogue, Art Centre Basel, Basel, & Hirmer, Munich, 2011, p 308.

17 Greub, p 308.

18 Gauguin, letter to Mette Gad, July 1891, in Guérin, p 52.

19 Gauguin, letter to Gad, July 1891, in Guérin, p 53.

20 Reginald G Gallop, *Reminiscences of Tahiti— Society Islands—during a six week's* [sic] *visit, Sept–Nov 1887*, Mitchell Library, State Library of New South Wales, Sydney, MLMSS 488/vol 4, p 58.

21 Gauguin, letter to Paul Sérusier, November 1891, in Guérin, p 54.

22 Guérin, pp xii–xiii.

23 Gauguin, letter to Paul Sérusier, 25 March 1892, in Guérin, p 57.

24 Christina Hellmich and Line Clausen Pedersen, *Gauguin: a spiritual journey*, exhibition catalogue, Fine Arts Museums of San Francisco, & DelMonico Books, San Francisco, 2018, p 11.

25 Gauguin, in Guérin, p xxv.

26 Mette Gad, in Hellmich and Pedersen, p 12.

27 Gauguin, letter to Daniel de Monfreid, 12 March 1897, in Guérin, p 124.

28 Gauguin, in Guérin, pp 65–6.

29 Gauguin, letter to Daniel de Monfreid, 12 December 1898, in Guérin, p 182.

30 Gauguin, letter to De Monfreid, 12 December 1898, in Guérin, p 181.

31 Gauguin, letter to Ambroise Vollard, January 1900, in Guérin, pp 204–5. Emphasis in the original.

32 Gauguin, letter to Daniel de Monfreid, November 1901, in Guérin, p 212.

33 Belinda Thomson (ed), *Gauguin: maker of myth*, exhibition catalogue, Tate Publishing, London, 2010, p 55.

34 Victor Segalen, letter to his parents, 5 August 1903, in Thomson, p 58.

List of works

List of works prepared by David Greenhalgh

Works are listed by artist, chronologically, then alphabetically by title. Titles in English are used, followed by French in parentheses where appropriate.

Gauguin's Tahitian language titles reflect the artist's spelling, with English translations in parentheses; it is known through his correspondence with Mette Gad that Gauguin asked for his Tahitian titles to be retained and preferenced over translations. The history of titles for Gauguin's work is often complex: sometimes changed by the artist during his lifetime, other times altered after the artist's death by collectors and dealers to reflect changing preferences for how a work should be interpreted. Where variant titles occur, the title provided by the lender is privileged.

Gauguin's work in print was often experimental, with individual works often printed in a multitude of states and without accurate records of edition sizes. To assist interested scholars, state and edition details listed refer to *Paul Gauguin: catalogue raisonné of his prints* by Joachim, Kornfeld and Mongan, 1988. Works were printed by Gauguin except where noted otherwise.

Tahitian and Marquesan works are listed by cultural group. Measurements are height × width × depth.

Works only on display at the National Gallery of Australia are marked *

Works only on display at the Museum of Fine Arts, Houston are marked **

Paul Gauguin
France 1848 – French Polynesia 1903

Landscape 1873
oil on canvas
50.5 × 81.6 cm
The Syndics of The Fitzwilliam Museum, University of Cambridge. A gift to the museum from the Very Rev E Milner-White, CBE, DSO, Dean of York, in devoted memory of his mother, Annie Booth-Milner-White, PD.20-1952
(p 126)

The Seine, Pont d'Iéna. Snowy weather
(*La Seine au pont d'Iéna. Temps de neige*) 1875
oil on canvas
65.4 × 92.4 cm
Musée d'Orsay, Paris. Bequest of Paul Jamot 1941, RF 1941 27
(p 128)

Still life with oysters (*Nature morte aux huîtres*)
1876
oil on canvas
53.3 × 93.3 cm
Virginia Museum of Fine Arts, Richmond.
Collection of Mr and Mrs Paul Mellon, 83.23 **
(p 129)

Apple trees at l'Hermitage (*Les pommiers de l'Hermitage*) 1879
oil on canvas
65 × 100 cm
Aargauer Kunsthaus, Aarau. Bequest of Dr Max Fretz 1958, 1086
(p 131)

Historic frame (*Cadre historié*) c 1880–85
carved walnut and photograph
18.9 × 33.6 × 1 cm
Musée d'Orsay, Paris. Gift of Corinne Peterson in memory of Fredrick Peterson (1873–1944) and Lucy Peterson (1876–1958) 2003, OAO 1420
(p 133)

Quarry around Pontoise (*Carrière aux environs de Pontoise*) 1882
oil on canvas
89 × 116 cm
Kunsthaus Zürich. Bequest of the Zürcher Kunstfreunde association 1981, 1981/0005
(p 135)

Narcissus fan handle with Degas dancer (*Poignée d'eventail aux narcisses avec danseuse de Degas*)
1884–85
painted and carved wood
27.9 × 2.9 × 1.9 cm
The Gwinnett family, Tarntanya/Adelaide
(p 133)

Landscape with red roof (*Paysage au toit rouge*) 1885
oil on canvas
81.5 × 66 cm
Rudolf Staechelin Collection
(p 141)

Ostre Anlaeg Park, Copenhagen 1885
oil on canvas
59.1 × 72.8 cm
Glasgow Life Museums on behalf of Glasgow City Council. Presented by the Trustees of the Hamilton Bequest 1944, 2465
(p 138)

Self-portrait (*Autoportrait*) 1885
oil on canvas
65.2 × 54.3 cm
Kimbell Art Museum, Fort Worth, AP 1997.03 **
(p 47)

Still life in an interior, Copenhagen (Nature morte dans un intérieur Copenhague) 1885
oil on canvas
60 × 73 cm
Private collection
(p 139)

Women bathing (Baigneuses à Dieppe) 1885
oil on canvas
38.1 × 46.2 cm
The National Museum of Western Art, Tokyo.
Matsukata Collection, P.1959-0104
(p 71)

Planter decorated with Breton shepherdess motifs (Jardinière [sujets de Bretagne]) c 1886–87
glazed stoneware, slip
27 × 40 × 22 cm
Private collection
(p 145)

Planter with Breton woman and sheep (Jardinière avec bretonne et moutons) c 1886–87
incised and modelled stoneware, paint and enamel
13.3 × 15.5 × 11.5 cm
Petit Palais, Musée des Beaux-Arts de la Ville de Paris. Dutuit bequest 1902, ODUT1787
(p 147)

Vase with geese (Vase aux oies) c 1886–87
modelled and painted earthenware
12 × 17.5 (diam) cm
Private collection. Courtesy Galerie Dina Vierny, Paris, P32
(p 147)

Jug with a double spout (Verseuse à double bec) 1886–87
glazed stoneware, slip
12.5 × 20.5 × 8 cm
Musée d'Art Moderne de Paris. Donated by Henry Thomas 1976, AMOA 353
(p 146)

Pot in the form of the head of a Breton woman (Pot en forme de tête de bretonne) 1886–87
stoneware, slip and gilded highlights
14 × 9.2 × 16.5 cm
Private collection
(p 148)

Vase decorated with Breton scenes (Vase à décor de scènes bretonnes) 1886–87
glazed stoneware, slip and gilded highlights
28.8 × 12 (diam) cm
Cinquantenaire Museum, Royal Museums of Fine Arts of Belgium, Brussels, 6756
(p 143)

Breton woman seen from behind (Bretonne vue de dos) 1886
pastel on paper
45.7 × 30 cm
Fondation Pierre Gianadda, Martigny
(p 143)

Still life with horse's head (Nature morte à la tête de cheval) 1886
oil on canvas
49 × 38.5 cm
Artizon Museum, Ishibashi Foundation, Tokyo, 22588
(p 140)

Still life with profile of Laval (Nature morte au profil de Laval) 1886
oil on canvas
46 × 38 cm
Indianapolis Museum of Art at Newfields. Samuel Josefowitz Collection of the School of Pont-Aven, through the generosity of Lilly Endowment Inc, the Josefowitz Family, Mr and Mrs James M Cornelius, Mr and Mrs Leonard J Betley, Lori and Dan Efroymson, and other Friends of the Museum, 1998.167
(p 151)

The red hat (Le chapeau rouge) 1886
oil on canvas
44.5 × 53 cm
Musée d'Orsay, Paris. Purchased 2019, RF MO P 2019 8
(p 150)

Vase 1886
partially glazed stoneware, paint
14.6 × 20.5 × 10.5 cm
Musée d'Orsay, Paris. Gift of Lucien Vollard 1943, AF 14329 4
(p 149)

Double pot c 1887–89
unglazed stoneware
15.5 × 12.8 × 11.5 cm
Te Fare Iamanaha – Musée de Tahiti et des Îles, Papeete
(p 153)

Fantastic vase with a grotesque head and the figure of a female bather, titled The Marchand d'esclave c 1887–89
glazed stoneware
26.7 × 22.9 × 17.8 cm
Private collection
(p 154)

Cleopatra pot 1887–88
partially glazed stoneware, slip and gold paint
13.5 × 12.5 × 10 cm
Van Gogh Museum, Amsterdam. Vincent van Gogh Foundation, V0037V1978
(p 152)

Jar with four feet (Jarre à quatre pieds) 1887–88
glazed stoneware, gilded highlights
18.2 × 15 × 15.5 cm
Private collection. Courtesy Galerie Dina Vierny, Paris, P31
(p 153)

Vase with bather, setting sun (Potiche à la baigneuse, soleil couchant) 1887–88
unglazed stoneware, coloured slips, gilded highlights
13.1 × 15.1 × 11.6 cm
Musée d'Orsay, Paris. Gift of Lucien Vollard 1943, AF 14329 6
(p 149)

Vase with the portrait mask of a woman (Pot décoré d'une tête de femme) 1887–88
partially glazed stoneware with gilded highlights
18 × 15 (diam) cm
Association des Amis du Petit Palais, Geneva
(p 152)

Still life with sketch after Delacroix (Nature morte à l'esquisse après Delacroix) c 1887
oil on canvas
45 × 30 cm
National Museum of Serbia, Belgrade, 1931
(p 157)

Still life with drawing by Delacroix (Nature morte à l'esquisse de Delacroix) 1887
oil on canvas
40 × 30 cm
Musée d'Art Moderne et Contemporain de Strasbourg, 55.974.0.662
(p 156)

Walking stick with a female nude and a Breton sabot on the handle c 1888–90
boxwood, mother-of-pearl, glass and iron
92.7 × 5.2 × 4.3 cm
The Metropolitan Museum of Art, New York. Bequest of Miss Adelaide Milton de Groot 1967, 67.187.45a, b
(p 184)

Bather fan (Baignade [II]) c 1888
pastel and watercolour over graphite on paper
11.4 × 40.4 cm
A Texas Collector **

Chaplet stoneware jugs (Pots en grès Chaplet) c 1888
gouache, watercolour, charcoal on Japan paper
30.5 × 40 cm
The Frances Lehman Loeb Art Center, Vassar College, Poughkeepsie. Bequest of Sarah Hamlin Stern, class of 1939, in memory of her husband, Henry Root Stern Jr, 1994.2.1
(p 155)

Children wrestling (Enfants luttant) 1888
oil on canvas
93 × 73 cm
Louvre Abu Dhabi, LAD 2010.001
(p 65)

Landscape near Pont-Aven 1888
also known as *L'aven en contre bas de la Montagne Sainte-Marguerite*
oil on canvas
72.9 × 92.2 cm
Artizon Museum, Ishibashi Foundation, Tokyo, 22505
(p 66)

Landscape of Brittany 1888
also known as *Petit berger breton*
oil on canvas
89.3 × 116.6 cm
The National Museum of Western Art, Tokyo. Matsukata Collection, P.1959-0105 *
(p 67)

Lane at Alyscamps, Arles (L'allée des Alyscamps, Arles) 1888
oil on canvas
72.5 × 91.5 cm
Sompo Museum of Art, Tokyo, W.316 *
(p 160)

Madame Roulin 1888
oil on canvas
50.5 × 63.5 cm
Saint Louis Art Museum. Funds given by Mrs Mark C Steinberg, 5:1959 **
(p 161)

Old man with a stick (Vieil homme au baton) 1888
oil on canvas
70 × 45 cm
Petit Palais, Musée des Beaux-Arts de la Ville de Paris, PPP623
(p 162)

Portrait of Madeleine Bernard (Portrait de Madeleine Bernard) (recto) 1888
oil on canvas
72 × 58 cm
Musée de Grenoble, MG 2190
(p 55)

Seascape with cow (Marine avec vache) 1888
oil on canvas
72.5 × 61 cm
Musée d'Orsay, Paris. Gift of Countess Vitali in memory of her brother Viscount Guy de Cholet 1923, RF 1938 48
(p 163)

Still life 'Fête Gloanec' (Nature morte 'Fête Gloanec') 1888
oil on canvas
36.5 × 52.5 cm
Musée des Beaux-Arts d'Orléans, MO.64.1405
(p 164)

Still life with Japanese print 1888
oil on canvas
31.7 × 55.5 cm
Private collection **
(p 169)

The swineherd (*Le gardien de porcs*) 1888
oil on canvas
73 × 93 cm
Los Angeles County Museum of Art. Gift of Lucille
Ellis Simon and family in honour of the museum's
25th anniversary, M.91.256
(p 166)

The wave (*La vague*) 1888
oil on canvas
60.2 × 72.6 cm
Private collection *
(p 165)

Washerwomen in Arles (*Laveuses à Arles*) 1888
oil on canvas
74 × 92 cm
Museo de Bellas Artes de Bilbao. Contributed by
the Provincial Council of Bizkaia in 1920, 82/18 **
(p 167)

Young Breton bathers (*Jeunes baigneurs bretons*)
1888
oil on canvas
92 × 72 cm
Hamburger Kunsthalle, Hamburg. On
permanent loan from the Stiftung Hamburger
Kunstsammlungen, acquired 1961. Restored with
support from the Hans-Jürgen Werner Stiftung
2016, HK-5063 *
(p 64)

Self-portrait (*Autoportrait*) c 1889
charcoal on wove paper
31 × 19.9 cm
Musée d'Art Moderne et Contemporain
de Strasbourg. Purchased 1921, XXI 159 **
(p 173)

Still life with fan (*Nature morte à l'éventail*) c 1889
oil on canvas
50.5 × 61.5 cm
Musée d'Orsay, Paris. Cession under the peace
treaty with Japan, 1959, RF 1959 7
(p 170)

Bonjour, Monsieur Gauguin 1889
oil on canvas and panel
74.9 × 54.8 × 1.9 cm
Hammer Museum, Los Angeles. Gift of the
Armand Hammer Foundation. The Armand
Hammer Collection, AH.90.31
(p 49)

Breton calvary (*Le calvaire breton*) 1889
also known as *The green Christ* (*Le Christ vert*)
oil on canvas
92 × 73.5 cm
Royal Museums of Fine Arts of Belgium,
Brussels, 4416
(p 57)

Breton girl spinning 1889
also known as *Joan of Arc* (*Jeanne d'Arc*)
oil on plaster
135 × 62 cm
Van Gogh Museum, Amsterdam, S0513S2006
(p 171)

Caribbean woman (*Femme caraïbe*) 1889
oil on wood panel
66.7 × 55.3 cm
Yoshino Gypsum Art Foundation, Tokyo *
(p 183)

Double-headed vase (*Vase en forme de double tête
de garçon*) 1889
glazed stoneware
21 × 14 × 21 cm
Private collection. Courtesy Galerie Dina Vierny,
Paris, P33
(p 172)

Human miseries (*Misères humaines*) 1889
graphite, ink and watercolour on tracing paper
21 × 39 cm
Private collection. Courtesy Galerie Dina Vierny,
Paris, P38
(p 174)

In Brittany (*En Bretagne*) 1889
watercolour, gold paint and gouache on paper
37.7 × 27 cm
The Whitworth, The University of Manchester,
D.1926 20
(p 175)

The ham (*Le jambon*) 1889
oil on canvas
50.1 × 57.7 cm
The Phillips Collection, Washington, DC.
Acquired 1951, 0761 **
(p 176)

The red cow (*La vache rouge*) 1889
oil on canvas
90.8 × 73 cm
Los Angeles County Museum of Art. Mr and Mrs
George Gard De Sylva Collection, M.48.17.2
(p 177)

Volpini suite 1889

Breton bathers (Baigneuses bretonnes)
zincograph, black ink on yellow wove paper
first edition
image 24.7 × 19.8 cm
sheet 49.5 × 63.9 cm
Bibliothèque de l'Institut national d'histoire
de l'art, collections Jacques Doucet, Paris,
PPN : 114822514 *
(p 181)

Breton women by a gate (Bretonnes à la barrière)
zincograph, black ink on yellow wove paper
first edition
image 17 × 21.5 cm
sheet 49.5 × 63.9 cm
Bibliothèque de l'Institut national d'histoire
de l'art, collections Jacques Doucet, Paris,
PPN : 114822530 *
(p 180)

Design for a plate: Leda and the swan (Projet d'assiette. Léda et le cygne)
zincograph, black ink on yellow wove paper,
hand-coloured with watercolour
first edition
image 22.1 × 20.4 cm
sheet 29 × 24.6 cm
Bibliothèque de l'Institut national d'histoire
de l'art, collections Jacques Doucet, Paris,
PPN : 114822476 *
(p 179)

Dramas of the sea (Les drames de la mer)
zincograph, black ink on yellow wove paper
first edition
image 17.8 × 27.3 cm
sheet 49.6 × 63.8 cm
Bibliothèque de l'Institut national d'histoire
de l'art, collections Jacques Doucet, Paris,
PPN : 114822557 *
(p 181)

Dramas of the sea, Brittany (Les drames de la mer, Bretagne)
zincograph, black ink on yellow wove paper
first edition
image 17.6 × 22.5 cm
sheet 49.6 × 64 cm
Bibliothèque de l'Institut national d'histoire
de l'art, collections Jacques Doucet, Paris,
PPN : 114822506 *
(p 181)

Human misery (Misères humaines)
zincograph, black ink on yellow wove paper
first edition
image 28.4 × 22.8 cm
sheet 49.6 × 63.9 cm
Bibliothèque de l'Institut national d'histoire
de l'art, collections Jacques Doucet, Paris,
PPN : 114822549 *
(p 181)

Joys of Brittany (Joies de Bretagne)
zincograph, black ink on yellow wove paper
first edition
image 20.2 × 24.1 cm
sheet 49.6 × 64 cm
Bibliothèque de l'Institut national d'histoire
de l'art, collections Jacques Doucet, Paris,
PPN : 114822484 *
(p 180)

Laundresses (Les laveuses)
zincograph, black ink on yellow wove paper
first edition
image 21.2 × 26.3 cm
sheet 49.5 × 63.6 cm
Bibliothèque de l'Institut national d'histoire
de l'art, collections Jacques Doucet, Paris,
PPN : 114822492 *
(p 180)

Martinique pastoral (Pastorales Martinique)
zincograph, black ink on yellow wove paper
first edition
image 18.7 × 22.4 cm
sheet 49.6 × 63.9 cm
Bibliothèque de l'Institut national d'histoire
de l'art, collections Jacques Doucet, Paris,
PPN : 114822573 *
(p 180)

Old women of Arles (Les vieilles filles [Arles])
zincograph, black ink on yellow wove paper
first edition
image 19.1 × 21 cm
sheet 49.5 × 63.7 cm
Bibliothèque de l'Institut national d'histoire
de l'art, collections Jacques Doucet, Paris,
PPN : 114822565 *
(p 180)

The grasshoppers and the ants (Les cigales et les fourmis)
zincograph, black ink on yellow wove paper
first edition
image 21.6 × 26.1 cm
sheet 49.5 × 64.1 cm
Bibliothèque de l'Institut national d'histoire
de l'art, collections Jacques Doucet, Paris,
PPN : 114822522 *
(p 180)

Volpini suite 1889

Breton bathers (Baigneuses bretonnes)
zincograph, black ink on yellow wove paper
first edition
image 24.5 × 20 cm
sheet 50 × 65 cm
The Cleveland Museum of Art.
Dudley P Allen Fund, 1954.55.3 **

Breton women by a gate
(*Bretonnes à la barrière*)
zincograph, black ink on yellow wove paper
first edition
image 16 × 21.5 cm
sheet 50 × 65 cm
The Cleveland Museum of Art.
Dudley P Allen Fund, 1954.55.4 **

Design for a plate: Leda and the swan (*Projet d'assiette. Léda et le cygne*) 1889
zincograph, black ink on yellow wove paper,
hand-coloured with watercolour
first edition
image 30.1 × 25.9 cm
sheet 50 × 65 cm
The Cleveland Museum of Art.
Dudley P Allen Fund, 1954.55.1 **

Dramas of the sea (*Les drames de la mer*)
zincograph, black ink on yellow wove paper
first edition
image 17.2 × 27.4 cm
sheet 50 × 65 cm
The Cleveland Museum of Art.
Dudley P Allen Fund, 1954.55.8 **

Dramas of the sea, Brittany (*Les drames de la mer, Bretagne*)
zincograph, black ink on yellow wove paper
first edition
image 16.6 × 22.6 cm
sheet 50 × 65 cm
The Cleveland Museum of Art.
Dudley P Allen Fund, 1954.55.7 **

Human misery (*Misères humaines*)
zincograph, black ink on yellow wove paper
first edition
image 28.4 × 23.3 cm
sheet 50 × 65 cm
The Cleveland Museum of Art.
Dudley P Allen Fund, 1954.55.5 **

Joys of Brittany (*Joies de Bretagne*)
zincograph, black ink on yellow wove paper
first edition
image 20.2 × 24.1 cm
sheet 50 × 65 cm
The Cleveland Museum of Art.
Dudley P Allen Fund, 1954.55.2 **

Laundresses (*Les laveuses*)
zincograph, black ink on yellow wove paper
first edition
image 20.8 × 26 cm
sheet 50 × 64.9 cm
The Cleveland Museum of Art.
Dudley P Allen Fund, 1954.55.6 **

Martinique pastoral (*Pastorales Martinique*)
zincograph, black ink on yellow wove paper
first edition
image 17.6 × 22.3 cm
sheet 50 × 65 cm
The Cleveland Museum of Art.
Dudley P Allen Fund, 1954.55.9 **

Old women of Arles (*Les vieilles filles [Arles]*)
zincograph, black ink on yellow wove paper
first edition
image 19.2 × 20.9 cm
sheet 50 × 65 cm
The Cleveland Museum of Art.
Dudley P Allen Fund, 1954.55.11 **

The grasshoppers and the ants (*Les cigales et les fourmis*)
zincograph, black ink on yellow wove paper
first edition
image 20.4 × 26.2 cm
sheet 50 × 65 cm
The Cleveland Museum of Art.
Dudley P Allen Fund, 1954.55.10 **

Portrait of the artist with The yellow Christ
(*Portrait de l'artiste au Christ jaune*) 1890–91
oil on canvas
38 × 46 cm
Musée d'Orsay, Paris. Purchased with the
participation of Philippe Meyer and Japanese
sponsorship coordinated by the daily *Nikkei*
1993, RF 1994 2
(p 52)

Dagger (*Poignard*) c 1890
painted wood, metal
57.8 × 5.6 × 5.6 cm
Musée d'Orsay, Paris. Gift of Jean Schmit 1938,
OA 9052
(p 184)

Lust (*La luxure*) 1890
carved oak and pine, with gilded highlights
and metal
70.5 × 14.7 × 11.7 cm
Willumsens Museum, Frederikssund, G.S.14
(p 182)

*Portraits of Roderic O'Connor and Jacob Meyer
de Haan and self-portrait* 1890
crayon on paper
sheet 24 × 44.5 cm
Willumsens Museum, Frederikssund, CS581
(p 187)

Two nudes on a Tahitian beach (*Deux femmes
tahitiennes nues sur la plage*) 1891–94
oil on canvas
90.8 × 64.8 cm
Honolulu Museum of Art. Gift of Anna Rice Cooke
1933, 35099
(p 191)

Head of a Tahitian woman (Tête de tahitienne)
1891–1901
charcoal and graphite on paper mounted on
cardboard
16.2 × 11 cm
Musée du quai Branly – Jacques Chirac, Paris. Gift
of Ary Leblond to Musée de la France d'outre-mer,
75.8947.1
(p 240)

*Bust of a young girl with a fox (study for The loss
of virginity) (Jeune fille et renard [étude pour La
perte du pucelage])* c 1891
conté crayon, white pastel and red chalk over
graphite on wove paper
31.2 × 33.2 cm (irreg)
Keith Stoltz, Wilson, Wyoming
(p 187)

Umete (Ceremonial dish) c 1891
carved *pua* wood, hollow relief and incisions
5.2 × 45.1 × 20.1 cm
Musée d'Orsay, Paris. Gift of Lucien Vollard 1943,
AF 14329 2
(p 82)

Faaturuma (Melancholic) 1891
oil on canvas
94 × 68.3 cm
The Nelson-Atkins Museum of Art, Kansas City.
Purchase: William Rockhill Nelson Trust, 38-5 **
(p 193)

Haere mai 1891
oil on canvas
72.5 × 92 cm
Solomon R Guggenheim Museum, New York.
Thannhauser Collection, Gift, Justin K Thannhauser
1978, 78.2514.16 **
(p 89)

I raro te oviri (Under the pandanus) 1891
oil on canvas
73 × 91.4 cm
Minneapolis Institute of Art. The William Hood
Dunwoody Fund, 41.4 **
(p 194)

Madame death (Madame la mort) 1891
charcoal with white-wash highlights on paper
33.5 × 23 cm
Musée d'Orsay, Paris. Gift from the Society of
Friends of the Musée d'Orsay 1991, RF 42998
(p 186)

Portrait of Stéphane Mallarmé 1891
etching and aquatint on laid paper
state 2(b)
printed by H Floury 1913–19
The Museum of Fine Arts, Houston. Gift of
Marjorie G and Evan C Horning, 79.260 **

*Portrait of Stéphane Mallarmé, dedicated to Daniel
de Monfreid* 1891
etching, with drypoint and engraving
state 2
image 18.3 × 26.1 cm
Chancellerie des Universités de Paris –
Bibliothèque littéraire Jacques Doucet, Paris,
MNR OA 237*
(p 186)

*Portrait of Suzanne Bambridge (Portrait de
Suzanne Bambridge)* 1891
oil on canvas
70 × 50 cm
Royal Museums of Fine Arts of Belgium, Brussels,
4491
(p 77)

Street in Tahiti (Rue de Tahiti) 1891
oil on canvas
115.5 × 88.5 cm
Toledo Museum of Art. Purchased with funds from
the Libbey Endowment. Gift of Edward Drummond
Libbey, 1939.82
(p 195)

Tahitian women (Femmes de Tahiti) 1891
oil on canvas
69 × 91.5 cm
Musée d'Orsay, Paris. Gift of Countess Vitali 1923,
RF 2765
(p 197)

*Tahitian women under the palm trees (Femmes près
des palmiers)* 1891
oil on canvas
92.1 × 71.8 cm
Private collection **
(p 196)

Te faaturuma (The brooding woman) 1891
oil on canvas
91.1 × 68.7 cm
Worcester Art Museum. Museum Purchase, 1921.186
(p 73)

Te raau rahi (The large tree) 1891
oil on canvas
74 × 92.8 cm
The Cleveland Museum of Art. Gift of Barbara
Ginn Griesinger, 1975.263
(p 199)

Reworked study for *Te nave nave fenua*
(The delightful land) (recto) 1892–94
charcoal and pastel on paper
94 × 47.6 cm
Des Moines Art Center. Gift of John and Elizabeth
Bates Cowles, 1958.76
(p 201)

Te nave nave fenua (*The delightful land*) (recto)
c 1892
pen and brown ink, brown ink wash, watercolour
and gouache on wove paper
29.5 × 21.8 cm
Musée de Grenoble. Bequest of Agutte-Sembat 1923,
MG 2227 (RO) *
(p 200)

The afternoon of a faun (*L'après-midi d'un faune*)
c 1892
carved (likely *tamanu*) wood
35.6 × 14.7 × 12.4 cm
Musée départemental Stéphane Mallarmé,
Vulaines-sur-Seine, 995.5.1 *
(p 198)

Arii matamoe (*The royal end*) 1892
oil on canvas
45.1 × 74.3 cm
The J Paul Getty Museum, Los Angeles, 2008.5
(p 80)

Atiti 1892
oil on canvas
29.7 × 24.7 cm
Kröller-Müller Museum, Otterlo, KM 104.366 **
(p 202)

Mahana ma'a 1892
oil on canvas
55.2 × 30 cm
Cincinnati Art Museum. Bequest of John
W Warrington, 1996.466
(p 203)

Mata mua (*In olden times*) 1892
oil on canvas
91 × 69 cm
Museo Nacional Thyssen-Bornemisza, Madrid,
Carmen Thyssen-Bornemisza Collection,
CTB.1984.8 **
(p 205)

Parahi te marae (*The sacred mountain*) 1892
oil on canvas
66 × 88.9 cm
Philadelphia Museum of Art. Gift of Mr and Mrs
Rodolphe Meyer de Schauensee 1980, 1980-1-1
(p 78)

Parau na te varua ino (*Words of the devil*) 1892
oil on canvas
91.7 × 68.5 cm
National Gallery of Art, Washington, DC. Gift of
the W Averell Harriman Foundation in memory
of Marie N Harriman, 1972.9.12
(p 207)

The vale (*Le vallon*) 1892
oil on canvas
41.5 × 67 cm
Private collection *
(p 206)

Manao tupapau (*She thinks of the ghost or the ghost
thinks of her*) 1893–94
end-grain boxwood block
20.4 × 35.3 × 2.3 cm
The Art Institute of Chicago. Mr and Mrs David
C Hilliard Fund; Meg and Mark Hausberg Fund;
Mr and Mrs T Stanton Amour Fund; Art and Peggy
Wood Fund; Marjorie and Frank Brookes Hubachek
Memorial Fund; Print and Drawing Fund; Julius
Lewis Fund; Mary S Adams Fund, 2015.359 **

Noa Noa (*Fragrance*), title block 1893–94
woodblock, fruit wood, with traces of zinc white
paint and ink
35.2 × 20.3 × 2.2 cm
The Metropolitan Museum of Art, New York.
Harris Brisbane Dick Fund 1937, 37.97
(p 210)

Noa Noa suite 1893–94

 Auti te pape (*Women at the river*)
 woodcut, printed in black ink, hand-coloured
 in yellow and blue-grey wash on laid Japan
 paper
 state 2(a)
 20.4 × 35.5 cm
 The British Museum, London. Bequest
 of Campbell Dodgson, 1949,0411.3674 *
 (p 214)

 Mahna no varua ino (*The devil speaks*)
 woodcut, printed twice from the same block,
 in brown and black inks on laid Japan paper
 state 3
 image 20.4 × 35.8 cm
 Musée du quai Branly – Jacques Chirac, Paris.
 Gift of Lucien Vollard to Musée de la France
 d'outre-mer, 75.14431.4 bis *
 (p 214)

 Manao tupapau (*The spirits of the dead
 are watching*)
 woodcut, printed in brown, light black
 and yellow ochre on Japan paper
 state 4(b)
 image 20.3 × 35.5 cm
 The British Museum, London. Bequest
 of Campbell Dodgson, 1949,0411.3678 *
 (p 215)

Maruru (*Offerings of gratitude*)
woodcut on wove paper
state 3
image 20.5 × 35.5 cm
sheet 27.6 × 47.7 cm
Musée du quai Branly – Jacques Chirac, Paris.
Gift of Lucien Vollard to Musée de la France
d'outre-mer, 75.14466 *
(p 215)

Nave nave fenua (*Delightful land*)
woodcut, hand-printed in black ink on
pink paper
state 1
image 35.6 × 20.3 cm
Bibliothèque nationale de France, Paris,
FRBNF46723510 *
(p 212)

Nave nave fenua (*Delightful land*)
woodcut, printed in black ink on white
wove paper
state 3
sheet 34.8 × 20.6 cm
Musée du quai Branly – Jacques Chirac, Paris.
Gift of Lucien Vollard to Musée de la France
d'outre-mer, 75.14431.2 bis *
(p 213)

Noa Noa (*Fragrant scent*)
woodcut, printed twice from the same
block, in black ink and yellow ochre, signs
of repainting along the lower edge
state 3(b)
image 36.2 × 19.8 cm
Musée du quai Branly – Jacques Chirac, Paris.
Gift of Lucien Vollard to Musée de la France
d'outre-mer, 75.14431.6
(p 211)

Noa Noa (*Fragrant scent*)
woodcut, printed in black ink on cream
wove paper
state 3
image 36.2 × 19.8 cm
sheet 47.6 × 27.4 cm
Musée du quai Branly – Jacques Chirac, Paris.
Gift of Lucien Vollard to Musée de la France
d'outre-mer, 75.14463
(p 211)

Te faruru (*Here we make love*)
woodcut, hand-printed in black ink on pink
wove paper
state 1
image 35.6 × 20.5 cm
Bibliothèque nationale de France, Paris,
FRBNF46723717 *
(p 213)

Te po (*Eternal night*)
woodcut, printed twice from the same block,
in brown and black inks on laid Japan paper
state 2
sheet 20.5 × 35.7 cm
Musée du quai Branly – Jacques Chirac, Paris.
Gift of Lucien Vollard to Musée de la France
d'outre-mer, 75.14431.1 *
(p 214)

Noa Noa suite 1893–94

Auti te pape (*Women at the river*)
woodcut in black, yellow and orange ink
on Japan paper
state 2(c)
printed by Louis Roy 1893–94
image 20.4 × 35.6 cm
sheet 24.8 × 38.7 cm
The Museum of Modern Art, New York. Gift
of Abby Aldrich Rockefeller 1940, 305.1940 **

Mahna no varua ino (*The devil speaks*)
woodcut in black, red and yellow ink on
wove paper
state 4(d)
printed by Louis Roy 1893–94
image and sheet 20.2 × 35.3 cm (irreg)
National Gallery of Canada, Ottawa.
Purchased 1952, 6026 **

Mahna no varua ino (*The demon speaks*) (verso)
woodcut in black, orange, yellow and green ink
on Japan paper
state 4(d)
printed by Louis Roy 1894–95
sheet 20.4 × 12.2 cm
National Gallery of Art, Washington, DC.
Rosenwald Collection, 1953.6.248.b **

Manao tupapau (*She is haunted by a spirit*)
woodcut in red, green and brown ink on
Japan paper
state 4(e)
printed by Tony or Jacques Beltrand before
1918
sheet 24.9 × 38.6 cm
Museum of Fine Arts Boston. William A Sargent
Fund, 55.242 **

Manao tupapau (*She is haunted by a spirit*)
woodcut in black, yellow and orange ink on
Japan paper
state 4(d)
printed by Louis Roy 1893–94
image 20.5 × 35.5 cm
sheet 25 × 39.8 cm
National Gallery of Art, Washington, DC.
Rosenwald Collection, 1950.17.82 **

Maruru (Offerings of gratitude)
woodcut in black, orange and yellow ink on
Japan paper
state 3(c)
printed by Louis Roy 1894
The McNay Art Museum, San Antonio.
Bequest of Mrs Jerry Lawson, 1994.111 **

Nave nave fenua (Delightful land)
woodcut in black and tan ink on wove paper,
lined in silk
state 4(b)
image 34.9 × 20.3 cm
sheet 47.6 × 27.2 cm
The Metropolitan Museum of Art, New York.
Harris Brisbane Dick Fund 1936, 36.6.4 **

Noa Noa (Fragrance)
woodcut in black ink with stencilled colour ink
on Japan paper
state 3(d)
printed by Louis Roy 1894
image 35.8 × 20.4 cm
The McNay Art Museum, San Antonio.
Bequest of Mrs Jerry Lawson, 1994.113 **

Te atua (The gods)
woodcut on Japan paper
state 1
image 20.5 × 35.5 cm
sheet 24.7 × 37.7 cm
The Museum of Modern Art, New York. Gift
of Abby Aldrich Rockefeller 1940, 301.1940 **
(p 110)

Te faruru (Here we make love)
woodcut in black, orange and red ink on buff
wove paper
state 3
image 35.4 × 20.3 cm
sheet 48 × 31.3 cm
The Metropolitan Museum of Art, New York.
Harris Brisbane Dick Fund, 1936. 36.6.8 **

Te po (Eternal night)
woodcut in black, orange and yellow ink on
Japan paper
state 4(c)
printed by Louis Roy 1894
image 20.7 × 35.9 cm
sheet 22.9 × 37.6 cm
UCLA Grunwald Center for the Graphic Arts,
Hammer Museum, Los Angeles. The Fred
Grunwald Collection, 1965.1.19 **

Te po (Eternal night)
woodcut in brown and black ink on
Japan paper
state 4(c)
printed by Louis Roy 1894
image 20.5 × 35.6 cm
mat 40.7 × 54 cm
The Nelson-Atkins Museum of Art, Kansas City.
Acquired through the Print Duplicate Fund,
71-9 **

The universe is being created (L'univers est créé)
woodcut in black and brown ink with selective
wiping over solvent-thinned and stencilled
colours in oil with brush and black ink on pink
wove paper
state 2(b)
image and sheet 20.3 × 35 cm
The Art Institute of Chicago. Clarence
Buckingham Collection, 1948.259 **

Manao tupapau (Watched by the spirit of the dead)
before June 1894
lithograph in black ink on wove paper
state 1B
published by André Marty, Paris, in *L'Estampe
originale* before June 1894
image 18.1 × 27.2 cm
sheet 42 × 57.4 cm
National Gallery of Canada, Ottawa.
Purchased 1960, 9065 **

Cane (Canne) 1893–95
carved wood, leather strap, metal
89.9 × 3.5 × 3.5 cm
Musée d'Orsay, Paris. Gift of Lucien Vollard 1943,
AF 14339
(p 184)

*Square decorative object with Tahitian gods
(Objet décoratif carré avec dieux tahitiens)* 1893–95
earthenware with painted highlights
34.4 × 14.1 × 14.1 cm
Musée d'Orsay, Paris. Gift of David David-Weill 1938,
OA 9514
(p 216)

Mask of a woman c 1893
modelled wax
38.5 × 23.3 cm
Private collection
(p 217)

*Portrait of the artist with the idol (Autoportrait
à l'idole)* c 1893
oil on canvas
43.8 × 32.7 cm
The McNay Art Museum, San Antonio. Bequest
of Marion Koogler McNay, 1950.46 **
(p 219)

Hina tefatou (The moon and the earth) 1893
oil on canvas
114.3 × 62.2 cm
The Museum of Modern Art, New York. Lillie P Bliss
Collection 1934, 50.1934
(p 70)

Mahana atua (Day of the god) 1894–95
woodcut in black ink with blue, red and orange
watercolour additions on Japan paper
state 1
image 18 × 20.3 cm
sheet 18.4 × 20.5 cm
The Art Institute of Chicago. Clarence Buckingham
Collection, 1948.267 **

Manao tupapau (The spirits of the dead are watching); *Māori woman in a landscape of branches and trees; Māori woman standing (Femme maorie dans un paysage de branches d'arbres; Femme maorie debout)* 1894–95
woodcut print from three blocks, printed in yellow and red ochre on fine laid paper lined on wove paper
sheet 31.9 × 41.5 cm
Musée du quai Branly – Jacques Chirac, Paris. Gift of Lucien Vollard to Musée de la France d'outre-mer, 75.14465
(p 221)

Noa Noa (Fragrance), small plate 1894–95
woodcut in black ink, with watercolour on parchment paper
state 1
image 14.5 × 11.8 cm
sheet 14.7 × 12 cm
The Art Institute of Chicago. Clarence Buckingham Collection, 1948.270 **

Tahitian idol—the goddess Hina 1894–95
woodcut in black ink, over yellow ochre wash on cream wove paper
image and sheet 14.8 × 11.9 cm
The Art Institute of Chicago. Gift of Edward McCormick Blair, 2002.245 **

Tahitian idol—the goddess Hina 1894–95
woodcut in reddish-brown ink with blue-grey watercolour on ivory wove paper, laid down on wove paper
image and sheet 14.2 × 9.9 cm
The Art Institute of Chicago. Clarence Buckingham Collection, 1948.268 **

Tahitian idol—the goddess Hina (Idole tahitienne) c 1894–95
woodcut, printed in black ink over monotype printed in terracotta and orange ochre on wove paper
state 1
14.9 × 11.8 cm
Seibert Collection
(p 218)

Breton village in the snow (Village breton sous la neige) c 1894
oil on canvas
62 × 87 cm
Musée d'Orsay, Paris. Purchased with funds from an anonymous Canadian gift 1952, RF 1952 29
(p 30)

Fan decorated with motifs from Te raau rahi (The large tree) c 1894
gouache on crepe paper
17.2 × 57.5 cm
Collection of the Carrick Hill Trust, Tarntanya/Adelaide. Hayward bequest 1983 *
(p 220)

Mahana atua (Day of the gods) (recto) 1894
woodblock
18 × 20 × 2.6 cm
National Gallery of Art, Washington, DC. Rosenwald Collection, 1943.3.1726.a **

Oviri (Savage) 1894
woodcut, in brown and black ink, with grey-wash highlights on wove paper
image 24.8 × 18.2 cm
sheet 33.5 × 39 cm
Musée du quai Branly – Jacques Chirac, Paris. Gift of Lucien Vollard to Musée de la France d'outre-mer, 75.14342.1
(p 221)

Paris in the snow (Paris sous la neige) 1894
oil on canvas
72 × 88 cm
Van Gogh Museum, Amsterdam. Vincent van Gogh Foundation, s0223V1962
(p 222)

Two Tahitian women standing (Deux tahitiennes debout) 1894
watercolour monotype on Japan paper, mounted on cardboard
18.5 × 14.5 cm
Private collection. Courtesy Galerie Dina Vierny, Paris, P34
(p 200)

Upaupa Schneklud (The player Schneklud) 1894
oil on canvas
92.7 × 73.3 cm
Baltimore Museum of Art. Given by Hilda K Blaustein in memory of her late husband, Jacob Blaustein, BMA 1979.163
(p 223)

Three wooden spoons 1895–1903
carved (likely *nono*) wood
18 × 5 × 3 cm
25 × 7.5 × 2.9 cm
18.5 × 4.7 × 3.2 cm
Te Fare Iamanaha – Musée de Tahiti et des Îles, Papeete, 2000.0.048–2000.0.050
(p 246)

Tahitian (Tahitien) c 1895
bronze
25 × 19 × 10 cm
Musée d'Orsay, Paris. Gift of Lucien Vollard 1943, AF 14392
(p 226)

Te arii vahine (The queen) (recto) 1896–97
watercolour, with opaque watercolour, over black chalk
17.6 × 23.5 cm
The Morgan Library and Museum, New York. Thaw Collection, 2006.55 **
(p 228)

Woman picking fruit and the savage
(*Femme ceuillant des fruits et oviri*) 1896–97
woodcut on thin Japan paper, laid down in reverse
on smooth wove paper
image 10.5 × 9 cm
sheet 13 × 10.3 cm
Museum of Fine Arts Boston. Bequest of WG Russell
Allen, 60.339 **

Young Maoris 1896–97
woodcut, printed twice in yellow and black ink,
on cream wove notebook paper ruled in blue
state 1(a)
image and sheet 8.8 × 10.7 cm
The Art Institute of Chicago. Gift of the Print
and Drawing Club, 1952.136 **

Poor fisherman (*Pauvre pêcheur*) 1896
oil on canvas
75 × 65 cm
Museu de Arte de São Paulo Assis Chateaubriand.
Gift of Henrik Spitzman-Jordan, Ricardo Jafet,
João Di Pietro 1958, MASP.00109
(p 227)

Savage poems (*Poèmes barbares*) 1896
oil on canvas
64.8 × 48.3 cm
Harvard Art Museums / Fogg Museum, Cambridge.
Bequest from the Collection of Maurice Wertheim,
Class of 1906, 1951.49 **
(p 229)

Self-portrait (near Golgotha)
(*Autoportrait [près du Golgotha]*) 1896
oil on canvas
75.5 × 63 cm
Museu de Arte de São Paulo Assis Chateaubriand.
Gift of Guilherme Guinle, Álvaro Soares Sampaio,
Francisco Pignatari, Fúlvio Morganti 1952,
MASP.00108
(p 54)

Bouquet of flowers (*Bouquet de fleurs avec
géraniums, grandes plantes et violettes*) 1897
oil on canvas
73 × 93 cm
Musée Marmottan Monet, Paris. Gift of Nelly
Sergeant-Duhem 1985, 5333
(p 242)

Breton calvary (*Le calvaire breton*) 1898–99
carved wood
16.5 × 26.5 × 3.4 cm
Bibliothèque nationale de France, Paris,
FRBNF46711106 *
(p 233)

Suite of late woodblock prints (also known as the
Vollard suite) 1898–99

Breton calvary (*Le calvaire breton*)
woodcut on Japan paper, hand-coloured
image 16.1 × 25 cm
Seibert Collection *
(p 233)

Change of residence (*Changement de résidence*)
woodcut
first state in brown overprinted by the
artist with the second (final) state in black,
numbered 28 by the artist
image 16 × 30.1 cm
Seibert Collection *
(p 234)

Eve
woodcut in black ink on Japan paper
image 29.5 × 21.9 cm
Bibliothèque nationale de France, Paris,
FRBNF46738020 *
(p 234)

Human miseries (*Misères humaines*)
woodcut in black ink on Japan paper
image 19.3 × 29.6 cm
Seibert Collection *
(p 235)

Interior of a hut (*Intérieur de case*)
woodcut, printed in black ink on thin Japan
paper
image 15.1 × 22.9 cm
Bibliothèque nationale de France, Paris,
FRBNF46737719 *
(p 235)

Te atua (The god)
woodcut in black on Japan paper, second state
impression printed on thin Japan paper pasted
on first state impression
image 24.4 × 22.7 cm
Bibliothèque nationale de France, Paris,
FRBNF46751984 *
(p 235)

The banana carrier (*Le porteur de fe'i*)
woodcut, printed on Japan paper
image 16.2 × 28.7 cm
Bibliothèque nationale de France, Paris,
FRBNF46751857 *
(p 235)

Women, animals and leaves (*Femmes, animaux
et fueillage*)
woodcut on thin Japan paper
state 2
image 16.3 × 33.5
Seibert Collection *
(p 234)

Suite of late woodblock prints (also known as the **Vollard suite**) 1898–99

Buddha (Bouddha)
woodcut printed in black ink on ivory Japan
tissue paper
state 1(b)
sheet and image 30.4 × 22.8 cm
Promised gift of Eileen B Glaser and Jay
Schachner, Tr:451-2016 **

Change of residence (Changement de résidence)
woodcut in black and brown ink on Japan
tissue paper
state 2(b)
sheet 16 × 30.3 cm
The Clark Art Institute, Williamstown.
Acquired by the Clark, 1962.77 **

Eve
woodcut in black ink on Japan tissue
paper state 2(b)
image and sheet 29.5 × 21.9 cm
The Metropolitan Museum of Art, New York.
Harris Brisbane Dick Fund 1936, 36.7.4 **

Human miseries (Misères humaines)
woodcut in black ink on Japan paper
image and sheet 19.2 × 29.3 cm
Collection of Eileen B Glaser and Jay
Schachner, TR:752-2023 **

Te arii vahine—opoi (The queen of beauty—langorous)
woodcut in black ink on transparent wove
tissue paper laid down to bristol board
state 1(a)
sheet 16.2 × 30.2 cm (irreg)
The Metropolitan Museum of Art, New York.
Harris Brisbane Dick Fund, 1926, 26.47 **

Te atua (Gods), small plate
woodcut, in black ink on thin Japan paper
laid down on woodcut in black on wove paper
state 2(b)
sheet 22.5 × 20.1 cm
National Gallery of Art, Washington, DC.
Rosenwald Collection, 1943.3.4609 **

The rape of Europa (L'enlevement d'Europe)
woodcut on China paper
state 1(a)
image and sheet 24.1 × 22.6 cm
UCLA Grunwald Center for the Graphic Arts,
Hammer Museum, Los Angeles. The Fred
Grunwald Collection, 1965.1.20 **

Wayside (Le calvaire breton)
woodcut in black ink on thin ivory Japan
paper, tipped on thin white Japan paper
state 1(b)
sheet 18.4 × 28.6 cm
UCLA Grunwald Center for the Graphic Arts,
Hammer Museum, Los Angeles. The Fred
Grunwald Collection, 1965.1.21 **

Study for *Where do we come from? What are
we? Where are we going? (D'où venons-nous?
Que sommes-nous? Où allons-nous?)* 1898
graphite, red and blue coloured pencil on
transparent paper over preliminary colour drawing
on wove paper
20.4 × 37.5 cm
Musée du quai Branly – Jacques Chirac, Paris.
Gift of Lucien Vollard to Musée de la France
d'outre-mer, 75.14341
(p 61)

*Tahitian woman II (Femme tahitienne allongée
dans un paysage)* 1898
oil on canvas
93.5 × 130 cm
National Museum of Serbia, Belgrade
(p 231)

Te pape nave nave (Delectable waters) 1898
oil on canvas
74 × 95.3 cm
National Gallery of Art, Washington, DC.
Collection of Mr and Mrs Paul Mellon, 1973.68.2
(p 237)

Three Tahitians (Trois tahitiens) 1899
oil on canvas
73 × 94 cm
National Galleries of Scotland, Edinburgh.
Presented by Sir Alexander Maitland in memory
of his wife Rosalind 1960, NG 2221
(p 239)

The departure of Adam and Eve c 1900
monotype, pencil and wash on wove paper
62.9 × 48.5 cm
William W and Nadine M McGuire, Wayzata,
Minnesota
(p 240)

Te atua (The gods) c 1901–02
carved and painted redwood
58 × 20 cm
Te Fare Iamanaha – Musée de Tahiti et des
Îles, Papeete
(p 241)

Peace and war (La paix et la guerre) 1901
carved oak with traces of paint and gold highlights
29.5 × 66 × 4 cm
Musée d'Orsay, Paris, RF 4681
(p 241)

*Polynesian woman with children
(Famille tahitienne)* 1901
oil on canvas
97 × 74 cm
The Art Institute of Chicago. Helen Birch Bartlett
Memorial Collection, 1927.46
(p 40)

Still life with Hope (Nature morte à l'Espérance)
1901
oil on canvas
65 × 77 cm
Private collection, Milan
(p 43)

Sunflowers and mangoes (Tournesols et mangues)
1901
oil on canvas
93 × 73 cm
Private collection **
(p 243)

Crouching Tahitian woman seen from the back
c 1902
watercolour monotype with opaque white
watercolour
54.9 × 30.7 cm
The Morgan Library and Museum, New York.
Thaw Collection, 2017.90 **
(p 249)

Rider, or the flight (Cavalier, ou la fuite) c 1902
monotype, drawing in black and grey ink on
wove paper
sheet 51.3 × 63.8 cm
Musée du quai Branly – Jacques Chirac, Paris.
Gift of Lucien Vollard to Musée de la France
d'outre-mer, 75.14457 *
(p 248)

Two Marquesans c 1902
traced monotype, printed in black-brown with
lighter brown areas
32.1 × 51 cm
The British Museum, London. Bequest of César
Mange de Hauke 1968, 19,680,210.31 *
(p 248)

Père Paillard 1902
also known as *Father Lechery*
carved and painted miro wood
67.9 × 18 × 20.7 cm
National Gallery of Art, Washington, DC.
Chester Dale Collection, 1963.10.238 **
(p 247)

Sister of Charity (La religieuse) 1902
oil on canvas
65.4 × 76.2 cm
The McNay Art Museum, San Antonio.
Bequest of Marion Koogle McNay, 1950.47
(p 250)

*Portrait of the artist by himself (Portrait de l'artiste
par lui-même)* 1903
oil on canvas
41.4 × 23.5 cm
Kunstmuseum Basel. Bequest of Dr Karl Hoffmann
1945, inv 1943
(p 45)

Women and a white horse (Femmes et cheval blanc)
1903
oil on canvas
73.3 × 91.7 cm
Museum of Fine Arts Boston. Bequest of
John T Spaulding, 48.547 **
(p 251)

Unknown artist

Head with horns before 1894
sandalwood with traces of polychrome
on a lacewood base
22 × 22.8 × 12 cm
The J Paul Getty Museum, Los Angeles, 2002.18
(p 246)

Polynesia

Austral Islands (Tupua'i)
Umete (Ceremonial bowl) 19th century
carved wood
12.5 × 105 × 44 cm
Te Fare Iamanaha – Musée de Tahiti et des Îles,
Papeete
(p 82)

Marquesas Islands
U'u (Club) 19th century or earlier
carved wood, vegetable fibre
151.5 × 26.5 × 12 cm
National Gallery of Australia, Kamberri/Canberra,
2008.185
(p 83)

Marquesas Islands
Tahi'i (Fan) early 19th century
carved wood, plant fibre
43 × 44.2 × 8 cm
Musée du quai Branly – Jacques Chirac, Paris.
Donated by Jean-Benoît Amédée Collet, 72.84.235.3
(p 81)

Marquesas Islands (Hakahau Valley, Ua Pou)
Ivi po'o 19th century
carved bone
4.4 × 2.9 × 2.1 cm
Te Fare Iamanaha – Musée de Tahiti et des Îles,
Papeete
(p 81)

Marquesas Islands
Tiki 19th century
carved basalt
12.2 × 7 × 5 cm
Te Fare Iamanaha – Musée de Tahiti et des Îles,
Papeete, D 2003.2.2
(p 79)

Marquesas Islands
Pu taiana or *Taiana* (*Ear ornament*)
late 19th century
carved bone, shell
1.8 × 4.6 × 0.5 cm
Musée du quai Branly – Jacques Chirac, Paris.
Donated in 1934 by Mr Élie Adrien Édouard Charlier
(1864–1937), former interim governor of the French
establishments in Oceania; Korrigane Expedition,
71.1938.196.1
(p 79)

Society Islands
Papahia (*Pounding table*) 19th century
carved wood
20.5 × 46.5 × 43 cm
Te Fare Iamanaha – Musée de Tahiti et des
Îles, Papeete
(p 81)

Uvéa Island
Tohihina (*Bark cloth*) 19th or early 20th century
bark cloth, pigment
56 × 208 cm
National Gallery of Australia, Kamberri/Canberra,
2012.843
(p 76)

Further reading

Exhibition catalogues

Bodelsen, Merete, *Gauguin and Van Gogh in Copenhagen in 1893*, Ordrupgaard, Copenhagen, 1984.

Boyle-Turner, Caroline, and Samuel Josefowitz, *Gauguin and the school of Pont-Aven: prints and paintings*, Royal Academy of Arts, London, 1989.

Brettel, Richard R, Françoise Cachin, Claire Frèches-Thory et al, *The art of Paul Gauguin*, National Gallery of Art, Washington, DC, 1988.

Brettell, Richard R, and Anne-Birgitte Fonsmark, *Gauguin and Impressionism*, Yale University Press, New Haven & London, 2005.

Druick, Douglas, and Peter Zegers, *Paul Gauguin: pages from the Pacific*, Auckland City Art Gallery in association with the Art Institute of Chicago, Auckland, 1995.

Druick, Douglas W, and Peter Kort Zegers, *Van Gogh and Gauguin: the studio of the south*, The Art Institute of Chicago, Chicago, 2001.

Eisenman, Stephen F (ed), *Paul Gauguin: artist of myth and dream*, Skira, Milan, 2007.

Field, Richard S, *Paul Gauguin: monotypes*, Philadelphia Museum of Art, Philadelphia, 1973.

Figura, Starr (ed), *Gauguin: metamorphoses*, The Museum of Modern Art, New York, 2014.

Fonsmark, Anne Birgitte (ed), *Gauguin and the impressionists: the Ordrupgaard Collection*, Royal Academy of Arts, London, 2020.

Gregersen, Anna Kærsgaard, and Anna Manly (eds), *Paul Gauguin: Why are you angry?*, trans Jane Rowley and Pamela Hargreaves, Ny Carlsberg Glyptotek, Copenhagen, 2022.

Greub, Suzanne (ed), *Gauguin / Polynesia*, Art Centre Basel, Basel, & Hirmer, Munich, 2011.

Groom, Gloria (ed), *Gauguin: artist as alchemist*, The Art Institute of Chicago, Chicago, 2017.

Homburg, Cornelia, and Christopher Riopelle (eds), *Gauguin: portraits*, National Gallery of Canada, Ottawa, 2019.

Ives, Colta, and Susan Alyson Stein, *The lure of the exotic: Gauguin in New York collections*, The Metropolitan Museum of Art, New York, 2002.

King, Natalie (ed), *Paradise Camp by Yuki Kihara*, Thames & Hudson Australia, Melbourne, 2022.

Nicholson, Bronwen, *Gauguin and Maori art*, Godwit in association with Auckland City Art Gallery, Auckland, 1995.

Pedersen, Line Clausen, and Flemming Friborg (eds), *Gauguin: tales from paradise*, 24 Ore Cultura, Milan, 2015.

Pedrosa, Adriano, Fernando Oliva and Laura Cosendey (eds), *Paul Gauguin: the other and I*, Museu de Arte de São Paulo Assis Chateaubriand, São Paulo, 2023.

Pickvance, Roland, *Gauguin and the Pont-Aven School*, Art Gallery of New South Wales, Sydney, 1994.

Salomé, Lauren (ed), *A city for Impressionism: Monet, Pissarro and Gauguin in Rouen*, Skira, Milan, 2010.

Shackelford, George TM, and Claire Frèches-Thory, *Gauguin: Tahiti*, MFA Publications, Boston, 2004.

Solana, Guillermo (ed), *Gauguin and the origins of Symbolism*, Philip Wilson Publishers, London, in association with Museo Thyssen-Bornemisza and Fundación Caja de Madrid, Madrid, 2004.

Thomson, Belinda (ed), *Gauguin: maker of myth*, Tate Publishing, London, 2010.

Thomson, Belinda, Frances Fowle and Lesley Stevenson, *Gauguin's vision*, National Galleries of Scotland, Edinburgh, 2005.

Wright, Alistair, and Calvin Brown, *Gauguin's paradise remembered: the Noa Noa prints*, Princeton University Art Museum, Princeton, 2010.

Zafran, Eric (ed), *Gauguin's nirvana: painters at Le Pouldu 1889–90*, Wadsworth Atheneum Museum of Art, Hartford, in association with Yale University Press, New Haven & London, 2001.

Books, including book chapters, articles, catalogues raisonnés and other resources

Bodelsen, Merete, 'Gauguin, the collector', *The Burlington Magazine*, vol 112, no 810 (Sept 1970), pp 590–616.
—— , *Gauguin's ceramics: a study in the development of his art*, Faber & Faber, London, in association with Nordisk Sprog-og Kultur, Copenhagen, 1964.

Boyle-Turner, Caroline, *Paul Gauguin & the Marquesas: paradise found?*, Éditions Vagamundo, Pont-Aven, 2016.

Brettell, Richard R, 'Gauguin in Tahiti, second period: 1895–1901', in *Gauguin: catalogue raisonné of the paintings, 1891–1903*, Wildenstein Plattner Institute.

Brettell, Richard R, and Elpida Vouitsis, 'Gauguin in Paris and Brittany: 1893–1895', in *Gauguin: catalogue raisonné of the paintings, 1891–1903*, Wildenstein Plattner Institute.

——, 'Gauguin in Tahiti, first period: 1891–1893', in *Gauguin: catalogue raisonné of the paintings, 1891–1903*, Wildenstein Plattner Institute.

Brooks, Peter, 'Gauguin's Tahitian body', in Norma Broude and Mary D Garrard (eds), *The expanding discourse*, Icon Editions, New York, 1992, pp 330–46.

Broude, Norma (ed), *Gauguin's challenge: new perspectives after Postmodernism*, Bloomsbury Visual Arts, New York & London, 2018.

Broude, Norma and Mary D Garrard (eds), *The expanding discourse*, Icon Editions, New York, 1992.

Cachin, Françoise, *Gauguin*, trans Bambi Ballard, Flammarion, Paris, 2003.

Childs, Elizabeth C, *Vanishing paradise: art and exoticism in colonial Tahiti*, University of California Press, Berkeley & Los Angeles, 2013.

Collins, Bradley, *Van Gogh and Gauguin: electric arguments and utopian dreams*, Westview Press, Boulder, 2001.

Denekamp, Nienke, and Laura Watkinson, *The Gauguin atlas*, trans Laura Watkinson, Yale University Press, New Haven, 2019.

Dorra, Henri, *The symbolism of Paul Gauguin: erotica, exotica, and the great dilemmas of humanity*, University of California Press, Berkeley, 2007.

Eisenman, Stephen, *Gauguin's skirt*, Thames & Hudson, New York, 1997.

Ellridge, Arthur, *Gauguin and the Nabis: prophets of Modernism*, trans Jean-Marie Clarke, Finest SA/Editions Pierre Terrail, Paris, 1995.

Friborg, Flemming, *Gauguin: the master, the monster and the myth*, Strandberg Publishing, Cophenhagen, 2023.

Gamboni, Dario, *Paul Gauguin: the mysterious centre of thought*, trans Chris Miller, Reaktion Books, London, 2014.

Gauguin, Paul, *Gauguin by himself*, (ed) Belinda Thomson, Little, Brown, London, 1993.

——, *Gauguin's letters from the South Seas*, trans Ruth Pielkovo, Dover Publications, New York, 1992.

——, *Letters to Ambroise Vollard & André Fontainas*, (ed) John Rewald, Grabhorn Press, San Francisco, 1943.

——, *Letters to his wife and friends*, (ed) Maurice Malingue, trans Henry J Stenning, Saturn Press, London, 1946.

——, *Noa Noa: a journal of the South Seas*, trans OF Theis, Noonday Press, New York, 1957.

——, *Noa Noa: Gauguin's Tahiti*, (ed) Nicholas Wadley, trans Jonathan Griffin, Phaidon, Oxford, 1985.

——, *Noa Noa: voyage à Tahiti*, Jan Forlag, Stockholm, 1947.

——, *The intimate journals of Paul Gauguin*, KPI, London, 1985.

——, *The writings of a savage*, (ed) Daniel Guérin, trans Eleanor Levieux, Da Capo Press, New York, 1996.

Gauguin, Pola, *My father, Paul Gauguin*, trans Arthur G Chater, Alfred A Knopf, New York, 1937.

Goddard, Linda, *Savage tales: the writings of Paul Gauguin*, Yale University Press, New Haven & London, 2019.

Gray, Christopher, *Sculpture and ceramics of Paul Gauguin*, Hacker Art Books, New York, 1980.

Guérin, Marcel, *L'œuvre gravé de Gauguin*, Alan Wofsy Fine Arts, San Francisco, 1980.

Hoog, Michel, *Paul Gauguin: life and work*, Rizzoli, New York, 1987.

Hruska, Libby, and Victoria Gannon (eds), *Gauguin: a spiritual journey*, trans Rose Vekony, Prestel, Munich, 2018.

Jirat-Wasiutyński, Vojtěch, and H Travers Newton Jr, *Technique and meaning in the paintings of Paul Gauguin*, Cambridge University Press, Cambridge, UK, 2000.

Le Bot, Marc, *Gauguin's Noa Noa*, trans Shaun Whiteside, Thames & Hudson, London, 1996.

Le Paul, Judy, and Charles-Guy Le Paul, *Gauguin and the impressionists at Pont-Aven*, Abbeville Press, New York, 1987.

Le Pinchon, Yann, *Gauguin: life, art, inspiration*, trans I Mark Paris, Abrams, New York, 1987.

Mathews, Nancy Mowll, *Paul Gauguin: an erotic life*, Yale University Press, New Haven, 2001.

Miller, John, *Noa Noa: the Tahitian journal of Paul Gauguin*, trans OF Theis, Chronicle Books, San Francisco, 1994.

Mongan, Elizabeth, Eberhard W Kornfeld and Harold Joachim, *Paul Gauguin: catalogue raisonné of his prints*, Galerie Kornfeld, Bern, 1988.

Ponnambalam, Devika, *I am not your Eve*,
 Bluemoose Books, Hebden Bridge, 2022.

Rewald, John, *Gauguin drawings*, Thomas Yoseloff,
 New York & London, 1958.

Shackelford, George TM, *Paul Gauguin: Where do we
 come from? What are we? Where are we going?*,
 MFA Publications, Boston, 2013.

Silverman, Debora, *Van Gogh and Gauguin:
 the search for sacred art*, Farrar, Straus
 and Giroux, New York, 2000.

Solomon-Godeau, Abigail, 'Going native: Paul
 Gauguin and the invention of Primitivist
 Modernism', in Norma Broude and Mary D
 Garrard (eds), *The expanding discourse*, Icon
 Editions, New York, 1992, pp 313–29.

Sweetman, David, *Paul Gauguin: a complete life*,
 Hodder & Stoughton, London, 1995.

Thomas, Nicholas, *Gauguin and Polynesia*,
 Bloomsbury Publishing, London, 2024.

Thomson, Belinda, *Gauguin*, Rizzoli, New York, 2020.

Vouitsis, Elpida, 'Gauguin in the Marquesas:
 1901–1903', in *Gauguin: catalogue raisonné
 of the paintings, 1891–1903*, Wildenstein
 Plattner Institute.

Wildenstein, Georges, *Gauguin*, Les Beaux-Arts,
 Éditions d'Études et de Documents, Paris, 1964.
—— , *Gauguin: a savage in the making: catalogue
 raisonné of the paintings (1873–1888)*,
 Wildenstein Institute, Paris, 2002.

Wildenstein Plattner Institute, *Gauguin:
 catalogue raisonné of the paintings, 1891–1903*,
 https://digitalprojects.wpi.art/gauguin.

Acknowledgements

Curator acknowledgements

To begin at the end—joining the 54-year-old Paul Gauguin as he summarised his life from one of the world's most remote archipelagos—bringing new perspectives on how we understand and relate to the legacy of this contentious modern master has relied on the support of a great many people.

My warmest gratitude goes to Carol Henry, Chief Executive of Art Exhibitions Australia, who invited me to curate what has resulted in *Gauguin's World: Tōna Iho, Tōna Ao*. It was a new opportunity for me to work with Art Exhibitions Australia after numerous joint projects were realised while I was director of the Musée d'Orsay then the Musée du Louvre, followed by the retrospective *Degas: a new vision* (2016) presented in Melbourne and Houston. Nick Mitzevich, Director of the National Gallery of Australia, enthusiastically welcomed my proposal to show Gauguin's entire career for the first time in Oceania. *Gauguin's World: Tōna Iho, Tōna Ao* is ideally positioned at the National Gallery, an institution whose founding document made acquisition recommendations to collect Pacific arts that reflect the importance of its geographic location. Gary Tinterow, Director of the Museum of Fine Arts, Houston, my accomplice on so many projects and for so many years, wanted to renew the happy collaboration that led to the success of *Degas: a new vision*. Therefore it is the three of them I must thank first, with their respective teams: Michael Jones, Jane Messenger and Greg Sewell; Susie Barr, Penny Sanderson, Lucina Ward and Daryl West-Moore; and Deborah Roldán and Ann Dumas.

To meditate from the perspective of Gauguin's final resting place on what occurred in his life, to understand his introspection and enchantment with the poetry of place, relied on the opportunity to visit Tahiti and Hiva Oa. My appreciation goes to the scholars and cultural leaders who welcomed me in Papeete and Atuona, discussing the complex issues surrounding Gauguin's legacy and embracing the question of what it would mean to return the artist to their broader region. Notably, these include Miriama Bono, Hinanui Cauchois, Emmanuelle Charrier, Joëlle Frébault, Moreani Frébault, Vaiana Giraud, Hiriata Millaud, Riccardo Pineri and Christian Robert.

I extend my special acknowledgement to the following for their research assistance and advice: Claire Bernardi, Béatrice de Plinval, Ophélie Ferlier-Bouat, Charlotte Hellman, Nathalie Houzé, Paule Laudon, Nicole Manuello, Tamara Maric, Stephane Martin, Chris Miller, Anne-Solène Rolland, Vincent Rondot and Caroline Thomas.

Finally, my deep appreciation for the generosity of the many museums and collectors who have lent their prized works of art to this exhibition, bringing *Gauguin's World: Tōna Iho, Tōna Ao* to realisation. I also extend my particular thanks to the museum professionals who open-handedly gave of their time and knowledge over the years in discussing the project and considering how they could best contribute to it.

Exhibition acknowledgements

Gauguin's World: Tōna Iho, Tōna Ao aims to provide new perspectives on how the artist and his complex practice are understood, exploring the radical experimentation and interrelationship between the diverse processes he applied, from one of the first to last works he created. This ambitious undertaking would not have been realised without the committed support of colleagues and associates in 19 countries.

We are particularly indebted to Sylvain Amic, Président of the Musée d'Orsay and the Musée de l'Orangerie, and his predecessor Dr Christophe Leribault, and Paul Perrin, Director of Conservation and Collections, for generously supporting the exhibition as the major lender. We also extend special thanks to Dr Hinanui Cauchois, Director of Te Fare Iamanaha – Musée de Tahiti et des Îles, and her predecessor Dr Miriama Bono, for openhandedly sharing their works by Gauguin and important nineteenth-century Marquesan sculptural works to further illuminate the years he spent in Polynesia.

The success of the project has depended on the ready assistance and magnanimity of all the lenders to the exhibition. We extend our deep appreciation to Dr Katharina Ammann and Kaspar Hemmeler, Aargauer Kunsthaus; James Rondeau and Dr Gloria Groom, The Art Institute of Chicago; Hiroshi Ishibashi, Artizon Museum; Marjorie Klein, Association des Amis du Petit Palais; Dr Asma Naeem, Baltimore Museum of Art; Fabien Oppermann, Bibliothèque littéraire Jacques Doucet; Sylvie Aubenas, Bibliothèque nationale de France; Hugo Chapman and Dr Catherine Daunt, The British Museum; Susan McCormack, Carrick Hill; Christophe Kerrero, Chancellerie des Universités de Paris; Cameron Kitchin, Cincinnati Art Museum; Bruno Verbergt, Cinquantenaire Museum, Royal Museums of Fine Arts of Belgium; Olivier Meslay, The Clark Art Institute; Dr William M Griswold, The Cleveland Museum of Art; Dr Kelly Baum, Des Moines Art Center; Luke Syson, The Fitzwilliam Museum; the late Léonard Gianadda, Fondation Pierre Gianadda; Dr T Barton Thurber, The Frances Lehman Loeb Art Center; Olivier Lorquin, Galerie Dina Vierny; Duncan Dornan, Glasgow Life Museums, Glasgow City Council; The Gwinnett family; Professor Dr Alexander Klar, Hamburger Kunsthalle; Ann Philbin, Hammer Museum; Martha Tedeschi, Harvard Art Museums; Dr Halona Norton-Westbrook, Honolulu Museum of Art; Dr Colette Pierce Burnette and Ms Kathryn Haigh, Indianapolis Museum of Art at Newfields; Professor Éric de Chassey, Institut national d'histoire de l'art; Dr Timothy Potts, The J Paul Getty Museum; Dr Eric M Lee and Dr George TM Shackelford, Kimbell Art Museum; Benno Tempel, Kröller-Müller Museum; Professor Ann Demeester, Kunsthaus Zürich; Dr Josef Helfenstein, Kunstmuseum Basel; Michael Govan, Los Angeles County Museum of Art; Manuel Rebaté, Louvre Abu Dhabi; William W and Nadine M McGuire; Dr Matthew McLendon, The McNay Art Museum; Max Hollein, The Metropolitan Museum of Art; Dr Katherine Crawford Luber, Minneapolis Institute of Art; Dr Colin B Bailey, The Morgan Library and Museum, Thaw Collection; Fabrice Hergott, Musée d'Art Moderne de Paris; Émilie Girard, Musée d'Art

Moderne et Contemporain de Strasbourg; Guy Tosatto, Musée de Grenoble; Jean-François Parigi and Karine Medrala-Cervo, Musée départemental Stéphane Mallarmé; Olivia Voisin, Musée des Beaux-Arts d'Orléans; Emmanuel Kasarhérou, Musée du quai Branly – Jacques Chirac; Érik Desmazières, Musée Marmottan Monet; Miguel Zugaza, Museo de Bellas Artes de Bilbao; Dr Guillermo Solana, Museo Nacional Thyssen-Bornemisza, Carmen Thyssen-Bornemisza Collection; Adriano Pedrosa, Museu de Arte de São Paulo Assis Chateaubriand; Matthew Teitelbaum, Museum of Fine Arts Boston; Dr Glenn D Lowry and Ann Temkin, The Museum of Modern Art, New York; Sir John Leighton, National Galleries of Scotland; Kaywin Feldman and Dr Mary Morton, National Gallery of Art, Washington, DC; Jean-François Bélisle, National Gallery of Canada; Dr Bojana Borić-Brešković, National Museum of Serbia; Professor Tanaka Masayuki, The National Museum of Western Art, Tokyo; Julián Zugazagoitia and Dr William Keyse Rudolph, The Nelson-Atkins Museum of Art; Dr Annick Lemoine, Petit Palais, Musée des Beaux-Arts de la Ville de Paris; Dr Sasha Suda, Philadelphia Museum of Art; Dr Jonathan P Binstock, The Phillips Collection; Mrs Sara Lammens and Davy Depelchin, Royal Museums of Fine Arts of Belgium; Rudolf Staechelin Collection; Min Jung Kim, Saint Louis Art Museum; Seibert Collection; Dr Mariët Westermann and former director Richard Armstrong, Solomon R Guggenheim Museum; Takefumi Umemoto, Sompo Museum of Art; Keith Stoltz; Adam M Levine, Toledo Museum of Art; Dr Emilie Gordenker, Van Gogh Museum; Alex Nyerges, Virginia Museum of Fine Arts; Dr Sook-Kyung Lee, The Whitworth, The University of Manchester; Lisbeth Lund, Willumsens Museum; Dr Matthias Waschek and Dr Claire Whitner, Worcester Art Museum; Eisaku Sudo, Yoshino Gypsum Art Foundation; and to those private collectors who have entrusted their loans to us and wish to remain anonymous.

We also wish to acknowledge with gratitude the assistance of particular colleagues: Scott Allan; Claire Bergeaud; Vanessa Beros; Professor Emerita Norma Broude; Oliver Camu; Guillaume Cerutti; Emmanuelle Charrier; David Cohen; Stéphanie de Brabander; Sylphide de Daranyi; Nina del Rio; Odile Dharcourt; Nathalie Dioh; Francesco Donadio; David Epstein; Sébastien Felmann; Flemming Friborg; Davide Gasparotto; Dr Vaiana Giraud; Claudine Godts; Robert Graham; GrandPalaisRMN; Quincy Houghton; Phillip Jones; Kyoto Kagawa; Dr Adina Kamien; Sam Keller; Dr Dragana Kovačič; Dr Ulf Küster; Pierrette Lacour; Nicole Manuello; Alice Massé; Karine Mauris; Chris Miller; Ranita Mukherjee; Richard Neville; John O'Halloran; Philippe Peltier; Kylie Pritchard; Tara Rastrick; Rosanna Raymond MNZM; Penelope Riley; Chris Riopelle; Judith Ryan AM; Nanako Sato; Marie Louise Sauerberg; Dr Annette Schlagenhauff; Hans-Ewald Schneider; Yasudide Shimbata; Elsa Smithgall; Jane Stewart; Dr Mahrukh Tarapor; Professor Nicholas Thomas; Boris Toucas; Dr Marine Vallée; Hizkia Van Kralingen; Emily Whittle; Guy Wildenstein; and Dr Stephan Wolohojian.

To explore Gauguin's legacy from the perspective of his time in Tahiti and the Marquesas Islands would not have been possible without contributions from those leaders who believe in the common language of culture, notably Moetai Brotherson, President, French Polynesia; Éliane Tevahitua, Vice-President, Minister of Culture, French Polynesia; Dr Hiriata Millaud, Deputy Director of the Vice-President's Office; Michel-Stanislas Villar, Advisor, Vice-President's Office; the Hon Lord Mayor, Hiva Oa, Marquesas Islands, Joëlle Frébault; and Tahiarii Yoram Pariente, Traditional practitioner and holder of knowledge. We also thank His Excellency Pierre-André Imbert, French Ambassador to Australia; His Excellency Michel Goffin, Belgian Ambassador to Australia; and Ms Alison Shea, Australian Consul-General to Tahiti.

Gauguin's World: Tōna Iho, Tōna Ao would not have been possible without the support and commitment of the following:

Government of Australia
The Hon Anthony Albanese MP, Prime Minister
 of Australia
The Hon Tony Burke MP, Minister for the Arts
Susan Templeman MP, Special Envoy for the Arts

Curator
Henri Loyrette

Art Exhibitions Australia

Carol Henry, Chief Executive
Michael Jones, Senior Project Manager
Greg Sewell, Accountant
Jane Messenger, Project Manager
Greta North, Project Manager
Ross Clendinning, Project Manager – Registration
Rachelle Webster, Executive Assistant

Board of Directors
Dr Mark Nelson, Chair
Dr Anne-Marie Schwirtlich AM, Deputy Chair
Carol Henry, Chief Executive
Richard Alcock AO
Dr Amanda Bell AM
Dr Matthew Martin
Prof Sir Jonathan Mills AO FRSE
Dr Sally Pitkin AO
Don Richter

National Gallery of Australia

National Gallery Council
Ryan Stokes AO, Chair
Ilana Atlas AO, Deputy Chair
Abdul-Rahman Abdullah
The Hon Richard Alston AO
Esther Anatolitis
Stephen Brady AO CVO
Helen Cook
Alison Kubler
Dr Nick Mitzevich, Director
Sally Scales
Prof Sally Smart

National Gallery Foundation

His Excellency General the Hon David Hurley AC,
DSC (Retd), Patron of the National Gallery
Foundation
Stephen Brady AO CVO, Chair
Philip Bacon AO, Deputy Chair
Julian Beaumont OAM
Anthony Berg AM
Robyn Burke
Julian Burt
Terrence Campbell AO
Sue Cato AM
The Hon Ashley Dawson-Damer AM
James Erskine
Tim Fairfax AC
Andrew Gwinnett
Hiroko Gwinnett
John Hindmarsh AM
Wayne Kratzmann AM
The Hon Dr Andrew Lu AM
Dr Peter Lundy RFD, Secretary
Michael Maher
Dr Michael Martin
Dr Nick Mitzevich, Director
Roslyn Packer AC
Penelope Seidler AM
Ezekiel Solomon AM
Kerry Stokes AC
Ryan Stokes AO
Ray Wilson OAM

National Gallery Executive

Dr Nick Mitzevich, Director
Adam Lindsay, Deputy Director
Susie Barr, Assistant Director, Marketing,
Communications and Visitor Experience
Sophie Gray, Project Director, Capital
Works Taskforce
Alison Halpin, Chief Operating Officer
Bruce Johnson McLean, Wierdi/Birri-Gubba
peoples, Assistant Director, First Nations
Engagement, Head Curator, First Nations Art
Felicity McGinnes, Chief Finance Officer
Helen Gee, Sophie Hunter, Jennifer Barrett and
Elizabeth Smith, Directorate

Curatorial Project Team

Carol Cains, A/Head Curator, International Art
Louise Cummins, Exhibitions Manager
Sally Foster, former Senior Curator, Prints
and Drawings
David Greenhalgh, Associate Curator,
International Art
Crispin Howarth, Curator, Pacific Arts,
International Art
Russell Storer, former Head Curator,
International Art
Lucina Ward, Senior Curator, International Art

First Nations Engagement Team

Bruce Johnson McLean, Wierdi/Birri-Gubba
peoples, Assistant Director, First Nations
Engagement, Head Curator, First Nations Art
Cara Kirkwood, Mandandanji/Mithaka peoples,
Head of First Nations Engagement and Strategy

National Gallery Management Team

Natalie Beattie, Head of Registration, and staff
Samantha Braniff, Head of Partnerships, and staff
Jade Carson, Chief Information Officer, and staff
Carol Cains, A/Head Curator, International Art,
and staff
Georgia Close, Head of National Learning, and staff
Tracy Cooper-Lavery, Head of Art Across Australia,
and staff
Terri Dwyer, Head of Human Resources, and staff
Mary Fisher, Head of Financial Accounting, and staff
Stefan Giammarco, Head of Visitor Experience,
and staff
Deborah Hart, Head Curator, Australian Art, and staff
Greg Ible, Head of Estate Management, and staff
Cara Kirkwood, Mandandanji/Mithaka peoples, Head
of First Nations Engagement and Strategy,
and staff
Elizabeth Little, Manager Research Library and
Archives, and staff
Marika Lucas-Edwards, Principal Content and
Digital Strategist, and staff
Elizabeth Malone, Head of Commercial Operations,
and staff
Laura McElhinney, Head of Financial Planning and
Analysis, and staff
Fiona McQueenie, Head of Communications,
and staff
Dominique Nagy, Head of Exhibitions, and staff
Kanesan Nathan, Head of Marketing, and staff
Kirsti Partridge, A/Head of Governance and
Strategic Planning, and staff
Maryanne Voyazis, Head of Development
and Executive Director, National Gallery
Foundation, and staff
Debbie Ward, Head of Conservation, and staff
Daryl West-Moore, Head of Creative Studio, and staff
Kerry White A/Head of Capital Works Taskforce,
and staff
Jan Wojna, Head of Project Management Office,
and staff

The Museum of Fine Arts, Houston

Gary Tinterow, Director, The Margaret Alkek
Williams Chair
Deborah L Roldán, Chief Exhibitions Officer &
Deputy Director for Curatorial Affairs
Ann Dumas, Consulting Curator
Dena Woodall, Curator of Prints and Drawings
Soraya Alcala, Conservator of Paintings
Julie Bakke, Chief Registrar
Dale Benson, Chief Preparator
Heather Brand, Publisher in Chief
Chris Goins, General Manager of Retail
Melanie Fahey, Senior Publicist
Phenon Finley-Smiley, Manager of Graphics
Michael Kennaugh, Lead Preparator
Michael Langley, Exhibition Designer
Kristin Liu, Graphic and Web Designer
Julya Lizarralde, Senior Exhibitions Coordinator
Matie Martinez-Leal, Paintings Conservator
John Obsta, Exhibitions Registrar
Nick Pedemonti, Conservator of Objects
Tina Tan, Conservator, Works on Paper

Photograph credits

Gauguin's World: Tōna Iho, Tōna Ao

All reproductions of works of art from the collection of the National Gallery of Australia are courtesy of the Gallery's Digital team, unless otherwise stated.

We thank those who wish to remain anonymous, and the following:

front cover: image courtesy National Galleries of Scotland, Edinburgh; p 2: image courtesy Kimbell Art Museum, Fort Worth; p 3: image courtesy Hammer Museum, Los Angeles; pp 4–5: © Musée d'Orsay, Paris, distributed GrandPalaisRmn (photo: René-Gabriel Ojeda); p 6: photo Museums of Strasbourg, M Bertola; p 7: image courtesy the McNay Art Museum, San Antonio; p 8: image courtesy Museu de Arte de São Paulo Assis Chateaubriand (photo: Eduardo Ortega); p 9: image courtesy Kunstmuseum Basel; p 30: © Musée d'Orsay, Paris, distributed GrandPalaisRmn (photo: Hervé Lewandowski); p 33 (fig 1): © Musée d'Orsay, Paris, distributed GrandPalaisRmn © rights reserved; Vahatetua Timo (19th–20th cent) © rights reserved; p 38 (fig 2): © Musée d'Orsay, Paris, distributed GrandPalaisRmn (photo: Patrice Schmidt); p 39 (fig 3): image courtesy Bridgeman Images; p 40: image courtesy the Art Institute of Chicago / Art Resource, NY; p 41 (fig 4): © Musée d'Orsay, Paris, distributed GrandPalaisRmn (photo: Tony Querrec); p 41 (fig 5): © Musée du Louvre, Paris, distributed GrandPalaisRmn (photo: Tony Querrec); p 42 (fig 6): © Musée d'Orsay, Paris, distributed GrandPalaisRmn (photo: Hervé Lewandowski); p 43: © Paolo Vandrasch; p 44 (fig 7): © Musée du Louvre, Paris, distributed GrandPalaisRmn (photo: Georges Poncet); p 45: image courtesy Kunstmuseum Basel; p 46 (fig 8): image courtesy Bridgeman Images; p 47: image courtesy Kimbell Art Museum, Fort Worth; p 48 (fig 9): © National Gallery Prague, 2024; p 48 (fig 10): © GrandPalaisRmn / image GrandPalaisRmn; p 49: image courtesy Hammer Museum, Los Angeles; p 51 (fig 11): image courtesy Buffalo AKG Art Museum / Art Resource, NY; p 51 (fig 12): © Musée d'Orsay, Paris, distributed GrandPalaisRmn (photo: Hervé Lewandowski); p 52: Musée d'Orsay, Paris, distributed GrandPalaisRmn (photo: René-Gabriel Ojeda); p 53 (fig 13): image courtesy HIP / Art Resource, NY; p 54: image courtesy Museu de Arte de São Paulo Assis Chateaubriand (photo: Eduardo Ortega); p 55: image courtesy Musée de Grenoble (photo: JL Lacroix); p 57: © Royal Museums of Fine Arts of Belgium, Brussels (photo: J Geleyns, Art Photography); p 60 (fig 14): image courtesy Museum of Fine Arts Boston; p 61: © Musée du quai Branly – Jacques Chirac, Paris, distributed GrandPalaisRmn; p 64: image courtesy Hamburger Kunsthalle, Hamburg (photo: Christoph Irrgang); p 65: © Department of Culture and Tourism – Abu Dhabi (photo: APF); p 66: image courtesy Artizon Museum, Ishibashi Foundation, Tokyo; p 67: image courtesy the National Museum of Western Art, Tokyo; p 70: image courtesy the Museum of Modern Art, New York / Scala, Florence; p 71: image courtesy the National Museum of Western Art, Tokyo; p 73:

image courtesy Worcester Art Museum / Bridgeman Images; p 77: © Royal Museums of Fine Arts of Belgium, Brussels (photo: J Geleyns, Art Photography); p 78: image courtesy Philadelphia Museum of Art; p 79 (left): © Musée du quai Branly – Jacques Chirac, Paris; p 79 (right): image courtesy Te Fare Iamanaha – Musée de Tahiti et des Îles, Papeete (photo: Danee Hazama); p 80: image courtesy the J Paul Getty Museum, Los Angeles; p 81 (top left): image courtesy Te Fare Iamanaha – Musée de Tahiti et des Îles, Papeete; p 81 (top right): © Musée du quai Branly – Jacques Chirac, Paris (photo: Claude Germain); p 81 (bottom): image courtesy Te Fare Iamanaha – Musée de Tahiti et des Îles, Papeete (photo: Danee Hazama); p 82 (top): © Musée d'Orsay, Paris, distributed GrandPalaisRmn (photo: Hervé Lewandowski); p 82 (bottom): image courtesy Te Fare Iamanaha – Musée de Tahiti et des Îles, Papeete (photo: Danee Hazama); p 89: image courtesy Solomon R Guggenheim Museum Foundation / Art Resource, NY; p 90 (fig 1): © The Israel Museum, Jerusalem (photo: Avshalom Avital); p 93 (fig 2): image courtesy Ny Carlsberg Glyptotek, Copenhagen; p 97 (fig 1): image courtesy Musée d'Orsay, Paris, distributed GrandPalaisRmn (photo: Stéphane Maréchalle); p 98 (fig 2): © Musée d'Orsay, Paris, distributed GrandPalaisRmn (photo: Hervé Lewandowski); p 99 (fig 3): image courtesy Saint Louis Art Museum; p 100 (fig 4): © Musée d'Orsay, Paris, distributed GrandPalaisRmn (photo: Gérard Blot); p 107 (fig 1): image courtesy Snark / Art Resource, NY; p 109 (fig 2): © Musée d'Orsay, Paris, distributed GrandPalaisRmn (photo: Hervé Lewandowski); p 109 (fig 3): image courtesy the Art Institute of Chicago / Art Resource, NY; p 110: © The Museum of Modern Art / Licensed by SCALA / Art Resource, NY; p 112 (fig 4): © The Metropolitan Museum of Art, New York (photo: Art Resource, NY); p 112 (fig 5): © Musée du quai Branly – Jacques Chirac, Paris, distributed GrandPalaisRmn; p 113 (fig 6): © The Metropolitan Museum of Art, New York (photo: Art Resource, NY); p 119 (fig 1): image courtesy Baltimore Museum of Art; p 122 (fig 2): © Kanaky; p 126: © The Fitzwilliam Museum, University of Cambridge; p 128: © Musée d'Orsay, Paris, distributed GrandPalaisRmn (photo: Hervé Lewandowski); p 129: © Virginia Museum of Fine Arts (photo: Katherine Wetzel); p 130 (fig 1): image courtesy the Metropolitan Museum of Art, New York; p 131: image courtesy Aargauer Kunsthaus, Aarau; p 132 (fig 2): image courtesy the Museum of Modern Art, New York; p 132 (fig 3): image courtesy Ordrupgaard, Copenhagen (photo: Anders Sune Berg); p 133 (top): © Musée d'Orsay, Paris, distributed GrandPalaisRmn (photo: René-Gabriel Ojeda); p 135: image courtesy Kunsthaus Zürich; p 136 (fig 4): image courtesy Philadelphia Museum of Art; p 136 (fig 5): © SZ Photo / Bridgeman Images; p 137 (fig 6): © NPL – DeA Picture Library / Bridgeman Images; p 138: © Glasgow Life Museums / Bridgeman Images; p 140: image courtesy Artizon Museum, Ishibashi Foundation, Tokyo; p 141: image courtesy Fondation Beyeler (photo credit: Robert Bayer); p 143 (above): image courtesy Fondation Pierre Gianadda, Martigny; p 143 (right):

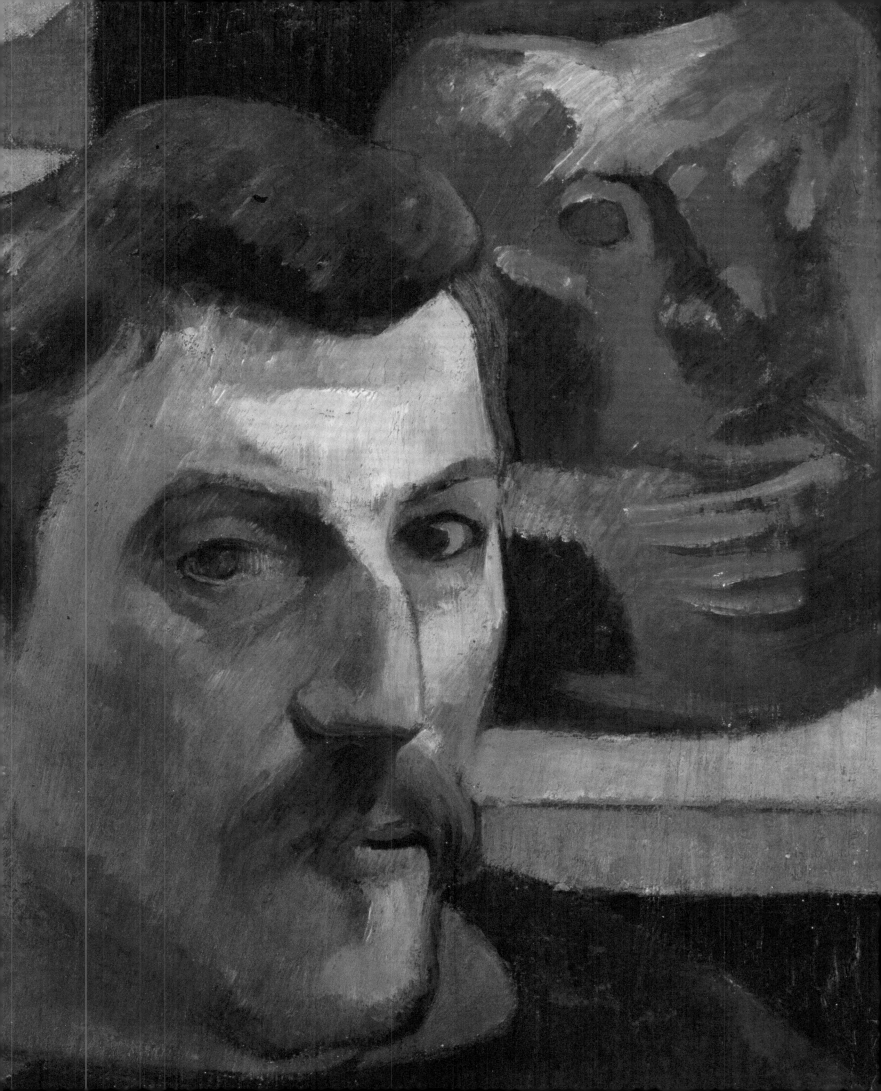

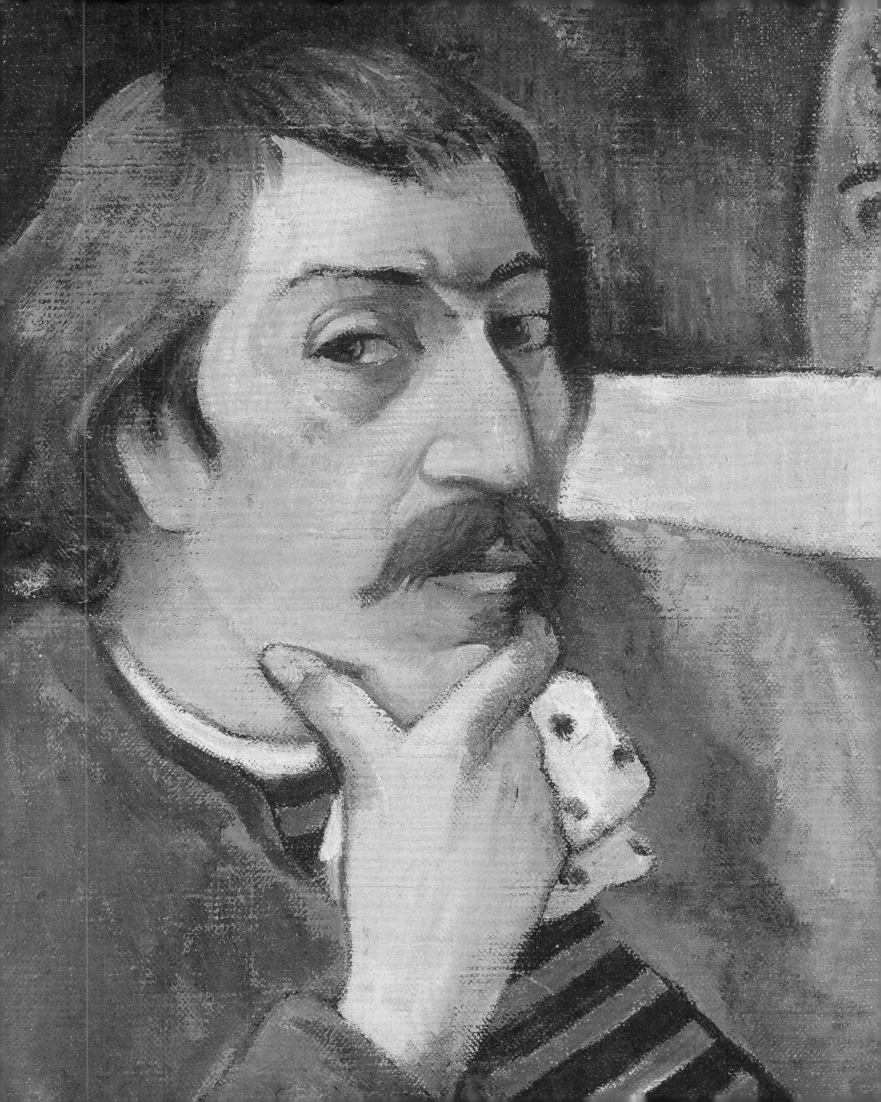

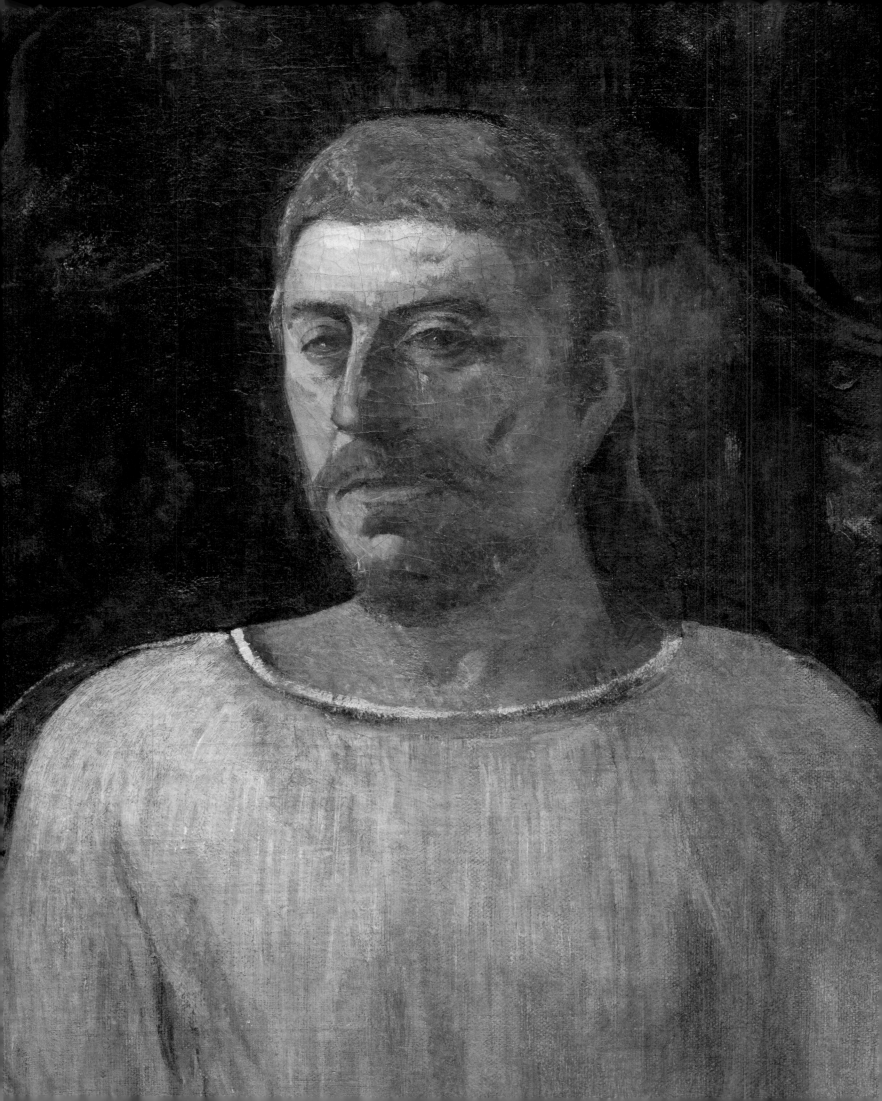

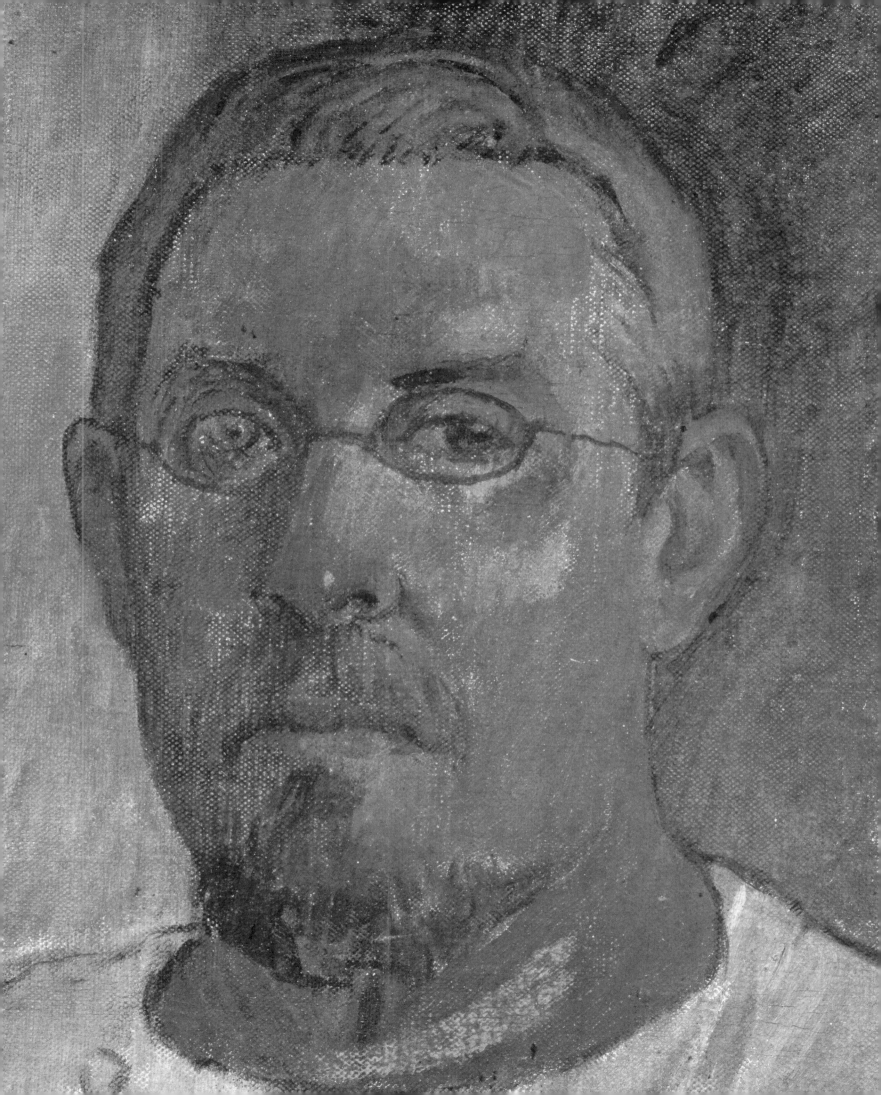

Acknowledgement of Country

The National Gallery of Australia respectfully acknowledges that we are on the Country of the Ngunnawal and Ngambri peoples of the Kamberri/Canberra region. We recognise their continuing connections to Country and culture, and we pay our respects to their Elders, leaders and artists, past and present.

We respectfully acknowledge all Traditional Custodians throughout Australia whose art we care for and to whose lands National Gallery exhibitions and staff travel.

Warning

Aboriginal and Torres Strait Islander people are respectfully advised that this publication may contain images and words of, and references to, people who have passed away. Where possible, permission has been sought to include this material.

Aboriginal and Torres Strait Islander placenames

The National Gallery of Australia recognises Aboriginal and Torres Strait Islander cultural heritage by including First Nations placenames in the publication. The placenames are current at the time of print but may change over time.

Gauguin's World
Tōna Iho, Tōna Ao

Henri Loyrette

Contents

Messages

Message from the Prime Minister of Australia

It gives me great pleasure to introduce *Gauguin's World: Tōna Iho, Tōna Ao*, the first comprehensive exhibition of Paul Gauguin's work to be held in the South Pacific.

Since it opened in 1982, the National Gallery of Australia has showcased some of our greatest art and brought to our shores some of the finest art the world has to offer. It has inspired us, engaged us and moved us, all while giving us a greater context for the art and, ultimately, for humanity itself.

This groundbreaking exhibition is very much part of that tradition. Drawing from public and private collections across the world, it will show local audiences just how innovative Gauguin's vision was, and position his artistic legacy within his most enduring inspiration: the peoples and landscapes of the Pacific.

Curated by Henri Loyrette, former director of the Louvre Museum and of the Musée d'Orsay, the exhibition traces Gauguin's artistic development from his early works of Impressionism to allegorical portraits and landscapes made in Tahiti and the Marquesas Islands. It demonstrates his radical impact on the art of his time, and how he introduced new subjects and perspectives to European painting.

Through related displays and programs, the National Gallery also provides important critical reflections on Gauguin's interaction with Pacific peoples and cultures, primarily through the voices of contemporary Pacific artists and thinkers. Australia's relationships with our Pacific neighbours continue to strengthen, and cultural engagement forms a crucial part in this. We are grateful for the Government of French Polynesia's support of this exhibition.

The Australian Government is proud to support *Gauguin's World: Tōna Iho, Tōna Ao* through its International Exhibitions Insurance Program, which has enabled these significant loans to travel to Australia. I thank Henri Loyrette and Art Exhibitions Australia for their roles in bringing together the exhibition. I commend Nick Mitzevich and his staff at the National Gallery for staging this important exhibition, which will undoubtedly enchant, challenge and inspire its visitors from across Australia and abroad.

The Hon Anthony Albanese MP
Prime Minister of Australia

Message from the Vice-President of French Polynesia

In exhibiting Gauguin's masterpieces through over 120 works, *Gauguin's World: Tōna Iho, Tōna Ao* at the National Gallery of Australia stands as a *première* in the South Pacific. Along with the artist's varied body of works extending from paintings, drawings and engravings to ceramics, sculptures and decorative arts, the exhibition places Polynesian cultural heritage and the influence of the islands, its traditions and languages at the core of Gauguin's inspiration.

Visual landmarks hidden in his paintings' backgrounds and objects and visual references worn or carried by characters he depicted epitomise the artist's interest in spirituality and symbolism and reflect on the deep connection he entertained with the local culture. From a thirst for remoteness and spirituality bathed with exoticism to a search for a 'vanishing paradise', the artist deepened his approach to Indigenous life and material culture through symbolism revealed both in his art practice and numerous of his vernacular titles.

Thus with great pride French Polynesia, through the collections of Te Fare Iamanaha – Musée de Tahiti et des Îles, is present among the lenders for this pivotal exhibition.

In addition to a series of wood spoons and a panel decorated by Gauguin held in local public collections, four objects from Te Fenua enata / Te Henua enana, Tahiti, and Tupua'i are on display. A sculpture and *ivi po'o* illustrate the strong presence of the Marquesan *tiki ètua* and were objects Gauguin could have seen even before his first stay in the Pacific, at the 1889 Exposition Universelle in Paris. Two other objects he may have seen while visiting exhibitions and museums, a Tahitian pounding table and a ceremonial dish from Tupua'i, reflect the wider resonance of Polynesian material culture in the artist's legacy, as well as the circulation of objects at that time in the region.

Along with the practices of other artists of his time, these objects, their cultural significance and visual characteristics, played a substantial role in the affirmation of Gauguin's art. This exhibition, in placing the islands as a starting point in unveiling the artist's artistic and spiritual journey, underlines the uniqueness of our cultural heritage. Beyond embodying the spirit of the South Seas that fascinated the artist, the presence of these objects allows their particularity to be expressed. *Gauguin's World: Tōna Iho, Tōna Ao* stands as a fantastic opportunity to highlight the richness of our culture and to strengthen institutional partnerships across Te-Mōana-Nui-a-Hīvā.

Éliane Tevahitua
Vice-President, Minister of Culture, Environment, Land Affairs and Handicraft, in charge of relations with Institutions, French Polynesia

Message from the ACT Chief Minister

The ACT Government through VisitCanberra is delighted to support the National Gallery of Australia's major winter exhibition, *Gauguin's World: Tōna Iho, Tōna Ao*. Visitors to the National Gallery have a once-in-a-lifetime opportunity to see over 130 iconic artworks by French post-impressionist artist Paul Gauguin. In an Australian first, Gauguin's work returns to the Pacific for all Australians to experience, exclusively in Canberra.

Curated by Henri Loyrette, former director of the Musée du Louvre and of the Musée d'Orsay in Paris, this remarkable exhibition brings together works from over 65 leading public and private lenders worldwide to explore new perspectives on Gauguin's life and work, as well as the historical impact and legacy.

The ACT Government's ongoing collaboration with the National Gallery contributes to a vibrant visitor economy, delivering positive economic and social benefits to the Canberra region.

I'd like to acknowledge the organising partners, Art Exhibitions Australia and the Museum of Fine Arts, Houston, for making this exhibition possible. I also congratulate Director Dr Nick Mitzevich and the National Gallery for staging this exceptional exhibition and showcasing our ongoing connections with the Pacific region.

Gauguin's World: Tōna Iho, Tōna Ao will be a remarkable cultural event, not to be missed. I hope you enjoy the exhibition and explore many of the other experiences on offer in Canberra during the winter months.

Andrew Barr MLA
ACT Chief Minister

Forewords

The poetic vision of *Gauguin's World: Tōna Iho, Tōna Ao* is encapsulated in the meaning of the Tahitian language in this title. *Tōna Iho* refers to one's inner world, one's soul, spirit, thoughts and beliefs. And *Tōna Ao* refers to all that constitutes and shapes one's world, the external influences and aspirations of an age. This extraordinary exhibition is the first to explore Gauguin's inner journey and his quest to develop his own identity. By revisiting Gauguin at a particular moment in his life, it deepens our understanding of one of the most polarising artists of his time and ours, whose significance endures through the compelling quality of his work.

We encounter the 54-year-old Gauguin in 1903 in one of the world's most remote archipelagos, the Marquesas Islands. Knowing that death is upon him, he paints his last self-portrait, unmasked, leaving us an image of the artist as himself. We join him as he looks back on the scattered memories of his life, reflecting on the relationships, circumstances, opinions and questions that informed his ambition and development as an artist. He knows he is passing into the history of art but unknowing of the extent to which he will profoundly influence the future of modernism.

Gauguin's career aptly summarises the artistic battles of the nineteenth century, and this publication deftly positions him as an artist engaged with the world around him. While today Gauguin's art is celebrated and his behaviour condemned in equal measure, *Gauguin's World: Tōna Iho, Tōna Ao* explores how Gauguin rejected values embraced by western culture in seeking an authentic engagement with other societies and belief systems—first in Brittany and Martinique, then in Tahiti and the Marquesas—to inform his evolving ideologies. His diverse bodies of work reveal how his lifelong peregrinations were accompanied by relentless experimentation in medium and technique. He constantly sought new materials, transforming traditions or inventing new ones to translate his ideas and experiences.

It is in the final stages of Gauguin's life, spent in Tahiti and the Marquesas, that we come to understand his aspirations and achievements more completely and within a larger context. His primitivism is not simply a search for new formal expression, motifs and references, nor is it a mode of aesthetic idealisation, unlike associated movements in the nineteenth and twentieth centuries. By tracing Gauguin's path as he sought increasingly remote locations in which to live and work, removed from the influence of western society, *Gauguin's World: Tōna Iho, Tōna Ao* explains how he lived the primitivism he sought, how he 'believed in a real correspondence between man and the world around him'.

We are indebted to the exhibition's curator, Henri Loyrette, for the magnificence of *Gauguin's World: Tōna Iho, Tōna Ao* and congratulate him on inspiring new ways of seeing and thinking about an artist whose legacy is popularly identified and extensively critiqued. The ambitious scale and complexity of the exhibition, which shows the full scope and originality of Gauguin's oeuvre in masterpieces rarely brought together, reflect the international esteem in which Mr Loyrette is held as both an arts administrator and historian. We thank him for his dedication to and leadership in the project.

Many museum professionals and historians have generously shared their knowledge and time over the past years. We especially wish to thank the contributing authors to the catalogue for their insightful essays: Dr Miriama Bono discusses

the artist's reputation and legacy within the context of contemporary Polynesia; Professor Emerita Norma Broude assesses Gauguin in the context of his maternal grandmother, the pioneering feminist and social activist Flora Tristan, to show how his art was positively shaped by his family history and the evolving feminisms of his own era; Dr Vaiana Giraud explores the importance of his lesser-known writing practice, its complexities and references; and Professor Nicholas Thomas focuses on Gauguin's Polynesian-period works, exploring their paradoxes while revealing how he responded to the people around him and the world before him.

A special acknowledgement is extended to Dr Hiriata Millaud, who developed the exhibition's Tahitian-language title and advised on how Gauguin's use of Tahitian suggests a far stronger affinity with the language than previously assumed, with broader cultural significance to Polynesian society.

Critical to the development of the exhibition was the importance of presenting a Gauguin exhibition in the Pacific for the first time, providing the opportunity for discussions with Tahitian scholars and cultural leaders about the artist's legacy, and within Polynesian communities more broadly. We thank the Government of French Polynesia for so enthusiastically embracing the idea, particularly President Moetai Brotherson and Vice-President Éliane Tevahitua. We also acknowledge the extensive support of the French Government.

To complete the story of *Gauguin's World: Tōna Iho, Tōna Ao*, we have relied on the magnanimity of some 90 lenders across both venues, both public and private. The exhibition has been realised through exceptional loans from the Musée d'Orsay in Paris, who has supported the exhibition as the major lender. Te Fare Iamanaha – Musée de Tahiti et des Îles in Papeete has shared its works by Gauguin and several treasured objects from Polynesia. We also extend our immense appreciation to all lenders for the significant part they have played in bringing Mr Loyrette's ambition to fruition.

Carol Henry
Chief Executive, Art Exhibitions Australia

Dr Nick Mitzevich
Director, National Gallery of Australia

Gary Tinterow
Director, The Margaret Alkek Williams Chair
The Museum of Fine Arts, Houston

National Gallery Chair

The National Gallery of Australia's founding document, the Lindsay Report of 1966, identified that the National Gallery must have a close dialogue with and represent the 'high cultural achievement' of Australia's neighbours in the Pacific Islands, as a priority in the development of the Gallery's art collections and displays.

Gauguin's World: Tōna Iho, Tōna Ao is the first major project on Paul Gauguin in the South Pacific and builds on the National Gallery's work over the past four decades to showcase works made in this region. The exhibition honours the foresight of our founders and promotes our vision to be Australia's international reference point for art, inspiring people to explore, experience and learn about the art of our region and from across the world.

The work of Gauguin changed the course of modern western art and it is important that we understand and appreciate his profound impact on the art of his time, as well as his ongoing legacy in the present. The National Gallery, as the leading art museum in the South Pacific, is proud to present this major exhibition of Gauguin's work, the first to be staged in the region where he lived and worked for the last period of his life and where he made what are arguably his most significant paintings.

The National Gallery's collaboration with Art Exhibitions Australia and the Museum of Fine Arts, Houston, along with the curatorial leadership and scholarship of Henri Loyrette, have made this ambitious exhibition possible. We are deeply grateful for their collegiality and support, enabling the National Gallery to fulfil its mission of sharing the preeminent art from around the world with all Australians.

It has been a privilege to work with our colleagues in French Polynesia, and I thank them for sharing their culture through art, scholarship and performance.

An exhibition of this calibre could not be held in Australia without the generous assistance of our private, corporate and government supporters. Sincere gratitude is extended to our Strategic Partner, the ACT Government through VisitCanberra, for its ongoing support of the National Gallery's major exhibitions. We are grateful for the support of Principal Sponsor Mazda Australia and Principal Donor Singapore Airlines, and to News Corp and Seven West Media for their media support.

Special thanks also go to our Exhibition Patrons Philip Bacon AO, Kay Bryan, Krystyna Campbell-Pretty AM, Christine Campbell and Terry Campbell AO, Maurice Cashmere, Penelope Seidler AM, Lyn Williams AM, Robert Meller and Helena Clarke, who have made a significant collective contribution to this project.

We gratefully acknowledge the Hon Tony Burke, Minister for the Arts, and the Australian Government through the Australian Government International Exhibitions Insurance Program, which was established by the Australian Government to provide funding for the purchase of insurance for significant cultural exhibitions, without which the high cost of commercial insurance would prohibit the staging of this and many other major exhibitions in Australia.

I would also like to thank the many public and private lenders to the exhibition for generously making their works available, with most being seen in this country for the first time.

I congratulate Henri Loyrette, Carol Henry, Nick Mitzevich, Gary Tinterow and their extraordinary teams for their vision and dedication in bringing this exceptional exhibition to Australia.

Ryan Stokes AO
Chair, National Gallery Council

Art Exhibitions Australia Chair

In 1891 Paul Gauguin went in search of a radical new artistic vision that he believed he would discover in Tahiti and the Marquesas Islands. The five-week voyage aboard *L'Oceanien* would see him stop in Australia (at Albany, Adelaide, Melbourne and Sydney)—the gateway to Oceania.

The importance of presenting a Gauguin exhibition for the first time in Australia, bringing the diverse practices of this defining modern master to our national audience, has long been an aspiration of Art Exhibitions Australia. But we also believe in the significance of returning Gauguin's Tahitian and Marquesas Islands works to Oceania, where the artist realised his desire for a new life and purity of artistic expression. Recognising and placing the artist back in our South Pacific region was of critical importance for curator Henri Loyrette, and was very much the premise from which he conceived *Gauguin's World: Tōna Iho, Tōna Ao*.

We are indebted to the vision and commitment of Mr Loyrette, esteemed scholar of nineteenth-century French art, who has long been generous to Australia. His scholarship and reputation have enabled us to secure exceptional loans from institutional and private collections in 16 countries and have assured the presentation of one of the most insightful exhibitions to be realised in Australia.

The question of what it would mean to return Gauguin's Polynesian works to Oceania and how it would continue to expand the interpretive framework, both from an art historical but also a twenty-first-century perspective, was central to the curatorial rationale. Our foundation, the Australian International Cultural Foundation, funded Mr Loyrette's research trip to Tahiti and Hiva Oa in support of his initiative to better understand how the landscape, people and culture were interpreted by Gauguin.

The opportunity for the curator to discuss the complex issues surrounding the artist's legacy with Tahitian scholars and cultural leaders was also important. We thank all those who welcomed the curator so warmly and who shared their knowledge so generously and hospitably. We also extend our appreciation to the Government of French Polynesia for their involvement in the exhibition opening celebrated in Kamberri/Canberra, and also acknowledge the broader support of the French Government.

Achieving the ambitious scope of *Gauguin's World: Tōna Iho, Tōna Ao* has relied on the significant generosity of over 65 lenders. The rarity of Gauguin's works, the treasured importance they occupy in collection displays combined with the distance to Australia, means each agreed loan was underpinned by a confident belief in Mr Loyrette's vision. We extend our deepest appreciation to all the public and private lenders.

An exhibition of this magnitude and complexity is a vast undertaking and we are indebted to the National Gallery of Australia and the Museum of Fine Arts, Houston, our partners in the project, for their commitment and expertise. The broader cultural and political resonances of *Gauguin's World: Tōna Iho, Tōna Ao* are ideally placed within the National Gallery of Australia. The Director, Dr Nick Mitzevich, is to be commended for his leadership and commitment to the project, extending the support of his staff and generous patrons to ensure the exhibition excels in every respect. This handsome catalogue, for which Mr Loyrette is both editor and major contributor, has been co-produced by the Gallery with Art Exhibitions Australia.

This exhibition represents the third occasion on which we have partnered with the Museum of Fine Arts, Houston, since Gary Tinterow became Director. He has also dedicated much of his career to furthering the scholarship of late nineteenth-century French art and first collaborated with Mr Loyrette in the 1980s. He has been a constant support to the curator throughout the project, believing in the significance of returning Gauguin to Oceania. He and his staff have given critical consideration to the list of works and assisted in securing many decisive loans, enriching the presentation of this exceptional exhibition.

We gratefully acknowledge that all our efforts have been underwritten by generous grants from the Federal and Territory governments. The indispensable Australian Government International Exhibitions Insurance Program, administered by the Office for the Arts under the Hon Tony Burke MP, Minister for the Arts, has provided essential funding, as has the ACT Government through Chief Minister Andrew Barr MLA.

We would also like to express our deep gratitude to the community of business sponsors who have been steadfast in their support of this exhibition. First and foremost is Principal Sponsor Mazda Australia, whose visionary patronage has ensured that the magnificence and complexity of Paul Gauguin's artistic practice has finally toured to our region. *Gauguin's World: Tōna Iho, Tōna Ao* also celebrates Mazda's 30-year sponsorship of Art Exhibitions Australia, and we thank them for their immeasurable enrichment of Australia's cultural life. Secondly, we proudly acknowledge Principal Donor Singapore Airlines, who have partnered with us since 1988 to fly the world's masterpieces to Australia. We commend both companies for their leadership within the cultural sector; both are clearly associated with the arts in Australia. We are grateful for the indispensable support received from our Major Media Partner News Corp, through *The Australian*, the *Herald Sun* and the *Daily Telegraph*, and media sponsors Seven West Media and the Australian Radio Network through Mix 106.3, Hit 104.7, KIIS 97.3, Mix 102.3, WSFM, Gold and Cruise. We thank the hospitality sponsor Capital Hotel Group. Finally, with sincere appreciation, we acknowledge the philanthropic support of the National Gallery of Australia's patrons who have helped bring specific works to Kamberri/Canberra.

We are extremely proud that we have been able to present such an important exhibition to Australia and sincerely hope that it results in a deeper appreciation of the artistic expression of Paul Gauguin during the last period of his life.

Dr Mark Nelson
Chair, Art Exhibitions Australia

Principal Sponsor

For three decades, Mazda Australia has partnered with Art Exhibitions Australia to enrich the cultural life of the nation. This enduring alliance has facilitated welcoming some of the world's most revered artistic masterpieces to our shores, collaborating with national and state galleries to deliver exceptional exhibitions.

In celebrating 30 years as the Principal Sponsor of this esteemed organisation, we take great pride in continuing our patronage with the exceptional opportunity to delve into the life and times of Paul Gauguin through a veritable treasure trove of more than 130 of his most ambitious works on display here at the National Gallery of Australia in Kamberri/Canberra.

Supporting the arts is a pivotal part of Mazda Australia's focus, as we act on our promise to deliver joy not only through our cars but in society.

We passionately believe that art inspires and energises the community, stirring emotion and encouraging reflection and debate.

One of our core values is applying a 'Challenger Spirit' to everything we do, which is why this exhibition is the perfect setting for broader discussions about Gauguin's legacy, with the issues raised to be tackled head-on in a balanced forum. We encourage and hope for open conversation, education and contemporary perspectives to be shared, all of which will bring valuable insight and added depth to this journey into each of his works.

It is also our pleasure to continue our support of Art Exhibitions Australia and its tireless dedication to Australia's thriving and sophisticated art scene, and our gratitude extends to Henri Loyrette for his accomplished curation, to the Musée d'Orsay, and to the many other generous custodians involved, for opening up their collections to the Oceanic region.

Gauguin's World: Tōna Iho, Tōna Ao promises to be a fascinating, immersive and enlightening experience for 2024, and we hope you enjoy visiting this exhibition as much as we've relished supporting it.

Vinesh Bhindi
Managing Director, Mazda Australia

Organising Partners

Major Lender

Musée d'Orsay

Exhibition realised with gratitude for
exceptional loans from the Musée d'Orsay

Principal Sponsor

Principal Donor

Strategic Partner

Government Partner

Major Partner

Exhibition Patrons

Philip Bacon AO

Kay Bryan

Supporting Patrons

Christine Campbell and
Terry Campbell AO

Krystyna Campbell-Pretty
AM

Maurice Cashmere

Penelope Seidler AM

Lyn Williams AM

Exhibition Supporters

Robert Meller and
Helena Clarke

Supporting Partners

Major Media Partner

THE AUSTRALIAN Herald Sun The Daily Telegraph

Art Exhibitions Australia Media Partner

 106.3 HIT 104.7 h.

National Gallery of Australia Media Partners

 The Sydney Morning Herald
INDEPENDENT. ALWAYS. THE AGE
INDEPENDENT. ALWAYS. WIN NETWORK The Canberra Times QMS

Lenders to the exhibition

*National Gallery of Australia only
**The Museum of Fine Arts, Houston only

Institutional lenders

Australia

Kamberri/Canberra
National Gallery of Australia
Tarntanya/Adelaide
Carrick Hill*

Belgium

Brussels
Cinquantenaire Museum, Royal Museums
of Fine Arts of Belgium
Royal Museums of Fine Arts of Belgium

Brazil

São Paulo
Museu de Arte de São Paulo Assis
Chateaubriand

Canada

Ottawa
National Gallery of Canada**

Denmark

Frederikssund
Willumsens Museum

France

Grenoble
Musée de Grenoble
Orléans
Musée des Beaux-Arts d'Orléans

Paris
Bibliothèque nationale de France
Chancellerie des Universités de Paris –
Bibliothèque littéraire Jacques Doucet*
Institut national d'histoire de l'art*
Musée d'Art Moderne de Paris
Musée d'Orsay
Musée du quai Branly – Jacques Chirac
Musée Marmottan Monet
Petit Palais, Musée des Beaux-Arts de la Ville
de Paris
Strasbourg
Musée d'Art Moderne et Contemporain
de Strasbourg
Vulaines-sur-Seine
Musée départemental Stéphane Mallarmé*

French Polynesia

Papeete
Te Fare Iamanaha – Musée de Tahiti et des Îles

Germany

Hamburg
Hamburger Kunsthalle*

Japan

Tokyo
Artizon Museum, Ishibashi Foundation
The National Museum of Western Art
Sompo Museum of Art*
Yoshino Gypsum Art Foundation*

The Netherlands

Amsterdam
Van Gogh Museum
Otterlo
Kröller-Müller Museum**

Serbia

Belgrade
National Museum of Serbia

Spain

Bilbao
Museo de Bellas Artes de Bilbao **

Madrid
Museo Nacional Thyssen-Bornemisza, Carmen
 Thyssen-Bornemisza Collection **

Switzerland

Aarau
Aargauer Kunsthaus

Basel
Kunstmuseum Basel

Geneva
Association des Amis du Petit Palais

Martigny
Fondation Pierre Gianadda

Zürich
Kunsthaus Zürich

United Arab Emirates

Abu Dhabi
Louvre Abu Dhabi

United Kingdom

Cambridge
The Fitzwilliam Museum

Edinburgh
National Galleries of Scotland

Glasgow
Glasgow Life Museums

London
The British Museum *

Manchester
The Whitworth, The University of Manchester

United States of America

Baltimore
Baltimore Museum of Art

Boston
Museum of Fine Arts Boston **

Cambridge
Harvard Art Museums / Fogg Museum **

Chicago
The Art Institute of Chicago

Cincinnati
Cincinnati Art Museum

Cleveland
The Cleveland Museum of Art

Des Moines
Des Moines Art Center

Fort Worth
Kimbell Art Museum **

Honolulu
Honolulu Museum of Art

Houston
The Museum of Fine Arts, Houston **

Indianapolis
Indianapolis Museum of Art at Newfields

Kansas City
The Nelson-Atkins Museum of Art **

Los Angeles
Hammer Museum
The J Paul Getty Museum
Los Angeles County Museum of Art

Minneapolis
Minneapolis Institute of Art **

New York City
The Metropolitan Museum of Art
The Morgan Library and Museum **
The Museum of Modern Art
Solomon R Guggenheim Museum **

Philadelphia
Philadelphia Museum of Art

Poughkeepsie
The Frances Lehman Loeb Art Center,
 Vassar College

Richmond
Virginia Museum of Fine Arts *

St Louis
Saint Louis Art Museum **

San Antonio
The McNay Art Museum

Toledo
Toledo Museum of Art

Washington, DC
National Gallery of Art
The Phillips Collection **

Williamstown
The Clark Art Institute **

Worcester
Worcester Art Museum

Private collections

Galerie Dina Vierny
The Gwinnett family
William W and Nadine M McGuire
Seibert Collection
Rudolf Staechelin Collection
Keith Stoltz
and those lenders who wish to remain anonymous

Henri Loyrette

'Into the far distance and into the self': what Gauguin saw from his window in the Marquesas

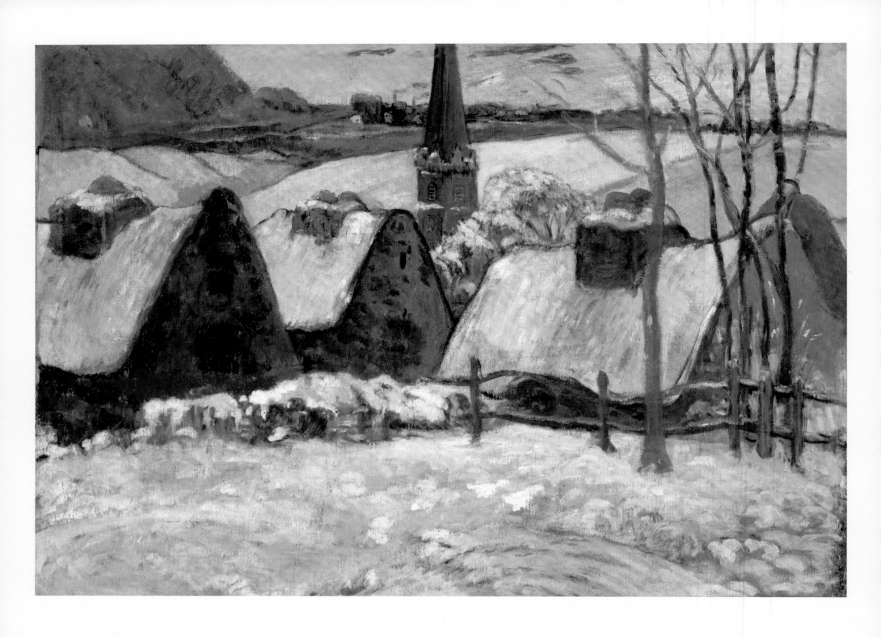

Breton village in the snow
(*Village breton sous la neige*) c 1894
oil on canvas
62 × 87 cm
Musée d'Orsay, Paris. Purchased with
funds from an anonymous Canadian
gift 1952, RF 1952 29

ON 20 SEPTEMBER 1902, at the age of 24, Victor Segalen was appointed medical officer to *La Durance,* a colonial dispatch-boat based at Papeete. Four months later, he arrived in Tahiti to take up his post and immediately left on a tour of the Pacific Islands. In early August 1903, *La Durance* docked in the Marquesas Islands to pick up the personal effects of Paul Gauguin, who had died at Hiva Oa on 8 May. In the chest of documents collected by the acting colonial administrator, Segalen discovered the manuscript of *Noa Noa* and, some days later, was able to speak in Hiva Oa to people who had known the artist. On 2 September, back in Papeete, he attended the second auction of Gauguin's effects, and bought seven pictures, including *Breton village in the snow* c 1894 (p 30), the painter's palette, and five wood carvings that had formed part of the decoration of the Maison du Jouir,[1] the artist's last home. On 29 November, the first letter that Segalen wrote to Daniel de Monfreid, Gauguin's friend and executor, marked the beginning of a lasting friendship.[2]

Behind this scant biographical summary lies a story that illuminates not only the origins of a great writer but the life and critical fortunes of Paul Gauguin. When he embarked for Papeete at Le Havre, Segalen was a sickly young man suffering from ailments that he himself diagnosed as neurasthenic. Debarred from a naval career by myopia, he chose to become a medical officer. But he was also a good musician, an admirer of Wagner, a reader of Rimbaud and Nietzsche, and friend to Joris-Karl Huysmans, the symbolist poet Saint-Pol-Roux and Rémy de Gourmont, who introduced him to the *Mercure de France* circle. Before his departure, he heard about Gauguin from Saint-Pol-Roux, who had met the painter in 1886,[3] and from Gourmont and the *Mercure* milieu, with which Gauguin kept company in Paris and regularly corresponded during his stay in Polynesia.

But his was a limited knowledge, based on word of mouth rather than any serious acquaintance with the artist's work. Fortuitously, the journey via New York City and San Francisco became a voyage of initiation thanks to the conversation of archaeologist Léon Lejeal, a 'specialist in old things from the New World'.[4] Lejeal showed him the rich pre-Columbian holdings of the American Museum of Natural History in New York and encouraged him to do ethnographic work in Oceania. When Segalen disembarked in Tahiti a few weeks later, his interest in Gauguin, prompted by his symbolist circle, was thus reinforced by a newfound curiosity about non-European civilisations. Gauguin became a model for him—a sort of 'secret sharer'—when, rejecting Lejeal's recommendation of scientific research on Polynesian peoples, he chose a novelistic approach, which bore fruit in *Les Immémoriaux* (*A lapse of memory*) 1907. Had not Gauguin already accomplished, in painting and sculpture, what Segalen aspired to do in fiction? To speak of Gauguin as Segalen did throughout his brief existence was to speak of himself, to plead *pro domo*; it was a way of discovering himself.

We are still indebted to Segalen's teleological vision of Gauguin's life and work; he saw the painter in his successive avatars going in search of ever-more 'primitive' sources in ever-more remote places, seeking a condition ever-more like that of 'savagery'. This had led Gauguin first to Brittany, then to Martinique, Tahiti and the Marquesas, and transformed the self-taught impressionist and pupil of Pissarro into an artist close to the 'Māoris of the forgotten past' who painted 'the man of former times'.[5]

When Segalen reached Hiva Oa, all that remained of Gauguin was his ashes. But the embers were, figuratively speaking, still warm. There he turned to his *Journal*:

Hiva Oa is something else as well—the encounter, via a demimonde, of a drop of pure symbolism. I have made my dutiful pilgrimage to Gauguin's studio, a fairly ordinary long *fare* [house] now completely bare, stripped clean. Gauguin died on 8 May. A morphine addict, worn out by alcohol, his heart failing, that morning he summoned his faithful Tioka; had a long, insightful conversation with Monsieur Vernier; then, having asked for some medicaments, died while they went to get them. He was loved by the natives, whom he defended against the gendarmes, the missionaries and the entire apparatus of murderous 'civilisation'. For example, he informed the last Marquesans that they could not be forced to go to school. *That was, in a way, the last remaining support for the ancient forms of worship.* Opposite the entrance to his *fare*, under a crudely built roof, there was a curious earthen figure; a Buddha, but one apparently born in Māori country, still intent on his ritual pose but having taken on Marquesan features. Below it, verses in Gauguin's hand:

TE ATUA
The gods are dead, and with them Atuana. [...][6]

It is a short but handsome obituary; the solitude and despair are there but it also touches on Gauguin's art—his Symbolism and Syncretism—and does justice to his militancy. Through this decisive, initial contact, and his reading a few days later of the manuscript of *Noa Noa*, Segalen immediately identified Gauguin as an 'outlaw', whom he came to associate with Nietzsche and Rimbaud. Gauguin revealed Segalen to himself and defined his future path. 'I shall perform an act of piety,' he wrote, 'by assembling as many as possible of these notes, books and manuscripts, which *I alone* can appreciate here—and *I pride myself* on it—because everything that I love is brought together here, the entire *Mercure de France* family, all whom I claim for my own in Paris...'.[7]

The short time spent by Segalen in the Marquesas was quite enough to register the fragility of Gauguin's traces. Faithful to his promise, he strove to record them, listing the relics (pictures, manuscripts, carvings, etc) and gathering oral evidence. Some months later, in January 1904, he assembled these meagre remains in a magnificent funeral oration, 'Gauguin dans son dernier décor' ('Gauguin in his last setting'), which was published in *Mercure de France* on 1 June.[8] Reference to Symbolism, so revelatory in the first flush of the *Journal*, might have seemed inevitable in this, its house magazine, but though he writes in symbolist mode, Segalen does not so much as mention the word. That is because he no longer saw in Gauguin the assiduous reader of the *Mercure*, the friend of Gourmont, Alfred Jarry, Saint-Pol-Roux, Albert Aurier and Julien Leclercq. No, Gauguin was, Segalen wrote, a 'monster', a man 'who could not be contained within the moral, intellectual or social categories by which most individuals are adequately defined'—a 'monster', then, detached from the Paris milieu, 'primitive and uncouth', 'various and, in everything he did, excessive'. His house (his 'last setting') was an expression of the man's nature, and to describe it was to portray him: it was his 'scenic gesture'. Grown from 'the grassy soil', it espoused nature; 'sprung forth without affectation from the resources of the land', it used only native techniques. Before going into the house, Segalen returns to the 'curious earthen figure' that had caught his attention before. To the brief description in the *Journal*, he adds the fragility of the 'desiccated clay, crumbling in the rain', the propitiatory character of the 'divine effigy',

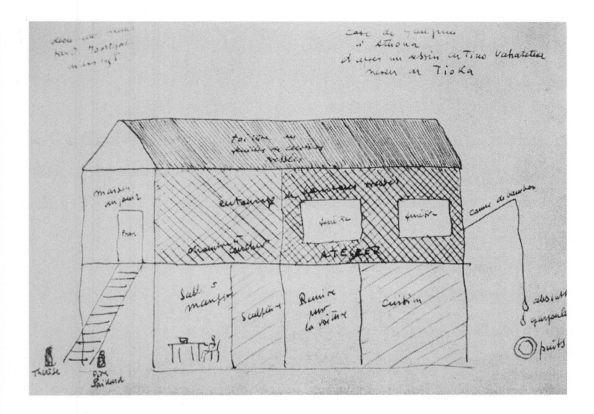

a 'representation of the atua [god] of days gone by' but paradigmatic of Gauguin's composite art: 'the pose is Buddhist', he observes, 'but the muscular lips, the eyes prominent and close together [...], the straight nose barely wider at the nostrils, all these are native features'. And he concludes with that lapidary description from the *Journal*: 'It is a Buddha but one born in Māori country'.

Under this statuette was a title and some lines in Gauguin's hand, which Segalen recorded:

TE ATUA
The gods are dead, and with them Atuana.
The sun that once set him ablaze now dozes off
In dismal sleep, with only brief awakenings to dream:
Then in Eve's eye there dawns the tree of regret
Pensive, she smiles down at her breast
Of sterile gold, sealed by divine intent...[9]

Then Segalen climbs the 'short staircase that leads to the raised wooden floor', paying no heed to the lower parts of the hut (dining room, sculpture studio, a shelter for his trap and the kitchen[10], fig 1) and comes to a 'minimal room opening onto the studio itself, whose entire gable is wide open to the light'. The outer door is framed with carved wooden panels:

seeming at once rough-hewn and precise, with explanatory captions and rubbed with matt colours; at the top is incised 'Maison du Jouir' [House of Pleasure]. On either side are two panels in which shadowy figures with fleshy, blue-tinged lips advance in slow or convulsive poses, and which advise, in gold letters:

[Women,] be amorous and you will be happy—Be mysterious and you will be happy.

Then two nude female figures in clumsy outline like some prehistoric work.

This is the first published mention of a substantial ensemble: Gauguin's final masterpiece and all that remains today of his 'last setting'.[11] In the studio itself, Segalen speaks of a 'jumble of native weapons', 'a little old organ', a harp, 'ill-assorted pieces of furniture and very few pictures'. Among the latter were two self-portraits: one from 1896, *Near Golgotha* (p 54), 'the pain-filled portrait in which, on a background of barely discernible calvaries, the powerful torso rises', and the other, more recent, which 'in a wholly oblique pose' articulates the 'strong neck' and 'imperious nose' (p 45).[12] 'Very much to the fore in the studio' was 'the most interesting work', *Maternity II* 1899 (Private collection), but also 'the work of his last moments', the 'glacial vision of Breton winter' (p 30) that Segalen believed to be the last picture Gauguin ever painted.

But Gauguin's 'last setting', as Segalen went on to write, also included the 'pale Marquesans' amid whom Gauguin lived out his last months; some of them 'faithful and good', and others menacing, but all incompatible with western morality and affording the artist 'splendid forms' and an entire repertory of poses. He staged them on a 'panoramic backdrop', the magnificent landscape that surrounded him: 'a great vertical drop into the delectable valley from the giant mountain-wall, striped with slender metallic waterfalls, and topped by a perpetual bank of stagnant, horizontal clouds that shears the mountains of their serrated peaks'. In the foreground, beyond the tall, rocky headlands by which the shore is framed, the sea is no longer the calm, flat waters pacified by the reefs that protect Tahitian beaches, but an ocean in perpetual, clamorous motion, which 'lives and beats and erodes'. Yet in this fragrant, resonant landscape, where everything exults in its excess of life, the 'tall, slim, pallid Marquesans' are dying—indeed, dying out—devastated by opium, alcohol, consumption and syphilis, the gifts of 'civilisation'. 'In ten years,' Segalen predicts, 'they will have ceased to be "savages". They will simply have ceased to be.' The gods are dead and humankind will soon follow. 'Therefore, on one clear morning of the cool season, Gauguin died there too.'

—

In 1916, in a final 'Homage to Gauguin', Segalen again returned to that 'painful spectre'—to the painter who had haunted his entire life. The homage was written to preface the correspondence between Gauguin and Daniel de Monfreid.[13] His long essay spared only a few paragraphs for the work it was intended to introduce, instead giving a biography of the painter complemented by Segalen's own memories. Over the previous 12 years, a once-indistinct image had gained focus. Jean de Rotonchamp[14] had published his biography and Octave Mirbeau and Daniel de Monfreid had been busy; Ambroise Vollard was spreading both the word and the works, while Charles Morice, in his 'Enquête sur les tendances actuelles des arts plastiques' ('Inquiry into current trends in the plastic arts') 1905 had established Gauguin's importance in the artistic scene—on a par with that of Cézanne—and defined him as the 'primitive' par excellence.[15] In France as in Europe and America, exhibitions had proliferated: in Paris (Salon d'Automne 1906; Galerie Ambroise Vollard 1910), Budapest (1907), Munich and Dresden (1910), London (1911), St Petersburg (1912), New York, Chicago and Boston (1913), Stuttgart (1913) and Dresden (1914).[16] Shchukin and Morozov had acquired an

impressive series of masterpieces and, in 1913, thanks to Henri Focillon, *Nave nave mahana* 1896 (*Delightful day*, Musée des Beaux-Arts, Lyon) had become the first Gauguin work acquired by a French public collection.

Segalen himself had changed, distancing himself still further from the symbolists. He had found in China a world 'the opposite of our own [...], at the furthest extreme of the civilised countries', and now considered the 'tropics' 'exotic' in terms of its climate but not its 'humanity'.[17] Gauguin, his secret sharer, had accompanied him all the way, developing in tandem with him. Segalen's biographical sketch lazily rehearses Rotonchamp's discoveries: Gauguin's Peruvian ancestors, the tribulations of the young sailor, the success of the 'apprentice banker' and his marriage into the 'grand bourgeoisie of Copenhagen', which marked the summit of 'this model life'. And the sudden and miraculous revelation of painting. 'Now let my readers finally deign to show their astonishment: in this chronicle of a great painter, by now over 28 years old, painting has never yet been mentioned.' Gauguin's painting, in Segalen's view, was not owed to the influence of Gustave Arosa, the friend of Pissarro and a fervent collector, but to the 'propagative virtue' of Sundays, an 'emptiness' that, after the overburdened week, made room for idleness and boredom: 'One fine Sunday, to fill time, Gauguin began to paint'. It is a strange account of a vocation. There follow the details of his new career: Pissarro's lessons, Huysmans's enthusiasm for the *Nude study* (Ny Carlsberg Glyptotek, Copenhagen) exhibited at the *Impressionist* exhibition of 1881, the calamitous stay in Denmark quickly followed by penury, incomprehension and the disintegration of his marriage. The successive destinations: Brittany, Martinique, Brittany. And then Paris in 1889–91, those two years during which, according to Segalen, Gauguin's genius was under threat, captive as he was to the symbolist milieu and therefore among youths whose only occupation was to 'tear into the not merely gamy but downright rotten flesh of Naturalism'. And 'this is why Gauguin's Paris adventure amounted to little more than a single bad canvas, its theatrical props placed without rhythm or gravity—a fox, a rustic wedding, a nude girl—the whole thing wrought together in a pasty effort under the heading *The loss of virginity* [The Chrysler Museum, Norfolk] and quickly consigned to the attic'.

But after this long preamble, in which Segalen piles on early disappointments and fumbling errors, the hour of redemption sounds: 'Finally—and the many words expended so far in this homage lead only to this—Paul Gauguin, at the age of 43, turned towards the country most remote from all the continents, the archipelago scattered over the seas of the Great Ocean and, choosing among thousands of islands the One and Only, packed his bags for Tahiti'. It was an instinctive choice 'gloriously rewarded', since there Gauguin received the 'revelation of his mastery': '[The] domain where he built his reigning house was revealed to Gauguin by Tahiti'. Thanks to this almost mystical encounter, Gauguin at last found the 'palette' that he needed, in other words the physical and mental singularity, enigmatic and incomparable, of Māori men and women, a theogony 'all phosphorus and fire', a cornucopian nature, desire and its fulfilment, 'sleep, awakening, bathing and the cool air'. All at once, after so long a wait, a sense of proximity and comprehension. They explain why 'Gauguin now painted in desperate fury, day and night':

> For Gauguin had within him this singular genius of the species, the demon of archaicism at the very birth of time. To go back to the Māoris of the forgotten past was no effort; he found himself in them or very close to them, and quite naturally painted the man of former times.

But in Segalen's eyes, Gauguin, during this first Tahitian sojourn, was already close to the end. Death was stalking him and he knew it; he was 'haunted by unhappiness', by the precarious balance between destructive and creative powers. Confronted with the misdeeds of the colonial power, with administrative obstructionism and disdain for his art, he took up the Māori cause and involved himself in interminable struggles. When he reached the Marquesas in September 1901, Segalen asserts, Gauguin knew that he would die there. There he built something that he had never known in previous and fleeting habitations, his first and last house. And there Segalen found Gauguin, a man he had never known alive though they had been 'contemporaries in Polynesia'. In a long coda, the author-navigator returns to the end, to Atuona, the little kiosk housing a god, and the Maison du Jouir, enriching his description with new layers. He brings into play the testimony of the Marquesans and of the Protestant priest Vernier, who helped Gauguin till the last. He again evokes the self-portrait *Near Golgotha* (p 54), emphasising the Christ-like nature of the figure and insisting on Gauguin's awareness of his approaching death, expressed in a frenzy of painting and writing ('gripped by fear of death, he painted and he wrote'). Here are Gospel-like pages, from which nothing is missing: not the agony in the garden, nor Christ's 'remove this cup from me'; not the desire to create a legacy nor the hostility of the Pharisees. Segalen would have liked to bring back the 'clay statue, a foot high'. In it, he discerned the 'savage genius of Gauguin'. But it was already too late. The little god too was returning to earth: dust to dust. All he could find was the wooden pedestal with the inscription copied onto it by Gauguin: 'The gods are dead'.

—

In his anxiety to decipher Gauguin's personality and gauge why he felt so strong a connection, Segalen says little about the paintings and it would be hard to divine the characteristics of Gauguin's art from this extensive homage. The nature of that corpus is best understood *a contrario*—since Gauguin is never named—from the essay that Segalen devoted to 'Gustave Moreau, maître-imagier de l'orphisme' ('Gustave Moreau, master image-maker of Orphism') 1908. Moreau's paintings, 'escaping, in an astounding, a paradoxical swerve, from the conventions of French painting', find refuge exclusively in literature and thus facilitate the most various and uncertain interpretations; they illustrate the fundamental misunderstanding of a 'marvellous poet [who] wanted to be a painter, and for 60 years painted ideas and drew epics'. Segalen notes the absence of stylistic variation in Moreau's corpus; there is no development, there are no 'periods'; it can only be categorised by subject, its divisions are 'all thought, all narrative'. The primacy of the idea leads to the 'obsessive repetition' of 'identical curves' and 'unchangeable shades'.

This is the original sin: the means of expression are subordinated. Line and colour no longer match and 'draughtsmanship, outline and profile' impose themselves 'independently of mass, values and shadow'. This chaos is compounded by the dishonest use of materials: in Moreau, oil imitates enamel, embroidery and the glitter of jewels, and is satisfied with 'every bastardised manifestation, facsimiles, bronze-stained white, artifices of all kinds', whereas '*Matter* should speak for itself'.[18] In short, for Moreau, any sleight of hand will do to promote his ideas, which take their form in a setting of overweening and error-prone erudition, borrowing from India, Egypt, Greece and Persia, confusing languages and syncretising the most diverse references. The 'ceremonious mantle' that envelops it constitutes,

in Segalen's eyes, the glory of 'Moreau-civilisation', but the intellectual world beneath is 'sterile'.

Alongside Moreau's recalcitrance toward novelty, his reclusiveness and the sense that he was buried under the weight of his ideas, Gauguin is the perfect counterexample: an artist whose work constantly changes, period by period; who seeks variety in his materials and a match between medium and subject, line and colour; who seeks inspiration in multiple sources and is not averse to mixing them but never abandons the test of reality, the initial study from nature, even if it is then alchemically transformed; who never seeks shelter in the comfort of home but is always looking for more distant and 'wilder' horizons. Moreau died entombed in his Paris museum-mausoleum by the world that he had created, while Gauguin died remote from Paris in the house that he had built for himself, a precarious establishment of which only a few relics and the vagaries of memory survive.

—

Let us therefore start with Gauguin's last months in the Marquesas, from the point where he had become 'that legendary artist who, from out of the depths of Polynesia, sends forth his disconcerting, inimitable works, the definitive works of a man who has disappeared from the world', who like 'the great dead' has already 'entered the history of art'.[19] Let us start with Segalen, with a time when the traces left by Gauguin had not yet been effaced. Start with the last self-portrait and look back towards the first. Start with his last piece of writing, *Avant et après* (*Before and after*) 1903, which summarises an entire life, reviving hostilities and friendships, and has the value of a testament. Start with the Maison du Jouir and this 'last setting'. For *Gauguin's World: Tōna Iho, Tōna Ao*, this first exhibition in Oceania, let us begin at the end, with the death of a French artist at the ends of the earth, not in order to retrace the fortunes and failings of an unparalleled career, but in order to meditate, from that perspective, on what occurred.

With the Maison du Jouir, Gauguin—who till then had only ever lived in improvised circumstances—for the first time constructed a house to match his own taste and meet his own needs. He wanted it to be definitive, unlike his earlier and ill-fated construction at Puna'auia. It owed little to Marquesan houses but as has often been remarked was freely inspired by those he had seen in the Auckland Museum of Ethnology during his short stay there in August 1895. A house on two floors: at ground level, the services, with the kitchen at one end, at the other his sculpture workshop, both partitioned; between them an open dining room. On the first floor, reached by external stairs, a narrow room separated by a partition from the studio, which was a vast space oriented north-west and illuminated by several large windows. The studio 'was an absolute lumber-room, without any sort of order. A small harmonium stood in the middle of the floor, the easels being placed in front of a large window at the far end of the room.' There was also a mandolin, a guitar, 'two chests of drawers', strong padlocked chests and 'shelves made from ordinary wooden planks'. 'On the walls,' as the Swedish anthropologist and writer Bengt Danielsson notes, 'were some reproductions of paintings and 45 pornographic photographs, which he had bought at Port Said on the way out from France' in 1895.[20] Today there is a replica of the Maison du Jouir on its original site at Atuona. Yet all that remains of the original are the panels that once framed the entrance, which were bought by Segalen and are now in the Musée d'Orsay (fig 2).

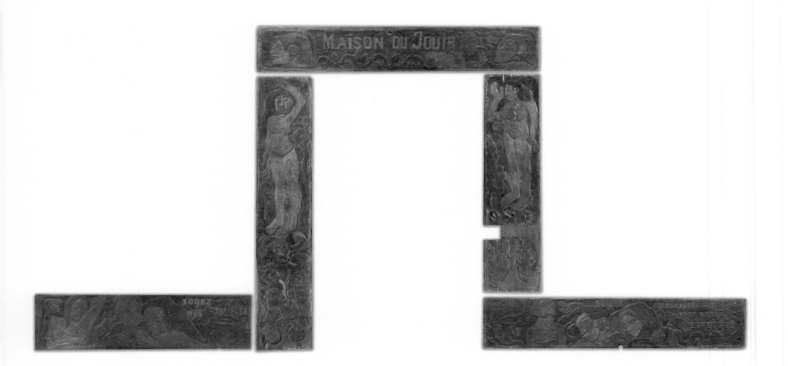

Scholars have focused on these, Gauguin's final decorative masterpiece, at the expense of the design of his final dwelling. The panels have been variously explained; many disparate sources have been suggested and the story of their survival has been traced,[21] but they remain enigmatic. Not least the name Maison du Jouir, carved into the lintel and cited as if self-explanatory. But here Gauguin uses French—he who was so careful to give vernacular titles to his Polynesian works; this was clearly for his own benefit. It is his *maison* ('house') and more stable and definitive than a *case* ('hut'), the word that he regularly used for his Tahitian dwellings. It is a word rich in meaning. The other noun that he uses, *le jouir*, is very rare, though found in Montaigne ('C'est le jouir non le posséder qui rend heureux': It is the enjoying not the possessing that makes us happy).[22] The name Maison du Jouir therefore has an archaic flavour at one with the 'primitive' quality of the carved panels: a Rabelaisian sonority that mockingly evokes the names conventionally bestowed on French 'secondary residences'.[23]

Taking 'house' in the sense of 'bawdy house' and *le jouir* as the climax of sexual pleasure, it is often assumed that the name referred to a tropical brothel. It is possible that Gauguin entertained this provocation, seeking to 'exorcise' a plot of land granted by the church. But the words are not monovalent and cannot be restricted to this amiable joke. Today the intransitive verb *jouir* means 'to orgasm' and this, as the *Dictionnaire Robert de la langue française* decrees, 'makes the absolute use of the verb in any other context difficult'. But in the nineteenth century the word was more broadly understood. Listing the uses of *jouir* with an indirect object, Émile Littré's *Dictionnaire de la langue française* 1878 notes 'To be able to profit from / [enjoy] what one has, life, time, fortune' and 'feel a sensual pleasure' without that acceptation being confined to the sexual. And both dictionaries cite the speaker in Lamartine's poem 'Le lac' ('The lake') 1820: '"Let us love then, let us love! Let us make haste and enjoy [*jouissons de*] / the fleeting hour!"' *Jouir* thus means seizing the day rather than trusting to the consolations of the afterlife. In the words of the epitaph allegedly composed for the comtesse de Verrue, it means

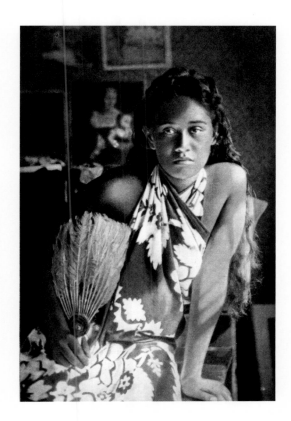

making 'one's paradise in this world—just to be sure'. Thus Gauguin in his final dwelling-place—we might almost say his tomb—also lived in his paradise.[24]

He built this house 'in the centre of the village', though one could hardly divine its presence, 'almost entirely surrounded by trees' and 'cooled by breezes from the sea 300 metres away blowing gently through the coconut palms'. These lines are moving in their simplicity and happiness; Gauguin has, after so many tribulations, 'everything that a modest artist could dream of'. And he describes 'a huge studio with a bed tucked away in one corner; everything to hand, arranged on shelves; the whole thing raised two metres above the ground', 'where one eats, does a little carpentering or cooks'.[25] In *Before and after*, Gauguin tells us that the walls were papered with 'all sorts of odds and ends that appear extraordinary because here they are unusual: Japanese prints, photographs of paintings, Manet, Puvis de Chavannes, Degas, Rembrandt, Raphael, Michelangelo, Holbein'.[26] Further on, he details the photograph of a Degas 'painting' that he has in front of him, *Harlequin's dance* 1890—not, in fact, an oil but a pastel (Museo Nacional de Bellas Artes, Buenos Aires)—mentioning its strict geometry and the 'studied' gazes exchanged between the harlequin in the foreground and the distant dancers, though he sees no 'symbol' in the work, only 'choreography'.[27] From there he moves on to a triple portrait by Holbein, which is, he says, in Dresden—it is in fact in Basel: *Portrait of the artist's family* 1528–29 (Kunstmuseum Basel). He is astonished by the 'very small hands, too small, without bones or muscles'; they 'annoy' him.[28] The photographic portrait of Gauguin's model Tohotaua made by Louis Grélet in 1901 in the Maison du Jouir shows us how these works were arranged (fig 3). Just to the left of the model's head is the reproduction of the Holbein and above it that of the Degas pastel. Beside that is a photograph of Puvis's *Hope* c 1871–72 in its small version (Musée d'Orsay, Paris, fig 6), and below it a photo of a sculpted Buddha.[29]

It would be wrong to see these reproductions as mere documentation. Gauguin has something different in mind: in the Maison du Jouir, he is hanging his own museum.[30] The photos are large—full-scale, perhaps, for the Holbein and Degas—and framed. They bring to mind friends and supporters (Degas, Puvis) and shared admirations (Holbein), placing masters modern and old and works from different civilisations on an equal footing. One would like to know how Gauguin covered the other walls of his studio, the choice and arrangement of Japanese prints and photo reproductions from other artists. But confining ourselves to what we know from the Tohotaua photo portrait, we observe that the works exhibited had inspired and were still inspiring Gauguin. *Hope*'s pose is adopted in two masterpieces from 1892, *Vairaumati tei oa* (*Her name is Vairaumati*, Hermitage Museum, St Petersburg) and *Te aa no areois* (*The seed of the areoi*, The Museum of Modern Art, New York); the Holbein triple portrait shares with *Polynesian woman with children* 1901 (p 40) a maternal tenderness and the diagonal form of the hands, along with the unified background, simplified forms and limited range of colours.

Behind Gauguin's choices we sense his kinship with Degas, which had been growing over the previous several years. Degas, present in the 'Gauguin Museum', as we have seen, with *Harlequin's dance*; Degas quoted in *Still life with Hope* 1901 (p 43), in which, under Puvis's picture, Gauguin has depicted a Degas

OPPOSITE (FIG 2)
Maison du Jouir (House of Pleasure) c 1901–02
relief carving on sequoia (redwood) with paint
40 × 244 × 2.3 cm
Musée d'Orsay, Paris.
Purchased 1953, RF 2723

ABOVE (FIG 3)
Louis Grélet
Tohotaua 1901

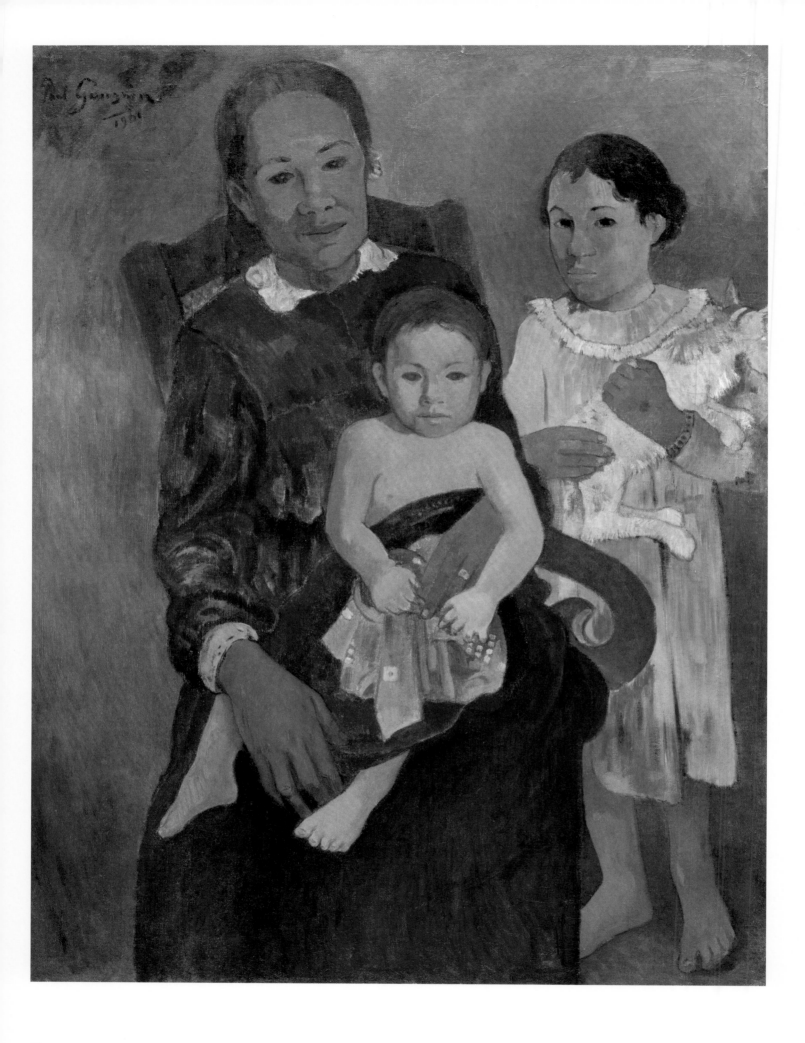

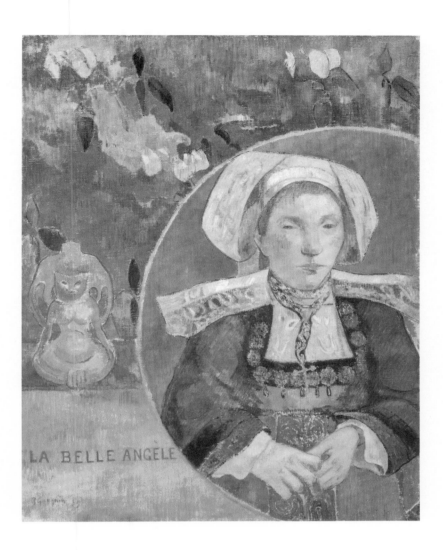

etching, *The little dressing room* 1879–80;[31] Degas revisited by Gauguin in *The siesta* c 1892–94 (The Metropolitan Museum of Art, Annenberg Collection, New York) in which, on a plank floor whose receding lines rise high into the picture (a formula dear to Degas), we see four Tahitian women resting like weary ballerinas; or again in the two paintings of *Riders on the beach* 1902 (Private collection, and Museum Folkwang, Essen), a Marquesan version of racecourses in Paris or Normandy.

They had in common their admiration for particular artists: Gauguin's admiration for Holbein was no doubt strengthened and may indeed have been implanted by Degas. When in 1891 Degas bought *The beautiful Angèle* 1889 (Musée d'Orsay, Paris, fig 4), he must have enjoyed the modern Breton interpretation given by Gauguin to Holbein's *Portrait of Anne of Cleves* c 1539, which he had copied in the Louvre many years before (fig 5). Holbein's paintings, particularly those in Basel, had a prominent place in Degas's imaginary museum; Daniel Halévy records one of his conversations in which, on 1 October 1896, the painter spoke 'with emotion of the Basel Holbeins' and thus of the picture that Gauguin so much admired;[32] in April 1895, Degas bought two albums of photographs reproducing Holbein works.[33]

The notion of a 'museum' was one of Degas's own preoccupations. We know how, mainly in the 1890s, he established a major collection, less to satisfy a hedonist passion than to see his own works in the museum he then envisaged surrounded by those of the artists he loved; in this way he rejected both the 'dubious bedfellows'

that he so detested in the hanging of the Musée du Luxembourg (the Paris modern art museum of the time)—by which he meant the company of academic artists he despised—and the egotistical museum of Moreau in which only Moreau appeared. Gauguin had a similar reaction when, in *Racontars de rapin (Ramblings of a wannabe painter)*, which he wrote in the Marquesas in September 1902, he denounced the Musée du Luxembourg as a 'whorehouse' in which the few impressionists granted admittance were forced to appear beside the dregs of academic painting.[34]
The 'Degas Museum' was not unlike the Maison du Jouir, featuring their contemporaries—Manet, Cézanne, Van Gogh and Gauguin himself, in a starring role—preceded by two masters, Ingres and Delacroix, whom Degas venerated and with whom he claimed kinship,

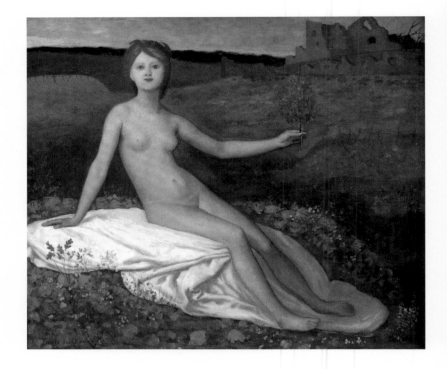

alongside an important collection of Japanese prints, 'casts of Javanese women's hands', Neapolitan dolls, textiles of all kinds (handkerchiefs, 'old oriental carpets'), a collection of walking sticks 'of all kinds and all shapes' including one presented by Gauguin in November 1893—in short, a mixture of works from various civilisations: arts specialised and popular, high and low.[35]

Still life with Hope (p 43) thus binds together the shared preoccupations and tastes that both men brought to bear on the idea of a museum. Clustered around the central sunflowers which evoke his friend Van Gogh—in 1895, Degas purchased Vincent's *Withered sunflowers (two cut sunflowers)* 1887 (Kunstmuseum Bern), which had previously belonged to Gauguin[36]—he placed an etching by Degas, emphasising the significance that both men attributed to the graphic arts, the painting of Puvis, whose synthetic touch Degas so admired, a little Japanese bowl and a larger Marquesan one.

In the Maison du Jouir, Gauguin felt that having lived—in the terms of his friend Mallarmé—in so many 'corridors', he had now found a 'room of his own'. True, here no curtains fell 'with familiar folds'; there was none of the upholstered comfort of the poet's house. But Mallarmé's house too was 'occupied by his thoughts'.[37] Gauguin had as we have seen freighted it with biographical significance; it, like his last works and writings, constitutes a kind of testimony, and therefore forms with them a single, indivisible whole. A very complex self-portrait and one of the last. Gauguin in a nutshell.

—

In September 1902, Gauguin's health suffered a further decline. To deal with the pain he was forced to 'fall back again on morphine injections' then, frightened of overdosing, 'he had recourse to laudanum, which made him perpetually drowsy'.[38] 'I don't seem to get better,' he wrote to Daniel de Monfreid in October 1902, 'I produce little and very poorly on account of the suffering I am in'.[39] In open rebellion against the colonial authorities and the Catholic mission, he had few friends on whom he could rely. Among them was Nguyen Van Cam, known as Ky Dong, a notably well-

ABOVE (FIG 6)
Pierre Puvis de Chavannes
Hope (L'Espérance)
c 1871–72
oil on canvas
70.5 × 82.2 cm
Musée d'Orsay, Paris, INV 20117

OPPOSITE
Still life with Hope (Nature morte à l'Espérance) 1901
oil on canvas
65 × 77 cm
Private collection, Milan

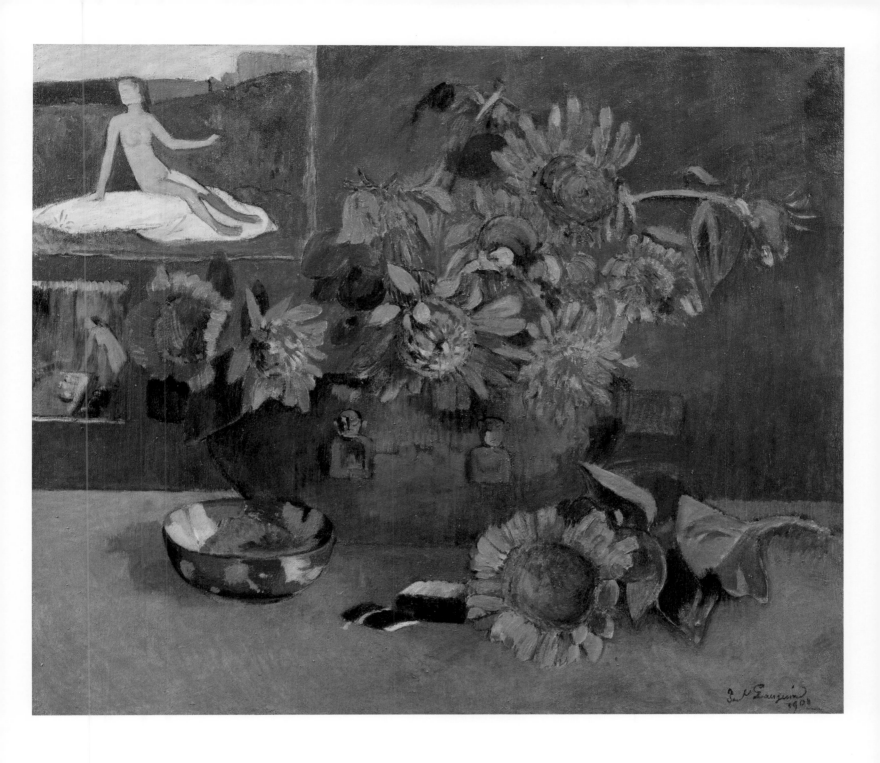

educated young Vietnamese (1875–1929), who had
been exiled to Hiva Oa by the French government of
Indochina for his anti-colonial activities. 'During this
depressing period,' Bengt Danielsson tells us, Ky Dong
'was one of the few persons [...] allowed into his studio'.
'One day, after failing in every [...] attempt to cheer his
friend up, Ky Dong sat down at one of the easels and
began to paint. Gauguin's interest was aroused [...] and
before long he had limped across [...] to inspect the
result. Ky Dong was painting his portrait. Without a
word, Gauguin picked up a mirror and, thrusting his
friend aside, took the brush and finished the portrait
himself.'[40] Danielsson learned this from Louis Grélet,
the photographer of Tohotaua, to whom Ky Dong gave
the work in 1905 (p 45). I should like to believe the
story but the thin, fluid paintwork shows no sign of a
new start or pentimento. The blue line that covers the
shoulders, outlines the neck of the shirt and emphasises
the right profile of the face in the manner of a beginner
establishing his composition might perhaps be
questioned. But the fact is that Gauguin, so attentive to
his own image, gives us here his final self-portrait.

And it owes nothing to the moment's prompting,
the desire to remedy a friend's incompetence or leave
him some little souvenir. After so many avatars, after
Gauguin had, to paraphrase Rimbaud, drained to the
dregs 'all the lives due to him' and was coming to the

end of his time, the artist showed himself as he was: a man in early middle age, his
face filled out and his gaze clear behind his eyeglass lenses. Neither arrogant nor
combative, but by no means resigned or dejected. No sign of despair or physical
pain. We are close to the self-portraits by Chardin or Bonnard: Gauguin as he sees
himself in the mirror. But unlike Chardin or Bonnard, this self-portrait is the last in
a long series that punctuated his career, a point that we cannot ignore. The small,
narrow portrait format is unusual. It presses in on the painter's torso, which stands
out on a neutral background and is bare of ornament. The face, turned slightly to
the right, catches the lateral light. Gauguin wears a white shirt, collarless like that
of men sentenced to death, though it could also evoke a vest, toga or priest's alb
.... The form, composition and extreme simplicity, concentrating attention on the
face, immediately bring to mind Fayum portraits (fig 7), those 'portraits of eternity'
covering the mummy at face level to safeguard the memory of the deceased.[41] It thus
acquires a memorial value—the image of one's self that one wishes to bequeath.
No more masks. Where are those heavily emphasised eye sockets and cheekbones,
the jaw whose angularity and the nose whose curve he so often exaggerated, the flesh
that he emblazoned with red and that disquieting, that incandescent sidelong gaze?

Yet it is the same man, close to the young, attentive artist who took refuge
in a Copenhagen attic, palette in hand, to give himself up to the craft he longed to
live by (p 47). 'There is but one thing that I can do: paint', he wrote to Pissarro then,
underlining the words as he ran afoul of in-laws who considered him 'less than
nothing'.[42] In that first self-portrait of 1885, Gauguin represents himself as a painter

ABOVE (FIG 7)
Unknown artist
Portrait of a mummy 250 CE
encaustic on lime wood
33 × 19 cm
Musée du Louvre, Paris.
Department of Egyptian
Antiquities, N 2732 1

OPPOSITE
Portrait of the artist by himself
(*Portrait de l'artiste par lui-
même*) 1903
oil on canvas
41.4 × 23.5 cm
Kunstmuseum Basel. Bequest of
Dr Karl Hoffmann 1945, inv 1943

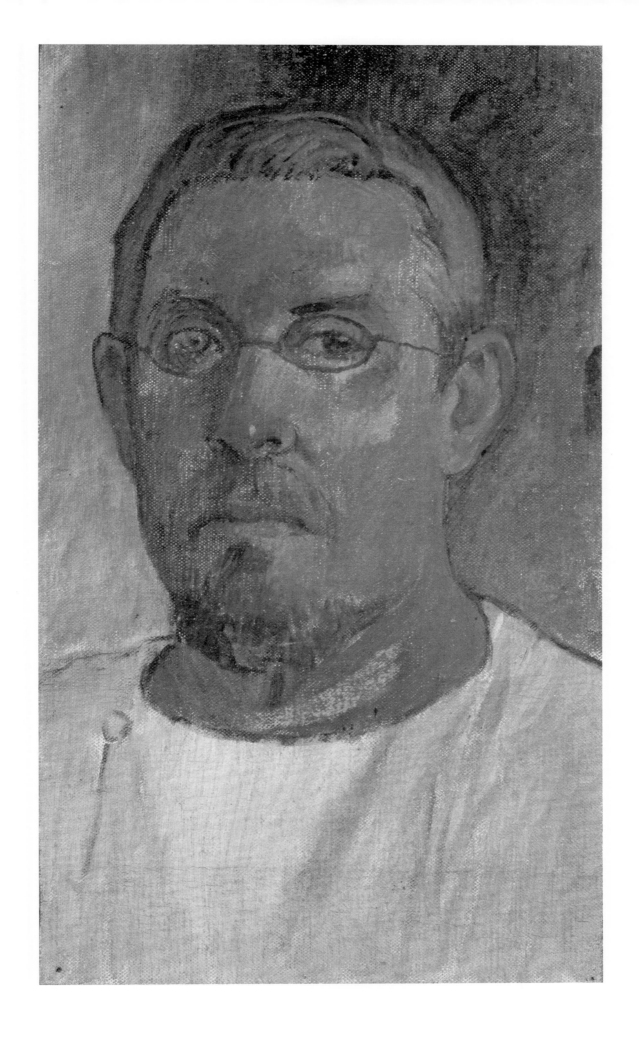

with the instruments of his profession in hand. He did this again, almost a decade later, showing himself in the 'bizarre costume' that ensured his notoriety in the artistic milieu, 'the Astrakhan hat, the enormous, dark blue greatcoat stiffened by precious embroidery, in which he seemed to Parisians a sumptuous, gigantic Magyar, a Rembrandt from 1635'[43] (fig 8). In this accoutrement he portrayed himself, to cite Françoise Cachin, as 'master and magus',[44] his authority underlined by the proud gaze, full of conviction, his hand prominently holding the brush. Gauguin painted this portrait for Charles Morice, the young poet, art critic and disciple of Mallarmé who had just published articles praising Gauguin: the 'Preface' to the catalogue of his exhibition at Durand-Ruel's gallery in November 1893 and, in December, a long article in the *Mercure de France* describing him as the leader of a movement contributing to 'the renewal and restoration of contemporary art'. And the portrait that Gauguin made for his proselyte therefore matches Morice's image of him—the master of 'a few sincere [artists] who follow him, Sérusier, Ranson, Denis, Vuillard, etc.'—and of his art. 'Let us here speak of painters' methods', Morice wrote, generalising from Gauguin's magisterial example:

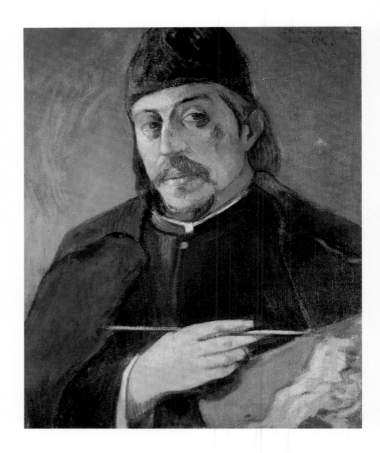

> With unimaginable speed, their thought is projected from their brains onto the spectacle—face or landscape—that they have before them, and to recover, to extract this thought from the spectacle, they unclutter, simplify, synthesise; set aside anything that could impede a clear view of the object; they reform, that is, they rectify everything that might deceive them as to the reality of the object.[45]

Thus, when he addresses Morice, Gauguin—often more prolix in his other self-portraits—'unclutters, simplifies and synthesises', standing out against a unified background and eliminating every accessory to the point where he effaces the embroideries and tracings of his garment and exalts his favourite colours, red, yellow and pink. This is Gauguin as seen by Morice.

Examining the 15 or so self-portraits painted or crafted by Gauguin, we can see that they answer to different ambitions and motives: portraits intended for friends (Van Gogh, Carrière, Morice, De Monfreid); those painted to fit a particular setting; some confined to the face; some with attributes; others again are 'pictures' in which the artist, easily identifiable, stages himself in some role or other. But he always takes care not to make 'a copy of a face', seeking instead, as he writes to Van Gogh, an 'abstraction'.[46] The term is not easy to define, but denotes a distancing from nature through 'altogether peculiar' draughtsmanship—this is intended to produce, by caricatural emphasis, an expressive 'mask'—and his recourse, in motifs and colours, to a symbolism sometimes extending to allegory.[47] With the exception of the first and last, all of Gauguin's self-portraits embody this complex alchemy.

Many have remarked on the self-promoting character of his self-portraits, as though they were born of hubris and had no other motive but publicity.[48] But as with

ABOVE (FIG 8)
Self-portrait with palette (Autoportrait à la palette)
1893–94
oil on canvas
92 × 73 cm
Private collection

OPPOSITE
Self-portrait (Autoportrait) 1885
oil on canvas
65.2 × 54.3 cm
Kimbell Art Museum,
Fort Worth, AP 1997.03

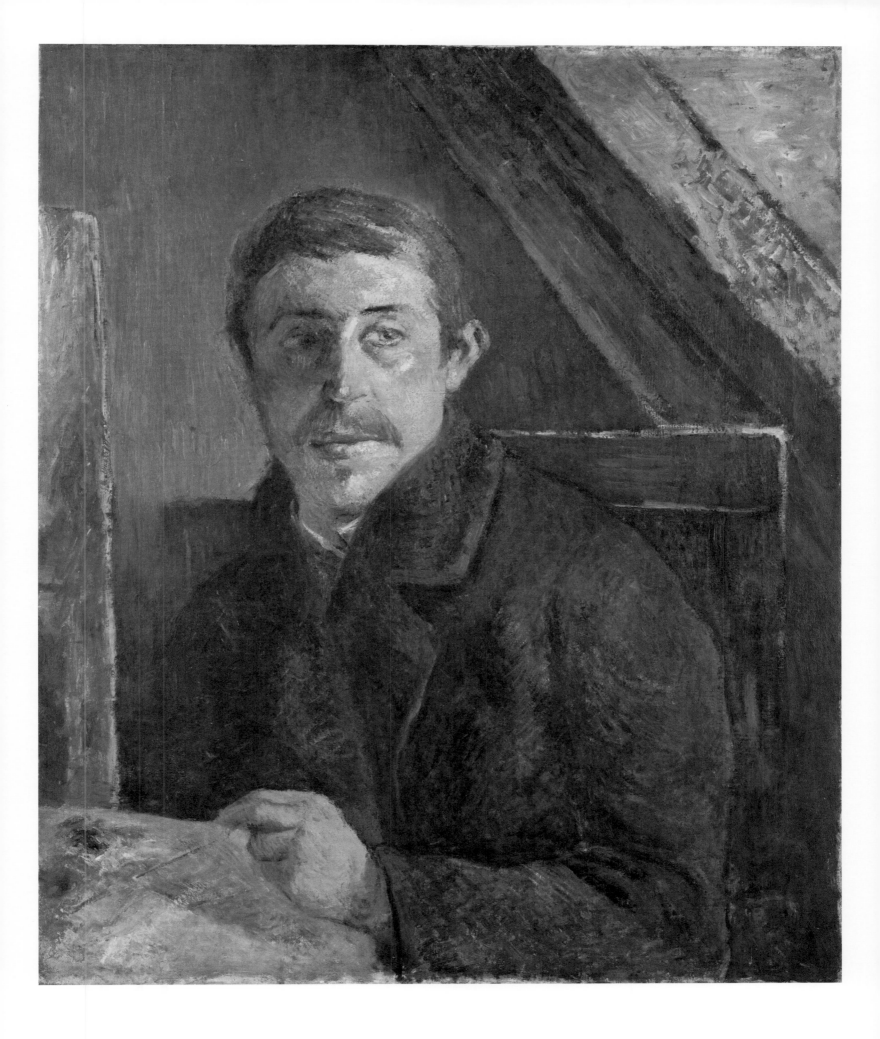

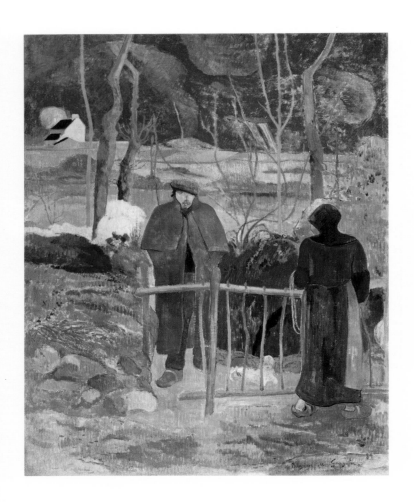

the self-portraits by Rembrandt, Courbet or Picasso, who also favoured autofictional representation, we should see in these works first and foremost a desire for introspection: the artist intent on expressing every facet of his innermost self while also setting down markers for his creative activity. Gauguin articulated this when he insisted on adding *Bonjour, Monsieur Gauguin* 1889 (National Gallery Prague, fig 9) to the exhibition of 41 works from Tahiti at the Durand-Ruel Gallery in 1893: 'He wanted this work to appear in his Tahitian exhibitions so that people could verify the logic of his development', wrote Morice, who co-organised the exhibition with Gauguin.[49] This self-portrait was preceded by a smaller version, also painted in 1889, to decorate the inn of his landlady, Marie Henry, at Le Pouldu (p 49). In the earlier version, now in the Hammer Museum, Los Angeles, the two protagonists (Gauguin and a Breton peasant woman) are smaller and the landscape is larger; they are more distant one from the other and the young woman moves towards the painter, whereas in the second she moves away. But the composition is essentially the same and, to revert to the distinction made from the outset among the self-portraits, both are 'pictures'. Both bear the inscription *Bonjour, Monsieur Gauguin*, at once title and signature; this is clearly a reference to Courbet's masterpiece *Bonjour, Monsieur Courbet* 1854 (fig 10), which entered the Musée Fabre in Montpellier along with the rest of the Bruyas Collection.

Gauguin visited that museum twice: in April 1884, when he made an oil copy of Delacroix's *Study based on the Aspasia model* c 1824 (Musée Fabre), and in mid December 1888, with Vincent van Gogh. It has been suggested on the basis of the second visit that *Bonjour, Monsieur Gauguin* was a response to Courbet and that it

ABOVE LEFT (FIG 9)
Bonjour, Monsieur Gauguin 1889
oil on canvas
93 × 73 cm
National Gallery Prague, O 3553

ABOVE RIGHT (FIG 10)
Gustave Courbet
The encounter or *Bonjour, Monsieur Courbet* (*La rencontre dit aussi Bonjour, Monsieur Courbet*) 1854
oil on canvas
132 × 150.5 cm
Musée Fabre, Montpellier. Gift Alfred Bruyas 1868, 868.1.23.

OPPOSITE
Bonjour, Monsieur Gauguin 1889
oil on canvas and panel
74.9 × 54.8 × 1.9 cm
Hammer Museum, Los Angeles. Gift of the Armand Hammer Foundation. The Armand Hammer Collection, AH.90.31

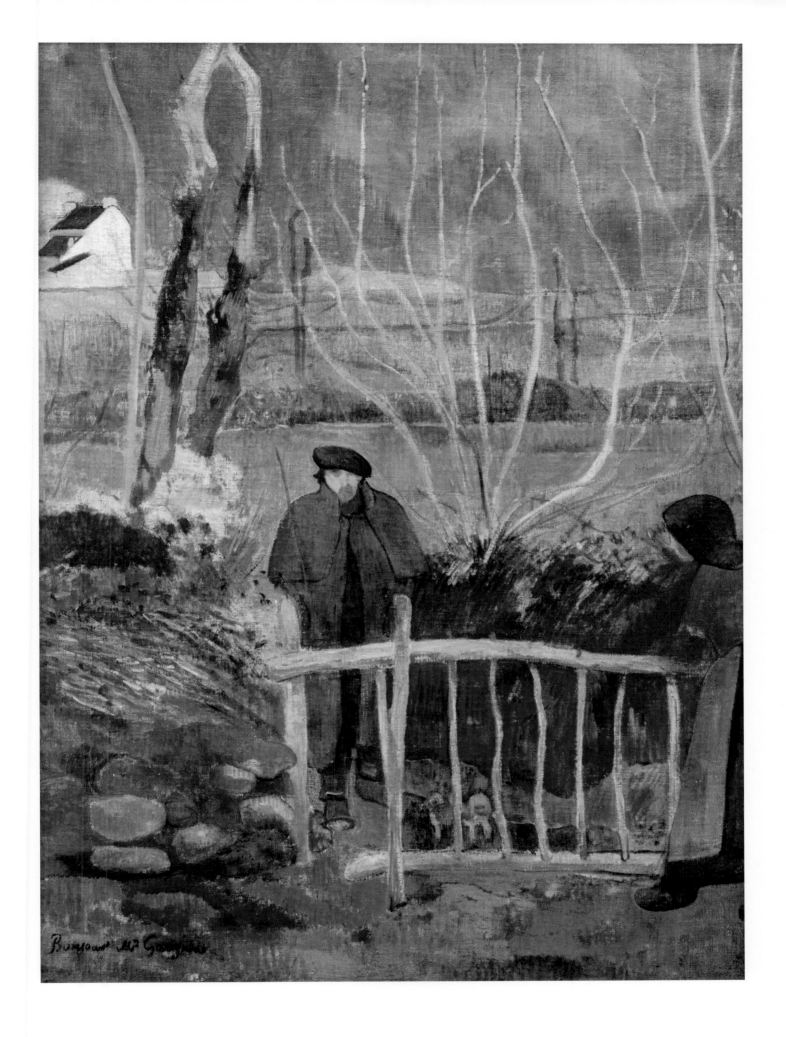

also pertains to Gauguin's tumultuous relationship with Van Gogh.[50] If this is true, there are nuances to add. As Gauguin said, the titles that he gave to his works—often inscribed on them—came *after* their execution; they do not therefore record the piece's inspiration so much as comment on its finalised form. Moreover, in their accounts of the museum neither artist has a word to say about *that* Courbet. Vincent immediately set down his reactions to the Musée Fabre in a letter to his brother Theo, while Gauguin said nothing, leaving Vincent to speak for him.[51] For both artists the visit, followed by an 'excessively electric' discussion, clearly left a mark. Vincent enumerates the portraits of Alfred Bruyas by various hands, dwelling on the one by Delacroix, in whose 'gentleman with a beard, red hair' he saw a striking resemblance to Theo and himself. But among the 'loads of Courbets', he mentions only *Young ladies of the village* 1851–52 ('magnificent') and *The sleeping spinner* 1853 ('superb').[52] It was not till early 1903 that Gauguin again spoke of his two visits to Montpellier, this time in *Before and after*, which was written in the Marquesas. In fact, he dwells only on the first and solo visit—no doubt wishing to minimise the role (and memory) of Van Gogh. He mentions, in passing, works from the Bruyas Collection—the many portraits, the paintings by Delacroix, Corot, Octave Tassaert—and 'a […] number of pictures' by Courbet, 'among them his great picture of the bathers'. But he concentrates on two masterpieces: one 'a masterly canvas by Chardin', which was in fact the *Portrait of Mme Crozat* 1741 by Jacques Aved, bought by the museum in 1839—a 'source of joy', he says—and the other 'by Ingres […] a famous picture the title of which […] I have forgotten', which was Ingres's *Antiochus and Stratonice* 1866, acquired in 1884. The visit of December 1888 is given perfunctory treatment: 'A good many years later I returned, in Vincent's company, and visited the museum again'.[53]

Gauguin's memory may be failing, he may be mistaken in his attributions and he may at this point in his life prefer his memories of Ingres and 'Chardin'—though they can hardly have been the subject so vehemently discussed with his friend. But it is strange that he makes no mention of *Bonjour, Monsieur Courbet*, which was bound to remind him of one of the paintings that meant most to him. So it is possible that the title was invented and added to the earlier of the two self-portraits as a sort of knowing wink to the artists who frequented Marie Henry's inn. There could hardly be a more striking contrast than that of Courbet, striding ahead, sure of himself and open to the world, and this monolithic, motionless Gauguin, buttoned into his greatcoat, his face partly occulted by the beret that covers his left eye; between, on the one hand, the patron and his servant respectfully saluting the great artist armed with his parasol and his painting set and, on the other, the astounded Breton peasant woman, who is perhaps alarmed by this vagabond personage; between the flat, graceless landscape, placed there only to open up a vast stretch of blue sky on which the three figures stand out, and the intricate landscape full of bare, slender branches that envelops Gauguin and the young woman; between the glittering heat of summer and the disquieting gloom of winter. These are the contrasts that Gauguin evokes when he refers to Courbet's painting in his title.

Indeed, the parody is exacerbated by the fact that *Bonjour, Monsieur Courbet* was the title bestowed in 1855 by critics and the public in order to make fun of Courbet's arrogance; for the artist, it was *The encounter*. Gauguin is making fun of himself: here, a generation later, is what an artist promoting his new art had become. Instead of an enlightened collector, an uncomprehending peasant woman; the road weaving its way into the distance had become a path closed off by a gate; and isolation and cold lie all around.

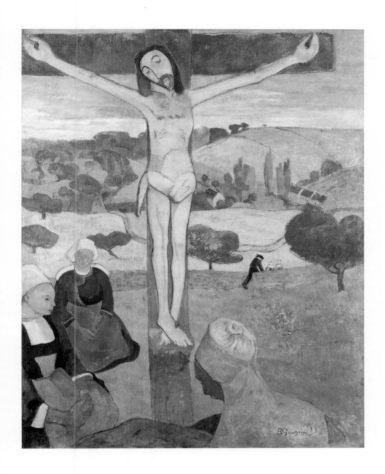

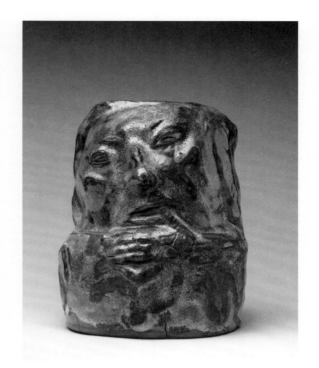

LEFT (FIG 11)
The yellow Christ
(*Le Christ jaune*) 1889
oil on canvas
92.1 × 73.4 cm
Buffalo AKG Art Museum.
General Purchase Funds 1946,
1946:4

RIGHT (FIG 12)
Anthropomorphic pot
(*Pot anthropomorphe*) 1889
glazed stoneware
28.4 × 21.5 (diam) cm
Musée d'Orsay, Paris. Gift of
Jean Schmit 1938, OA 9050

On the topic of *Bonjour, Monsieur Gauguin*, many critics have cited Gauguin's letter to his friend Émile Schuffenecker, dated 'around 20 December 1888' and therefore contemporary with his visit to Montpellier in the company of Van Gogh: 'Vincent sometimes calls me the man who comes from afar and is going afar'.[54] Van Gogh was speaking of a creative and spiritual journey rather than a trekker's prowess. As Gauguin says in the same letter, 'According to the legend, the Inca came directly from the sun, to which I shall return'.[55] But, in *Bonjour, Monsieur Gauguin*, he makes an allegory of this itinerary. We cannot help but recognise that the road to the sun is a long one; but here is a force of nature, defying the astonishment of those he meets as well as the obstacles on his route—a voyager like an apparition or, more exactly, a 'Wanderer', a one-eyed Wotan traversing the Breton landscape.

At a similar date—a key period in Gauguin's life and work—he portrays himself on a small rectangular canvas, which allows him to spread his broad shoulders; he is in three-quarter profile and his face, closed, sharp and angular, looks out at the spectator; behind him, in an incomprehensible arrangement, on the left his *The yellow Christ* (Buffalo AKG Art Museum, fig 11), painted in autumn 1889, and on the right a glazed earthenware tobacco pot that shows him as a grotesque head, which dates from the early months of that same year (Musée d'Orsay, Paris, fig 12).[56] This is *Portrait of the artist with The yellow Christ* 1890–91 (p 52), a complex work combining a diary entry with a manifesto. Gauguin at the crossroads; Gauguin presenting the diversity of his talents as painter and ceramicist; Gauguin the 'man of sorrows', the Redeemer, and at the same time some infernal gargoyle, 'a poor devil driven in upon himself to endure suffering'.[57] A triple self-portrait then, under three different categories but with one thing consistent, whether at the Gates of Paradise or in the depths of Hell: suffering.

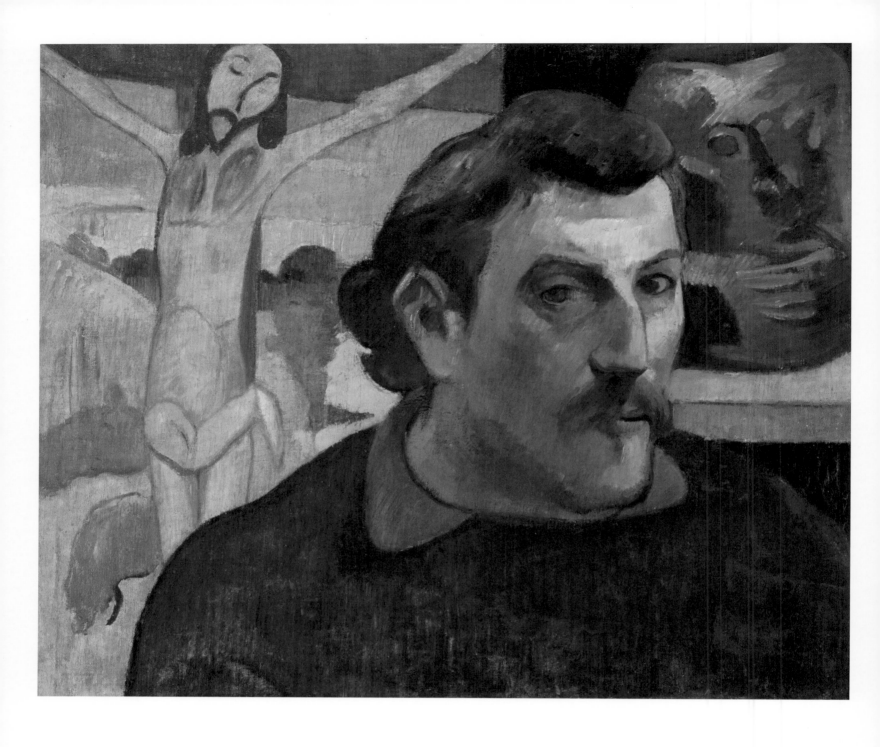

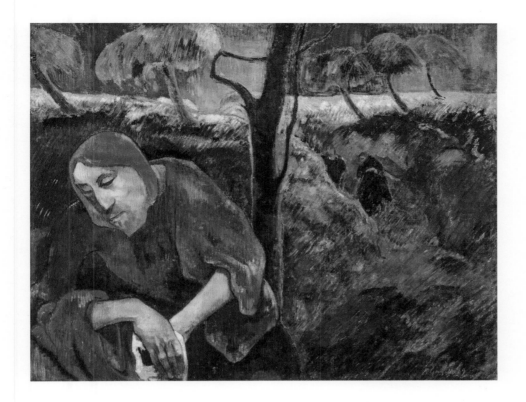

OPPOSITE
Portrait of the artist with The yellow Christ (Portrait de l'artiste au Christ jaune) 1890–91
oil on canvas
38 × 46 cm
Musée d'Orsay, Paris. Purchased with the participation of Philippe Meyer and Japanese sponsorship coordinated by the daily *Nikkei* 1993, RF 1994 2

ABOVE (FIG 13)
Christ in the garden of olives (Christ au jardin des oliviers) 1889
oil on canvas
72.4 × 91.4 cm
Norton Museum of Art, West Palm Beach. Gift of Elizabeth C Norton, 46.5

We know that when, in November 1889, Gauguin sent Van Gogh a sketch of his *Christ in the garden of olives* (Norton Museum of Art, West Palm Beach, fig 13), the first of his self-portraits as Christ, the Dutchman disapproved. He described it as too remote from 'the reality of things', adding 'perhaps it is better to attack things with simplicity than to seek abstractions'.[58] Used in this approximate way, 'abstraction' for both correspondents means—and we have already seen the word in Gauguin's writings—the 'faculty of the intelligence, an operation of the mind that separates, isolates, in order to consider it independently, one element (quality, relation) of the object to which it is united, and that does not present itself separately in reality'.[59] Under Gauguin's influence during their shared stay in Arles, Van Gogh had—with *Woman rocking a cradle* 1889 (The Metropolitan Museum of Art, New York) and *Woman reading a novel* 1888 (Private collection)—'allowed [him]self' to be led down that 'attractive route' but, dissatisfied with the result, had quickly realised its dangers.[60] Then, at the height of this dispute about the necessity and dangers of 'abstraction', Gauguin doubled down. *Portrait of the artist with The yellow Christ* goes well beyond *Self-portrait with Portrait of Emile Bernard (Les Misérables)* (Van Gogh Museum, Amsterdam) that a year before had set the seal on Gauguin and Van Gogh's friendship and which Gauguin already considered 'absolutely incomprehensible […] so abstract is it'.[61] True, Christ extends his protective arm over the artist, but his eyes are closed; dead on the cross, he has returned to God the Father. Gauguin, meanwhile, is on Hell's side. His face is repeated in the pot; his infernal double lit up like the artist by the 'great blaze' that stirs desire, fires ceramics and burns up the damned. We should note that he offered this grotesque and painful image to Madeleine Bernard, whom he had met at Pont-Aven and for whom he felt a profound attraction: 'It is a pretty rough thing [*une chose bien sauvage*] but bears […] the impression of myself,' he wrote to Madeleine's brother Émile, adding 'The pot is well cooled and […] has withstood a temperature of 1600 degrees'.[62] He could hardly be clearer: to the torments of artistic creation were added those of sexual desire (p 55).

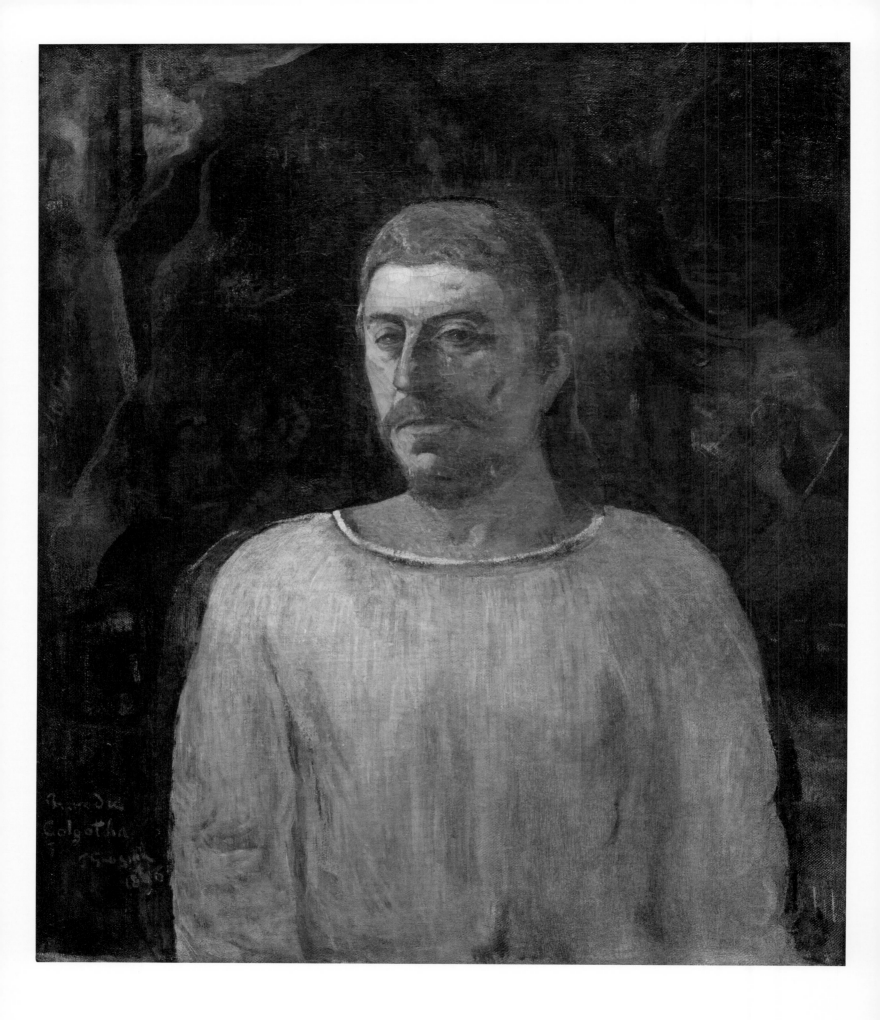

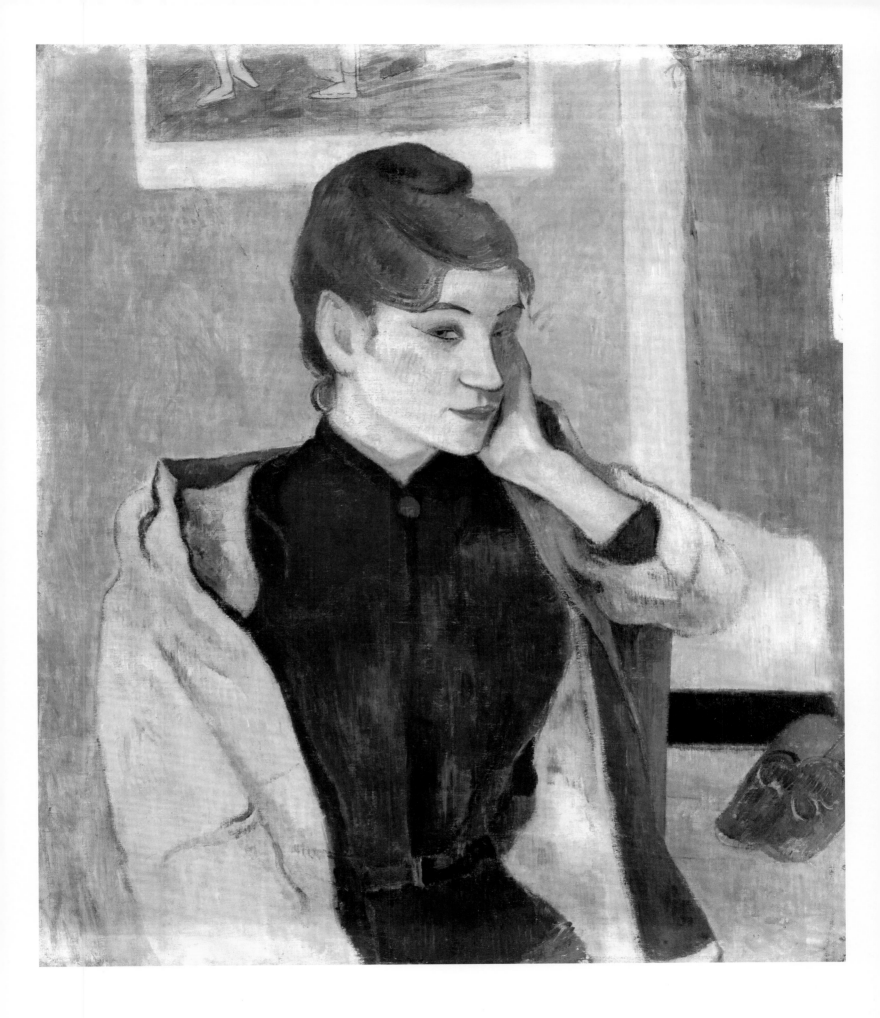

These contradictory impulses, this obsession with the absolute, a life all 'merciless struggle, terrible efforts, intoxication and despair', certainly struck Octave Mirbeau, who perhaps saw in Gauguin a brother—having, like the artist, known 'pain and the irony of pain, which is the threshold of mystery'—and perceived him as the artist most expressive of turn-of-the century anguish. The short, admirable preface that Mirbeau wrote in February 1891 for the catalogue of the sale Gauguin organised before his departure for Tahiti constituted the most exact assessment of his personality and art that had yet been made. 'Monsieur Gauguin,' he wrote, 'is an unquiet nature tormented by infinity. Never satisfied with what he has made, he is always seeking something beyond.' Mirbeau perceived this quest for transcendence in Gauguin's life and genes, in his Peruvian blood and that of the 'pariah' Flora Tristan (his grandmother), the young sailor's maritime voyages, his rejection of a lucrative profession to take up painting, his repeated departures for Brittany, Martinique and now Tahiti, but also in the constant interaction between this turbulent and revealing life and the painter's work. Hence his art, at once 'so complicated and so primitive, so clear and so obscure, so barbarous and so refined'. And when Mirbeau chose an example to illustrate this argument, he alighted on a single painting, *The yellow Christ* (fig 11):

> In this very yellow landscape—it is a dying yellow—at the top of a hill in Brittany, a late autumn sadly yellows; there a calvary stands out against the sky, its timbers shapeless, rotten and disjointed, stretching its warped arms out into the air. Christ, like some Papuan divinity, summarily hewn from a tree by a local artist—a pitiful, barbarian Christ—is daubed with yellow.

In two remarkably perceptive sentences, Mirbeau summarises Gauguin's entire art. Everything is there: the yellow, Brittany, the sky, the hewn wood, the popular, an exotic divinity and the barbarian. Under the impact of *The yellow Christ* and no doubt reading Gauguin's art through the prism of his own existential anguish, Mirbeau overemphasised the dolorous overtones. When they met, Gauguin had probably highlighted this aspect of his personality—his 'painful love of Jesus'—well aware of the ready reception this would find in Mirbeau.[63] Unable to buy *The yellow Christ*, which belonged to Schuffenecker, Mirbeau chose *Christ in the garden of olives* 1889 (fig 13), in which Gauguin paints himself as Christ on the night of the Passion, abandoned by his disciples.

That dark night—that abandonment—recur in the *Self-portrait* painted six years later and inscribed *Near Golgotha* (p 54), in which Gauguin does not so much identify as claim kinship with Christ. He poses with torso facing forward and his face, as always, in three-quarter profile; broad shoulders, sidelong look. But here he has divested himself of the costumes and accessories so dear to his heart, wearing only a white tunic or collarless shirt, with his bare neck ready for the guillotine or martyrdom. Here he depicts himself as monolithic and monumental, determined and proud; this is no longer the Man of Sorrows. In the dark, dense background, on either side of his more brightly lit face, two figures are limned in stone or swallowed up by the dark. Is this some memory of the calvaries he saw and painted in Brittany (p 57)? An evocation of some 'spirit of the dead' that watches over the living? We cannot know. 'Near Golgotha' is, however, no geographical inscription; it signals an imminent, an ignominious and solitary death like that of Christ. Gauguin surely painted this poignant and intense picture in the first six months of 1896 when,

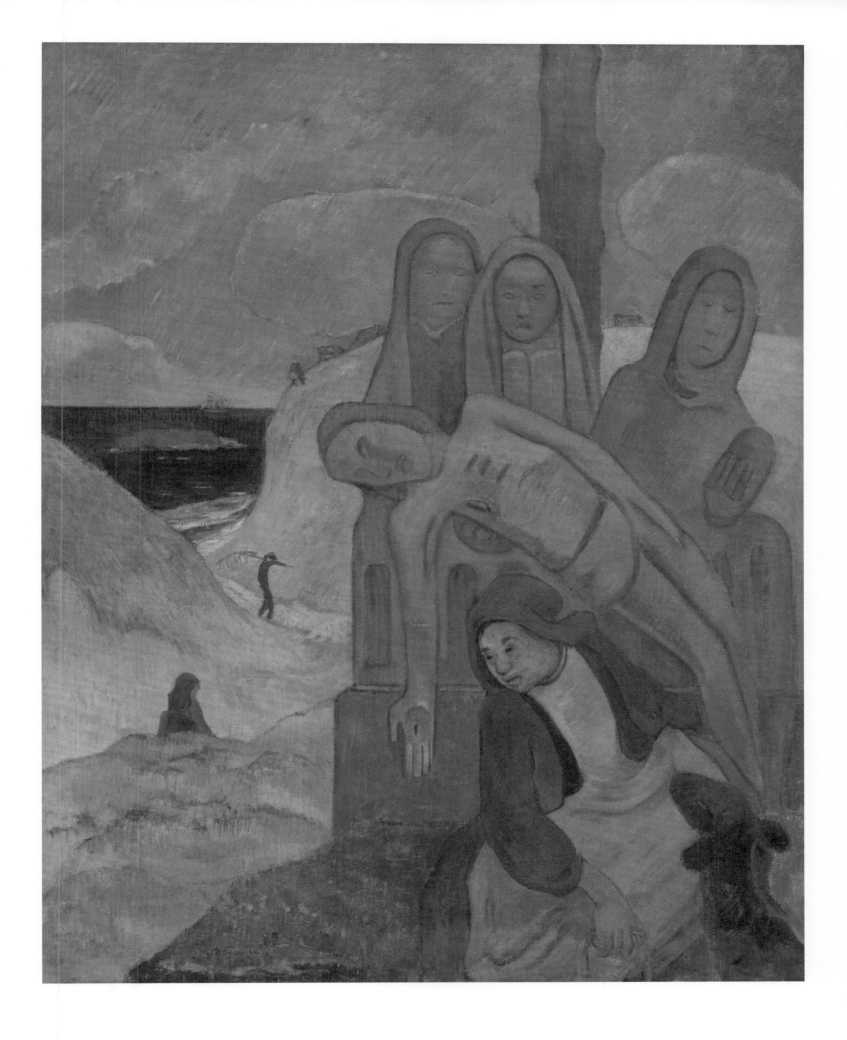

suffering terribly from a broken ankle and 'big sores' that would not heal, devoid of energy, down to his last penny, he was, he said, 'on the verge of suicide'.[64] That is the meaning of 'near Golgotha'. And Gauguin took the work with him to the Marquesas where it figured prominently in the Maison du Jouir like a memento mori. Segalen saw it in that 'last setting'—'the pain-filled portrait in which, on a background of barely discernible calvaries, the powerful torso rises'—next to the other more recent self-portrait (p 45). The latter was neither signed nor dated, as if all that were now a matter of indifference, but the 'strong neck' and 'imperious nose'[65] remained. A final shedding of all attributes. Death is close. Only painting remains.

—

Returning to the Marquesas, at once our point of departure and point of arrival, having studied the Maison du Jouir, Gauguin's only true home—a structure 'wholly occupied by his thoughts'—then having conducted our tour through the painted and modelled self-portraits that stud his entire career, we must now go back to the writings from the end of his life, which form the last folds of this introspective triptych. They have often had bad press and are rarely considered the equal of his visual production; they have served merely as a stock of aphorisms, anecdotes and documentary detail. But Gauguin prided himself on being a writer too—a correspondent, journalist, pamphleteer, theoretician and obituarist; he invented new forms (*Noa Noa*) and his manuscripts are works of art. Paradoxically, his writings are the most stable and definitive part of his corpus. The Maison du Jouir is a mere memory, of which we have only partial descriptions; it cannot be accurately reconstituted. The painted and carved works of his final years have often been damaged because of the poor quality of the materials, the disadvantageous climatic conditions and the perilous long-distance transport to which they were subjected. Some have been abusively restored or even completed by others' hands and the catalogue is full of doubtful works. The writings remain—*scripta manent*—though they are sometimes difficult to interpret, contain allusions that we cannot understand, and are badly in need of a critical edition.

When Gauguin left for the Marquesas, he did so in hopes of a new life and renewed creativity, but he knew it was his last voyage. He was too well acquainted with Tahiti; worn out by his incessant struggles with the administration, weary of landscapes by then excessively familiar, he was anxious to find new models. He thought that the Marquesas would offer 'new and terrifying elements' which would allow him to 'do some fine things'.[66] But after the first few weeks, occupied with settling in and constructing the Maison du Jouir, anguish moral and physical reclaimed him. In March 1902, he announced that he had 'begun serious work'[67] but the respite was fleeting and, in May, he wrote in despair to Daniel de Monfreid:

> For two months I have been filled with one mortal fear: that I am not the Gauguin I used to be. These past few years, which have been terribly hard, and my health, which I am slow in recovering, have made me extremely impressionable, and being in that condition, I have no energy whatsoever (and no one to comfort or console me), utter isolation.[68]

And from that point onward until his death a year later, his letters rehearsed the same litany of suffering: the solitude he had sought but which had become isolation; incessant pain from his broken ankle, which would not heal, and from invasive

eczema, making any movement difficult; his work erratic; growing anxiety about the fate of his corpus; and extreme penury. He had discovered a refuge 'surrounded by trees'[69] but could not turn a blind eye on the outside world or colonial injustice and again took up the struggle: Bishop Martin, Governor Petit, the colonial inspectors and the local gendarmerie were vehemently berated, each in their turn.

In early 1902, Gauguin finished writing *L'esprit moderne et le catholicisme* (*Modern thought and Catholicism*), a reflection begun five years earlier on the origin and interrelation of religions, on the Creation, the immortality of the soul, the figure of Christ and the perversion of his original message by the Catholic Church, and the subsequent establishment of a 'false morality'—one that sanctioned might over right, meaning patriotic and colonial imperialism and social inequalities. In mid September, he sent to André Fontainas, a critic at the *Mercure de France*, the manuscript of *Ramblings of a wannabe painter*, the short autobiographical piece in which he tried 'to talk about painting, not as one of the Literati, but as a painter', combining accusations against critics and institutions with assessments of various artists of his own and earlier times.[70] But the *Mercure* was not interested. Gauguin affected not to mind, telling Fontainas that he had 'just written quite a miscellany of childish recollections, the wherefore of my instincts, of my intellectual development: thus what I have seen and heard (with criticisms of men and things), my art, that of others, my admirations and my hates'.[71] This he entitled *Before and after*. Thereafter, until his death some months later, he did everything he could to persuade Fontainas and De Monfreid to put together the sum needed to publish this book through the sale of his works. In vain.

Gauguin clearly enjoyed writing. It afforded him an escape from his isolation. But this late frenzy came primarily from the need to explain himself: to situate himself in the art of his time and, as death approached, to explain the ambitions he had entertained and the legacy he was leaving. These writings were intended as his testament. He was fully aware of the incomprehension his work faced; no one knew what he meant or intended. Thus *Modern thought and Catholicism* returns to the figure of Christ—and therefore also to Gauguin, as we have seen. It explores the religious syncretism that pervades the Tahitian works and offers an interpretation of his greatest masterpiece, whose uncertain fate so alarmed him: *Where do we come from? What are we? Where are we going?* 1897–98 (Museum of Fine Arts Boston, fig 14; see also p 61). *Before and after* answers the queries of those many collectors of modern painting such as the Rouarts who had collected all the great names of Impressionism but were asking their friend Degas for an 'explanation' of Gauguin's painting.[72] Here are commentaries and special pleading, but these are also militant writings, fuelled by indignation and enthusiasm. His words take up 'the good fight' (Émile Zola's assessment of his art criticism);[73] they are the wrestling of Jacob 'fighting the angel he doesn't recognise—we, fleeing Catholic Pharisaism and battling in insufficiently dissipated darkness the unknown Christ'.[74] The artist gives battle with arms he knows are inadequate:

> As he finishes his work, the author notices in rereading it that it is a Chinese puzzle, as they say. May the reader excuse him! In such arduous matters (science and theology), what is he to do? Other than what he did,—pursue the goal proposed. [...] By the same token this is no fantastical work but a *polemical work*, one of conviction.[75]

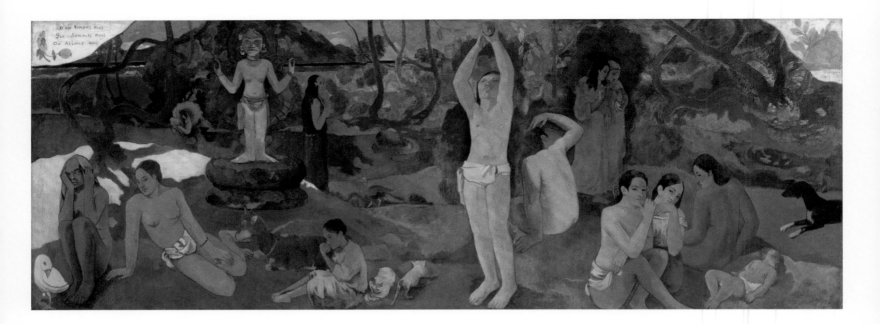

And he is carried away, his syntax stumbling, his style repetitious, his sources unreliable and his memory uncertain—aware of his failings, he takes a certain pride in them. Dedicating *Modern thought and Catholicism* to Charles Morice, he emphasises the truant nature of his thought, saying that the essay is 'an offering born of a whim, a whim born of an instinct, an instinct born in a mysterious [foretime]'.[76] His work, at once jumbled and overabundant, is disconcerting in its clumsy handling of concepts, absurd parallels (Jesus, Horus and Ra), endlessly approximate interpretations and the difficulty of orientating oneself in the text or of applying what Gauguin writes to what he paints or sculpts. But he is also fascinating in what he says about himself, the whirlwinds of his thought, his extremely varied reading (the Bible, Plato, Confucius, Pascal, Pierre-Simon de Laplace, Gerald Massey) and his 'imagination'.[77] Again and again, he refers to a 'mysterious foretime', whence came his childhood memories of studying at the Petit Séminaire in Orléans and of his grandmother Flora Tristan—who was, like him, a 'pariah', like him all righteous anger, who preached a humanitarian religion and the equality of the sexes, which her grandson also preached but did not practise.

These memories, latent in *Modern thought and Catholicism*, are scattered through *Before and after* and *Ramblings*, where they are evoked precisely and with feeling. One hardly dares say that *Before and after* is a great book, since from the outset the author warns us that 'This is not a book' and makes a leitmotif of his warning.[78] Rejecting any other description of his efforts, he finally settles on *bavardage* ('idle chatter').[79] By which he means remarks seemingly unconnected but held together by a jerky, vibrant rhythm, carried forward unremittingly by short sentences, frequent paragraph breaks and the urgency of what he has to say: 'a storm on the brain', like that experienced by Jean Valjean in *Les Misérables*.[80] In short, Gauguin in full flow. 'This is not a book' because he does not know how to write and is not a writer by 'trade',[81] because he rejects the artifices of composition and the tricks of style that would falsify his vision and prevent him telling the truth. By contrast, he says, Zola's laundry women talk like Zola[82] and when Pierre Loti writes of Polynesia or Japan he seems never to quit his officer's or academician's uniform.[83] Make no mistake, Gauguin does not want to 'know how to write' any more than he wants to 'know how to draw': 'To know how to draw is not the same as drawing well'.[84]

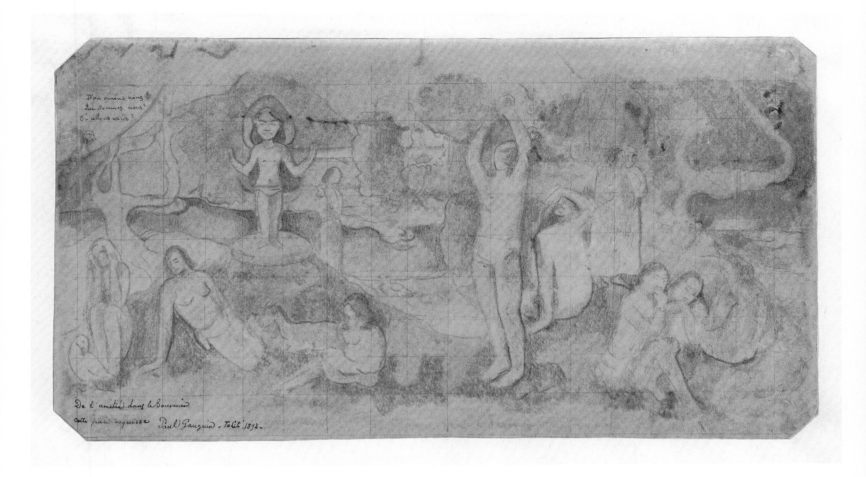

OPPOSITE (FIG 14)
Where do we come from? What are we? Where are we going? (D'où venons-nous? Que sommes-nous? Où allons-nous?) 1897–98
oil on canvas
139.1 × 374.6 cm
Museum of Fine Arts Boston.
Tompkins Collection – Arthur Gordon Tompkins Fund, 36.270

ABOVE
Study for *Where do we come from? What are we? Where are we going? (D'où venons-nous? Que sommes-nous? Où allons-nous?)* 1898
graphite, red and blue coloured pencil on transparent paper over preliminary colour drawing on wove paper
20.4 × 37.5 cm
Musée du quai Branly – Jacques Chirac, Paris. Gift of Lucien Vollard to Musée de la France d'outre-mer, 75.14341

Ingres, 'voluntarily obstinate', as Gauguin asserts, detected the 'incoherence' of the draughtsmanship taught by the École des Beaux-Arts and 'began to rebuild a logical and beautiful language for his own use'.[85] Gauguin, in his visual art as in his writings, does the same. So we can understand the dismay of the editors of the *Mercure de France*; there was no one to do what Morice had done for *Noa Noa*, that is, 'bring out', alongside the voice of the 'savage', 'the style of a civilised man'.[86] In *Before and after*, Gauguin writes from the Marquesas *to* Paris and *for* Paris—for André Fontainas and Rémy de Gourmont, for Alfred Jarry, to whom he was so close, for the *Mercure de France*, and in memory of Mallarmé and his Tuesday Salons in the rue de Rome. Say what he will, he is a true writer and produces a masterpiece.

In 1902 in the Marquesas, Gauguin sees and describes his entire life in brief, disordered sequences: a series of freeze frames. All those who counted in his life make their appearances in the credit sequence, though some once-prominent influences are reduced to walk-on roles. Seen from Atuona, Pissarro, his first master and supporter, to whom he was so close artistically, seems very remote. Distance has reduced him to so slight a figure that he merits only a casual jibe about the vacuity of his subjects. Van Gogh makes frequent appearances: Gauguin promises that he will someday write about him at greater length but here contents himself with rectifying the rumours about their friendship and insisting on the Dutchman's latent madness, the disorder of his life and his uncontrollable expenditure. He dwells above all on the violent scenes that marked the end of their stay at Arles. When he speaks of Vincent as an artist, he does so only in order to boast of having saved him from the siren songs of Neo-Impressionism and to draw attention to 'everything contradictory between his painting and his opinions'—Vincent's preposterous admiration for Ernest Meissonnier and Adolphe Monticelli, his 'profound hatred' for Ingres and his contempt for Degas and Cézanne. Later, he excuses Van Gogh's fumbling efforts: 'When I arrived in Arles, Vincent was trying to find himself, while I [...] a good deal older, was a mature man'.[87] This is obviously a very unjust way of rewriting their story.

But at the end of his career, Gauguin shuffles the cards afresh. Pissarro and Van Gogh are marginalised and his friends from Pont-Aven are forgotten; Gauguin wishes to die beside Cézanne, Puvis and, above all, Degas. Of the three, his oldest admiration was for Cézanne, since it dates back to the late 1870s, when they were introduced by Pissarro. Perhaps the lack of a true friendship diminished that admiration, while Cézanne's reputation, increasing over the last decade of the century, was something of a slap in the face to Gauguin, who enjoyed no such fame. But in *Ramblings*, he emphasises Cézanne's singularity—he 'does not come from anyone; he is content with being Cézanne'—and his polyphonic use of colour: 'He has the whole orchestra at his fingertips'.[88] And in *Before and after* we find one of his most moving homages. Discreetly, in a section entitled 'Anodyne critiques', having disparaged Pissarro and Paul Signac and paid Eugène Carrière a rather enigmatic compliment, he comes to speak of Cézanne: 'Ripe grapes overflow the edges of a shallow bowl: on the cloth, green and plum-red apples mingle. / The whites are blue and the blues are white. A hell of a painter, this Cézane [*sic*]'.[89] This evokes a painting that Gauguin had once owned, *Still life with fruit dish* 1879–80 (The Museum of Modern Art, New York); he considered it the high point of his collection. In 1890, he placed it in the background of his very beautiful *Woman in front of a still life by Cezanne* (The Art Institute of Chicago). He had promised that he would never part with the Cézanne but was forced to sell in 1896. It was a bitter, melancholy souvenir of his years of financial security. Two years earlier—though Gauguin may never have

known—his admirer Maurice Denis had revived the memory of this painting in his *Homage to Cézanne* 1900 (Musée d'Orsay, Paris), in which he portrayed the group of young painters known as the Nabis—Paul Sérusier, Vuillard, Ker-Xavier Roussel, himself and Bonnard—standing with Odilon Redon around the still life that had belonged to Gauguin. He thus paid his dues to Gauguin, and not only via the Cézanne: Denis included a fragment of a Tahitian painting in the background.

As early as 1887, Gauguin had set out to defend Puvis. True, it was at a time when the latter was returning to favour after his relative eclipse in the previous decade. The practitioners of the New Painting had considered him one of their own from the 1860s on, but eventually took their distance from him when he continued to receive major state commissions and to exhibit at the Salon. Gauguin speaks of the time when he was alone in admiring *The poor fisherman* 1881 (Musée d'Orsay, Paris) and *The prodigal son* 1879 (Kunsthaus Zürich, EG Bührle Collection), which 'gathered dust at Durand-Ruel's, without selling, even at modest prices'.[90] These are very approximate memories. Gauguin seeks to demonstrate that he had 'discovered' Puvis but he is right to point to the impressionists' persistent prejudice—we are in 1887—against the painter who decorated the Panthéon. And in 1889, when Huysmans portrayed Puvis in a less than flattering light, denying that he had 'brought a new note' to painting, Gauguin was indignant and answered in an unpublished reply: 'You don't look kindly on Puvis de Chavannes; you do not look kindly on his impulsiveness; simplicity and nobility have had their day. Well, eminent critic as you are, their day will come.'[91] The 'simplicity and nobility' in Puvis's synthetic draughtsmanship was something that he and Émile Bernard practised during the first six months of Gauguin's stay in Brittany in 1888 (pp 64–7). For this, Gauguin's visit to the Puvis exhibition at the Durand-Ruel Gallery in November–December 1887 was decisive. And in his arguments with Van Gogh during their stay in Arles, Gauguin saw Puvis as exemplary: 'It's funny, here Vincent sees Daumier-type work to do, but I, on the contrary, see another type: colored Puvis mixed with Japan'.[92] Gauguin is clear that only Puvis's draughtsmanship interests him and agreed with Huysmans in deprecating the painter's 'worn out' colours.[93] When he attended the banquet given in honour of Puvis on 15 January 1895, at which the critic Ferdinand Brunetière congratulated the hero of the hour on 'making great paintings of attenuated colours, without letting [him]self fall into overtly conspicuous colours', Gauguin rightly took this for a veiled critique of Impressionism and what he himself was trying to do.

He had another bone to pick with Puvis. The older artist was always 'comprehensible [...] knowing how to explain his idea'. So Gauguin wrote to Morice in July 1901, observing 'there is a whole world between Puvis and me':

NEXT SPREAD LEFT
Young Breton bathers
(*Jeunes baigneurs bretons*)
1888
oil on canvas
92 × 72 cm
Hamburger Kunsthalle,
Hamburg, HK-5063

NEXT SPREAD RIGHT
Children wrestling
(*Enfants luttant*) 1888
oil on canvas
93 × 73 cm
Louvre Abu Dhabi, LAD
2010.001

> Puvis explains his idea, yes, but he does not paint it. He is Greek, whereas I am a savage, a wolf in the woods without a collar. Puvis will call a picture *Purity* and to explain it will paint a young virgin with a lily in her hand—a hackneyed symbol, but which is understood by all. Gauguin under the title *Purity* will paint a landscape with limpid streams; no taint of civilised man....

And, taking the example of the enigmatic *Where do we come from? What are we? Where are we going?* (fig 14), he gives a deliberately elliptical interpretation, as he does of many Tahitian pictures: 'Explanatory attributes—known symbols—would congeal the canvas into a melancholy reality, and the problem indicated would no longer be a poem'. In other words: 'Emotion first! Understanding afterwards.'[94]

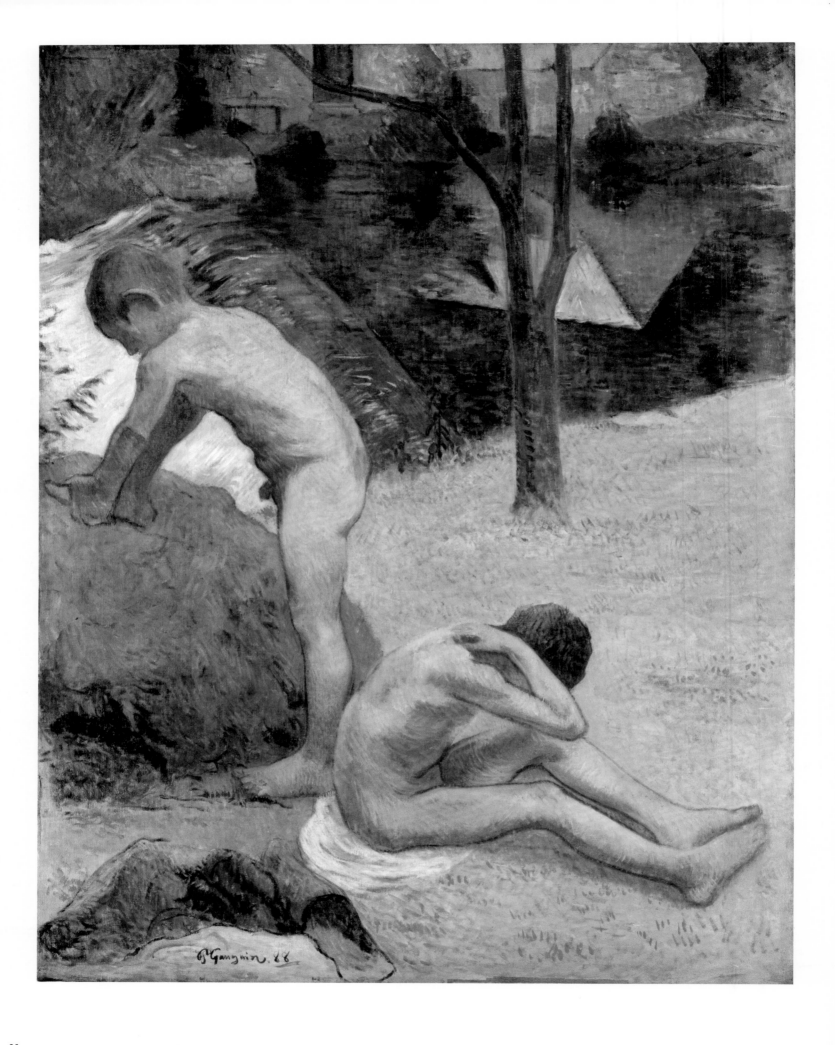

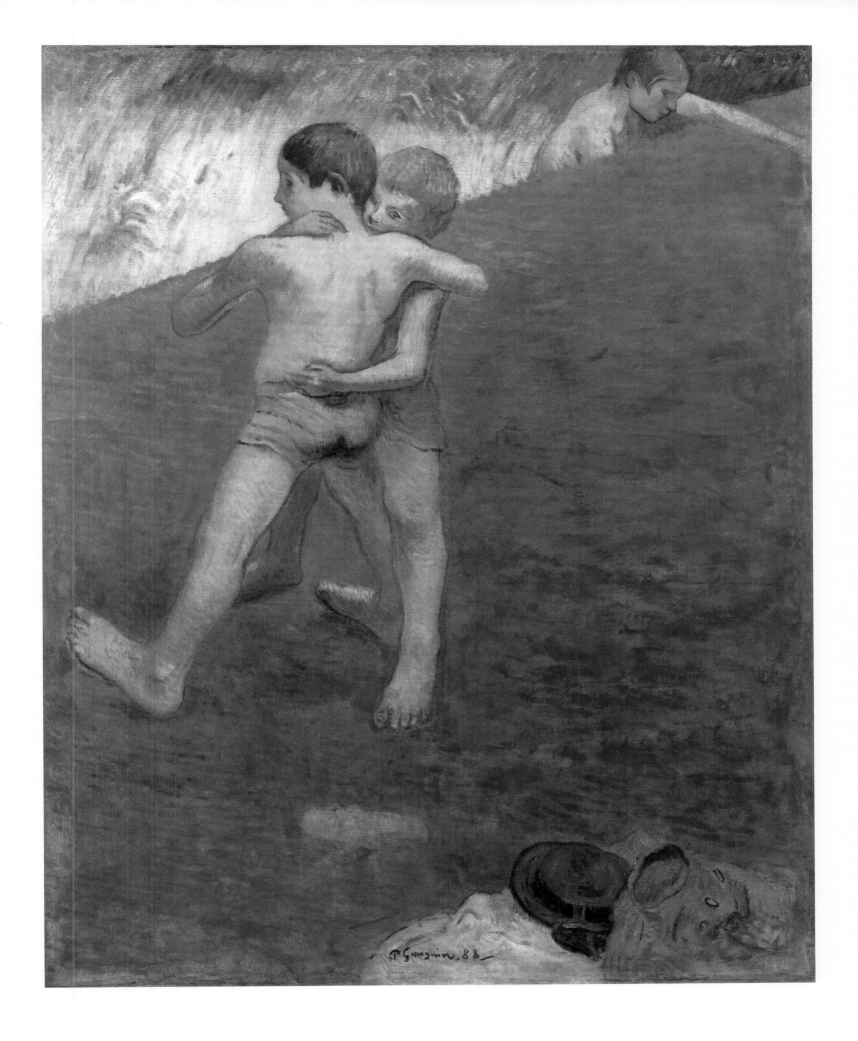

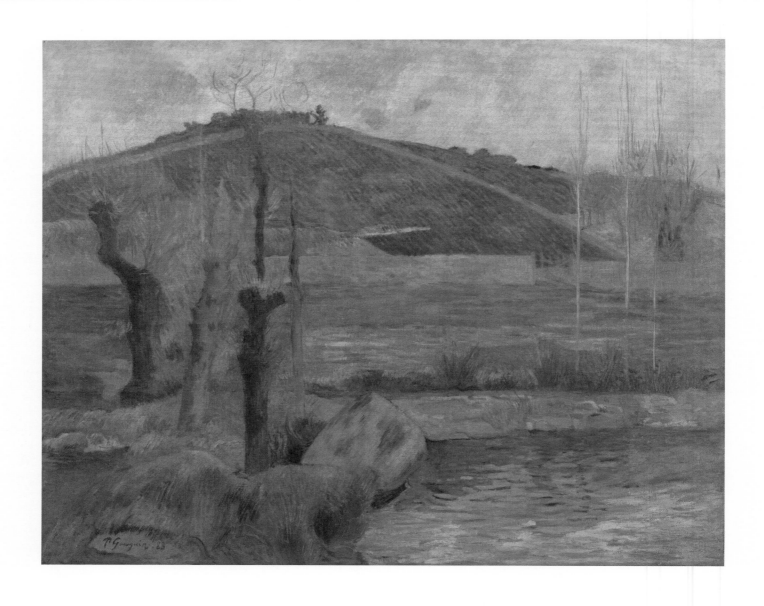

Landscape near Pont-Aven 1888
also known as *L'aven en
contre bas de la Montagne
Sainte-Marguerite*
oil on canvas
72.9 × 92.2 cm
Artizon Museum, Ishibashi
Foundation, Tokyo, 22505

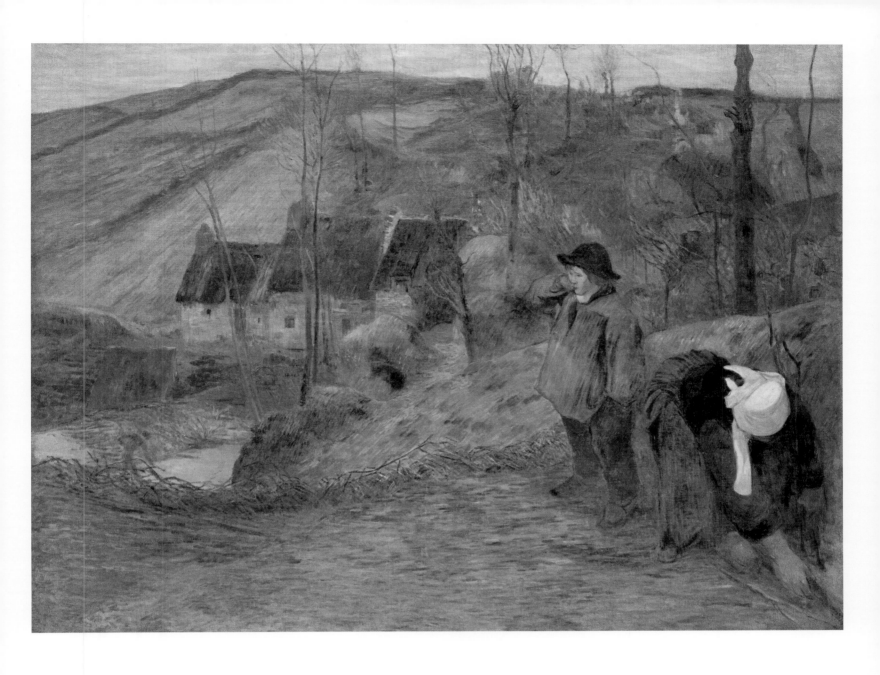

Landscape of Brittany 1888
also known as *Petit berger breton*
oil on canvas
89.3 × 116.6 cm
The National Museum of
Western Art, Tokyo. Matsukata
Collection, P.1959-0105

But the anaemic colours, too evidently borrowed from medieval fresco, and the elementary Symbolism that obstructs the imagination did not alienate Gauguin. Puvis remained present in his thoughts and art till his very last days.

—

The omnipresence of Degas in Gauguin's final years is striking. In the Maison du Jouir, as we have seen; in their shared taste in artists; and in the inspiration that Gauguin regularly took from his elder's works. Degas was both Gauguin's principal supporter and his reigning admiration. But it had not always been so, and between two such well-defined characters there were numerous conflicts, which litter the history of the *Impressionist* exhibitions. Thus, in 1882, Gauguin complained to Pissarro of Degas's noxious influence in the choice of exhibitors—'as far as Degas is concerned—and it is his will and his will alone—the tendency has been getting worse and worse; each year one Impressionist has left, making way for nonentities...'. This led to Degas's withdrawal.[95] In 1885, Gauguin reiterated these complaints—'Believe me, Degas has done a lot of damage to our movement', he wrote—before consigning him to a disenchanted old age: 'Degas, you'll see, will end his days a less happy man than the others, his vanity offended because he was not the one and only'.[96] But Degas, fiercely antisocial as he was, made excuses for that 'savage' Gauguin and when Henri Rouart's son asked him 'Who is Gauguin?' he answered with La Fontaine's fable about the wolf and the dog: a wolf who is all 'skin and bone' meets a fat mastiff, a guard dog with his shiny coat, who boasts of the pleasures of his lazy and well-fed existence. But the wolf takes flight when he sees the mark left by the collar by which the guard dog is chained. 'Gauguin is the wolf', Degas observed.[97]

For the art of these two artists is deceptively close. It rests on the same principle: art as artifice. 'One sees as one wants to see', Degas remarked, '—wrong. And the wrongness makes art'.[98] Gauguin lays claim to that 'wrongness' when he wants to 'avoid as far as possible that which gives the illusion of a thing';[99] when, contemptuous of scientific progress, and Meissonier's quest for exactitude in representing a horse's gait, he goes 'way back, further [back] than the horses of the Parthenon—all the way to the dear old wooden horsie of my childhood'.[100] Both therefore reject plein-air painting; the great transmutation occurs in the studio, filtered by memory and enriched by the imagination. Gauguin was not, he wrote in May 1900, 'a painter according to nature—today less than [ever]. With me, everything happens in my wild imagination.'[101] Moreover, what distinguishes Degas and Gauguin among the New Painters is their taste for technical experiment, in their hands not an idle curiosity but the powerhouse of creativity bringing a constant interplay between form and background. It is the quest for the medium appropriate to their diverse motifs, the search for the precise word and for unprecedented forms of expression.

We must consequently study their artistic relationship in a way that goes beyond the conventional listing of Degas quotations in Gauguin's works or of Gauguin masterpieces acquired by Degas. In the late 1870s, there had been a spirit of emulation between the two. Degas encouraged Gauguin to exhibit one of his sculptures for the first time at the *Impressionist* exhibition of 1879. This led Degas, too, to try his hand at sculpture and in 1881 he exhibited his masterpiece *The little fourteen-year-old dancer* c 1880. And the 'orgies of colours'[102] in which Degas indulged in the late 1890s—are these brilliant yellows, pinks and blue not a homage to Gauguin who, far away as he was, was then choosing the same colours and using them with the same intensity?

This deep-rooted artistic kinship, overcoming social difference, the incompatibility of their characters and lifestyles, and their political disagreements, explains the persistence of their reciprocal admiration. When, in November 1893, Gauguin exhibited his 41 Tahitian paintings, three of Brittany, and a few wood sculptures at the Durand-Ruel Gallery, of the entire impressionist generation only Degas took up his defence: 'Various painters', Pissarro observed, 'all find this exotic art too reminiscent of the Kanakians. Only Degas admires it, Monet and Renoir find all this simply bad.'[103] Degas's admiration was not confined to words. Over a few years, he acquired for himself not only 11 major paintings (including pp 70–1) by Gauguin, from every part of the latter's career, but drawings, engravings and monotypes as well as a carved walking stick, a gift from Gauguin to thank him for his support at the time of the 1893 exhibition.[104] If Degas had realised his idea of a museum, Gauguin's share in it would have been much greater than that of Cézanne or Van Gogh in terms both of the number and the quality of his works, and a clear sign of predilection. For his part, Gauguin wrote a very touching eulogy of Degas to his friend Daniel de Monfreid, who had just met the man:

> He is instinctively drawn to good-hearted, intelligent people. In terms of both *talent and behaviour*, Degas is a rare example of what an artist should be. [...] No one *has ever heard or seen him* commit one dirty trick, one tactless action, do one ugly thing....

And he summarised the man's character as 'Art, and dignity'.[105]

—

In *Before and after*, Gauguin writes of the connections he has made in his collaged collection:

> Japanese sketches, prints by Hokusai, lithographs by Daumier: cruel observations by [Jean-Louis] Forain, gathered together in an album, not by chance but my own deliberate will. I add a photograph of a painting by Giotto. Because despite their different appearances, I should like to demonstrate their relationships.[106]

These few lines might have been written by Degas, and we might say the same of the parallel Gauguin makes in *Ramblings* between Ingres and Delacroix, Degas's two tutelary deities.[107] Perhaps never before these final months in the Marquesas had the community of their tastes and notion of art emerged so clearly. But one major point of divergence remained. Perhaps incomprehension is the better word, since it did not diminish Degas's admiration for Gauguin's Polynesian works. Degas simply saw no need for exile: 'He had to have people around him with flowers on their heads and rings in their noses before he could feel at home. Now, if I should leave my [studio] for more than two days...'.[108] Indeed, why go abroad when the 'painter of dancers' could, night after night, find his Marquesas at the Paris Opéra? Why seek motifs in the most improbable locations, whose equivalent could be found in contemporary France? Why, since there existed nothing beyond memory, 'fantasy' and the imagination, give up the refuge of one's Paris studio?

For what Degas saw in Gauguin's paintings was something close to his own heart: bodies, movement, rhythm and dance. Consequently, in the handwritten

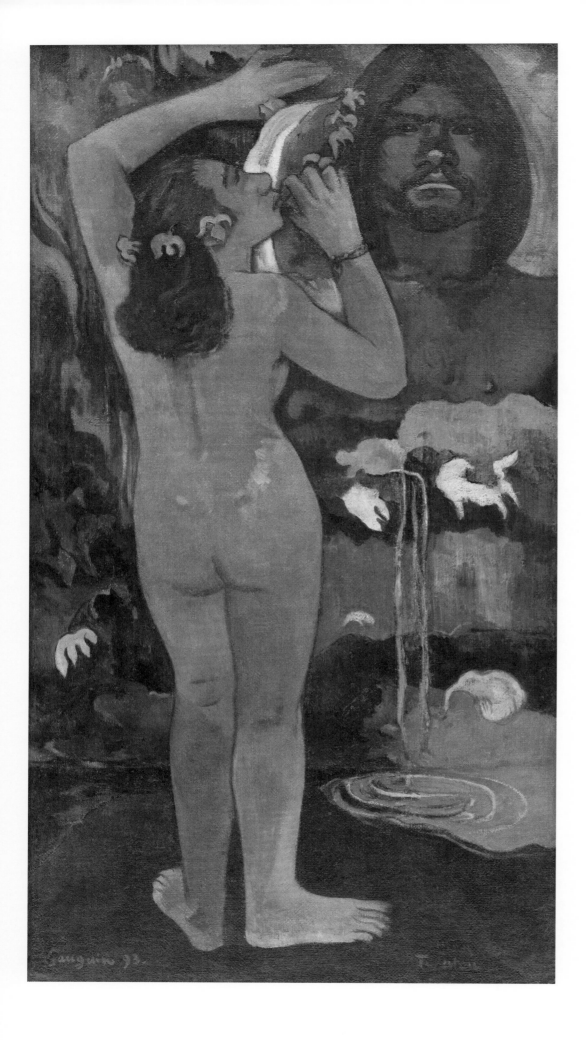

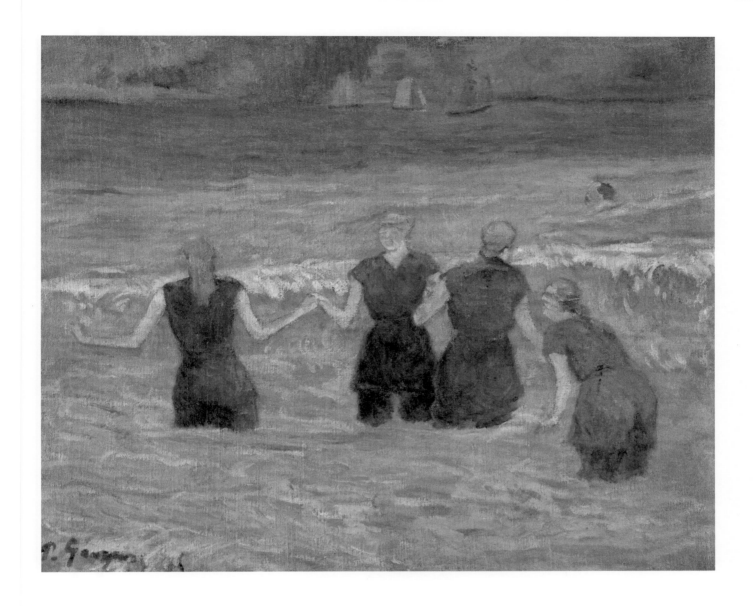

*Hina tefatou (The moon
and the earth)* 1893
oil on canvas
114.3 × 62.2 cm
The Museum of Modern
Art, New York. Lillie P Bliss
Collection 1934, 50.1934

*Women bathing
(Baigneuses à Dieppe)* 1885
oil on canvas
38.1 × 46.2 cm
The National Museum of
Western Art, Tokyo. Matsukata
Collection, P.1959-0104

notes (now in a private collection) that he made about the works by Gauguin that he acquired, he never reproduces the Tahitian title inscribed on the canvas. He avoids all such references. Of *Mahana no atua* 1894 (*Day of the god*, The Art Institute of Chicago), he wrote 'procession by the sea and dance / men or women bathing in the foreground'; of *Hina tefatou* 1893 (*The moon and the earth*, p 70), 'Back of nude woman drinking or / whispering into the ear of the head / of a Tahitian god'; of *Te faaturuma* 1891 (*The brooding woman*, p 73), 'Woman sulking / Tahitian woman squatting / Legs crossed, face [propped] on / her hand'; of *Vahine no te vi* 1892 (*Woman of the mango*, Baltimore Museum of Art), 'Woman of Taïti in violet dress / holding a piece of fruit in her right hand, / on yellow orange background. White / collarette, and white flower drawing on dress.' He has no interest whatever in gods, rituals or ethnography; he focuses on the composition, figure, pose and colour. What Degas did not understand was that, though Gauguin's travels had an economic motivation (the need for somewhere cheap to live) and pertained to his never truly realised dream of living as a 'savage', the primary consideration was his desire for new motifs. But, for Gauguin, motif is not simply something captured by the eye but is inscribed in a vast network of 'correspondences' in the Baudelairean acceptation, which involves all the senses. For Gauguin, nature is indeed a 'temple, where the living / columns sometimes breathe confusing speech', in which humankind 'walks within these groves of symbols' and 'perfumes, colours, sounds may correspond'.[109] Painting is, he noted in 1901, an art of 'suggestion' rather than 'description, just as in music', and defies explanation.[110] As early as 1888, in Brittany, where he had found the 'wild and primitive', he had noticed this synaesthetic 'correspondence': 'When my wooden shoes echo on this granite ground, I hear the dull, muted, powerful sound I am looking for in painting'.[111] And could not the tropics, 'those brighter countries under the stronger sun', through a form of light unknown in the West, radically alter how one apprehends what one sees?[112] Would he not find there those 'olfactory ecstasies' that Théophile Gautier expected, in prefacing Baudelaire, of some 'Tahiti of a dream'?[113]

This alchemical expertise is always at work in Gauguin's painting, which, keeping its distance from the real, makes room for dream, apparition, ambiguity, error and mystery.[114] In his view, this was lacking in Degas, as he rather obscurely wrote to Émile Bernard in 1889: 'You know how much I admire what Degas does and yet I sometimes feel that he lacks a sense of the "beyond", a feeling heart'.[115] Degas could seem dry as dust and often made a show of brusquerie and heartlessness— but Gauguin never experienced anything but generosity from him. Was Gauguin suggesting that Degas showed too great an attachment in his work to reality, with no place left for the 'beyond'? But everything that Degas does is phantasmagorical.[116]

Gauguin's quest for an increasingly remote elsewhere allowed him again and again to confront new motifs: new bodies, new landscapes, new climates, new odours, new sounds, musics and languages, new gods and new suns. What counted for him was the living spectacle. His primitivism was not simply a search for new formal expressions, nor should research confine itself to inventorying the 'primitive' works that inspired him. For that would leave his lifelong peregrinations unexplained; he could, after all, have found what he was looking for in Paris among the staged villages of the Expositions Universelles and in the Ethnographical Museum of the Trocadéro. The generation of Matisse and Picasso, focusing on mere objects, would prove happy to do this. Gauguin's 'primitivism' consisted at one and the same time of a lifestyle different from the usual stage-by-stage careers of contemporary artists—throughout

Te faaturuma (*The brooding woman*) 1891 oil on canvas 91.1 × 68.7 cm Worcester Art Museum. Museum Purchase, 1921.186

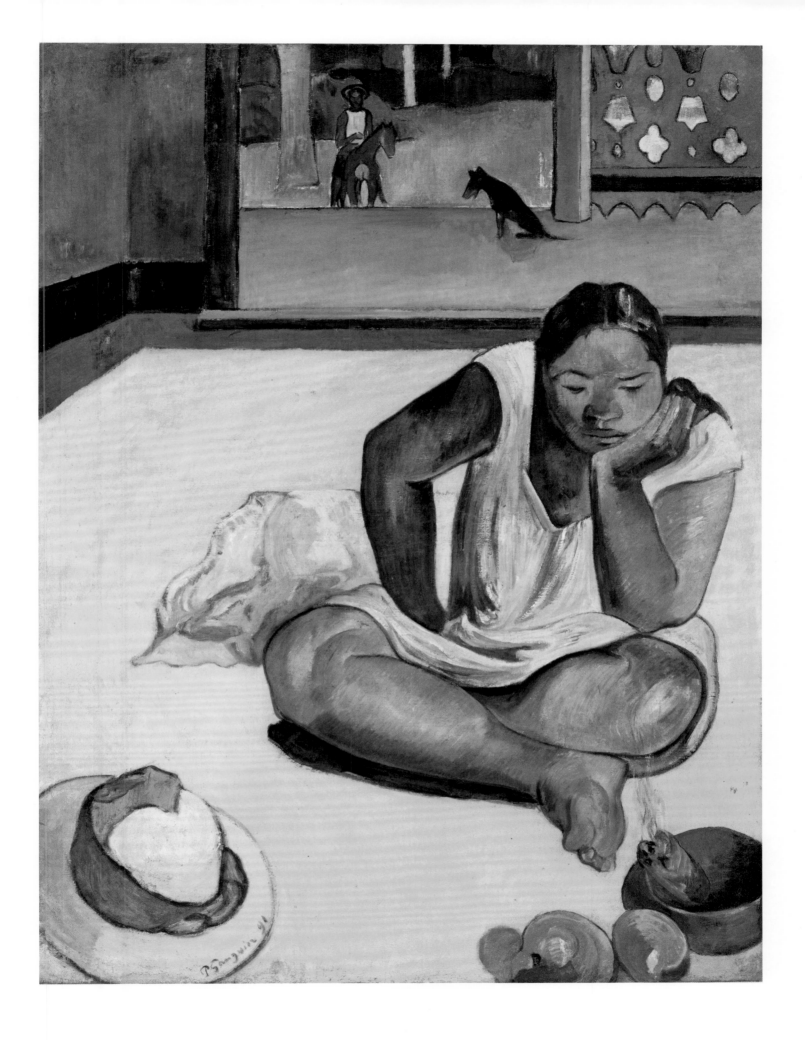

his career he kept saying that he wanted to live as a 'savage' or 'primitive'; of his esteem for sources (popular, Egyptian, Mesopotamian, Oceanian, from Brittany to Borobudur and from Giotto to Marquesan *tikis*) till then little utilised and never in such combinations; and perhaps still more of the use of techniques, materials and methods at odds with traditional practices.

Gauguin revived the medieval art of stained glass; he laid on paint with a 'very thick knife on *coarse sackcloth*';[117] favoured woodcut because it harked back to 'the early days of woodcut engraving';[118] questioned the use of easel painting;[119] and discarded gilded and scrolled frames in favour of a simple white wood frame.[120] Was not the triumphant, resounding yellow with which he covered the walls of his studio in the rue Vercingétorix, the yellow onto which he engraved his *Volpini suite* (pp 179–81) and which he spread over his Breton fields (p 67) and Tahitian *marae* (p 78), a re-emergence of the 'gold backgrounds' of the Trecento that he so loved? For these reasons, one cannot consider Gauguin as a prologue to the history of 'Primitivism' that was to attain fuller development in the following generation, with Picasso, Matisse, Braque or Derain.[121] On one hand, we have already seen that he did not set about things in the same fashion; on the other, we must place him in a much more remote genealogy. Gauguin took part in the quest for ever-more primitive sources—questioning the prevailing lifestyle too, as did the Barbus (Jacques-Louis David's hyper-classicising students), the Nazarenes and the Pre-Raphaelites. Within this tendency, artists rejected Vasari's notion of progress in the arts; this was what drove Ingres to turn to the painters from before Raphael, and saw subsequent generations move on from the Italian primitives to Byzantium, Archaic Greece, Sumer, Oceania, Africa and the pre-Columbian Americas; it continued into the twentieth century when some artists, having run out of discoveries, turned towards children's art and Art brut. But Gauguin alone, with courage, obstinacy, inevitable recidivism and a complete devotion to his art, really lived out the primitivism that he sought.

—

The artist who died in Atuona on 8 May 1903 remained a Parisian artist. True, after endless wandering, he had reached the Antipodes and had, as he wished, become a 'savage'. True, in Tahiti and the Marquesas he combatted the misdeeds of colonialism and adopted certain local customs, but he always kept his distance. The 'savage' that he yearned to become was an illusion and unable, like Victor Hugo's Ursus, to realise that ambition, he became 'the one who is alone': 'The solitary man is a modified savage, accepted by civilisation. He who wanders most is most alone; hence his continual change of place. [...] He passed his life in passing on his way.'[122] There is perhaps no better characterisation of Gauguin than those few lines from one of his favourite authors. This is something that his friend Stéphane Mallarmé was quick to understand. In the toast that he proposed during the banquet of 1891, celebrating Gauguin's departure for Tahiti, he suggested drinking to 'the return of Paul Gauguin; but not without first admiring this proud consciousness which, in all the radiance of its talent, tempers it by exiling himself into the far distance and into the self'.[123]

'Into the far distance and into the self': there could hardly be a better summary. After those few months in the Marquesas, which recapitulated an entire life, Gauguin died surrounded by those who were close to him. The living and the dead; his artist friends, who received their verdict, just or unjust, in his last judgement, and some members of his family, above all his grandmother Flora Tristan

who, like him, was acquainted with 'insane expeditions'. The memories return: his childhood in Peru, the suicide of a neighbour, a man guillotined at dawn, a 'kind uncle from Orléans whom they called Zizi' and 'a few coloured marbles'.[124] Then he could write the last word of *Before and after*, the word 'infamous', which he threw like a projectile that must again and again pierce our hearts.

'At my window, here at Atuona in the Marquesas, everything is growing dark. The dances are ended, the sweet melodies have died away.'[125]

And so to leave-taking. The hour has come.

Henri Loyrette is a French scholar who as Président and Director of the Musée du Louvre, Paris (2001–13) was especially recognised for expanding the display of the Museum's collection and of the Museum itself to Louvre-Lens in northern France and to Louvre Abu Dhabi.

Loyrette's areas of specialisation are nineteenth-century painting and architecture. He has continuously researched Edgar Degas (on whom he is an acknowledged expert), Édouard Manet and other nineteenth-century European artists. His groundbreaking exhibitions include *Degas à l'Opéra* 2019 (Musée d'Orsay, Paris, and National Gallery of Art, Washington, DC), *Degas: a new vision* 2016 (National Gallery of Victoria, Melbourne, and the Museum of Fine Arts, Houston), *The origins of Impressionism* 1994 (Galeries nationales du Grand Palais, Paris, and the Metropolitan Museum of Art, New York), *Degas 1834–1917* 1988 (Galeries nationales du Grand Palais, Paris, Musée des Beaux-Arts du Canada, Ottawa, and the Metropolitan Museum of Art, New York) and *Chicago, birth of a metropolis* 1987 (Musée d'Orsay, Paris, and the Art Institute of Chicago). His writings include major books on Degas and other nineteenth-century artists, and on Gustave Eiffel, Eugène Viollet-le-Duc and Marcel Proust.

Loyrette has held important positions in French cultural organisations and has been widely honoured. Prior to his position at the Musée du Louvre, he was Président of the Musée d'Orsay and the Musée de l'Orangerie. Upon his appointment to the Académie des Beaux-Arts in 1997 he was its youngest-ever elected member. He is Chair of the Giacometti Foundation and of the Cité internationale des arts.

In Gauguin's paintings and sculptures he seldom incorporated direct borrowings from Polynesian art and material culture. He was familiar with Oceanian sources prior to visiting the region, but it was only once there, and only during his first stay in Tahiti, that he was inspired to employ them. His focus was not on the mere object, nor was it confined to inventorying the works that inspired him. He transformed the meaning and context of the original to recreate a 'lost culture' or infuse his work with symbolic meaning. *Gauguin's World: Tōna Iho, Tōna Ao* explores his reimagining of the sculptural traditions of the Marquesas Islands and creating of new contexts for utilitarian objects, by uniting his points of reference with his works.

RIGHT
Uvéa Island
Tohihina (Bark cloth)
19th or early 20th century
bark cloth, pigment
56 × 208 cm
National Gallery of Australia,
Kamberri/Canberra, 2012.843

OPPOSITE
Portrait of Suzanne Bambridge
(*Portrait de Suzanne Bambridge*)
1891
oil on canvas
70 × 50 cm
Royal Museums of Fine Arts of
Belgium, Brussels, 4491

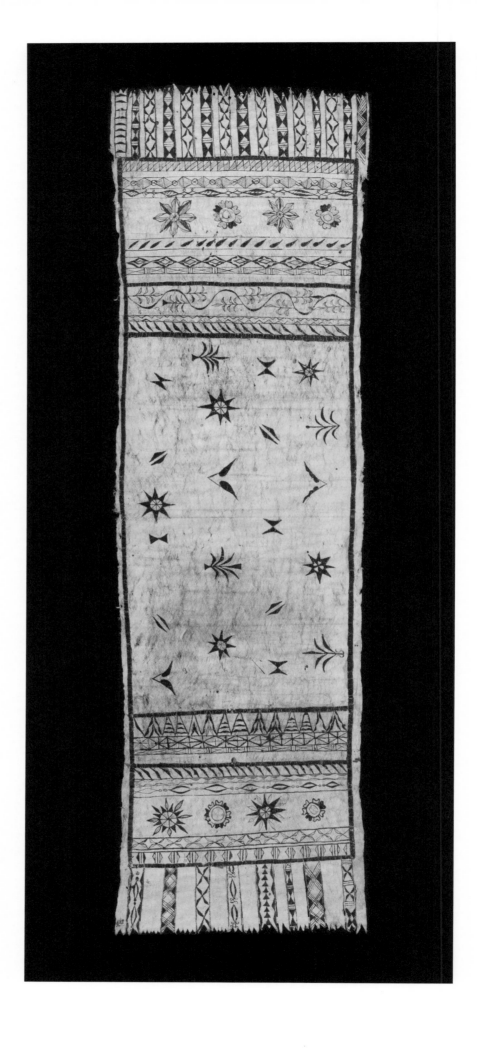

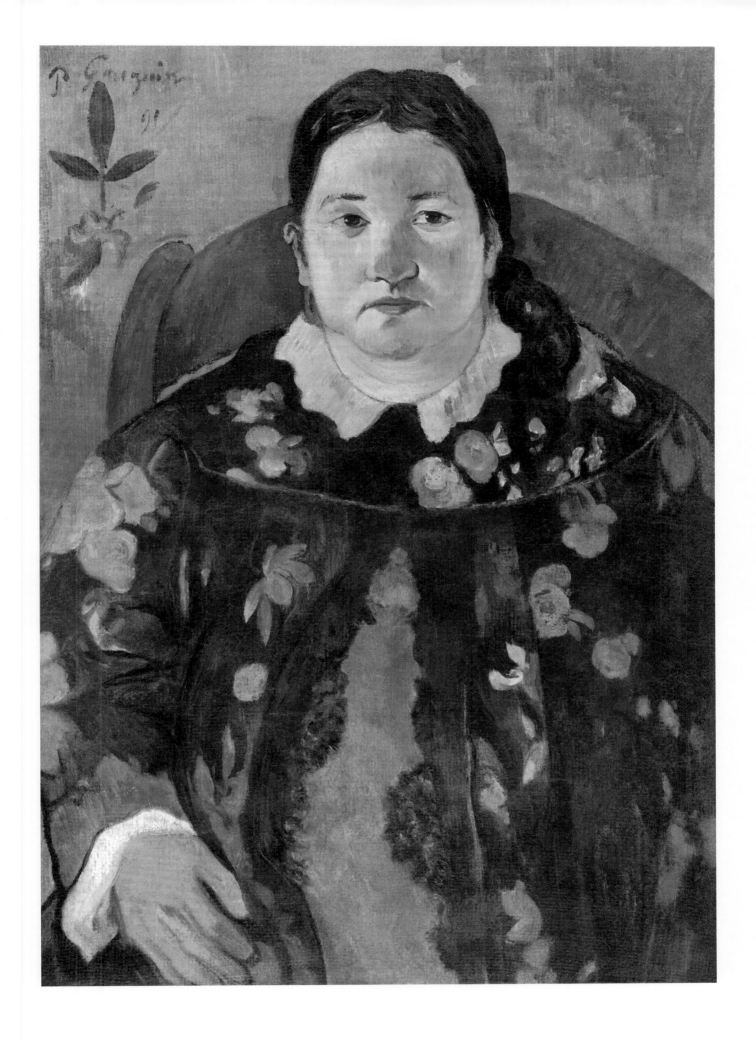

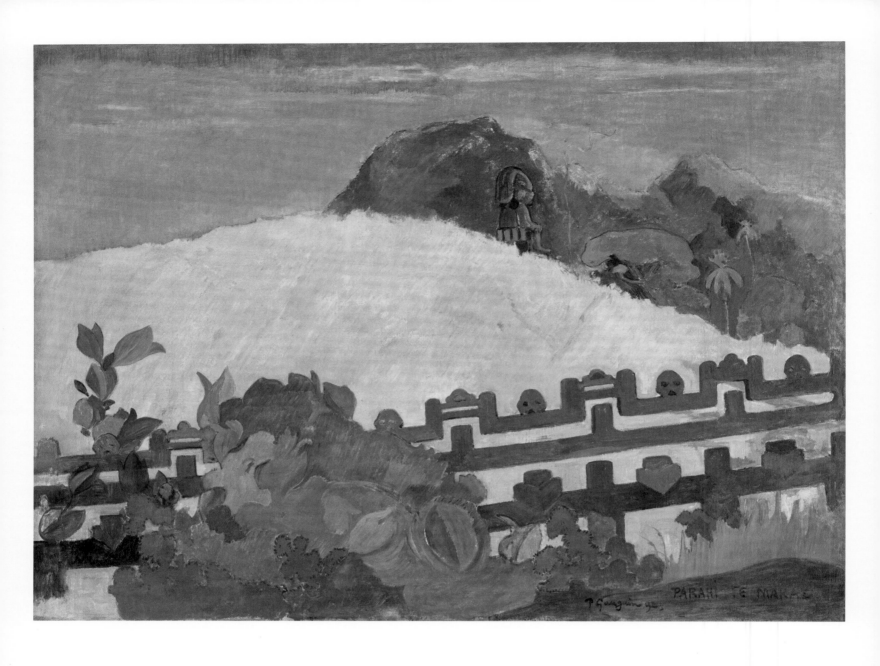

Parahi te marae
(*The sacred mountain*) 1892
oil on canvas
66 × 88.9 cm
Philadelphia Museum of Art.
Gift of Mr and Mrs Rodolphe
Meyer de Schauensee 1980,
1980-1-1

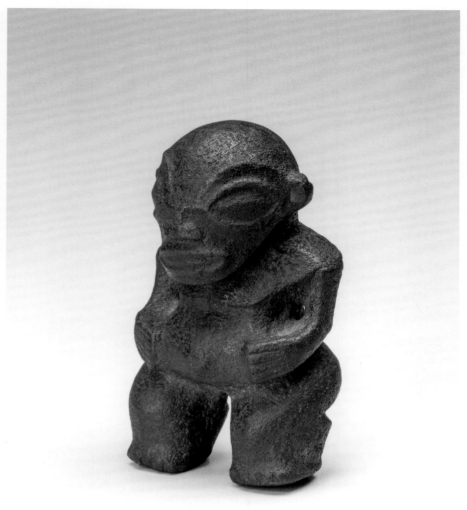

LEFT
Marquesas Islands
Pu taiana or *Taiana*
(*Ear ornament*)
late 19th century
carved bone, shell
1.8 × 4.6 × 0.5 cm
Musée du quai Branly –
Jacques Chirac, Paris.
Donated in 1934 by Mr Élie
Adrien Édouard Charlier
(1864–1937), former interim
governor of the French
establishments in Oceania;
Korrigane Expedition,
71.1938.196.1

RIGHT
Marquesas Islands
Tiki 19th century
carved basalt
12.2 × 7 × 5 cm
Te Fare Iamanaha – Musée
de Tahiti et des Îles, Papeete,
D 2003.2.2

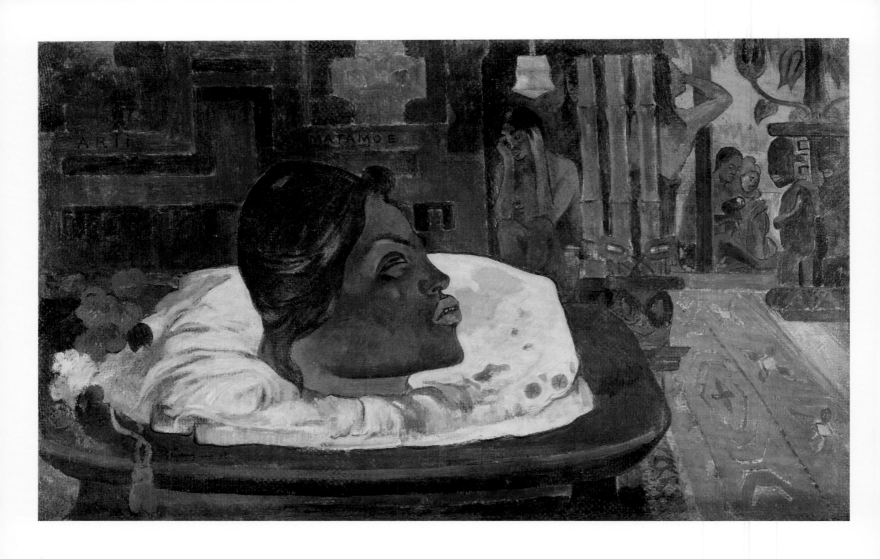

Arii matamoe (*The royal end*)
1892
oil on canvas
45.1 × 74.3 cm
The J Paul Getty Museum,
Los Angeles, 2008.5

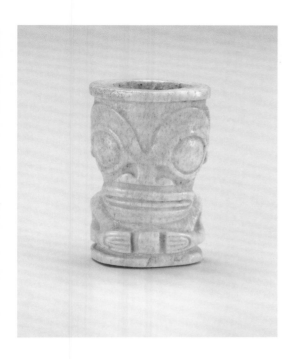

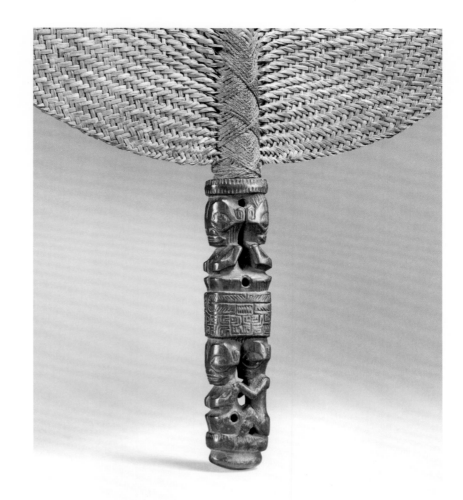

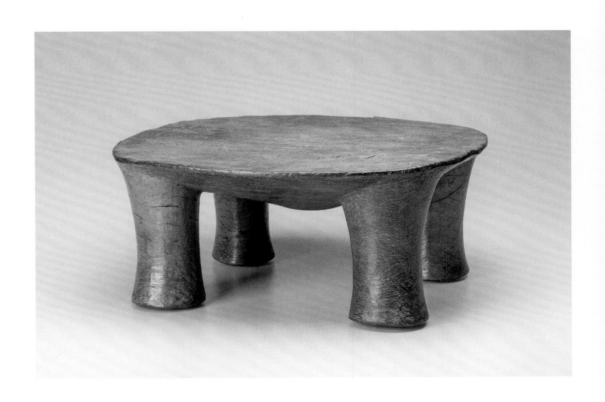

TOP LEFT
Marquesas Islands
(Hakahau Valley, Ua Pou)
Ivi po'o 19th century
carved bone
4.4 × 2.9 × 2.1 cm
Te Fare Iamanaha – Musée
de Tahiti et des Îles, Papeete

TOP RIGHT
Marquesas Islands
Tahi'i (Fan) (detail)
early 19th century
carved wood, plant fibre
43 × 44.2 × 8 cm
Musée du quai Branly – Jacques
Chirac, Paris. Donated by Jean-
Benoît Amédée Collet, 72.84.235.3

BOTTOM
Society Islands
Papahia (Pounding table)
19th century
carved wood
20.5 × 46.5 × 43 cm
Te Fare Iamanaha – Musée
de Tahiti et des Îles, Papeete

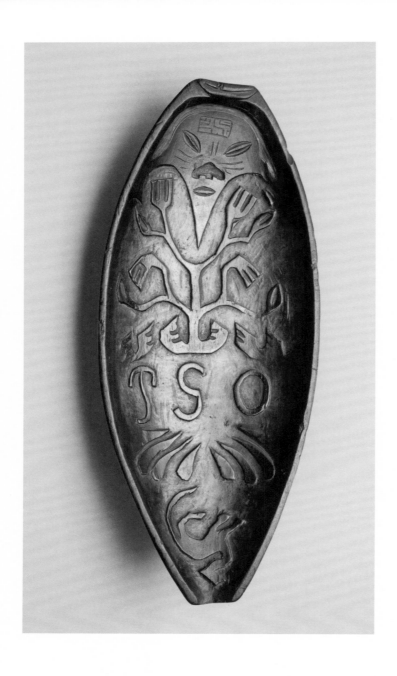

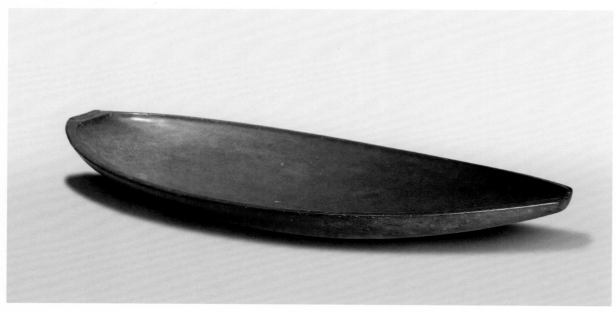

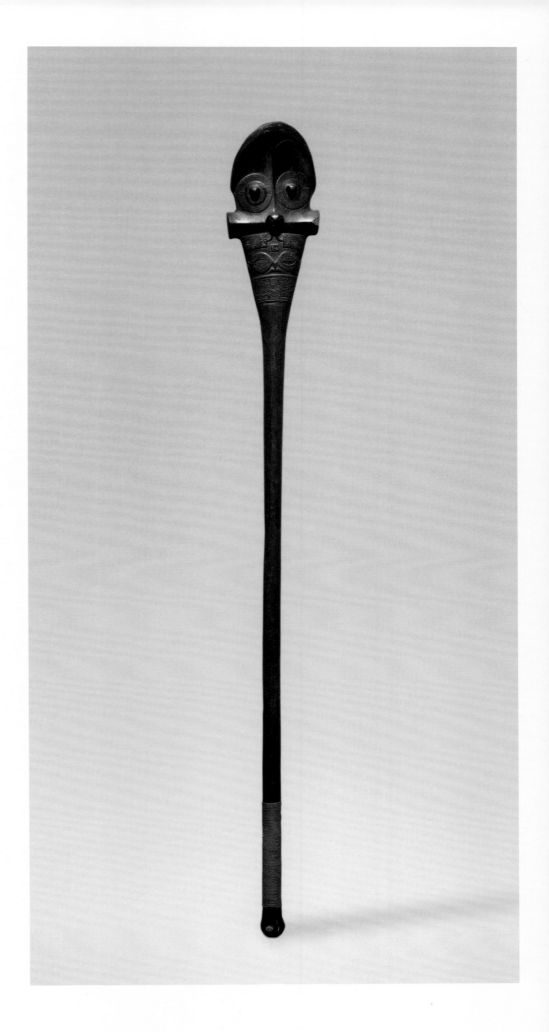

OPPOSITE TOP

Umete (Ceremonial dish) c 1891
carved *pua* wood, hollow relief
and incisions
5.2 × 45.1 × 20.1 cm
Musée d'Orsay, Paris. Gift of
Lucien Vollard 1943, AF 14329 2

OPPOSITE BOTTOM

Austral Islands (Tupua'i)
Umete (Ceremonial bowl)
19th century
carved wood
12.5 × 105 × 44 cm
Te Fare Iamanaha – Musée
de Tahiti et des Îles, Papeete

RIGHT

Marquesas Islands
U'u (Club) 19th century or
earlier
carved wood, vegetable fibre
151.5 × 26.5 × 12 cm
National Gallery of Australia,
Kamberri/Canberra, 2008.185

Nicholas Thomas

The painting
of modern
Polynesian life

Nicholas Thomas first visited Polynesia in 1984 to undertake research in the Marquesas Islands. He has since travelled extensively across the Pacific, written on Indigenous histories, empire and art, and curated extensively. His books include *Islanders: the Pacific in the age of empire* (Yale University Press, New Haven, 2010), which was awarded the Wolfson History Prize, *Possessions: Indigenous art / colonial culture / decolonization* (Thames & Hudson, London, 1999/2021) and several collaborations with Pacific artists including Mark Adams and John Pule. *Oceania*, co-curated by Thomas with Peter Brunt for the Royal Academy of Arts in London and the Musée du quai Branly – Jacques Chirac in Paris in 2018–19, was acclaimed as a landmark exhibition. Since 2006, he has been Professor of Historical Anthropology, Director of the Museum of Archaeology and Anthropology at the University of Cambridge, and a Fellow of Trinity College, Cambridge.

PAUL GAUGUIN IS A GLOBALLY FAMOUS ARTIST, and several of his paintings are as emblematic of modern European art as Van Gogh's sunflowers. Yet, paradoxically, the broad range of his art is not well known: its heterogeneity and complexity have been obscured by the artist's biographical notoriety. The status as artist-insurgent that Gauguin claimed, his many voyages, his death on Hiva Oa and above all his relationships with young women in the Pacific islands had made him an ambiguous celebrity even a century ago. Now he is often charged with colonial appropriation in his art and sexual abuse in his life. Received images of Gauguin obscure the sheer eclecticism of the art and the manifold and difficult character of that work, not only in painting but in sculpture in various media, works on paper, in his books and otherwise. 'Gauguin' evokes an artist of myth, dream, spirituality, the exotic and the voluptuous.[1]

To be sure, Gauguin did paint esoteric subjects that evoked ancestral Polynesian tradition and religion. One of the most extraordinary works from his first Tahitian sojourn (1891–93) is *Parahi te marae* 1892 (p 78), which means simply 'There is the temple'. Across eastern Polynesia, Islanders had long constructed ritual precincts known as *marae* in Tahiti, *me'ae* in the Marquesas, and *heiau* in the Hawai'ian Islands. In Tahiti, they typically consisted of substantial rectangular spaces marked out by low stone walls. At one end, usually the one closer to the island's interior or the mountain, a raised platform was the most sacred area and historically the site of sacrifices conducted for a variety of purposes. Some *marae* were more elaborate stepped structures. They incorporated wood platforms upon which offerings were placed; bark-cloth pennants marked the sanctity of the sites and their environs.[2]

Around Tahiti, there were and are numerous *marae*. At the time of Gauguin's residence they were likely all overgrown and generally avoided because they were considered evil by the Christian church, which the island's population had embraced 75 years earlier. They were also feared for the intense and dangerous sanctity that remained associated with the sites. It is unlikely that any local would have guided Gauguin to such a place and unclear whether he made any effort to seek *marae* out. Yet on coach journeys he undertook from time to time between Mataiea on the south coast where he was living and the port town of Papeete, he would have passed within one hundred metres or so of numerous temple precincts that can be readily visited today.

So it isn't surprising that the *marae* in the painting is contrived. The temple is not situated where it would have been on level ground but on a foothill, a vibrant yellow mound. On its far side is a huge, apparently stone statue, a female figure shown in other Gauguin paintings and prints being worshipped. She is identified as Hina, a goddess with multiple identities that Gauguin associated with the moon. Although Tahitians sculpted *ti'i*, wood images of deities, they did not create monumental stone figures like those of Rapa Nui (Easter Island); the figure in the painting is an outright invention in the Tahitian context. But the work's most striking element is the fence in the foreground. It is radically enlarged from and loosely based on Marquesan ear ornaments known as *pu taiana* (p 79), intricately sculpted from ivory and featuring tiny openwork *tiki* figures, sometimes representing one or two specific myths such as the story of the two daughters of Pahuatiti persuaded by a chief to humiliate the hero Akaui by pissing from their swing into a bowl of kava just as he raises it to his mouth.[3] Gauguin's fence reproduces these ornaments' right-angled openwork but turns their most legible figurative feature into a line of

skulls in the interests of evoking a sombre site of death and commemoration. Comic subversions in Marquesan art, which he is unlikely to have understood at any level of detail, had no place in the painting.

Given the energy with which Gauguin had already borrowed from Peruvian ceramics, Japanese and medieval art as well as from his own contemporaries, it is not surprising that in Tahiti the painter should work elements of Oceanian sculpture into his paintings. Yet there was something unprecedented and truly amazing in the way that he made the visual organisation of Marquesan motifs into such a prominent feature in the very architecture of this painting, as they comprise a highly distinctive design system utterly different to relatively familiar figurative conventions of the Borobudur frieze from Java, for example, which he otherwise employed extensively. The appropriation could be seen and now more than ever is likely to be seen as reprehensible cultural colonisation. Yet the painterly gambit was inherently contradictory. While Gauguin took from local tradition to suit his purpose, the work he created affirmed through the motif's provocative presence that the Tahitian landscape was powerfully and permanently defined by Polynesian spirituality, no matter how bowdlerised his representation of ancestral presence proves in this case.

In the context of this essay, *Parahi te marae* is revealing in another way. It is one of many Gauguin works that attempted and successfully realised a singular artistic project; here, the adaptation of intricate sculptural motifs in the imaging and the imagining of the inhabited, mythic Oceanic landscape. Other of his artistic projects of the period included Christian themes represented in Tahitian settings in the famous work *Ia Orana Maria* 1891 (*Hail Mary*, The Metropolitan Museum of Art, New York) and the use of Rapanui script and other artefacts of ancestral religion in *Merahi metua no Tehamana* 1893 (*The ancestors of Tehamana* or *Tehamana has many parents*, The Art Institute of Chicago) to suggest a modern young woman's genealogy and Polynesian identity. What is arresting about these projects is that the works were one-offs. One can readily imagine another artist producing a whole series mobilising Marquesan iconography or presenting a suite of conventional scenes of Christian art in the Tahitian environment, but Gauguin tried out these experiments and produced paintings that he affirmed he was satisfied with in some cases and that ever since have been considered singular accomplishments—yet that he then never tried again. Degas, Monet, Van Gogh and others are famously associated with motifs and experiments they returned to, relentlessly in some cases; what Gauguin did again and again was try something radical and distinctive then turn to something else. Often for him that one painting was the whole project.

Gauguin's work was marked earlier by this eclecticism and through his career. As he later said he liked figures best but ranged over portraiture, landscape and still life, and also did different things within these genres.[4] The common view of his work from Oceania as dominated by mythic, exotic, esoteric or erotic imagery has resulted in an essentially false view of his oeuvre. There is a standard narrative of his artistic development acknowledging his early mentorship by Camille Pissarro but suggesting that he turned away from Pissarro's Impressionism and the 'naturalism' with which it was associated to Symbolism and what Gauguin called synthetism. But in fact this Pissarro-style naturalism arguably remains vital to Gauguin's art throughout his life and is certainly conspicuous in much work he did in Tahiti.

Haere mai 1891 (p 89) is an evening scene. In the foreground in shadows two large pigs forage among dark green pasture and brush. In the middle ground bright yellow foliage is tinged scarlet. To the left there is a big erect tree, somewhat

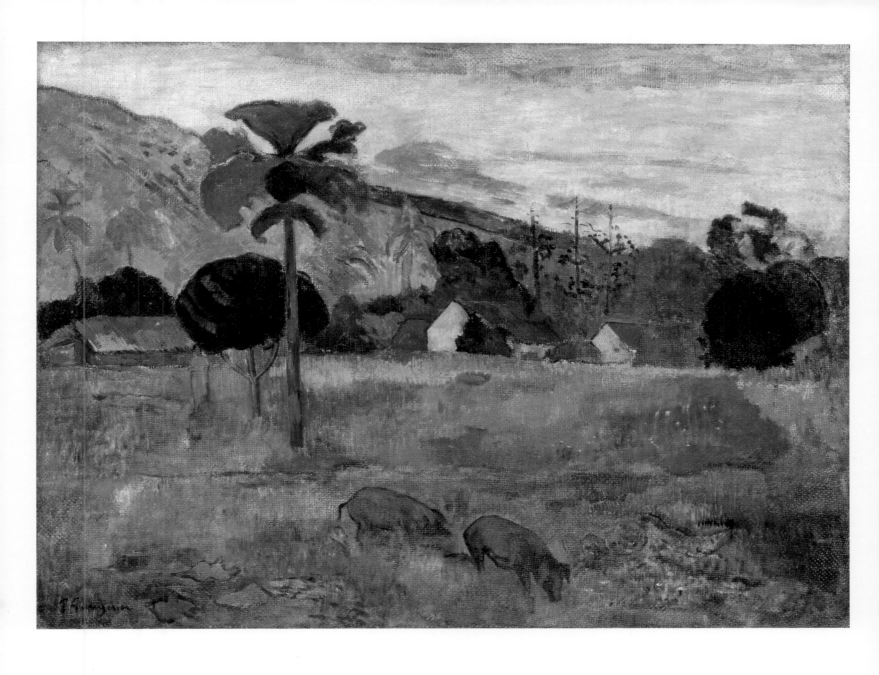

Haere mai 1891
oil on canvas
72.5 × 92 cm
Solomon R Guggenheim Museum, New
York. Thannhauser Collection, Gift,
Justin K Thannhauser 1978, 78.2514.16

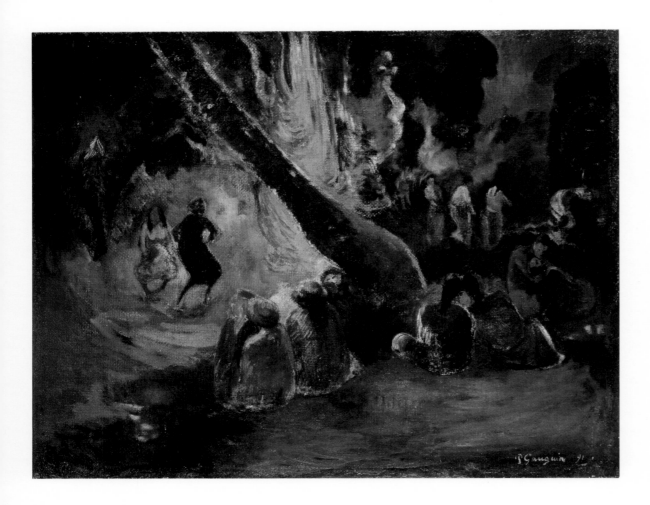

like a fan palm, and behind it a bamboo house. To the centre and right there are
a couple of houses with white end walls; these are not traditional Tahitian *fare*
but presumably painted wood bungalows, the period's modern dwellings. In the
background a ridge ascends to the left. Before the bamboo dwelling a woman is
standing. The title means 'come hither'. The words can form part of a ceremonial
welcome but are also used daily to summon children, for example. As it is evening the
woman is presumably calling the animals back towards the house (pigs may respond
to an owner calling). Or she addresses a person or people who are out of view.

Of just over 90 paintings that Gauguin made during his first period in
Tahiti almost half are works like this: they situate people coming, going or at
rest in their environments. Some of the figures are solitary, some contemplative,
others are engaged in some ordinary task. They come back from a garden with
food, for example. Or they are gathered, resting together, in conversation. In these
works Islanders are in the environs of thatched or modern houses and are dressed
as Islanders of the time were: they wear *pāreu*, the sheets of printed fabric that
people today still commonly wear, or they wear longer dresses which became
customary after conversion to Christianity, variations on 'island dresses' worn
in many parts of the Pacific today.

Upa upa 1891 (*The fire dance*, fig 1) is a striking painting for those aware of
Gauguin's most celebrated pre-Oceanic works. Its composition recalls what is often
considered the greatest achievement of his several periods in Brittany: *Vision of
the sermon (Jacob wrestling with the angel)* 1888 (National Galleries of Scotland,
Edinburgh). That painting was stimulated by the Breton *pardon*, a ceremonial

FIG 1
Upa upa (*The fire dance*) 1891
oil on canvas
72.6 × 92.3 cm
The Israel Museum, Jerusalem.
Gift of Yad Hanadiv, Jerusalem,
from the collection of Miriam
Alexandrine de Rothschild,
daughter of the first Baron
Edmond de Rothschild, B66.1040

procession that drew communities together in a pilgrimage around local shrines and chapels undertaken by large groups in customary dress—though Gauguin was prompted not by any aspect of such ceremonial gatherings (represented by many artists who visited Pont-Aven) but to paint a work which drew attention to superstition he imputed to the population. It depicted a group of women together with their priest, outdoors immediately after a sermon. It visualised their vision of Jacob wrestling with the angel. Gauguin made it famously clear in a letter to Van Gogh that the foreground was real and the background mystical; that is, that the people were real, the background imaginary. This juxtaposition was structured into the work's composition through the prominent angled apple tree: its dominant form divides front from back, the natural from the mystical.

In *Upa upa* an angled coconut palm is similarly prominent and there is a marked division between a triangle occupying the left of the work, brightly illuminated by a bonfire, with a darker foreground where women are seated, and a more obscure area beyond occupied by a few figures in white who seem to move away.

'Upa 'upa was a generic term for dance. Early visitors to Tahiti often described dance emphasising the overt sexuality of performance though this was an aspect of specific dances rather than all, such as those of the 'arioi, travelling performance groups dedicated to the cult of the god 'Oro. 'Upa 'upa was banned by the church following conversion among Islanders, though it was sustained covertly and by the 1890s was probably widely engaged in. (Since the 1960s it has been revived more ambitiously and for some 50 years has been prominent in Polynesian cultural expression, not least through Heiva, the large-scale annual competitions). Gauguin represents an occasion in which participants and spectators both comprise women in modern dress. Puzzlingly, the woman on the left appears to adopt a male dancer's movements which bring one's bent knees together and wide apart in rapid succession. The dark figure to her right may be swaying her hips equally rapidly which is the standard female movement; this was dance for entertainment, not ceremony. Those observing them are women in modern robes and the woven pandanus hats Islanders began making in the nineteenth century and still make and consider fashionable today. In the shadows a couple are intimate. Those in the background may also be dancing or simply making their way away.

After his return to Paris, Gauguin based a woodcut of the *Noa Noa* suite on this painting, giving the new work the title *Mahna no varua ino* 1893–94 (which should have read *Mahana no varua ino*, the Day of the Evil Spirit, p 214), indicating that the scene depicted a ritual event. He deliberately made some versions of the print dark and blurred, heightening an obscurity appropriate to an incarnation or sacrament. Yet the painting depicts something more ordinary—that is, an outdoor party.

—

Gauguin had no formal artistic training but in important respects his practice was conventional. He famously posed certain figures, particularly those in devotional attitudes, after Buddhist sculpture and a range of other sources yet he also always sketched from life and in correspondence mentioned his need for models, indeed a constant need for a model. Those he depicted particularly in the foregrounds of works were occasionally painted from photographs but more typically from his studies of individuals: these were particular people, not generic Islanders.

Not long after he arrived in Mataiea he had the opportunity to paint a woman of the locality. He considered her of the 'true Tahitian race'. The genesis of the resulting painting is related in the *Noa Noa* manuscript in somewhat convoluted passages, in two slightly different versions.[5] The detail of the stories is not important here apart from one point upon which they agree. Gauguin says he began to sketch the woman hastily or asked her if he could paint her portrait; she appeared angered and left him abruptly then came back an hour later 'in a beautiful dress'. Though sections of *Noa Noa* are certainly concocted and passages dealing with Tahitian myth are well known to have been plagiarised from earlier colonists' books, his anecdote of the encounter is essentially plausible: the detail about her return is not one he would have contrived or had any reason to invent.

The resulting painting is *Vahine no te tiare* 1891 (Ny Carlsberg Glyptotek, Copenhagen, fig 2), generally translated as *Woman with a flower*, though *tiare* is specifically *Gardenia taitensis*; early Polynesian settlers introduced this western Pacific plant to Tahiti and neighbouring islands, and it is used in floral *lei* (necklaces), to scent coconut oil and medicinally. The woman is utterly confident in herself, arrestingly dignified; Gauguin saw in her 'the robust fire of bounded strength'; the flower in her ear 'listened to her perfume'. While he often conceived colour via music, here he imagines scent via sound.

And her dress is indeed beautiful. Commentators have often criticised what is seen as the evangelical imposition of European dress upon Islander women. That reaction is understandable: secular, critical intellectuals have not had much time for Christian missionaries in recent decades. But what is at risk of being overlooked was the enduring value of fabric including introduced fabrics seen as prestigious rarities by Pacific peoples in the early decades of colonial contact. For decades Islanders avidly bartered for or sought as gifts textiles and garments Europeans were introducing. For their part, Europeans eagerly adopted calico, muslin, chintz and silk from South and East Asia among other forms of cloth, while in the Pacific they acquired 'specimens' of plain and decorated bark cloth. As early as the 1820s colonial visitors to Tahiti lamented what they considered the incongruous adoption of imported fabric while not reflecting on their societies' enduring enthusiasm regarding novel textiles. The significance of the issue is that it appeared that Islander women were already victims of missionary and colonial repression, hence ready to be exploited artistically by painters including Gauguin. But it is in fact clear that the *vahine no te tiare* willingly permitted herself to be painted. The reason she initially dismissed Gauguin's request yet then returned was that she wanted to dress for the portrait as she considered appropriate: she presented herself as she wanted to be represented.

—

Some Gauguin paintings are strikingly enigmatic. Others—a still life, a landscape—appear simple enough yet are more subtly difficult. Why depict sunflowers and a sculpted Marquesan bowl as things arranged together? Among the deeper paradoxes of Gauguin's art is that as he became increasingly committed to what he called 'abstraction' he made people he depicted more present and real than ever. It's not easy in the twenty-first century to understand exactly what he meant by this term: he did not create nonrepresentational paintings so prominent in major twentieth-century movements. 'Abstraction' for Gauguin meant painting that 'dared anything', driven by its own imperatives. Specifically it meant the Cloisonnism or synthetism

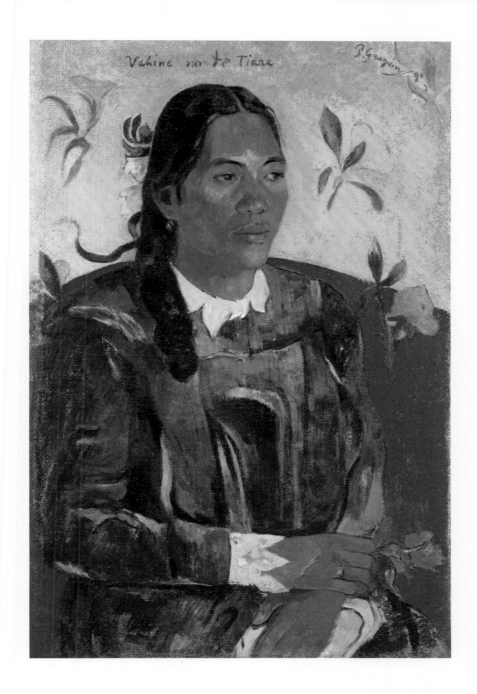

FIG 2
Vahine no te tiare
(*Woman with a flower*) 1891
oil on canvas
70.5 × 46.5 cm
Ny Carlsberg Glyptotek,
Copenhagen, MIN 1828

that Émile Bernard helped him arrive at in Brittany in 1888, which built works out of strong fields of luminous contrasting colour reminiscent of the distinct panels in stained glass. The effect was to give people he depicted distinctive solidity, presence and an almost monumental beauty.

The challenge of Gauguin's work is that it is all of the above: the mysterious sanctity of *Parahi te marae*, the Christian-Polynesian hybrid of *Ia Orana Maria*, the everyday island environment of *Haere mai*, the raucous nocturnal sociality in *Upa upa*, the esoteric rite of that painting's reworking as *Mahna no varua ino*. What was colonial and modern was prominent in Gauguin's art. The Islanders he painted such as the woman in *Vahine no te tiare* were inhabitants of a colonial world. This painting like so many of his works may be interpreted today in different ways by viewers. Some may see her sad, others as dignified, self-possessed, facing the future. Her mood, like so much else, is open to adjudication. What is not in doubt is that Gauguin responded to the people he encountered and the world before him.

Vaiana Giraud

Gauguin the writer: *Noa Noa* and other prose

Vaiana Giraud is deeply involved in Polynesian culture and events, first as communications manager and then as cultural events producer at the Maison de la Culture in Papeete (2003–21). She is passionate about the literary approach to Polynesia in Gauguin's work, and holds a PhD in French literature (with the dissertation 'Paul Gauguin: the role and place of writing in his work'), obtained in 2010 under the supervision of Mme Camelin, Professor Emerita of French Literature at the University of Poitiers, France.

Editorial director of the cultural journal *Hiro'a* from 2007 to 2020, Giraud is now head of the Traditional Crafts Department, part of the Government of French Polynesia, since 2021, where she coordinates and drives the animation and support of the sector. Since 2018, she has also been a member of the scientific and technical committee working on the creation of the planned Espace Gauguin in Papeari, Tahiti.

'GAUGUIN WAS A MONSTER [...] utterly, imperiously monstrous', wrote Victor Segalen, a young naval surgeon who arrived in the Marquesas shortly after the artist's death: 'various, and in everything he did, excessive'.[1] Segalen was able to read Gauguin's papers as he brought the painter's effects back to Papeete for auction. His understanding of Gauguin's worldview was therefore almost unrivalled among his contemporaries. He was dazzled by this vision of Polynesia, acknowledging Gauguin as a true intercessor, and Segalen's writings under that vision's impact remain indispensable.

Segalen perceived in Gauguin's prose 'a prodigious acuity of vision'[2] and, indeed, the painter, ceramicist and sculptor cannot be understood without these writings. Yet Gauguin's writings are the least familiar part of his corpus; some were lost, some remained unpublished, and others were misunderstood or ignored. They deserve attention. 'You want to know who I am,' he asks: 'Are my works not enough for you?'[3]

A prolific writer

Gauguin began writing in 1884, publishing his first articles in Paris, but we shall focus on the texts composed during and after his first voyage to Polynesia, in 1892. Developing an original literary style, he then wrote nearly a text a year and tried multiple times to have some of them published.

In the late nineteenth century, when art and literature went hand in hand, there was nothing unusual about an artist composing literary texts. Gauguin celebrates the vibrant, fragrant island in the poetic *Noa Noa* 1893; in the periodicals *Le sourire* (*The smile*) and *Les guêpes* (*The wasps*), both 1899, the uncompromising polemicist denounces colonisation; in *L'esprit moderne et le catholicisme* (*Modern thought and Catholicism*) 1897 we hear the avant-garde philosopher. Towards the end of his life, his style acquired a new confidence: *Racontars de rapin* (*Ramblings of a wannabe painter*) 1902 and *Avant et après* (*Before and after*) 1903 recount his solitude. *Cahier pour Aline* (*Notebook for Aline*) 1893 expresses his love for his daughter and *Ancien culte mahorie* (*Ancient Māori religion*) 1892 reflects his wonder at the civilisation that he was discovering (fig 1). His writings are complementary to his art and reflect his suffering and rages, his isolation and his courage. We find in them an aspect of the man absent from his paintings, which beautifully evoke Polynesian culture's temporal sensibility, then on the verge of disappearing.

These texts are distinctive for their exalted rhythms and fragmentary style; they move from stroke to stroke, like a painting. Gauguin described *Before and after* in a letter to André Fontainas: 'It is not in the least a literary work, but something quite different: civilised man and the barbarian face to face. Consequently the style must be in harmony with the subject, undressed like the whole man and frequently shocking. However this comes easy to me—I am not a writer.'[4]

FIG 1
Page from *Ancien culte mahorie* (*Ancient Māori religion*) date unknown
manuscript, black ink and watercolour
21.5 × 17 cm
Musée d'Orsay, Paris.
Acquired 1927, RF 10755, 13

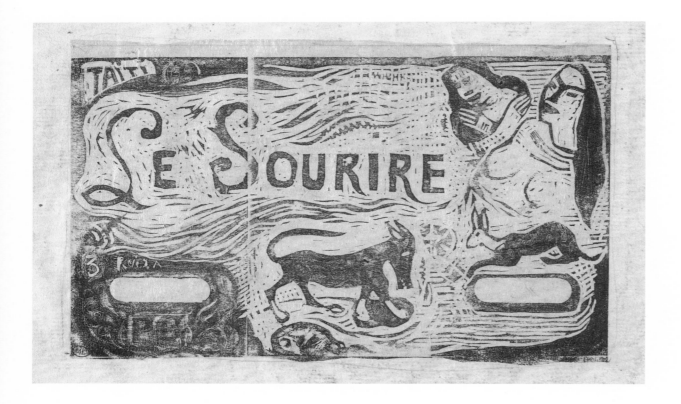

And yet Gauguin writes: to while away his solitude, save his art, preserve his unique voice and convey his ideas to his Paris circle in which he wanted to maintain a symbolic presence while being geographically removed. A tireless correspondent, he wrote to his wife, Mette Sophie Gad, to his friends and to the members of the artistic scene. He had witnessed revolutionary developments in fin-de-siècle art: the births of Symbolism and Post-Impressionism and the advent of photography. These cultural events, which left their historical marks, are illuminated by his visionary gaze. Among his correspondents were Stéphane Mallarmé, the Symbolist poet; Alfred Vallette, a man of letters and founder of the *Mercure de France*, a literary journal that soon acquired its own celebrated publishing house; André Fontainas, poet and critic for the *Mercure*, whom Gauguin asked to ensure the publication of *Before and after*; and Albert Aurier, a poet and critic who helped introduce Impressionism to a wider public. Gauguin's scrupulous revision of his texts shows the importance he gave to them. And late in his life he was most insistent that certain of his correspondents should publish at least two of his works 'at no matter what price':[5] *Ramblings of a wannabe painter* and *Before and after*.

Themes

Gauguin's writing is first and foremost the record of something that marked him for life: his encounter with Polynesia. It gave rise to two magnificently illustrated works, *Ancient Māori religion* and *Noa Noa*, which embody his astonished delight at what he found. 'What a religion the ancient Oceanic religion is. What a marvel! My brain is bursting with it and all it suggests to me will certainly frighten people', he exclaimed, more or less on arrival.[6] In *Ancient Māori religion*, he attempted to articulate this experience in solemn rhythms of poetic language: 'Taaroa was his name; the void was his dwelling. No earth, no sky, no mankind. […] Taaroa is light.'[7]

During his second trip there, between 1895 and 1900, writing became the primary tool in his battle with the colonial system. *The smile* and *The wasps* speak of

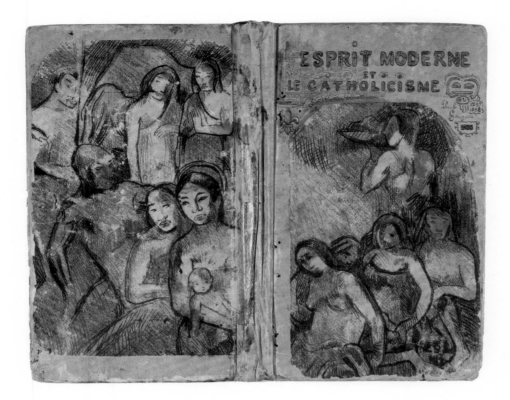

the struggle he constantly waged with the colonial administration in tones not unlike those of newspapers of the day (fig 2). *Ramblings of a wannabe painter*, by contrast, offers a kind of artistic counter-critique. Irony, caricature and anecdotes, whether real or imagined, impart a striking variety to these texts.

While in Polynesia, Gauguin also wrote *Modern thought and Catholicism*, denouncing the way in which religions' spirit can be perverted by their institutions. He was deeply imbued with Buddhist notions, knew a wide range of religious texts and was fascinated by the figure of Christ. Seeking to harmonise Catholicism and Buddhism with ancestral Polynesian religion, he proclaimed their essential unity in this pamphlet, with its context of fin-de-siècle modernity. 'From a philosophical point of view, it is perhaps the best-expressed thing I have ever written', he concluded in 1898 (fig 3).

Finally there are his literary works. 'Sparse notes, lacking continuity, / Like dreams, as like everything else in life, / made of pieces'[8] was his description of *Notebook for Aline*, while *Before and after*, his final work, was autobiographical and echoed his previous writing to the extent of borrowing from previous texts; it sums up his work as writer.

What role does *Noa Noa* occupy in his corpus? Its title means 'fragrant'. While not the most important of his writings, it is surely his best-known text. *Noa Noa* is as radical in its construction as in its aims. Is it a travel diary, a tale of romantic discovery or an exotic exhibition catalogue? It exemplifies Gauguin's complexity as we shall see.

Noa Noa: from original project to final text

The idea for *Noa Noa* came to Gauguin after his return from his first voyage to Tahiti. In 1893, he told his wife, Mette, in a letter: 'I am also preparing a book on Tahiti, which will facilitate the understanding of my painting'.[9] He worked on it until March 1894, when it was still only a bundle of pages with a few illustrations.[10]

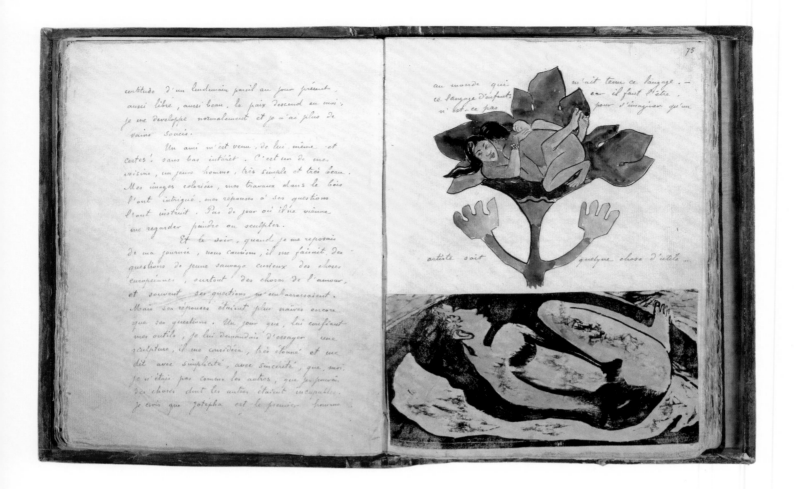

Profoundly aware of his works' transgressiveness relative to mainstream art, Gauguin wanted his Paris exhibition to be accompanied by a text setting his works in their Polynesian context. Several passages in *Noa Noa* testify to this, including what he wrote about the painting *Pape moe* 1893 (*Mysterious water*, Private collection): 'Reaching a detour—what I saw—Description of the picture of *Pape moe*',[11] which condenses an inspirational incident on a mountain walk.

The writing project soon took a new turn and Gauguin enlisted the help of Charles Morice, a symbolist poet and Mallarmé disciple: 'I am going to bring out a book, with my friend Charles Morice, that will tell about my life in Tahiti and the way I feel about art. Morice comments in verse on the works that I have brought back from there', he declared in *L'Écho de Paris* in 1895.[12] He surely hoped this would broaden the response to his work. Late in his life he told Daniel de Monfreid: 'The idea had occurred to me, when speaking of noncivilized [sic] people, to bring out their character alongside our own [...]. Then too, writing is not my line of work, as they say, which of us two was the better: the naïve and rough-spoken savage or the man rotted by civilization?'[13]

His plan was thwarted; Morice, taking unwarranted liberties, modified Gauguin's words, ultimately publishing the entire text without his permission.[14]

Gauguin's own copy is in the Musée d'Orsay collection in Paris. Tired of waiting for his friend's poems he eventually added photographs, collages and paintings to the blank pages reserved for Morice's poems, sometimes even covering up his own text. The images do not illustrate *Noa Noa* but refer to other anecdotes, other works by the artist and his paintings (fig 4).

FIG 4
Couple embracing and text manuscript (Couple enlacé et texte manuscrit)
pages from *Noa Noa*
date unknown
manuscript, watercolour, pen and colour inks, engraving
31.5 × 23.2 cm
Musée d'Orsay, Paris. Gift of Daniel de Monfreid 1927, 16-557433, 86-000465

The literary tale

Noa Noa presents itself as a tale told in the first person. This form born of oral traditions was very fashionable in the nineteenth century; the implied authenticity suited Gauguin's purpose perfectly. Not claiming to be an author but nevertheless seeking to be published, he chose a narrative form central to literary tradition. In its brevity, orality, emotive tone and forays into the mysterious or wonderful, *Noa Noa* takes us along with Gauguin into an unknown universe for a reader living in Paris.

The book is intended to be educational if not didactic, with passages on religion and Polynesian cosmogony and customs; this intention is clear even in Gauguin's syntax. The artist wants to show that he belongs to two worlds, that of Polynesia and that of Paris, at times confiding in the reader and at times acting as a guide. This finds expression in the use of Tahitian words, translated at first in brackets then simply underlined: 'Thus restored, they again took the road for Papeete, their breasts leading [...] spreading round about them that mixture of animal scent and of sandalwood and gardenias: "*Teine merahi Noa Noa* (now very fragrant)", the women said'.[15]

Gauguin wants his readers to think he's been initiated into Polynesian ancestor worship and its mysteries. *Noa Noa* begins with an event that's mysterious enough but rooted in reality: with King Pomare dying the population gathers at Papeete, forewarned of his impending death by light configurations on the mountains. Gauguin's partner, Teha'amana, figures as a guardian of the past confiding secrets of ancient worship to him.[16]

Style is important in *Noa Noa*; his contemporaries described Gauguin's writing as 'artistic'. The book constitutes a hybrid genre, at once a memoir of his voyage and the story of his cultural integration. Like most of his writings it thus contributes in constructing his legend as man, artist, savage—and author.

And in *Noa Noa*, his first text he sought to have published, Gauguin didn't defer from attacking a popular author whose vision he detested: Pierre Loti.

Poles apart from Loti

One characteristic of *Noa Noa* is its use of what might be called 'ready-made' material, as its contemporary readers would have recognised quickly from Pierre Loti's very popular *Le mariage de Loti* (*The marriage of Loti*) 1882. Gauguin is very critical of Loti's autobiographical fiction and its superficial westernised approach to Polynesia. *The marriage of Loti* relates experiences of the British naval officer Harry Grant, which are close to those of the French officer Julien Viaud, who was then adopting the alias Pierre Loti for his writing, a pseudonym he'd been given in Polynesia. He describes the court of Queen Pomare, Polynesian society and his relationship with a very young girl, Rarahu, with whom he establishes a union in Tahitian style, by settling with her by simple mutual agreement. Charmed by Rarahu and this new way of life but steadily disenchanted, Loti speaks of the swathe cut through Polynesia's population due to disease brought by Europeans and of colonisation's effects, with fin-de-siècle pessimism inflecting his writerly aesthetic. At a time when Pierre Loti was at the height of his popularity,[17] Gauguin's narrative follows Loti's to dissociate himself quite precisely from its message.

We recognise in *Noa Noa* the narrative structure of *The marriage of Loti*. Rarahu, Loti's partner, is 14 and adopted; Teha'amana is 13 and has a foster mother. Both writers state that they are uncertain about living with these very young girls but that nevertheless they surrender to their charm. Their unions become

an education in language, religion and cosmogony, which each says he has come to understand through his partner. In both cases, the European lover abandons 'his' tearful young woman; Rarahu is dying, while Tehaʻamana never expects to see Gauguin again.

Both works begin with a powerful sense of disappointment. In *Noa Noa*, Gauguin writes: 'To a man who has travelled a good deal this small island is not, like the bay of Rio Janeiro, a magic sight'.[18] And later, after the brief funeral ceremony of the last king: 'That was all—everything went back to normal [...]. It was all over— nothing but civilised people left. I was sad, coming so far to...'[19]

And as Loti observes: 'Years have gone by and made a man of me. I have been almost all over the world, and at last I behold the island of my dreams. But I have found nothing but melancholy and bitter disappointment.'[20] He then adds: 'And civilization, too, has been overbusy; our hateful colonial civilization, with our conventionality, our habits and vices; and wild poetry flees away with the customs and traditions of the past'.[21]

While the disappointment Gauguin felt towards the island and its inhabitants triggered a rich and profound quest for what he sought as authentic, Loti's experience confirmed him in his impotence as he witnessed the inevitable death of the country he had only begun to experience and of most of the people he had come to know.

Gauguin's narrative counters Pierre Loti's message with mordant irony. While the novel's naval officer enthusiastically takes up the delights of Queen Pomare's court in Papeete, the artist in his writing flees the capital in search of greater authenticity. Rarahu is Christian; Tehaʻamana is said to still know the rites and legends of earlier times. In the novel, Loti's departure leaves him in despair; he has failed in his quest to find the child his brother had with a Tahitian woman. Conversely, Gauguin eventually discovers inspiration and an unfettered depth that he sought, and is able to conclude: 'Goodbye, hospitable soil. —I went away two years older, younger by twenty years; more of a barbarian, too, and yet knowing more.'[22]

Social critique

Despite its apparent sincerity, Gauguin's story is fictional. We know this from parallel testimony that his despairing letters to Daniel de Monfreid provide. Since these speak of his isolation, ill health and petty nuisances by which he is assailed, the letters run counter to the light-hearted happiness described in *Noa Noa*.

Social critique, often a feature in short forms such as the folk tale, makes itself heard in Gauguin's text. He excoriates western civilisation as embodied by its representatives, criticising colony members from the outset in a manner that seems to draw as much on literary tradition as on his own experience. The author Pierre Loti barely touches on this theme while his character Loti enters colonial society in Polynesia and spends enjoyable time with Queen Pomare's entourage.

Noa Noa's appendix begins with these tough words: 'After the work of art— The truth, the dirty truth.'[23] Gauguin was able to return to France thanks to a French naval captain's charity in agreeing to take him on board. This oscillation between the first pages' disillusionment and the magic of those that follow is integral to *Noa Noa*, a story of wonder with a final section condemning France's domestic and colonial administrations.

Reading the artist to understand him

'An artist must be free or he is not an artist',[24] Gauguin tells us, and his literary practice illustrates this maxim. He was a prolific writer and a multi-faceted artist; taken together, his works allow us to glimpse the man as a whole through his numerous complementary artistic practices.

We cannot but mourn the loss of what must be nearly half of his writing, according to the legal inventory of the painter's assets carried out in Atuona on the island of Hiva Oa where he passed away. And we can only imagine the extent of that loss and of our ignorance that surely curtails our understanding of his work and of the man. Gauguin, writing to André Fontainas in 1902, declared that 'My work from the start until this day—as can be seen—is congruent with all the gradations which comprise an artist's education—about all this I have preserved silence and shall continue to do so being persuaded the truth does not emerge from argument but from the work that is done'.[25] His writing is an essential part of that work.

Norma Broude

Paul Gauguin and his art in the era of cancel culture: reception and reassessments

Norma Broude is Professor Emerita of Art History at American University in Washington, DC. A pioneering feminist scholar and specialist in nineteenth-century French and Italian painting, Broude is known for her critical reassessments of Impressionism and the work of Degas, Caillebotte, Cassatt, Seurat and the Italian Macchiaioli. Her paradigm-shifting books include *World impressionism: the international movement 1860–1920* (Abrams, New York, 1990); *Impressionism, a feminist reading: the gendering of art, science, and nature in the nineteenth century* (Rizzoli, New York, 1991, and HarperCollins, New York, 1997); and most recently, *Gauguin's challenge: new perspectives after Postmodernism* (Bloomsbury Visual Arts, New York & London, 2018).

MORE THAN HALF A CENTURY AGO postmodern critiques began to present the art-historical world with a demythologised Paul Gauguin, a much diminished image of the artist/hero who had once been universally admired as 'the father of modernist primitivism' but who was now being reframed and reassessed for the sexist and colonialist foundations of his art and its reception.[1] That powerful critique— revelatory and paradigm-changing though it seemed at the time—initially did little to alter Gauguin's place in the mainstream canon. Nor did it diminish his popularity among museum-goers, who continued to flock to the steady stream of Gauguin exhibitions that were mounted by major museums in the decades that followed. Its effects nonetheless were deeply felt and continue to be felt today within segments of the academic and critical communities, where of late they have grown to almost fever pitch. Condemning Gauguin as much for his life as for his art and abetted by an internet echo chamber that likes to traffic in blanket labels, critics and reviewers have begun to ask such questions as 'Is it time Gauguin got cancelled?'[2] and 'Is it time to stop looking at Gauguin altogether?'[3]

This unnuanced but increasingly popular image of Gauguin in the critical media—as a predatory womaniser, agent of colonial domination, and even sexual offender whose art should be 'cancelled'—has become, moreover, remarkably resistant to re-examination despite recent scholarly efforts to contextualise it and to challenge the alignment of Gauguin with a set of patriarchal values that in reality he openly denounced.[4] In my essay 'Flora Tristan's grandson: reconsidering the feminist critique of Paul Gauguin' (2018), I examined the relationship of Gauguin's thinking to that of Flora Tristan (1803–1844), the well-known utopian socialist and feminist activist who was also his grandmother, and whose radical ideas advocating for the empowerment of women Gauguin knew and drew upon both in his writings and in his art (fig 1).[5] How, I asked, are we to reconcile the image of the brutal sexist pig and colonial tourist that has become a staple of the revisionist critique of Gauguin with the remarkably progressive positions that he took in his writings about some of the central issues that confronted women in his era? These ranged from the prevalence and social causes of prostitution to the punitive civil and religious laws that governed marriage and divorce, to the cultural practices and sexual constraints that disempowered women and restricted their rights and capabilities in 'civilised' societies. Many of Gauguin's positions on these issues clearly echo those that had been advanced by Tristan, social reformer and crusader for the rights of women and workers, more than a half-century earlier.[6] Like Tristan, Gauguin regarded the bourgeois institution of marriage as another form of prostitution. Sharing her outrage and often echoing her words, he called it 'nothing but a sale' as a result of which 'woman falls into abjection, condemned to marry if her fortune allows it, or to remain virgin'.[7] For the unmarried woman, he declared the right to give birth

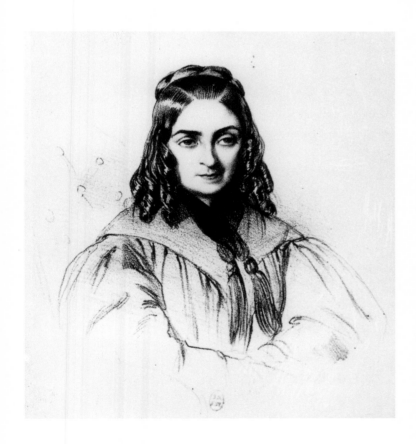

FIG 1
Unknown artist
Portrait of Flora Tristan
Bibliothèque nationale de
France, Paris

and raise her child with 'as much respect as the woman who sells herself exclusively in marriage'.[8] And arguing as Tristan had done for redefining the relationship of the sexes within a new egalitarian social order, he further advocated for women's right to find happiness in their independence and to earn their own living, he said, 'as the pathway to that right'.[9]

Although Gauguin never met Tristan, who died four years before his birth, his contemporaries were well aware of her importance for his thinking. In 1891, for example, the critic Octave Mirbeau ascribed to Tristan and her socialist politics a formative influence on Gauguin and the household in which he had been brought up.[10] Gauguin's enduring respect for Tristan is established on a primary level by the prominent position he accorded her in the family history he set down toward the end of his life in *Avant et après* (*Before and after*) 1903.[11] His deep and abiding interest in her ideas and accomplishments as a social activist is further established by references in his letters to her books, from which he copied extensive passages to keep with him,[12] and to which he was careful to maintain access despite his peripatetic existence. Tristan's books, especially her *Promenades dans Londres* (*Promenades in London*) 1840 and *Union Ouvrière* (*The Workers' Union*) 1843, were important to Gauguin both before and after his departure for Tahiti. They inflected his thinking on the social concerns he shared with Tristan and may have borne fruit in some of his own later efforts at social protest and activism in Polynesia, protests that were directed largely against the hypocrisy and corruption of the colonial administration and its mistreatment of the Indigenous population in general and women in particular.[13]

Despite ongoing and relentless efforts by church and state to change old patterns, what Gauguin nevertheless hoped to find in Polynesia, his writings suggest, were social structures and cultural values, hierarchies of gender and the cultural construction of identity that differed significantly from those of contemporary Europe. In his journal *Noa Noa* 1893–94/1901, for example, he pointed to androgynous similarities in body type among men and women in Tahiti and observed the positive effects that this had on their relationships with one another. In contrast to the artificiality of the female body ('modeled on a bizarre ideal of slenderness') and of male–female interactions in the West, in Tahiti, he wrote, 'there is something virile in the women and something feminine in the men. This similarity of the sexes makes their relations the easier.'[14] But despite this apparently more egalitarian vision of gender relations, late twentieth-century critics have taken issue with the predominance of women in Gauguin's imagery, characterising it as a colonialist strategy designed to infantilise and sexualise the 'other'.[15]

More recently, I have proposed instead that Gauguin's preoccupation with the female in his art may have sprung not from an impulse to infantilise the Polynesian world but rather from a desire to uncover older and alternative forms of social organisation that had privileged the female in pre-colonial myth and culture. His awareness of the present-day demise—but also survival—of some of those older cultural patterns and hierarchies manifests in his art not only through the ubiquity of women in scenes of daily life in Polynesia but also through his written, painted and carved images of royal women such as Queen Maraü and the Princess Vaïtua[16] and of mythic female deities such as Hina, goddess of the moon, and Vairaumati, the mortal goddess of regeneration;[17] as well as Ōviri, the 'savage' embodiment of maternal power and female dominance, a figure that Gauguin chose to stand guard over his own final resting place (fig 2).[18]

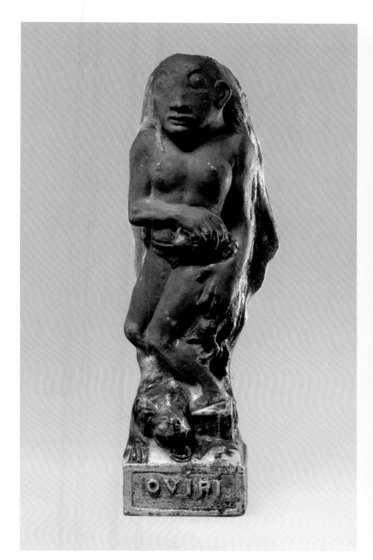

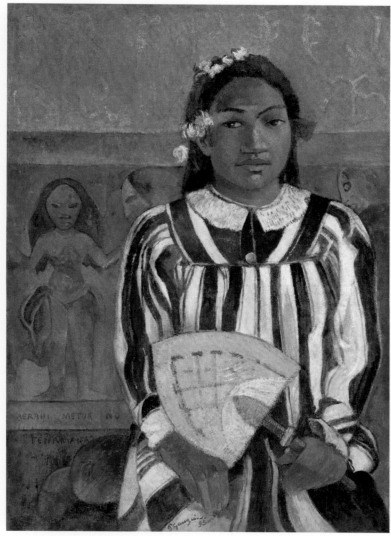

In his Tahitian journal *Noa Noa*, Gauguin professed to have learned stories of ancient Polynesian religious cosmologies and origin myths from his young mistress Teha'amana. But in actuality, Gauguin had transcribed those stories into his manuscript from a totally different source, an earlier volume by the French ethnologist and travel writer Jacques-Antoine Moerenhout, his *Voyages aux îles du grand océan* (*Voyages to the islands of the great ocean*) 1837. And for this dual act of denial and 'plagiarism' as it has been called, Gauguin has frequently been derided in the literature.[19] But more important and interesting to me than the terms of this older critique is the question of why Gauguin would have thought it appropriate for the past to be transmitted through Teha'amana, and what might have been the advantages in his mind of pretending that she was his source?

In many ancient and traditional societies, it has long been customary to regard women as the preservers and transmitters of authentic cultural memory and knowledge.[20] And Gauguin, in his 1893 painting known as *Merahi metua no Tehamana* (*The ancestors of Tehamana* or *Tehamana has many parents*, The Art Institute of Chicago, fig 3), has clearly assigned Teha'amana this role. Seated primly, her body shrouded in a missionary-style dress but with fragrant flowers in her hair and a knowing gleam in her eye, she carries a fan, a traditional emblem of family rank

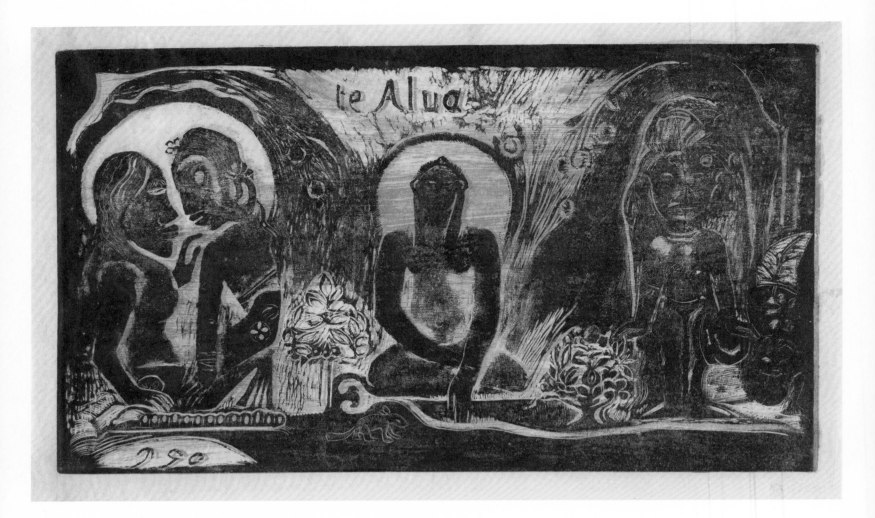

Te atua (*The gods*) 1893–94
woodcut on Japan paper
state 1
image 20.5 × 35.5 cm
sheet 24.7 × 37.7 cm
The Museum of Modern Art,
New York. Gift of
Abby Aldrich Rockefeller
1940, 301.1940

and authority.[21] Her sideward glance clearly connects her to the painted image behind her of Hina, the mythic goddess of the moon. In Māori origin myths, it was from Hina that all were descended because she had argued successfully against the earth god Te fatou to secure the rebirth of humankind (p 110).[22] Presented here as her descendant, Teha'amana sits against two large red ovoid forms at the lower left of the composition, identified as mangoes that allude to the bounty of the earth. But their bright red colour, repeated in the flower behind Teha'amana's ear, also offers a powerful allusion to female fecundity and to the menstrual blood known to have been celebrated in pre-colonial tribal rites and ceremonies in the Māori world as a primal link to creation myths and to the gods.[23]

In Gauguin's imagination, despite European interventions and present-day realities, Teha'amana was the living embodiment of an unbroken link to a female line and to an authentic traditional past in Oceania, where in many areas, anthropologists tell us, patterns of kinship, descent and status had been matrilineal—reckoned through the female line.[24] It was believed, art historian Anne D'Alleva writes, that 'elite lineages inherited more mana [divine force] than others, and women, who in giving birth ushered children from the spirit world to this world, were conduits for it'.[25]

Although their roles may have been diminished under colonial rule, women had held high positions in pre-contact Tahitian society and continued to do so in Gauguin's day. D'Alleva speaks of 'the prominence of women *ari'i*, women of authority' in Tahiti in the 1890s as a surviving 'feature of older society'. 'And the inheritance of important *ari'i* titles', she writes, 'could pass through women as well as men'.[26] In her study of the ways in which material and visual culture determined relations of power in eighteenth-century Tahiti and the Society Islands, D'Alleva further identifies two traditional and complementary social roles for high-ranking women, which may have resonated still in Gauguin's time: that of the 'sacred maiden' and that of the authoritative 'masculine woman'. The former, sisters and daughters of high-ranking titleholders, were uniquely empowered to perform ritual dances and ceremonies, with 'sacred and genealogical meanings embedded in their costumes'. The latter, older women who had become politically active and were powerful titleholders in their own right, were conceptualised in the culture as being or acting like men, and their roles were not dependent on their marital or maternal status.[27]

The late work by Gauguin that most forcefully sums up and projects what he may have internalised about these remnants of a matrilineal past, now modified by the patriarchal realities of the colonial present, is *Two women* (The Metropolitan Museum of Art, New York, fig 4). Likely painted in 1901 or 1902 just before or after Gauguin's move from Tahiti to the Marquesas Islands,[28] it is a much-transformed adaptation of a contemporary photograph (fig 5), which shows two Tahitian women full length and in missionary garb, seated together on the steps of a traditional house. In the photo, the frail and shrunken older woman on the left recedes behind the more assertive younger woman who holds her arm protectively. In his painting, Gauguin has radically transmuted this scene into a close-up and iconic, half-length and over life-size double portrait of the two women, now looming large against the flattened picture plane, their heads unified by an expanse of dark green foliage that seems to crown them like a ceremonial headdress. In Gauguin's image, the older woman is now positioned higher in the picture space. No longer frail in appearance but with strongly chiselled facial features accentuated, she takes the lead, while the younger woman rests her hand gently on her elder's arm as a signifier of continuity and connection.

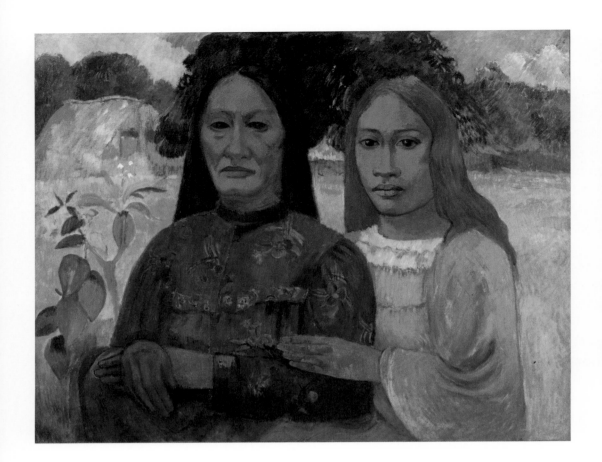

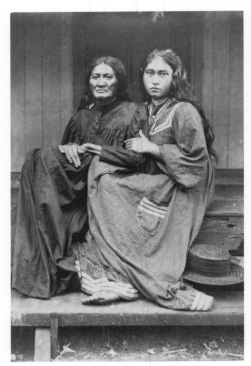

Like *Merahi metua no Tehamana, Two women* is a painting that summons
up ancestral relationships through the female line, paying powerful tribute to the
surviving echoes of an Indigenous culture and its values. In his portrayal of the two
women, despite the restricted circumstances of their colonial lives as signalled by
their missionary dress, Gauguin succeeds in conveying something of the power and
authority with which ancient matrilineal societies had endowed the female line.
Although these two women have been described in the literature as mother and
daughter, reflecting our own culture's understanding of the primary relationship
between an older and younger woman, it is suggestive and important to know that
the familial connection between the two women pictured in the photograph was in
reality that of aunt and niece.[29] This provides a compelling reminder, intentional or
otherwise, that the primary familial relationship and closest alliance in matrilineal
societies was not between parent and child or husband and wife, but between sisters
and brothers, who were bound by the covenant of their clan to provide for one
another and their children throughout their lives.[30]

Two women is a painting in which Gauguin and his sitters pose a clear
challenge to western-male cultural authority, perhaps accounting for its
characterisation by one mid twentieth-century male critic as 'unpleasant'.[31] It is
instructive to juxtapose it with Gauguin's slightly earlier *Two Tahitian women* 1899
(The Metropolitan Museum of Art, New York, fig 6). The contrast suggests the
basis for that critic's judgement as well as some of the personal challenges that
Gauguin faced and the dichotomies with which he struggled in Polynesia. The tension
foregrounded by these paintings, whose female subjects relate very differently to
their audiences—compliant in the earlier canvas and powerfully centred in the later
one—springs from Gauguin's practical need on the one hand to aestheticise and

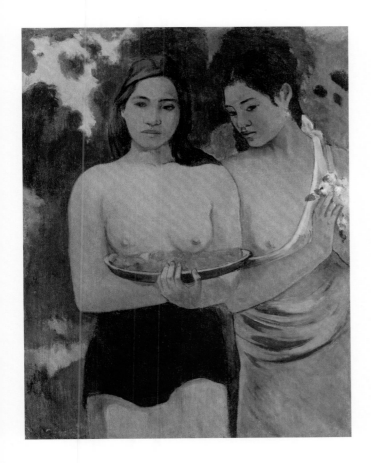

sexualise Indigenous people in Polynesia for consumption by Parisian audiences and, on the other, his politically clear-sighted response to the imposition of colonialism and its suppression of an Indigenous culture, a culture that had endowed women with social and spiritual power and whose values still survived. It is a tension that mirrors Gauguin's own conflicted roots, identities and allegiances.

If—and as I believe his work attests—one of Gauguin's goals in Polynesia was to seek out the real and mythic roles played by powerful women in that culture, he would have arrived from Europe well prepared to embrace and pursue such thinking. From the 1860s on, European anthropologists had begun to question the previously assumed universality of the patriarchal order and to debate the existence of alternative matriarchal and matrilineal forms of social organisation. The most influential of these was Jacob Johann Bachofen, a Swiss antiquarian and anthropologist who postulated a prehistoric matriarchy and an ancient 'mother right' as the source of all human society. Bachofen's path-breaking book *Das Mutterrecht: eine Untersuchung über die Gynaikokratie der alten Welt nach ihrer religiösen und rechtlichen Natur* (*Mother right: an investigation of the religious and juridical character of matriarchy in the ancient world*) first appeared in Germany in 1861, and the impact of his thinking among subsequent generations throughout Europe and America was widespread.[32] Tastes in fiction as well, with the worldwide success of H Rider Haggard's 1887 novel *She*, are another indicator of the extent to which theories about matriarchy in ancient and primitive societies and debates over their implications for female autonomy in the modern world were gaining currency and penetrating popular culture during these decades.[33] Gauguin's quest for an authentic Tahitian past that privileged the female role can thus partly be understood in the context of these debates and theories in late nineteenth-century European anthropology and popular culture, which looked backwards to lost origins as Gauguin himself was prone to do.

None of this of course is to deny the existence of personal flaws and self-serving sexual behaviours on Gauguin's part, behaviours that are at the root of many of the present-day calls to 'cancel' him from our cultural memory. His crude response to the easy availability of sex in Polynesia, much quoted in the literature that defines him as sexist and racist, is indeed central to the part of his identity that constituted him as a privileged white European male of his era.[34] But distinct from that cohort and identity, I argue, other less normative aspects of his life experience had prepared Gauguin to entertain and even identify with the profoundly different roles that women had played and the spiritual and communal powers they had exercised in pre-colonial Polynesia.

Gauguin's openness to such thinking would have grown in part from his own experience, atypical in the West, of the role of strong women in the family structure; and once again the precedent, example and teachings of Flora Tristan were formative. The early nineteenth-century Saint-Simonian quest for a female messiah and that group's conception of a dual bi-gendered god were ideas that

OPPOSITE LEFT (FIG 4)
Two women (Deux femmes en robes rouge et bleue) c 1901–02
oil on canvas
73.7 × 92.1 cm
The Metropolitan Museum of Art, New York. Gift of Walter H and Leonore Annenberg 1997; Bequest of Walter H Annenberg 2002, 1997.391.3

OPPOSITE RIGHT (FIG 5)
Henri Lemasson
Not titled (inscribed 'vieille et jeune tahitiennes') 1897
photo print on aristotype paper
image 13 × 18 cm
Musée du quai Branly – Jacques Chirac, Paris, PA000144.15

ABOVE (FIG 6)
Two Tahitian women (Deux femmes tahitiennes) 1899
oil on canvas
94 × 72.4 cm
The Metropolitan Museum of Art, New York. Gift of William Church Osborn 1949, 49.58.1

Gauguin in fact associated with his grandmother.[35] Tristan, in turn, had created her own more activist version of the Saint-Simonian woman messiah in her novel *Méphis* 1838, where she assumes the form of an inspirational guide who will lead humankind to a better and more egalitarian future.[36] And in her journal *Le tour de France* 1844, published posthumously, Tristan recorded the gruelling journey she undertook at the end of her life to promote the founding of the Workers' Union and to rally the proletariat to the causes of feminism and socialism. Here Tristan resurrected the idea of the woman guide, grown now into a spiritually powerful and messianic figure with whom she fully identified.[37]

The history of Gauguin's own mother and grandmother, who for different reasons had had to raise children without the support of their husbands, may also have led Gauguin to expect or take for granted that Mette Gad (1850–1920), the strong and well-educated modern woman from Denmark whom he had married, could do the same.[38] Writing to Mette in 1887 about their separation and his inability to support the family, Gauguin declared: 'Whatever may be invented, no one will hit on anything better than a united family, and for that a head cannot be dispensed with: I want that head to be the wife, but she should have all responsibility and the task of feeding the family'.[39] This unconventional pronouncement, whether self-serving and masculinist on Gauguin's part or liberating and feminist (a distinction not always easy to make), could only have fuelled the ongoing struggles between them over traditional male and female roles within marriage.

Gauguin's literal as well as theoretical abandonment of western family life and its responsibilities has long been an issue in the critical literature and continues to provide fuel for his detractors. My goal in revisiting it here is not to condone Gauguin's role in what was clearly a bad marriage in European terms. Nor is it to deny that Mette, though competent, resourceful and successful in the end, was bitterly resentful and rightfully considered herself and the children she struggled to raise to have been misused and abandoned. My aim is not to take sides as many have done in the literature[40] but to draw attention instead to the complexity of their situations in an era of shifting gender roles and social mores. Gauguin himself ruefully acknowledged the volatility of these shifts, glimpsing at the end of his life the new twentieth-century's swiftly approaching liberation from the old orthodoxies and 'civilised' values that at great price to himself and others he had sought to challenge. 'It looks to me', he wrote, 'as if morality, like the sciences and all the rest, were on its way to a quite new morality which will perhaps be the opposite of that of today. Marriage, the family, and ever so many good things which they din into my ears, seem to be dashing off at full speed in an automobile.'[41]

—

Given the mounting influence of present-day critiques that exhort us to 'cancel' Gauguin and cease looking at his art altogether, I would ask that we consider why it is that Gauguin's progressive and feminist cultural positions have for so long been forgotten or ignored in the art-historical literature? And why do they continue to be ignored by his critics today? As late twentieth-century feminists were the first to point out, the mythic legend of Gauguin's South Seas 'paradise' and the glorification of his modernist primitivism were inventions at odds with the realities of nineteenth-century colonial occupation. They were inventions of a patriarchal system that, throughout much of the twentieth century, used Gauguin's art and that constructed romantic image of him to enhance its own values and its own power. But to what

extent, we should now ask, were Gauguin's life and art selectively appropriated by the patriarchy to serve its own purposes, foregrounding only what was compatible with its own ideology and burying the oppositional stands that, however imperfectly, Gauguin did try to take?

How did Flora Tristan's grandson threaten patriarchal thinking? What about him needed to be suppressed—and *was* suppressed by the masculinist mythologies that were constructed around him by an earlier era's patriarchal art history? If we go on ignoring these questions, we will unwittingly be providing support for the binary exaggerations and unnuanced pronouncements of today's cancel culture. To counter and rebalance the ahistorical excesses of that culture, art historians in the twenty-first century must continue to create for Gauguin an expanded critical framework in which contradictions and complexities can be permitted to play their part, a framework that is multifaceted rather than monolithic, and which will allow us to recognise the ways in which Flora Tristan's grandson and his art were positively shaped by his family history and by the evolving feminisms of his own era.

This essay was originally published in *Paul Gauguin: the other and I*, exhibition catalogue, Museu de Arte de São Paulo (MASP), São Paulo, 2023, pp 65–78. It was adapted from my earlier study 'Flora Tristan's grandson: reconsidering the feminist critique of Paul Gauguin' where the reader will find further development of issues that are raised here. See Norma Broude (ed), *Gauguin's challenge: new perspectives after Postmodernism*, Bloomsbury Visual Arts, New York & London, 2018, pp 69–100.

Miriama Bono

Imagining a reconciliation beyond myth and polemics

Miriama Bono is a Polynesian artist, curator and architect. She was the General Delegate of FIFO, the International Oceanian Documentary Film Festival, from 2010 to 2014, and became the association's President in 2015.

She was appointed Director of Te Fare Iamanaha – Musée de Tahiti et des Îles in 2017. During her tenure she took charge of renovating the museum, overseeing building work and coordinating international cooperation projects that led to the return to Polynesia in 2023 of 20 major pieces of Polynesian heritage from the collections of the British Museum, the Museum of Archaeology and Anthropology at the University of Cambridge and the Musée du quai Branly – Jacques Chirac.

THE WORK OF PAUL GAUGUIN is unknown in Tahiti. For the inhabitants of the capital, Papeete, 'Paul Gauguin' refers to a secondary school, a street or a cruise ship. There is also a museum, currently closed, at Papeari, near one of his earliest dwellings in Tahiti; the prospect of the museum's refurbishment is brought up intermittently. More permanent is the Paul Gauguin Cultural Centre at Hiva Oa in the Marquesas, which opens at the request of its relatively few visitors, most of whom are tourists.

And finally, Gauguin 'is' a few old postcards and some reproductions of his work, particularly of the painting *Vahine no te vi* 1892 (*Woman of the mango*, Baltimore Museum of Art, fig 1).

Paul Gauguin and Tahiti: the topic is redolent of bygone polemics. One is bound to cite his relations with the French colonial administration, the church, with Polynesians, with women and notably with young girls. This last group is practically the only one on which Polynesian opinion is heard or consulted today. With the exception of a few connoisseurs, intellectuals or guides, Polynesians are not much interested in Gauguin. As the author and anthropologist Jean-Marc Pambrun noted in 2003, Paul Gauguin the man 'engendered little [in Polynesia] beyond vague and unreliable anecdotes'.[1]

Westerners are often astonished by this attitude, somewhere between indifference and rejection, so closely do they associate Gauguin the artist with Tahiti and the Marquesas. But those sentiments are easily explained. Few Polynesians have had any chance to see his works; there are no Gauguin paintings in the islands, and the few remaining objects or drawings attributed to him are not exhibited. Consequently for the Polynesian public the only representations of Gauguin they may encounter are the polemics about the man and those inevitable postcards and reproductions; the latter are often mediocre and constitute a hindrance to the appreciation of Gauguin the painter—particularly since the reproductions known in Tahiti tirelessly perpetuate the myth of the passive, languid, lascivious *vahine*: woman/wife.

It is often by chance—for example, on a trip abroad—that the privileged few Polynesians are lucky enough to discover Gauguin the painter. They are astonished to recognise the vivid colours, so characteristic of their islands and the unique quality of light there. The landscapes depicted feel undeniably familiar but also possess a mystical dimension. And this is probably what will most appeal to them; that strange sensation of connection and familiarity enhanced by Gauguin's evocations of the natural and spiritual environment.

This spiritual dimension is reinforced by the Tahitian titles Gauguin gave certain of his works, with references immediately intelligible to Polynesians, such

FIG 1
Vahine no te vi (Woman of the mango) 1892
oil on canvas
73 × 45.1 cm
Baltimore Museum of Art.
The Cone Collection, formed by Dr Claribel Cone and Miss Etta Cone of Baltimore, Maryland, 1950.213

Imagining a reconciliation beyond myth and polemics

as those to the goddess of the moon, Hina, or to *tupaupau* (spirits). His use of Tahitian, as the ethnolinguist Hiriata Millaud pointed out in the catalogue of the exhibition *Ia Orana Gauguin*,[2] deserves a research project all to itself; the results would surely be fascinating. Gauguin's representations of the Marquesan *tiki* found in certain of his works are also revealing (p 78, p 205). The *tiki* is a very special figure; for Marquesans, it is a representation of the deified ancestor, the First Man. As Tara Hiquily and Christel Vieille-Ramseyer put it, 'Neither wholly divine nor completely human, Tiki is [...] a central figure in the Polynesian foundation myths. Often considered the first man or at least the origin of humankind, *tiki* is sometimes identified with other mythological entities from the Pacific, Tāna or Māui.'[3] *Tiki* can have two faces, one good-natured and benevolent, the other dark and hideous. He is represented in many forms: as an anthropomorphic statue on any scale from the monumental to the miniature (in stone or in wood), as a variable form used in the decoration of precious, martial or everyday objects, and in tattoos. He can also be represented partially: eyes, body or limbs can be assembled in different combinations (p 79).

In short, the representation of *tiki* is essential to Marquesans and takes multiple forms in their sacred repertoire, using a complex and refined graphic language that Gauguin partially adopted. This appropriation of the Marquesan graphic code prefigures the inspiration that *tiki* was to become for Polynesians and indeed internationally, through the language of tattoo.

Tiki, the deified ancestor, is the bearer of *mana*. As Alain Badadzan observes, 'this supernatural power is the very substance of the divine, but it also designates an infinite number of states, each characterised by a form of ideal completeness or finality. Thus *mana* can also be found at the roots or indeed at the endpoint of any form of creation or growth.'[4] Humans, too, are bearers of *mana*, which varies in strength according to their proximity to the gods and the world of *po*. Badadzan goes on to say that 'humans, the last-born of the gods, are deprived of immortality. Their domain is that of the *ao*, the world of light, a profane world compared to that of the *po*, which is both the time of genesis, the nocturnal world, and the dwelling of the gods. *Po*, associated with original darkness, is also the land of the dead.'[5] An *ari'i* (chief), warrior or priest can carry great *mana* within them. On their death, the *mana* remains present in their hair, teeth and bones, but can also be captured within *tiki*, statues or *ivi po'o* (small bone cylinders carved with the *tiki* form, p 81). This belief remains firmly enrooted and *tiki* are still respected and indeed feared. Gauguin was undoubtedly aware of this belief and the use of the *tiki* in his work is highly significant. It contributes to the mystery and spirituality expressed in his paintings and which form an integral part of the Polynesian conception of the world today.

His representation of the natural environment and particularly of trees such as the breadfruit tree is both highly evocative and familiar and full of meaning for Polynesians. The *tumu'uru*, the breadfruit tree, has been essential to Polynesians' survival, particularly during periods of famine. Mastering the breadfruit's ripening cycle, its transformation and conservation, was life-saving lore in Tahiti and in the Marquesas. An oral tradition transcribed in Teuira Henry's work *Tahiti aux temps anciens* (Ancient Tahiti) includes the legend of Rua-ta'ata, who sacrificed himself by changing his body into breadfruit to feed his family.[6] Rua-ta'ata's sacrifice speaks to the breadfruit's symbolic importance, which is widely present in Polynesia. Its fruit is still frequently consumed and the *tumu'uru* remains an important and symbolic tree.

Thus for the Polynesian viewer lucky enough to come face to face with Gauguin's work, his painting is full of familiar references. Yet very few have that opportunity and for most his work is confined to blurry images associated with the tourist sector. For in Tahiti Gauguin's name sells things as everywhere else. In this context, it is not surprising that his name indicates a cruise ship and a museum awaiting revival, both of which cater mainly to tourist demand. While Polynesians and Polynesia are supposed to lie at the heart of the painter's corpus, they have little way of discovering this and therefore show little interest in it.

Gauguin the artist, meanwhile, however little known in Polynesia, is a catalyst for many fraught issues. The paradoxical nature of his work casts light on certain contemporary problems, in particular that of collections of Polynesian artefacts. While his paintings represent Tahitians and Marquesans and their symbols are integral to those works, they almost never see them or the large number of Marquesan or Tahitian objects in museums many thousands of miles from where these works originated. Those collections are now considered 'embassies of culture' and are mainly owned and exhibited in Europe where the objects are admired for their beauty or exoticism. They have become 'works of art' sometimes still described as 'primitive' or 'tribal': collectable objects disconnected from their original and primary signification and their cultural representation. And Polynesians have very little access to them, as with Gauguin's works. One often reads that Gauguin was disappointed on arriving in Tahiti to find so few traces of the ancient civilisation he had come to discover. We understand his disappointment—imagine that of Polynesians who now have such very limited access to their own roots.

The exhibition *Gauguin's World: Tōna Iho, Tōna Ao*, held in the Pacific, will surely elicit questions about the paradoxes of Gauguin the man. It is also a vital opportunity to speak out about cultural artefacts' circulation and the nature of local heritage and to illuminate notions of sharing and decolonisation. Shouldn't Polynesians have the opportunity to emerge from clichés through which we have been represented? Put simply, we can't take a view on Gauguin's corpus because we can't see it. I want this exhibition to provide an occasion for interrogating the posterity of Gauguin's work among Pacific populations, more particularly among Tahitians and Marquesans. As Jean-Marc Pambrun pointed out during the conference on Gauguin and his heritage at the University of French Polynesia in 2003: 'until Polynesian artists have asserted their own identity and paid homage to their people or culture, at least until they are at peace with themselves, the notion of passionately devoting themselves to a foreigner in this wave of universality cannot help but seem futile and incongruous'.[7]

Pambrun was something of a pioneer in this line of thought, about which he wrote a theatre piece in 2004 that was published in 2009. In his words, 'The setting for *Les parfums du silence* [*Perfumes of silence*][8] is the Marquesas on 8 May 1903, the day of Gauguin's death. His decease is mourned by his Polynesian friends but gives rise to reflections about a people's identity, culture and future.'[9] In Pambrun's play, Marquesans speak, not westerners, allowing the playwright to turn their gaze back on the West and give voice to those too rarely asked for their opinion.

More recently the artist Kanaky created a series of screenprints, *C'est fini avec Gauguin* 2015 (*It's all over with Gauguin*, Private collection, fig 2). The prints were on a variety of supports: wood, metal, paper. Some became posters in the Papeete streets. Under the influence of Andy Warhol, Kanaky wanted to dispense with facile clichés; he reused images from postcards widely diffused in Tahiti during

the 1990s, interrogating 'limits of copyright and the acceptable'.[10] His objectives took the form of the question 'Am I capable of consistently bringing Gauguin back to life and providing a sequel to his work?'[11] The series was inspired by the painting *Tahitian women* 1891 (p 197) and had considerable success across the island.

It was the work of Yuki Kihara, though, a Sāmoan representing Aotearoa at the Venice Biennale 2022, that most clearly highlighted this change of paradigm. Turning Gauguin's work and frames of reference upside down—not least his personal life—Kihara utilised Gauguin's fame to raise questions she finds essential: transgenderism and global warming in Oceania. With humour and assurance, Kihara staged Gauguin paintings with the latter's female protagonists replaced with *fa'afafine* (cross-dressing men; literally 'in woman-style'). Her photographic and video productions are part of *Paradise Camp*, a flamboyantly coloured project avoiding the characteristic solemnity of that form.

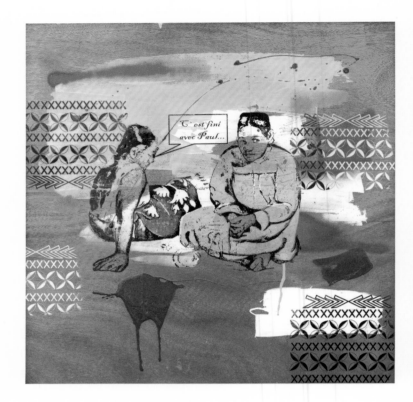

Forthright colours and brash light in Kihara's photographs taken in Sāmoa are very similar to those attributes in the Gauguin works she appropriated. After *Paradise Camp*'s presentation in Venice, she exhibited variations in Australia and then in Sāmoa. This Pacific 'tour' generated the opportunity to organise Talanoa forums: spaces where artistic and academic communities dialogued freely about Oceania's contemporary social problems.[12]

I like to think that Kihara appropriating Gauguin's name and work to explicate Oceanian problems (rather than promoting the tourist industry) is consonant with the painter's personality and his tendency to express solidarity with local peoples, especially in his later years in the Marquesas. One can't help thinking that her programme was a legitimate use of his fame—in short, that Gauguin was 'fair game'.

His name and work, no less than the names Tahiti and the Marquesas, seem to hold an undying fascination while inspiring polemics and controversy in equal measure. *Gauguin's World* is a powerful symbol for the Pacific and is an opportunity to see Polynesia from new perspectives, to provide Polynesians with the microphone and to reflect on contemporary problems, in particular that of cultural reconquest. It also provides an opportunity for those privileged Polynesians who are able to see the exhibition to decide whether they recognise themselves in Gauguin's work—that is, the opportunity to encounter that famous artist and painter, Paul Gauguin.

FIG 2
Kanaky
C'est fini avec Gauguin
(*It's all over with Gauguin*) 2015
screenprint with aerosol spray
paints on plywood panel
60 × 60 cm
Private collection